THE GOOD HOME

INTERIORS AND EXTERIORS

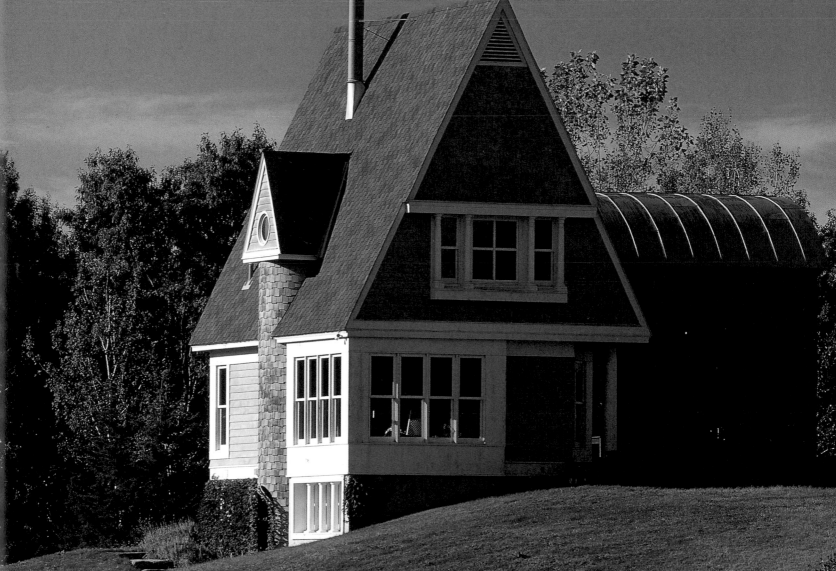

THE GOOD HOME

INTERIORS AND EXTERIORS

by Dennis Wedlick
Written with Philip Langdon

Art Director: James Pittman

First published in 2001 by HBI,
an imprint of HarperCollinsPublishers
10 East 53rd Street
New York, NY 10022-5299

Distributed in the U.S. and Canada by
Watson-Guptill Publications
770 Broadway
New York, NY 10003-9595
Tel: (800) 451-1741
 (732) 363-4511 in NJ, AK, HI
Fax: (732) 363-0338

ISBN: 0-8230-2096-7

Distributed throughout the rest of the world by
HarperCollins International
10 East 53rd Street
New York, NY 10022-5299
Fax: (212) 207-7654

ISBN: 0-9679143-2-9

Packaged by:
Grayson Publishing
James G. Trulove, Publisher
1700 17th Street, NW, Suite 505
Washington, DC 20009
Tel: (202) 387-8500
Fax: (202) 387-6160

Printed in Hong Kong

First Printing, 2001

3 4 5 6 7 8 9 /02 01

HALF-TITLE PAGE A perspective of the Maple Grove House,
which was the author's first house design.

TITLE PAGE This house in Kinderhook, New York, is the author's
weekend retreat.

ACKNOWLEDGMENTS

With thanks to all those who helped over the years with the
creation of this book: Jenny Allen, Alan Barlis, Chris Blake,
Kathy Chang, Paul Dreher, Gideon Gelber, Jeff Goldberg, Kelly
Ann Heeralal, Barbara Heller, Chris Hunt, Il Kim, Janet Mason,
Namita Modi, Nathan Monger, Anu Shah, Erica Stoller, James
Grayson Trulove, Gloria Hwang, Steven Wright

. . . and especially my partner in life: Curtis DeVito

Very special thanks to all my clients, who were so patient and
generous, for allowing their homes to be decorated and
photographed for this book.

ILLUSTRATION CREDITS

All images not otherwise credited are by Jeff Goldberg/Esto.

King Au: 45, 53.

Antoine Bootz: 98, 100, 101.

Louis Blanc: 29, 34, 37, 41.

M. Fredericks: 41, 54, 64, 65, 79, 82, 108, 115, 125, 193.

Thomas W. Schaller: 52, 140, 141, 142, 143.

Wayne Sorce: 42.

Dennis Wedlick: 1.

Photography by Jeff Goldberg/Esto: 5, 32, 180, 181, 182, 183,
186, 189. Courtesy *Architectural Digest*. © 1998 The Condé Nast
Publications. All rights reserved. Used with permission.

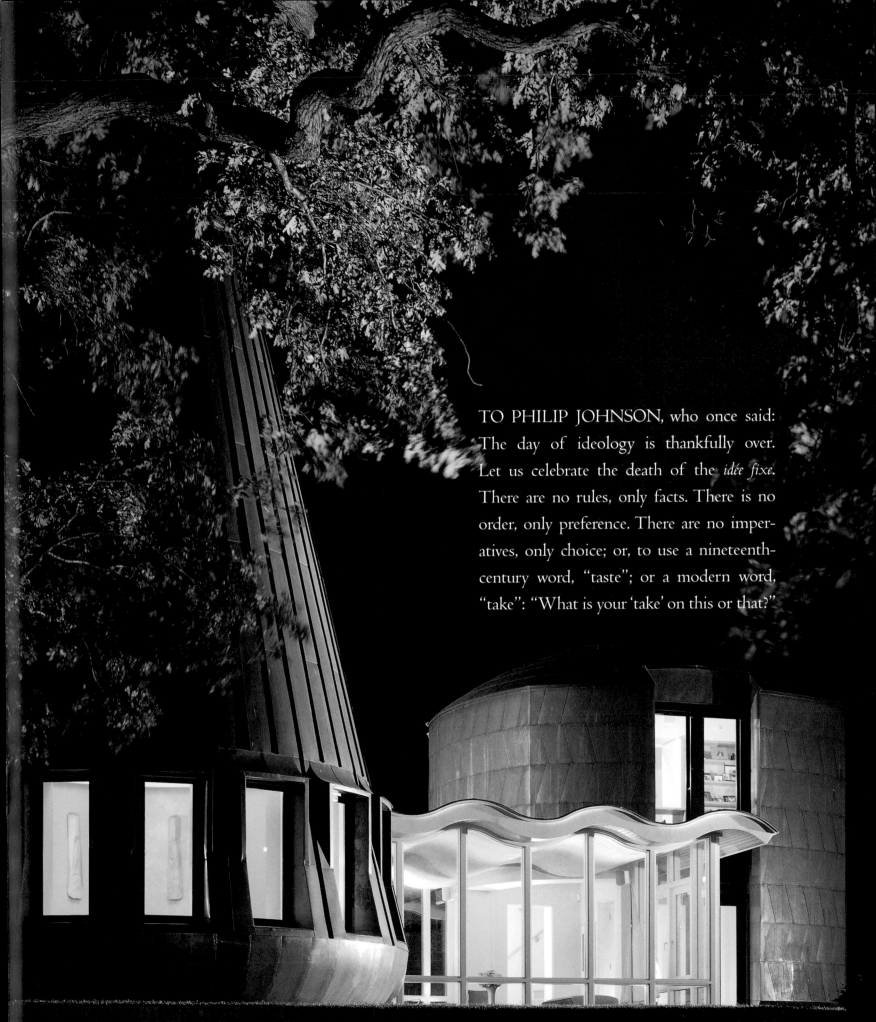

TO PHILIP JOHNSON, who once said: The day of ideology is thankfully over. Let us celebrate the death of the *idée fixe*. There are no rules, only facts. There is no order, only preference. There are no imperatives, only choice; or, to use a nineteenth-century word, "taste"; or a modern word, "take": "What is your 'take' on this or that?"

TABLE OF CONTENTS

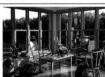
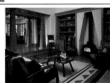
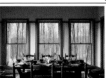
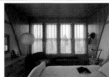
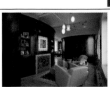

EXTERIORS PAGE 106

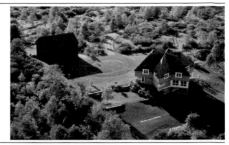
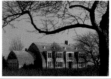
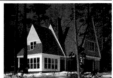

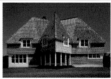

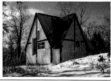
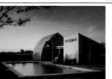

CREATING THE GOOD HOME
A RETURN TO THE PICTURESQUE

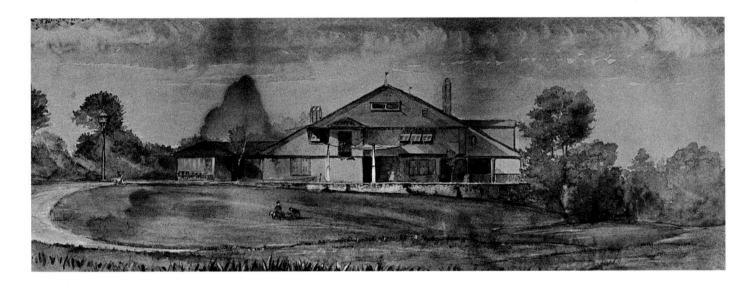

What is a "good home"? To me it is, above all, a house imbued with soul, a house whose character arouses emotion and sentiment. You might think that a quality of this sort would be the most natural thing in the world to find in a home, but the fact is, many of today's houses have no soul.

The majority of people in this country are exceedingly well housed in physical terms. In the last thirty years the median size of a single-family dwelling has grown 50 percent, to 2,225 square feet. Houses deliver previously unheard-of levels of climate control. Sophisticated entertainment, lighting, and safety systems are easily had. Kitchens are well-equipped and are designed increasingly not just as food preparation areas but as gathering spaces. Children typically sleep in their own bedrooms, and many have their own baths. There are more bathrooms per house in the U.S. than anywhere else on earth—over half of the new dwellings in America contain at least 2 ½ bathrooms. Master bedrooms have expanded to such an extent that they are often termed master suites, containing separate sleeping, dressing, and sitting areas.

But the idea of creating houses that are expressive—houses that engage people's feelings and arouse their imagination—has received less attention. This is a shame, for no matter how up-to-date its equipment or how generous its square footage, a house will turn out disappointingly if it does not resonate with our emotions. I believe a house should be romantic. It should stir a response. In this book, I try to give you a sense of what a house with soul can be, and some understanding of the techniques you can use to create such a house. You'll get a taste of the elements and compositions that generate satisfying houses, and learn some language you can use to communicate those ideas. This book does not attempt to answer every question that could be asked, but it will give you an introduction to important ideas and techniques, drawing from a portfolio of houses of my design.

Expressive Houses of the Past

Throughout history, houses have been expressive in a variety of ways, and have conveyed many different ideas, attitudes, and moods. Their inspiration has come from the materials they used, the shape of the surrounding landscape, the aspirations of the builders, and the character of the owners, to name just a few of the starting points. Expressiveness can be found, in muted form, even in some of the houses that by historical standards were quite restrained. Look at a classic American house form: the New England center-hall colonial, which the descendants of Puritan settlers built in the eighteenth and early nineteenth centuries. These houses rigorously avoided flamboyance. Their whole character was based on the use of highly regular, visually balanced forms. Often the main doorway was positioned precisely in the center of the facade, flanked by symmetrically arranged windows. Most exterior walls were simple rectangles clad in shingles or clapboards. Above the walls rose an uncomplicated gabled roof of moderate pitch. The houses were an idealized portrayal of New England's founding establishment—Congregationalism condensed into carpentry. Visually harmonious with their neighbors, purged of every excess, the houses rejected romantic and individualistic impulses. And yet their very sobriety and restraint were, in a way, expressive. It is impossible to look at these dignified houses, with their profoundly orderly facades and equally orderly interiors, and not gain some respect for their inhabitants' attitude toward life. The houses communicated,

TOP Sayrelands, a center-hall house built in Bridgehampton, New York, c. 1775.

BOTTOM Benjamin Hall Jr. house, a more elaborate, Georgian version of center-hall design, built about 1785 in Medford, Massachusetts. These rigid classical designs were, and continue to be, the most common choice for the conventional homebuilder.

FACING PAGE The Prescott Hall Butler house, a picturesque design in the Shingle Style, built in St. James, New York, by McKim, Mead, & Bugelow, 1878-80. The asymmetrical, seemingly haphazard, composition made this house appear shockingly casual for the times. Its playful informality was quickly imitated by the well-to-do for all their vacation homes.

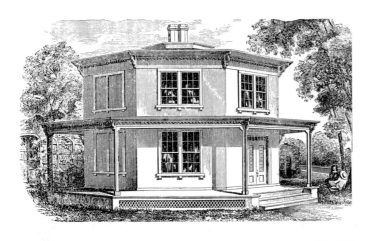

ABOVE *The Octagon house, residence of John J. Brown in Williamsburgh, New York, designed by Morgan and Brothers and publicized by O.S. Fowler, c. 1870. Daring and innovative, this Picturesque design developed a nearly cult following among those who wished for something new.*

through their discipline and exactitude, the same outlook that local ministers propagated through sermons. Such houses must have been a tremendous source of satisfaction to their owners. To sit in well-ordered, unostentatious rooms where natural light sifted through eight-over-eight windows was to occupy a place of moral certitude. So New England center-hall colonials had soul after all. Their uncomplicated straightforwardness has made them much admired and copied even today, though I would question whether houses designed this way express current lifestyles and culture.

The Picturesque Movement, which began to influence American houses by the 1840s and 1850s and which included the Shingle Style, the Stick Style, the Queen Anne style, and Japanese influence, made a striking contrast against the disciplined New England colonials. Probably the finest genre of the Picturesque was the Shingle Style, which swept across coastal sections of the nation in the late nineteenth century. This style conveyed a comparatively relaxed and indulgent feeling. Unlike early New England houses, which seemed intent on resisting any laxness, Shingle Style dwellings gave the impression of basking in their seaside settings. They were perfect for affluent post–Civil War families intent on enjoying scenery, imagination, creature comforts, and respites from work.

The Picturesque movement continued to influence the design of houses into the early twentieth century, a period in which the train, the streetcar, and the automobile were bringing about the new residential landscape of suburbia. In the suburbs, elaborate custom-built detached houses were built at an unprecedented rate. At first, suburbs were created mainly for the affluent upper middle class, featuring houses that, even if they were moderate-sized and on modest lots, were sometimes designed to appear to be country manor houses. The look of these homes ranged from the popular Tudor and Spanish Colonial to styles newly invented by contemporary architects such as Greene and Greene, Bernard Maybeck, Julia Morgan, and Frank Lloyd Wright. Styles were often chosen without regard to context, reflecting instead the whims of the owners or their architects. A house in California might appropriately resemble a Mediterranean villa, but so too might one in the very un-Mediterranean climate and topography of Westchester County, New York. Architects whose work was far more inventive and personal relished the visual shock of their elaborate follies.

After World War II, large speculative developments for the working class began to spring up in the outlying suburbs. For affordability's sake, simple, crude, repetitive designs such as the "Cape Cod" and the "ranch" were built in multiples of hundreds, even thousands. At the same time, the architectural community abandoned its admiration for the picturesque and turned to the machine esthetic of the Modern Movement. Practicality, cost, and taste considerations prevented the Modern style of glass, metal, and masonry from wielding much impact on the majority of houses. Without interested patrons, talented architects were forced to pursue their new love mostly on the drawing boards, removing themselves further and further from human connection. And without creative architects, house designs were reduced to the most mundane, easily copied models. Even today, most homes are built from pre-packaged house plans that vary little from design to design, creating a landscape of sameness across the country.

Though houses inevitably borrow some ideas from earlier dwellings, the good house is not, at heart, an imitation. It is a house shaped by the desires and visions of its owners and by the character of its setting. To truly have soul, a house must express the nature of the people who live in it, their aspirations or fancies, convictions about architecture, landscape, or other matters. The house must have what an art theorist would call "content." A huge range of ideas and feelings—from restraint and dignity to friendliness and openness to seclusion and mysteriousness—can be communicated through a good house.

Opportunities for Personal Expression

When a small part of the world is shaped precisely as we would wish it to be, an almost magical sensation arises—a feeling of enchantment. This is one of the magnificent rewards of the good house. Let me give you an example from my own experience from my personal life. A few years ago I designed a small, shingled house in the Hudson Valley where my partner Curtis DeVito and I could retreat from New York City at the end of the hectic workweek. The budget for the house was limited, therefore the interior had to be easy to build and relatively compact—containing a small basement for utilities, a 400-square-foot ground floor, a two-room second floor, and a tiny third-floor loft. Despite its small size, the house is in no sense impoverished. For me (and, as far as

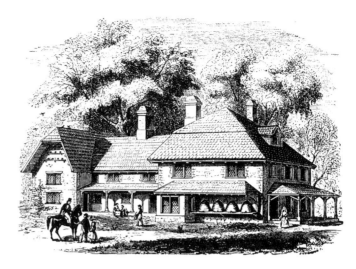

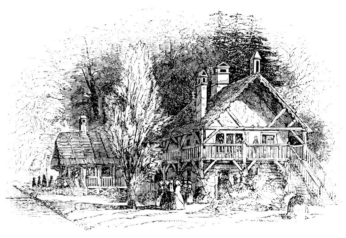

TOP Architect Andrew Jackson Downing's elaborate concept for "A Northern Farm House," c. 1850.

BOTTOM Downing's sketch of "A Picturesque Swiss Cottage," c. 1850. Downing is known as the father of the Picturesque movement in architecture. Picturesque elements and powerful imagery are evident in every one of his designs.

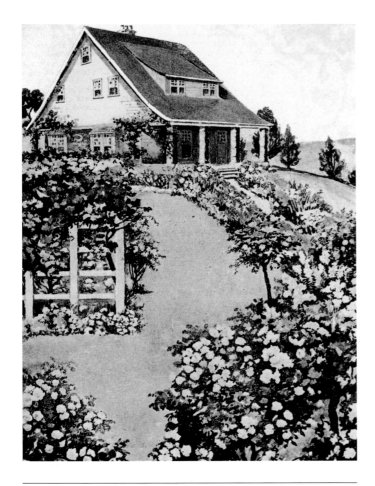

ABOVE A house and rose garden by Gustav Stickley, c. 1912. Stickley brought the aesthetics of the Picturesque into the twentieth century. As a modern man, he chose to emphasize maximum visual effects with minimum effort.

I can discern, for everyone else who has visited it), the house exudes feeling. On some nights, I've gone outside and stood with my head tilted back, silently gazing up at a single, picturesque little dormer that projects from the plunging roof. Just contemplating that playful, slightly odd dormer in a steeply pitched roof beneath the star-filled rural sky invariably affects my mood. Standing there, I find that the tensions and annoyances of the day dissipate. I can think only good thoughts.

That's what a house with soul can do. It can stimulate the imagination and refresh the spirit. The real question is why so many houses are built without feeling. When you were a child, most likely you had a keen, if unspoken, awareness that certain houses were charged with feeling. Some houses seemed to have an air of mystery or foreboding. Others were lighthearted. Some were fun to be in, others dull. Some could provoke a smile. Others seemed gloomy. It was hard not to notice the power of an interesting house.

Then you grew up. You learned about practical matters—storage space, laying out the kitchen around a work triangle, anticipating the traffic flow, and other functional considerations. Contractors and suppliers of household furnishings steered you into the realm of components—cabinetry, doors, windows, sinks, flooring, moldings, wall coverings. In the face of so many choices and such insistent practicality, your romantic instincts receded. Even in custom houses, it is common for only a small amount of attention to be paid to imaginative and evocative qualities—qualities important to our spirit. The solution, in my judgment, is to take practical and functional matters into account but remember that they do not constitute the sum total of house design. You can have a house that provides the spaces and amenities you want and stays within your budget, but is also expressive.

Return to the Picturesque
The kind of house I've come to love the most, and have come to identify as the antidote to lack of expressiveness, is most accurately described as picturesque. Picturesque is an old term. In the sense that I use it, it is not a synonym for "pretty." In the nineteenth century, when houses in "the picturesque style" were advocated by architect Alexander Jackson Davis and landscape designer Andrew Jackson Downing, the word had a very specific meaning. A picturesque dwelling was one that had irregular or unexpected

features that caught people's attention and engaged their interest. The English writer William Hazlitt said in the 1820s that "the picturesque is that which stands out, and catches the attention by some striking peculiarity," attracting notice because of contrast. In the 1850s, Baudelaire argued that the beautiful "always contains a touch of strangeness, of simple, unpremeditated and unconscious strangeness. . . . This dash of strangeness, which constitutes and defines individuality (without which there can be no Beauty), plays in art the role of taste and of seasoning in cooking." Restrained buildings like the early New England houses were expressive in their own way, but they did not have the liveliness, the irregularity, the seasoning of picturesque buildings. Like Baudelaire, I believe the liveliness and irregularity of the picturesque yield great emotional rewards.

The picturesque impulse, though referred to by Downing as a "style," has never been limited to a single style in the sense that we use that word today. In the 1840s and 1850s, when the influence of Davis and Downing reached its peak, picturesque designers frequently produced buildings in the Gothic Revival style, also known as the "perpendicular" style because of its strong vertical lines. The Gothic Revival sometimes used pointed-arch windows and doorways to project a dynamic look. It popularized board-and-batten siding, which accentuated the verticality of the exterior. It developed exuberant ornamentation. Whereas the preceding Greek Revival and Federal styles had achieved calmness and tranquillity through a careful balance of horizontal and vertical lines, picturesque designs were more restless and emotive.

The genius of the Picturesque movement lay in its proponents' recognition that buildings could shed their inertness and take on an almost mesmerizing quality. We have an opportunity to recover what was sublime about the picturesque and use it to enhance houses today.

A picturesque architect does not work from a strict, concrete set of principles. Rather the designer looks for ways to make the house arresting, distinctive, and moving. Downing observed that beauty often "grows out of the enrichment of some useful or elegant features of the house." A house's esthetic impact can be enhanced, for instance, by a roof with a shape that departs from the norm; a dramatic roof has a powerful effect on people. It can also be enhanced by a porch or veranda that's handled with flair. It can benefit from giving the inhabitants places for prospect—appealing spots

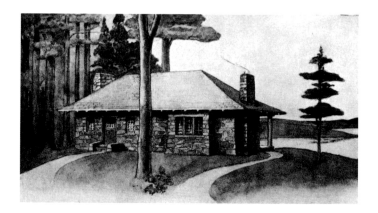

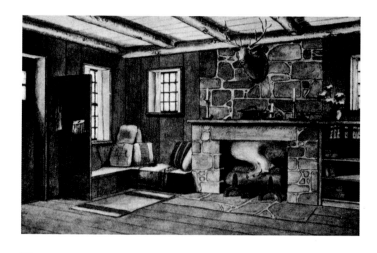

TOP *Front view of a bungalow by Stickley, c. 1909.*

BOTTOM *Chimneypiece and fireside nook in the bungalow's living room. The rustic atmosphere of this small home is established by a few well-chosen details.*

ABOVE A bedroom in the Gothic style, A.J. Downing, c. 1850. The shape of the room is what gives this interior an ecclesiastical, or simply inspiring, feeling.

from which to look out across the landscape or into portions of the interior. The kind of windows and their size and placement can infuse vitality into an otherwise run-of-the-mill dwelling. In one house, I designed a round window that sits at floor level in a landing between the first and second floors. That little window is a constant source of fascination; it's an unusual shape in an unusual place. Although it certainly has a function—dispelling darkness in a stairway and providing a passing view—the main reason it's there is that it makes the staircase and the house feel special.

Certain kinds of spaces are full of feeling—alcoves and window seats, for example. People instinctively love a small, semi-secluded spot where they can envision themselves or their children curling up with a book. Nineteenth-century houses were full of pleasure spots where a person could settle into his or her own little world, somewhat sequestered from the rest of the household yet not completely out of touch.

The height of a room, or of an entire interior, can be exaggerated to play upon people's feelings. The way one room or space connects to another can be handled imaginatively. A bedroom may have sloping walls formed by the underside of the roof, generating a cozy feeling. Another technique is to move the house's main entrance to an unusual location, so that entering the house is a memorable experience. In designing the exterior, it's necessary to think about what obligations the house has to its street or its neighborhood; an isolated country house is relatively free of communal responsibilities, but a house on a city block is part of an ensemble.

These, then, are some of the ideas a designer works with in forming a picturesque house. Any house consists of many elements, and they can be arranged to make living there a joy. The picturesque is mainly an architecture of subtleties rather than thunderous effects. It takes only a few intriguing moves to create a wonderful atmosphere.

I prefer picturesque elements to be objects or spaces that people will use. But in some cases, the mere existence of a special feature, regardless of how little the occupants use it, is enough to make that feature worthwhile. How much time will you spend sitting in a window seat? An hour per week? The amount of time you sit there almost doesn't matter. Just looking at an inviting window seat will give you pleasure. If the anticipation of relaxing in that naturally illuminated little space brightens your mood while you're driving home from work, the house has already added pleasure to your day.

Trusting Your Emotions

The best results are achieved when the designer listens closely to the desires, dreams, and wishes of the prospective homebuyers or renovators. The house is meant, after all, to express your feelings and correspond to your notions of what makes a house alluring. If there is any obstacle standing in the way of the clients, it is their frequent reluctance to say what they would ideally like their house to be. People are accustomed to being told what to want by magazines, builders, contractors, suppliers, and even, sad to say, by some architects. They may conclude that their own instincts must be faulty if they contradict the ideas of professional advice-givers. But the advice-givers frequently hew too closely to what everybody else is doing or to their own long-established routines. Ultimately, you need to have confidence in your tastes and desires.

When I have clients who fear doing anything unusual, it is usually because it may reduce their house's resale value or make them look out-of-step among their friends. I don't insist that such considerations be dismissed out of hand, but I encourage people to plumb their own feelings. If you want satisfaction from your home, think about what fires your imagination. What kinds of feelings do you like in a home? What fantasies do you have of the perfect place? A skillful architect can use this information to discover a "subject" for the house, just as there is often a subject for a painting. For example, one couple that came to me said they liked barns. I didn't use the idea literally to design a barn. Converted barns often do not serve well for human habitation. Instead, I used the idea of a barn—the concept of a large, strong overall form, with window areas projecting from it—to design a house that would have the feeling of a barn and the practicality of a good house.

Renovating or designing a house is an opportunity to make a reflection of you or your household. This can be intensely personal—the architectural equivalent of painting a picture. Each person should write his or her own wish list for the architect. (Individual lists are more revealing and useful for the architect than a compromise list produced jointly by a couple or by an entire family.) The architect can use these insights to find an overall theme for the house and to create vignettes—a series of focal points that suggest something interesting about the house. If the architect performs his job well, the house will brighten the inhabitants' lives and resonate with their personalities.

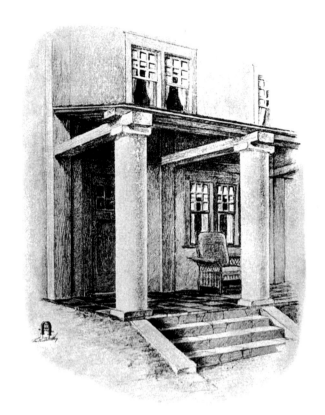

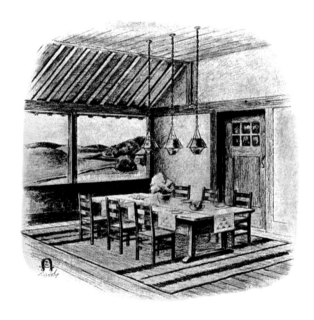

TOP Entrance porch to a house built of concrete, Gustav Stickley, 1909. Although he is most famous for his wooden chairs, Stickley's reputation is based on his ability to express the character of all materials in his picturesque details. Their proximity to the thin wooden awning they support makes the stout concrete posts shown here appear even weightier than they really are.

BOTTOM Open-air dining room by Stickley, 1909. Transparency, shaped spaces, and picturesque details such as the continuous rail trim and ribbing of the ceiling are all evident in this illustration.

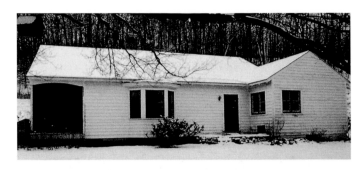

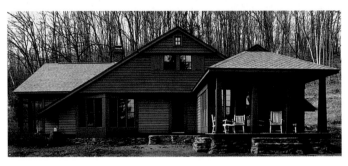

TOP Pumpkin Hill House in the Hudson River Valley (before renovation).

BOTTOM Pumpkin Hill House after a renovation I designed in 1986. The original house had no character. By adding picturesque elements such as the low-slung gable, the prow window, and a porch with tapered columns, the house was transformed into an expression of a rustic retreat.

You can also go about your search indirectly. Ask what sorts of reminiscences you have about houses you've lived in or visited. Tap your positive memories, and your negative ones, for indications of what you might like to have, and not have, in a new or renovated home.

Some desires are easy to acknowledge because they're on the socially-approved list. Expressing friendliness toward the neighbors, for example, is something that few would frown upon. But maybe you're averse to contact with people nearby. It's best to confide that in your architect, who can design the house so that it does not encourage unsolicited drop-ins. If you want the house to impress the world with how well you're doing, say so. Vanity is not the ideal personal attribute, but it's definitely part of the human condition. A good architect can convert such desires into a house that suits your preferences and at the same time minimizes or eliminates negative repercussions. The clever architect sometimes functions as alchemist, turning lead into gold.

People often have contradictory desires. They want a place that is rustic yet modern. They want openness to the outdoors, yet they want seclusion. Opposing wishes are not necessarily difficult to reconcile. I often lay out rooms so that they capture a dramatic expanse of landscape and yet contain areas that have a strong sense of enclosure. Part of the space may feel like the great outdoors, while another part of it feels sheltered. An expressive house can reconcile opposing desires.

Be wary, however, of placing too great an emphasis on function. Sometimes a feature or arrangement that initially seems unjustifiable is the thing that spurs the greatest enjoyment. A loft bedroom, for example, may seem out of the question because it would be small and would have to be reached by ladder. But in fact, climbing up and down from the loft may give a pleasurable sensation. A child, a teenager, or even a limber adult may love a loft; its very novelty contributes to its charm. The fact that a loft is a bit hard to get to may render it more private. There's a lot of subtle emotional content in these decisions. What you thought were straightforward, logical decisions may in fact contain nuances, and these nuances can lead to the house being a great place to live.

Bringing It All Together

An example of how a variety of picturesque techniques can come together is the Maple Grove House, built on land that

one of my clients bought at the base of the Berkshire Hills in western Massachusetts. I was asked to design a house on a knoll in a stand of maple trees (thus the name). The client, a Southerner who had moved north, admired the area's homes dating back to the Federal and Georgian periods, no doubt because their Classical composition reminded him of rural homes in the South from the same period. Though he admired the stately farmhouses, he felt that recreating one of them in his woodland would be inappropriate, so he asked me to design a house that would reflect his admiration for the region's architecture and at the same time be respectful of the enchanting stand of trees.

My response was to organize the approach to the house as if I were writing a screenplay based on images inspired by the client's thoughts and feelings.

Opening scene: A stand of maple trees huddled together atop a snow-covered mound. The remains of an old peg-and-rail fence create a jagged vignette at the base of the hill.

That scene begins to tell a story about the land, which was probably cleared at one time for farming or for grazing livestock and which reverted to woodland after agricultural operations were abandoned. The beauty of the land lay in its isolated, removed quality—a quality the owner wanted to preserve.

Scene Two: Barely visible, concealed by the dense trees, a hovel of a house lies just beyond the hill crest.

This part of the story leads me to design the house as if it were hiding. Surrounded by silver maples, the house has a giant pyramidal roof covered in dark, silvery gray shingles, barely visible even in the dead of winter. Below the roof, which contains more than half of the house's living area, the ground floor is clad in a weathered brown-gray, the color of bark. But this floor is deeply recessed from the roof edge. The roof casts shadow so that the this part of the exterior is shrouded from the eyes of passersby.

Scene Three: What appeared from afar to be a humble encampment resembles a noble temple when seen up close.

Rather than humble, the house is actually surprisingly grand for a woodland cottage. Doric columns support the massive pyramidal roof. Oversized windows, which could not be seen from a distance, come into view, revealing an interior as grand as the roof. The space just behind the front windows is perfectly symmetrical; a dining room rising to a vaulted ceiling lines up with a formal living room which has as its

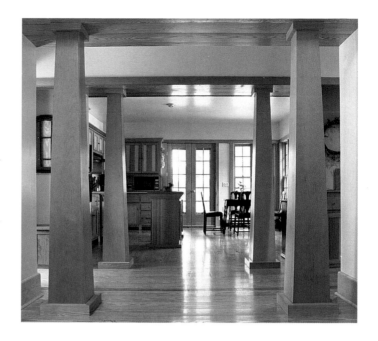

ABOVE Interior of Pumpkin Hill after the renovation. A complete Picturesque makeover can achieve any effect the owner desires. Here, the interior continues the Stickleyesque bungalow theme of the exterior.

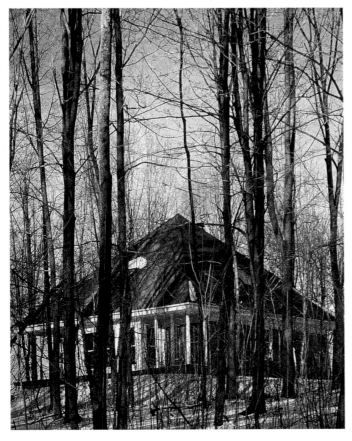

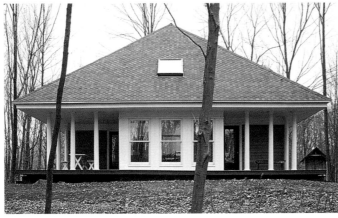

TOP and BOTTOM Maple Grove, a house I designed in 1987 that is located at the foot of the Berkshires of western Massachusetts. From a distance the house is reclusive, barely seen through the trees even in winter. Up close, the house is open and inviting.

focal point a majestic fireplace. Between the living and dining spaces stand two more Doric columns, which support a newel-and-balustrade balcony running the full width of the room below. The colonnade, windows, and balcony were all patterned after Federal and Georgian houses the client admired. Those were proud homes not intended to be hidden in the woods, so I omitted the entablatures and pediments associated with more public-oriented architecture. The way I use the columns, they seem to hark further back than the old Classical-influenced farmhouses built nearby, and suggest the rustic temples of the ancients. Here in the woods, the mind can imagine wooden, pre-Doric pillars standing row upon row, supporting a rustic canopy above a crude statue of a god, as if the maple trees were pillars holding up the sky.

The screenplay was a fitting analogy for this design because the concept behind the house needed to unfold through movement and through the passing of time. That is just one example of how the picturesque approach can work. There are a variety of ways to put picturesque methods into practice, so in this book you will find houses that differ widely in their feeling, style, and landscape. The techniques relied upon by this approach to design are not unique to this particular house; they can be used in many different situations.

Another way of putting it is that a few basic architectural elements may be used in different ways to produce houses that appear to be quite dissimilar. For the house in the stand of maple trees, I paid close attention to a very limited number of elements: mainly the roof shape, the columns, the fenestration, and the entryway. Those elements were carefully chosen and combined to create the look of a humble cottage with a grand flair. These same elements could be combined in a different way or in different proportions to create an entirely different effect. If, for example, this house had just two pillars instead of six across its front, it would have been humble both from afar and from close up. On the other hand, if dormers had been added to the roof, the house would have appeared twice as big. From a distance, it would have seemed grander. The use of shadows cast by setbacks and overhangs could further alter the house's character. In this house, the shadows created by the setbacks and overhangs add a touch of mystery to the house's appearance; but shadows can also add congeniality. The shadow of a large overhang seems to invite passersby to seek shelter from the weather.

Picturesque exterior design is also a matter of making architectural compositions in the landscape. In this example, designing a house to appear hidden in the woods shows how an existing setting can offer an opportunity to create a particular impression, one that springs from the relationship between the building, the topography, and the vegetation. The composition of this house's appearance is severely symmetrical from the front, presenting the formality that was wanted. At the same time it is completely asymmetrical from the left or right side, suggesting informality as you wind your way around it. Through the variety of examples presented in this book, the reasons why the arrangement of windows and doors, and dormers and roofs, needs to be finessed in order to convey feelings and character will become clear.

The picturesque concepts that convey a particular character or mood on a house's exterior can be manifested again on the interior, or they can be reversed if you prefer. In the house in the maples, the feelings conveyed on the outside continue inside, dressing up this modest dwelling through a few tricks of the eye. An inexpensive and small fireplace is decked out in a monumental fashion and set where it forms the main focal point for the entire first floor. Framing the fireplace are two Doric columns, which are unpainted, revealing their low-cost, finger-jointed construction. The transparency of the dining room reveals to an observant person that the inspiration for all the house's slender columns was the surrounding maple trees. The way one room opens to next and then to the outdoors reconfirms that this is a house that is proud of its context.

These, then, are a few of the picturesque interior details and spatial planning techniques that the houses in this book employ. I hope that in these pages you will find inspiration for designing your own good house, a house both filled with feelings and expressive of them.

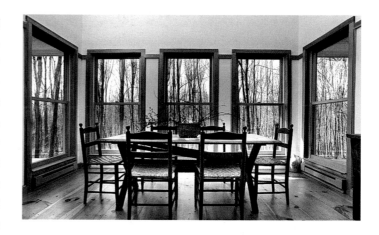

ABOVE The dining room of the Maple Grove House was designed to feel as if it were set in middle of the woods.

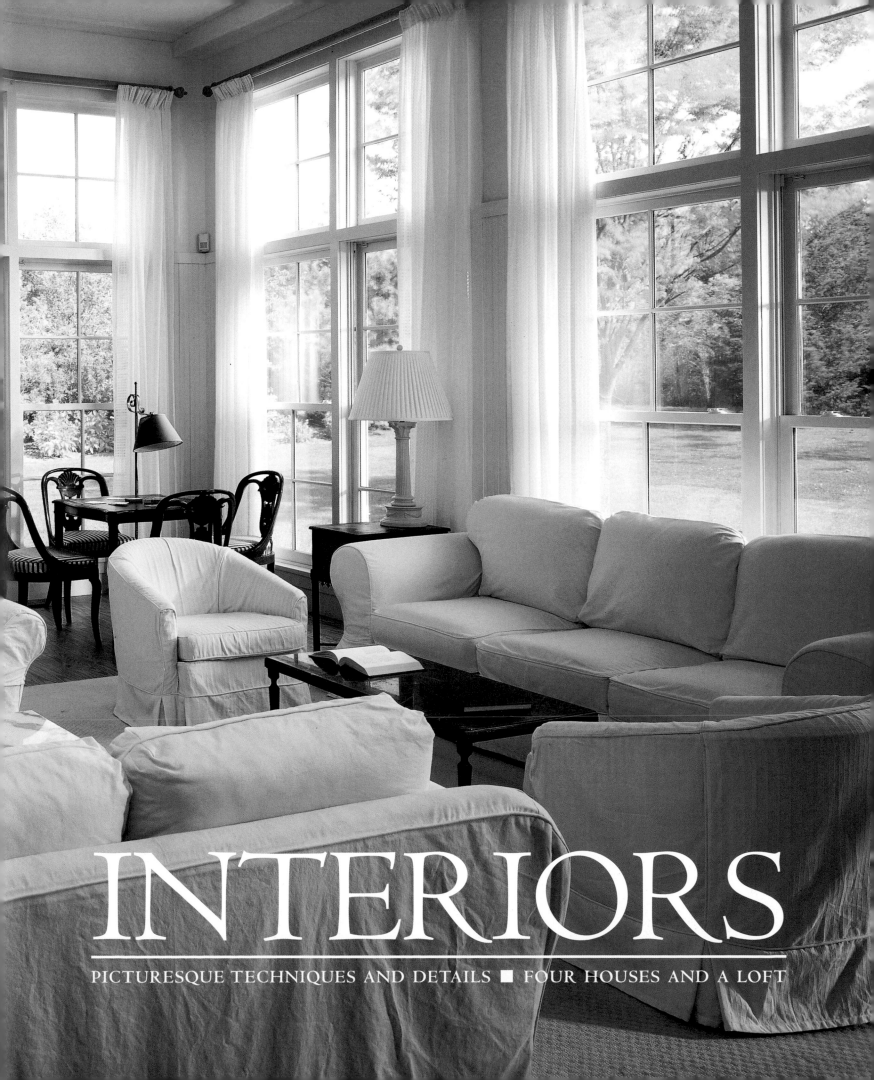

INTERIORS

PICTURESQUE TECHNIQUES AND DETAILS ■ FOUR HOUSES AND A LOFT

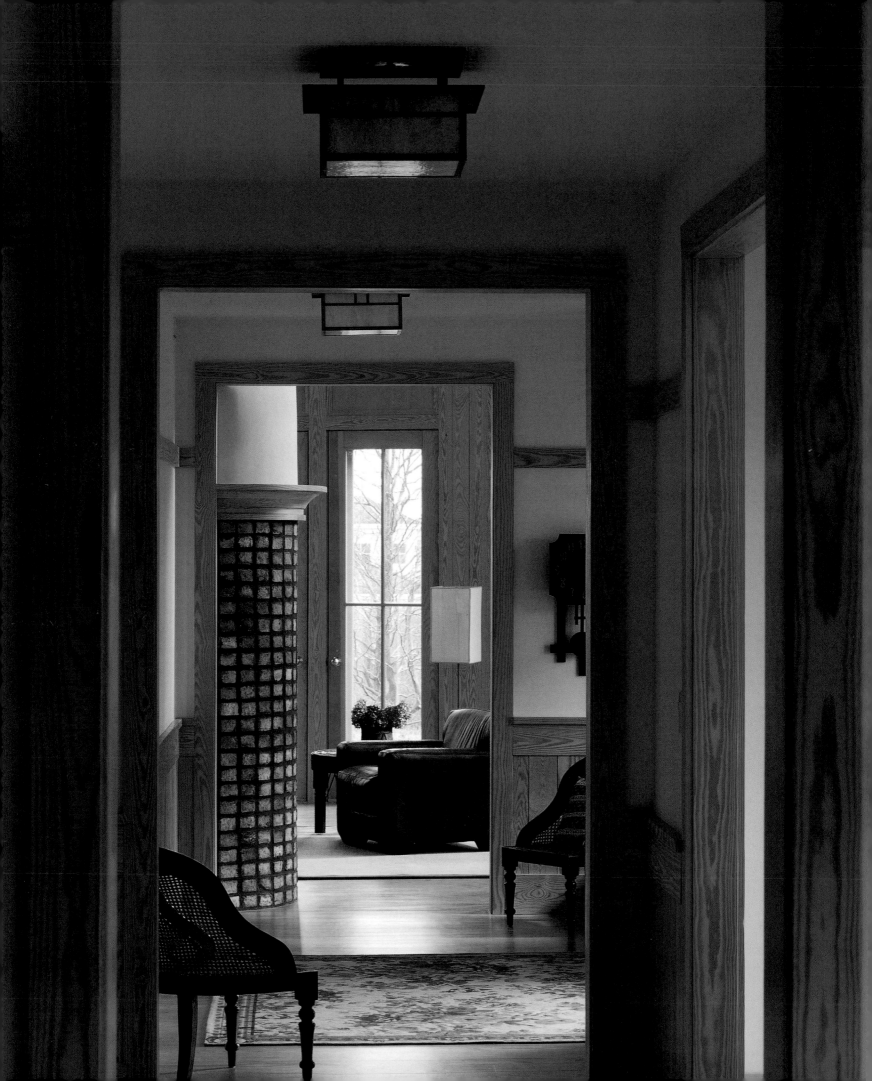

PICTURESQUE TECHNIQUES

FIVE ESSENTIALS CAN GO A LONG WAY TOWARD RAISING A
HOUSE FROM ORDINARINESS INTO THE REALM OF PURE DELIGHT.
THEY ARE: ENFILADE, FOCAL POINTS, TRANSPARENCY, SHAPED
SPACES, AND ENTICING STAIRWAYS.

No matter how small or how large it is, any house can be picturesque. The key is to employ forms and features that stir the imagination and emotions. A picturesque home should generate feelings—feelings of mystery, surprise, *delight*. The single most effective way of doing this is by orchestrating a variety of visual and spatial experiences, always playing on the anticipation of more to come. In a good house, a visitor should sense that there is always something of interest waiting to be explored—around a corner, up a stairway, in another room, out in the landscape. Glimpses of an intriguing object or scene, often something only partly seen, incite people's curiosity and give a house its magic.

A picturesque plan is fluid; it allows for one room to open into or overlap another. Freedom from the constraints of a preconceived order makes it easier to incorporate interesting quirks and surprising perspectives into the design. It also maximizes the opportunities for having the house reflect the personalities, interests, and living patterns of the owners.

Though it's common for people, even those who are affluent, to think they can't have certain features in a house because these elements are not customary, an expressive house is, in fact, receptive to whatever fancies and sentiments the owners associate with a fulfilling environment. If, for example, you've always been fascinated by cupola-topped nineteenth-century manors, you can create the feeling of such a room in your own house, even if it is only a cottage. Spaces that are fun to be in, such as alcoves, window seats, and balconies, can instill humanness and romance in a home. They give a house soul.

LEFT Here, a succession of doorways lines up. The curved fireplace surround has been made so large that someone entering the room from this side might not immediately know what it is; this adds surprise to the progression. It's often pleasant to end a series of aligned spaces with glass, giving a view to the outdoors.

PREVIOUS PAGE A dramatic sense of transparency can be created by grouping several windows together. Transom windows sit on top of pairs of double-hung windows, extending the transparency practically to the ceiling. Because the windows are closely spaced and continue from one wall to another, the living room has an eroded corner presenting especially broad views. In a setting like this, people feel they're not just in a room; they're in a landscape.

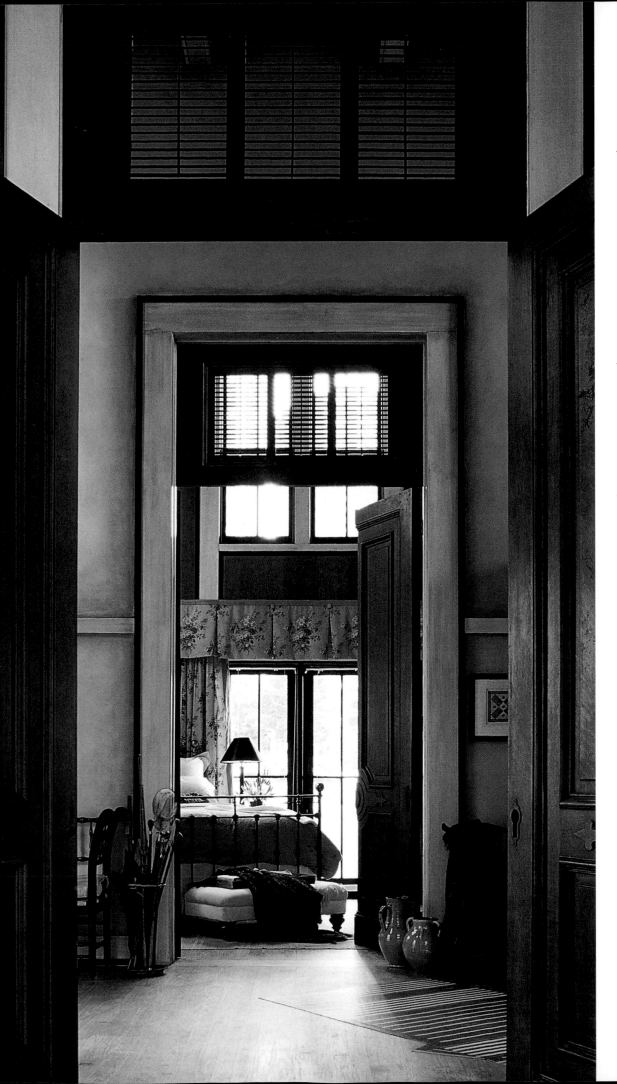

LEFT A doorway frames a second doorway, which in turn frames windows along the exterior. The enfilade culminates in a view of the outdoors. Contrasting paint colors from one space to the next emphasize the progression and make an interior that is not especially large feel monumental.

RIGHT The tapered columns in the foreground are echoed by a second pair of columns defining the entrance to the kitchen. This view is from the family room, which is two steps down. The steps and the columns form a kind of proscenium, which has the effect of putting the kitchen activity "onstage." One can imagine children presenting a mini-play in the space flanked by the near columns.

One of the basic techniques for organizing and encouraging visual experiences within a home or other building is known to architects as ENFILADE; it's the practice of lining up elements such as rooms, doorways, or windows in a row. I design many of my houses so that one space opens into another space, which opens into yet another, eventually leading the eye outside the house and into nature. This technique can give even a small house a gratifying sense of depth and spaciousness. You can sit in a tiny, intimate spot and visually survey much of the house; you get a wonderful combination of coziness and openness.

It's not necessary, or even desirable, to make every space fully visible. Sometimes slivers of nearby and distant spaces will pique the imagination, whereas full, immediate disclosure would dispel the sense of mystery. In lining up spaces, I often use columns as accents. Columns indicate, with subtlety and beauty, where one space gives way to another. They do not need to be so conspicuous that they dominate a space; in fact, it's better to have them quietly enrich the interior rather than be centers of attention.

The best termination for an enfilade is a view of the outdoors. This can be achieved through a single window, a wall of windows, or a pair of French doors. When spaces open to each other and then to the outdoors, the house has a bright and airy quality. The light flows through the continuous spaces, as do the cross-breezes from aligned windows and doors.

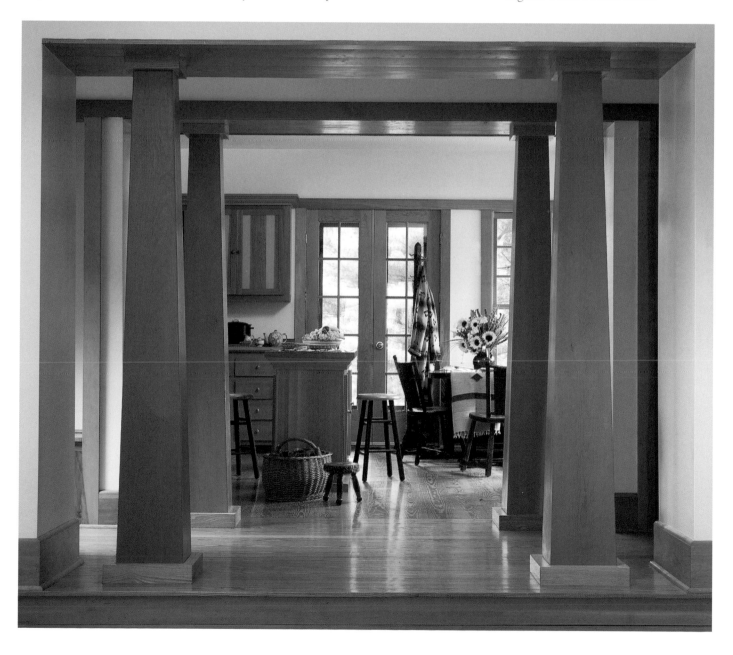

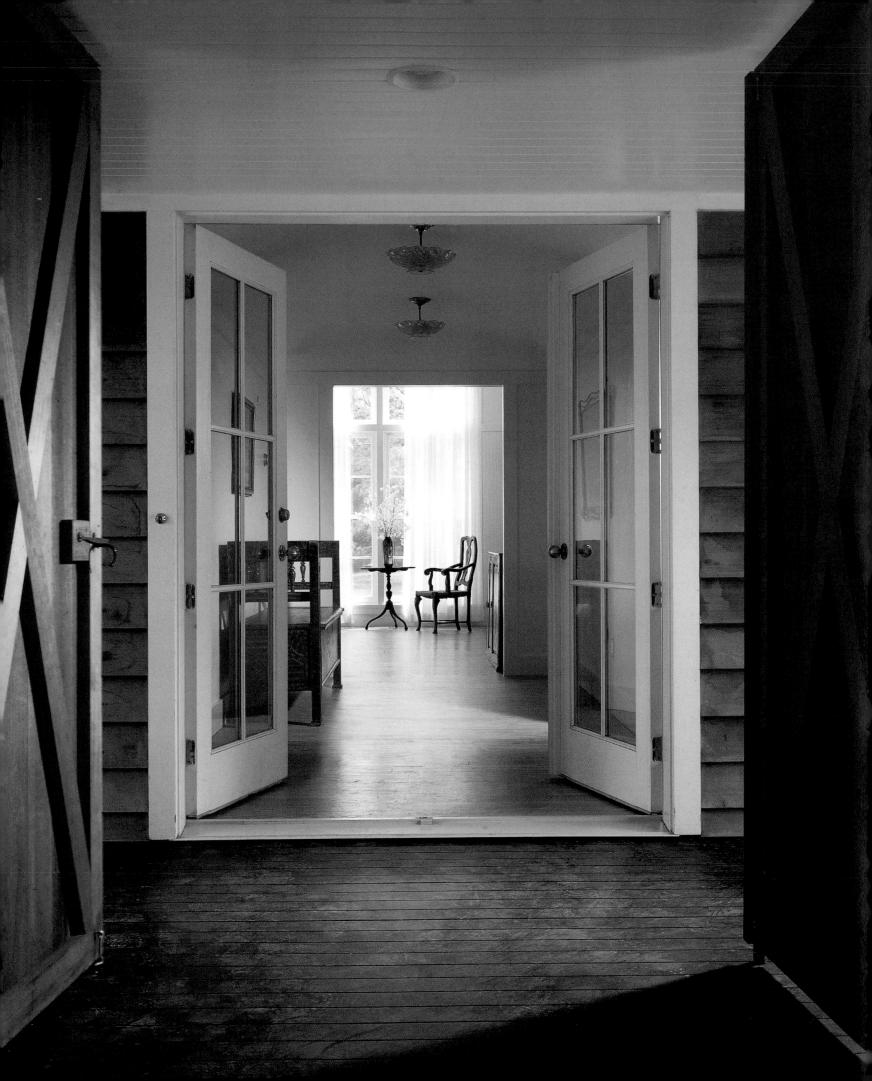

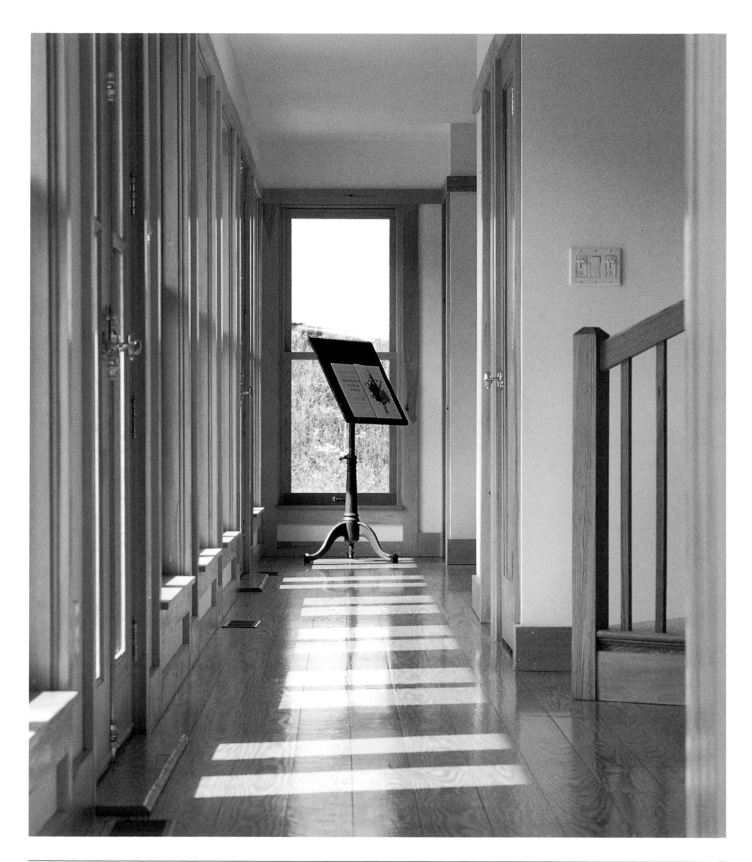

LEFT Rustic doors from the house's garage center on the French doors in the breezeway, which align with the opening to the living room beyond, creating a grand procession for daily comings and goings.

ABOVE A pleasurable rhythm is generated by a line of windows and glass-paned doors that runs along the enfilade of spaces.

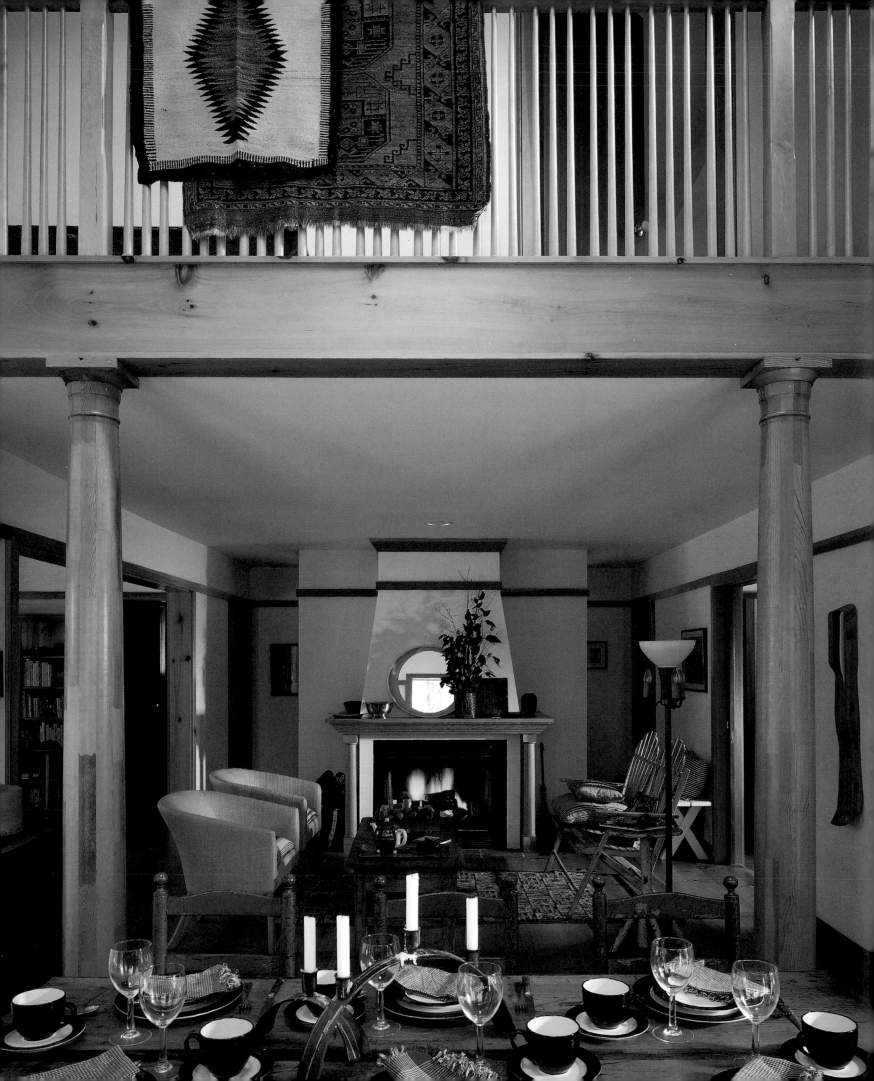

At some point in the course of circulating through a house, you need to feel that you have arrived. In order to create this feeling, the architect must give the main communal room—perhaps the living, dining, or family room—at least one **FOCAL POINT**. A focal point responds to the eye's desire for some pleasing object or scene that it can rest upon. It can give small spaces a grand, monumental feel and can give human scale to large spaces. One object that has served this purpose extraordinarily well is the fireplace. The fireplace mantel, hearth, and hood all contribute to its powerful, sculptural presence. When lit, the glow of the fire enlivens the entire room.

Other typical focal points include works of art, unusually-shaped windows, and interesting lighting fixtures. In some cases, an object can be placed in a wall niche; this may direct everyone's attention to it. Objects that attract people's attention can be orchestrated into a series of vignettes throughout the house. You might place an interior focal point, such as a fireplace, on one wall and place an expanse of windows on the opposite wall. Occupants of the room will then have something interesting to look at in either direction. Ideally, the vista itself would include something to focus on, such as a tree.

For viewers to obtain the full benefit of a focal point, the room must be composed to emphasize it. That is, the room should have symmetry in design or layout, and the focal point should be placed at the match line. This could be as simple as locating the focal point in the center of a wall. Or, in irregularly shaped rooms, it could mean that the focal point should be flanked by identical bookcases, doorways, or other picturesque elements.

LEFT A tapering fireplace flanked by miniature columns makes a strong focal point for a combination living/dining area. Columns subtly demarcate where one area gives way to another.

ABOVE A fireplace with a curved hood serves as a focal point for this dining room. Though modest in size, the fireplace helps to give the room visual organization. Since this is a two-sided fireplace, it also forms a focal point for the adjacent family room.

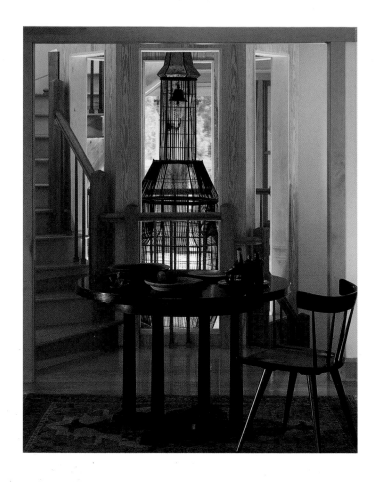

Sometimes an object can serve as a focal point for more than one space.

ABOVE An elaborate birdcage hangs in the precise center of a house, visible from the kitchen, the entry hall, and a winding stairway. The activity of the birds makes it a lively centerpiece.

RIGHT A wood-burning stove, symmetrically placed in a niche between matching built-in cabinets, might at first glance seem to be the focal point of this room. Actually, the tapered niche (or Mayan arch) makes a greater impression than the stove does. An interesting shape can be more compelling than the object it frames.

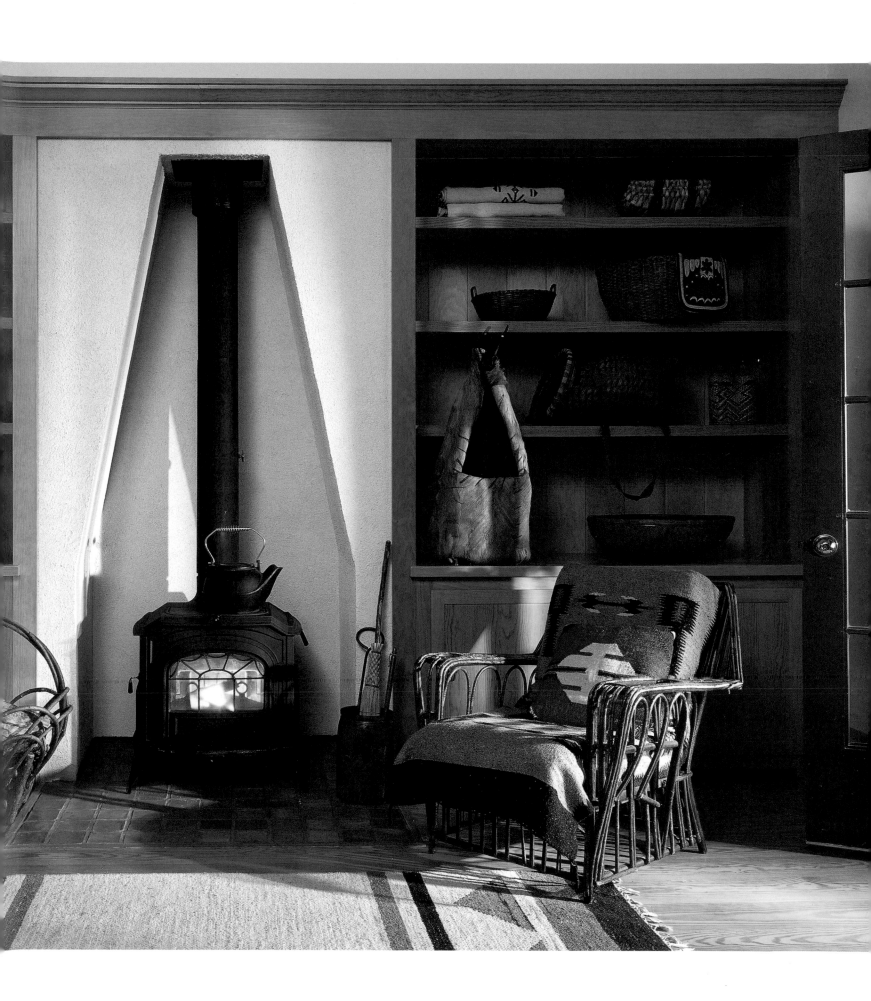

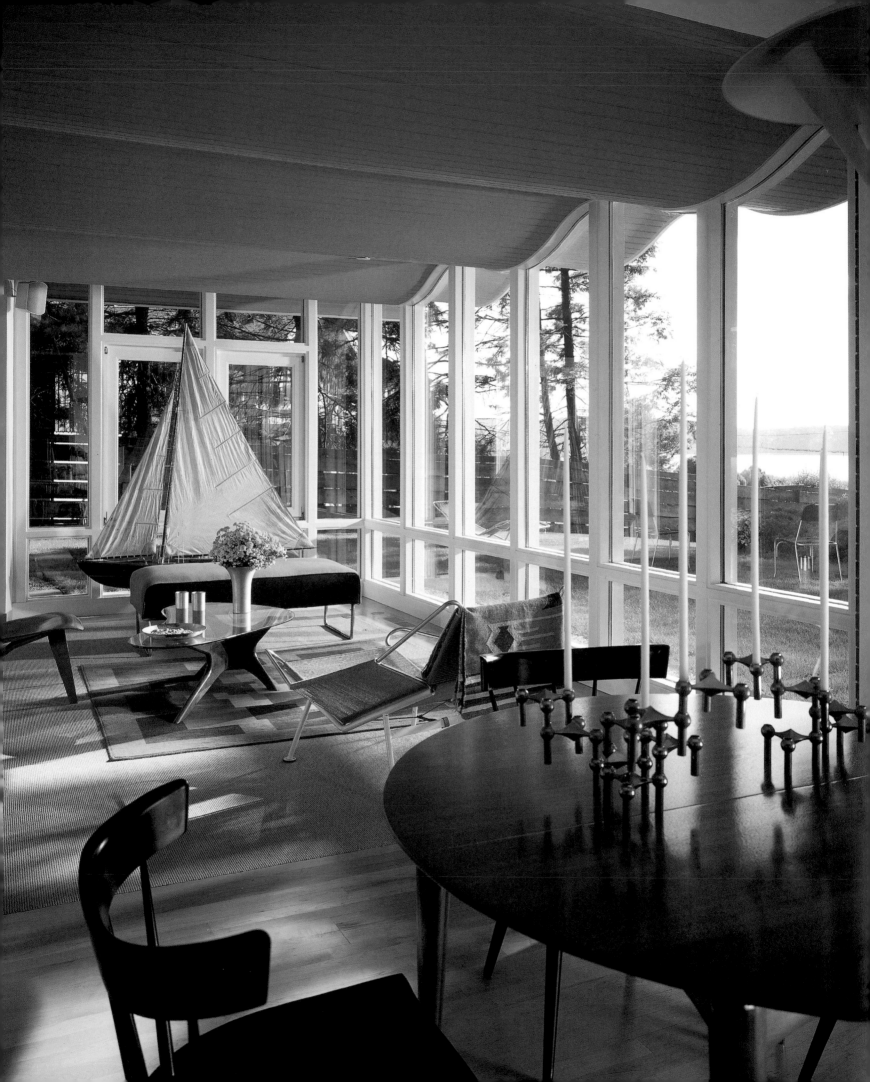

Windows are critically important to a house's character. Whenever feasible, I consider ganging two, three, or four windows together, especially in corners. Such grouped windows give a house a liberating sense of **TRANSPARENCY**. With visual exposure to the outdoors, it's possible to work inside for hours and not feel cooped up; you can derive pleasure from being continually aware of the changing sun, wind, sky, and landscape.

The Modern Movement in architecture very effectively propagated the idea of having large sheets of glass extend from floor to ceiling—sometimes across an entire wall— breaking down the barrier between indoors and outdoors. The idea was to visually remove the walls entirely. I prefer, however, a more layered effect achieved by using windows instead of walls of glass. The windows' mullions and trim make subtle shadow patterns and give the rooms structure and surfaces that please the eye. When grouped together, traditional windows, such as wooden double-hung ones, offer visibility that is almost as generous as that of a Modernist wall of glass, yet they enable the occupants to get the advantages of light and views without feeling totally exposed. In addition, windows can open, bringing the outdoors in for all of the other senses, not just for the eyes.

Bringing views of the landscape indoors is perhaps the most effective picturesque move. The landscape changes continually during the course of a year. The shifting scene and the interior spaces are made still more compelling by constant changes in the natural light. Transparency is one of the qualities that can give a house its allure—its soul.

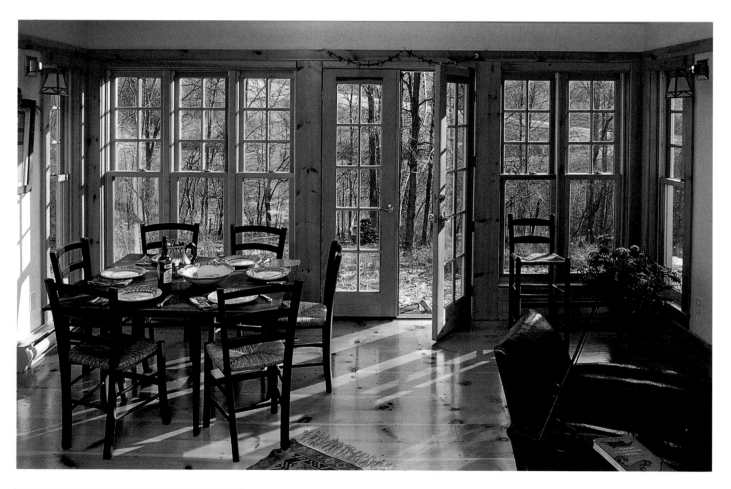

LEFT Windows ganged together and going around a corner create an appealing transparency, putting the outdoor surroundings on display. The undulating ceiling is echoed by the window shapes, giving the room expressiveness.

ABOVE A wall of French doors and six-over-one wood windows provides a view that's warmed by surfaces of natural pine. The mullions, muntins, and frames of the windows and doors allow you to focus on the solid elements of the wall rather than always focusing on the outdoors. When sunlight strikes from a certain angle, the windows appear more translucent than transparent.

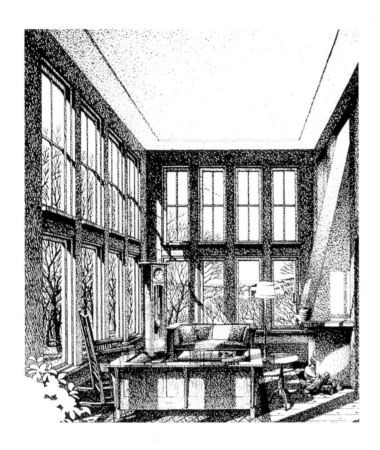

ABOVE Two stories of windows make an airy interior space that feels intimately connected to the modulations of light and shadow throughout the day. Besides generous views, the room contains two interior focal points: a grandfather clock in the corner and a fireplace anchoring the wall to the right.

RIGHT Intervals of wall between the windows help people to focus on solid surfaces and to envision this space as a room, not just an exposed perch. The furnishings provide a coziness sometimes missing from spaces that offer so much transparency.

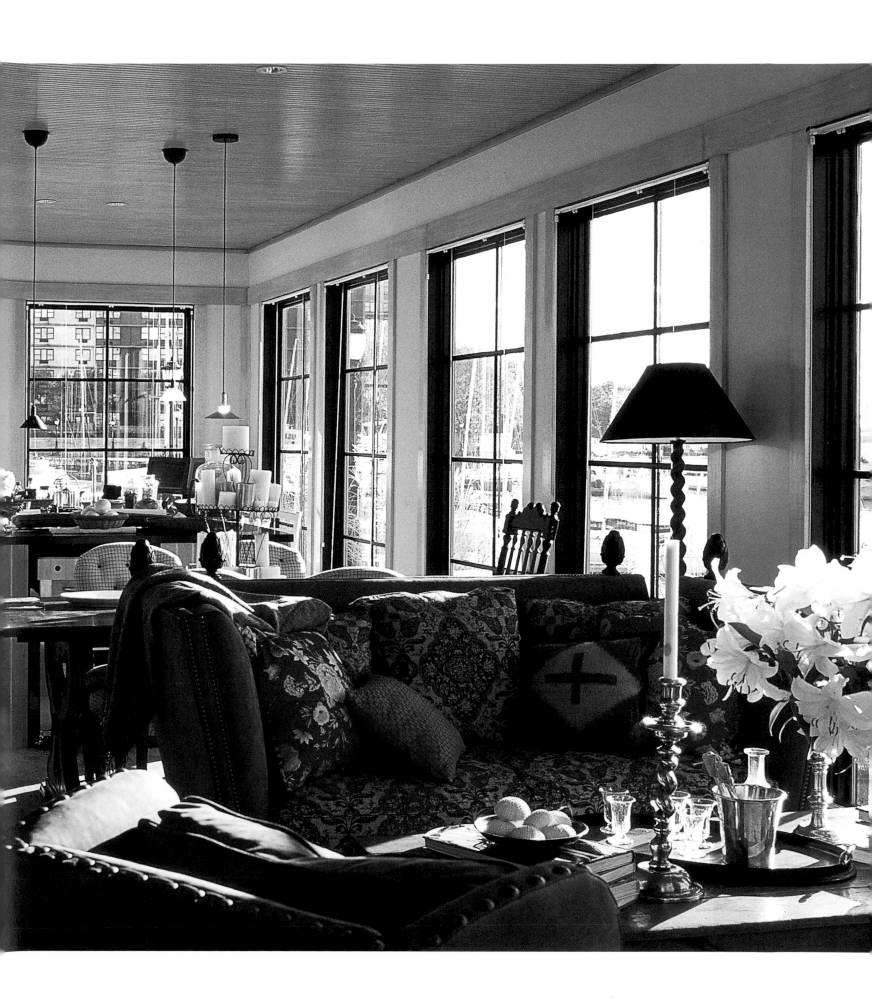

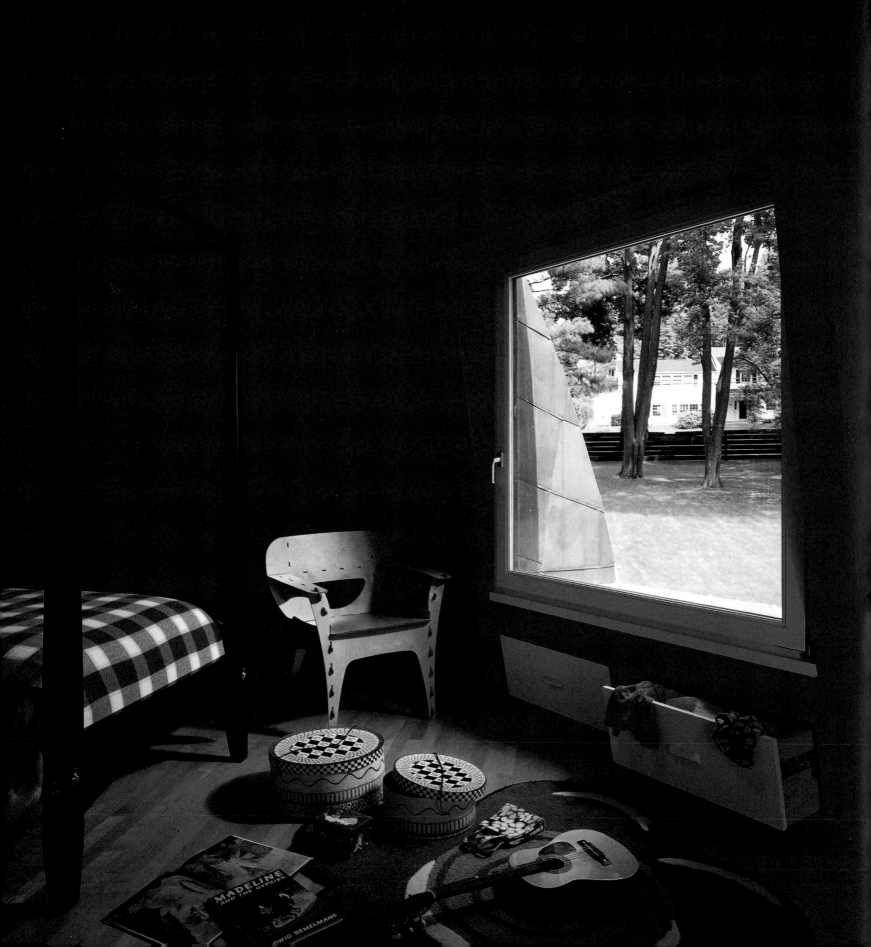

The spaces that you move through should be as interesting as the focal points within them and the movement itself. **SHAPED SPACES**—spaces that are designed for a particular spatial effect—make for particularly interesting rooms and are quite dynamic. A high ceiling often adds greatly to a room's character, especially if it contrasts with a lower ceiling nearby. Walking from a compressed area such as an entry foyer or hallway into an expansive living area is more of an event than walking through a single-height interior. You can give a small house some magic by making the second-floor rooms open to the underside of the roof. Climbing from the level-ceilinged rooms of the first floor, you will be delighted to find a whole series of rooms with odd-shaped ceilings.

In larger homes, you might consider giving one of the principal rooms a high, peaked ceiling or some other unusual shape that makes the house feel out of the ordinary. If there is a place inside the house where a person can be up high looking down into that extraordinary space, people will seek it out—or at least imagine themselves in that commanding perch. Sometimes having one special space that evokes that "wow" response is all that's needed to make a house stand out.

Shaped spaces may also be reflective of the house's exterior form. I never shy away from designing curiously shaped houses, for I know that such shapes not only add interest to the outside, they also enliven the inside. The feeling of being inside a ship, barn, or turret is more thrilling than being in conventional indoor space. Our natural attraction to forms of exposed structure such as beamed ceilings and timber posts stems from the desire to feel not entirely removed from the great outdoors. It is satisfying to sense that you are enclosed, but not cut off.

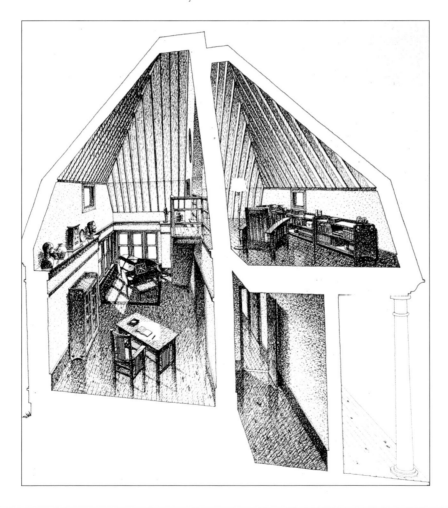

LEFT This children's room is a pure volumetric fantasy.

ABOVE The large volume in this drawing is subdivided to create a stirring, cathedral-like space overlooked by a loft, which feels almost cozy by contrast. Depending on how the interior is subdivided, one roof form can generate several completely different effects.

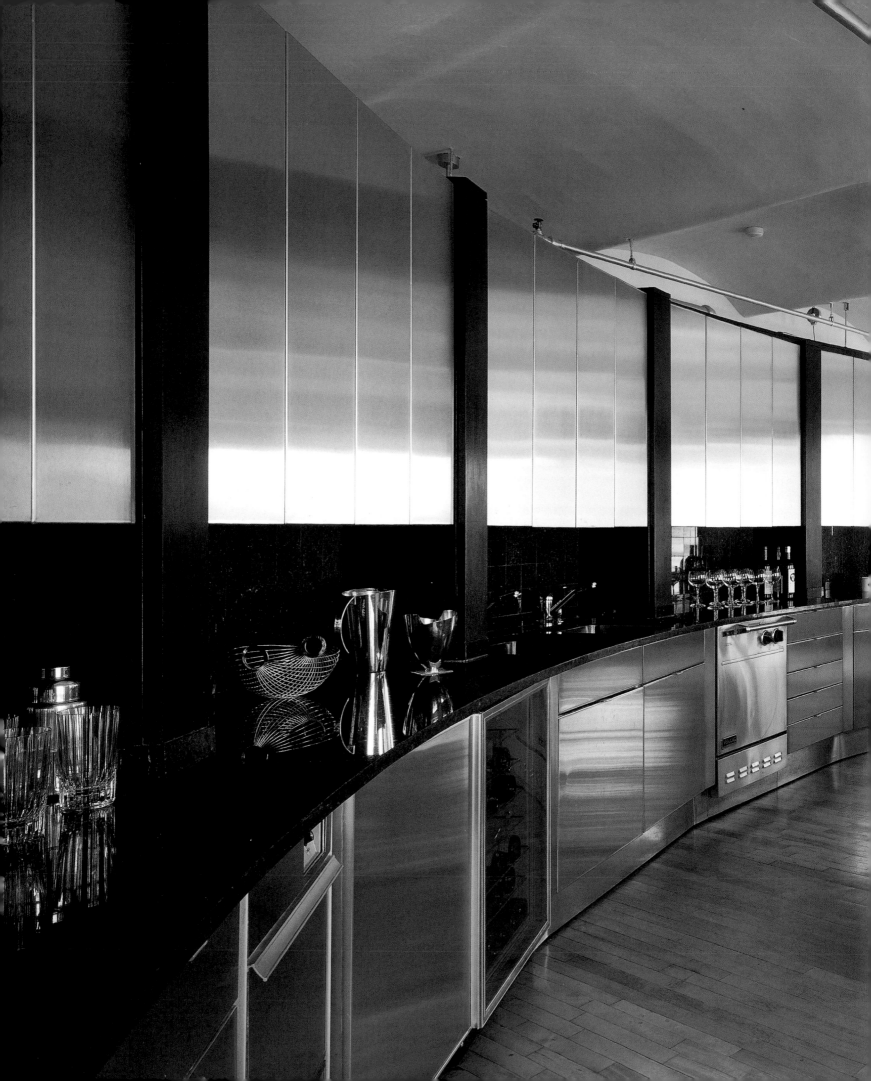

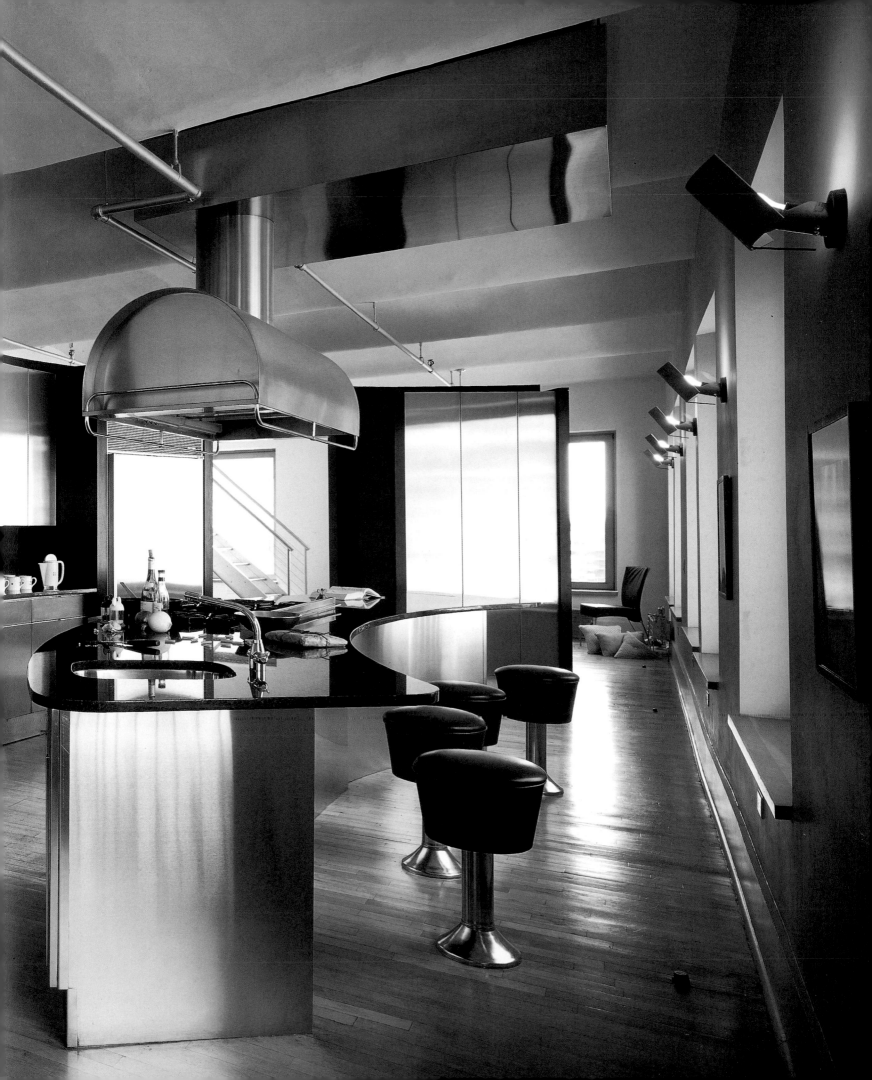

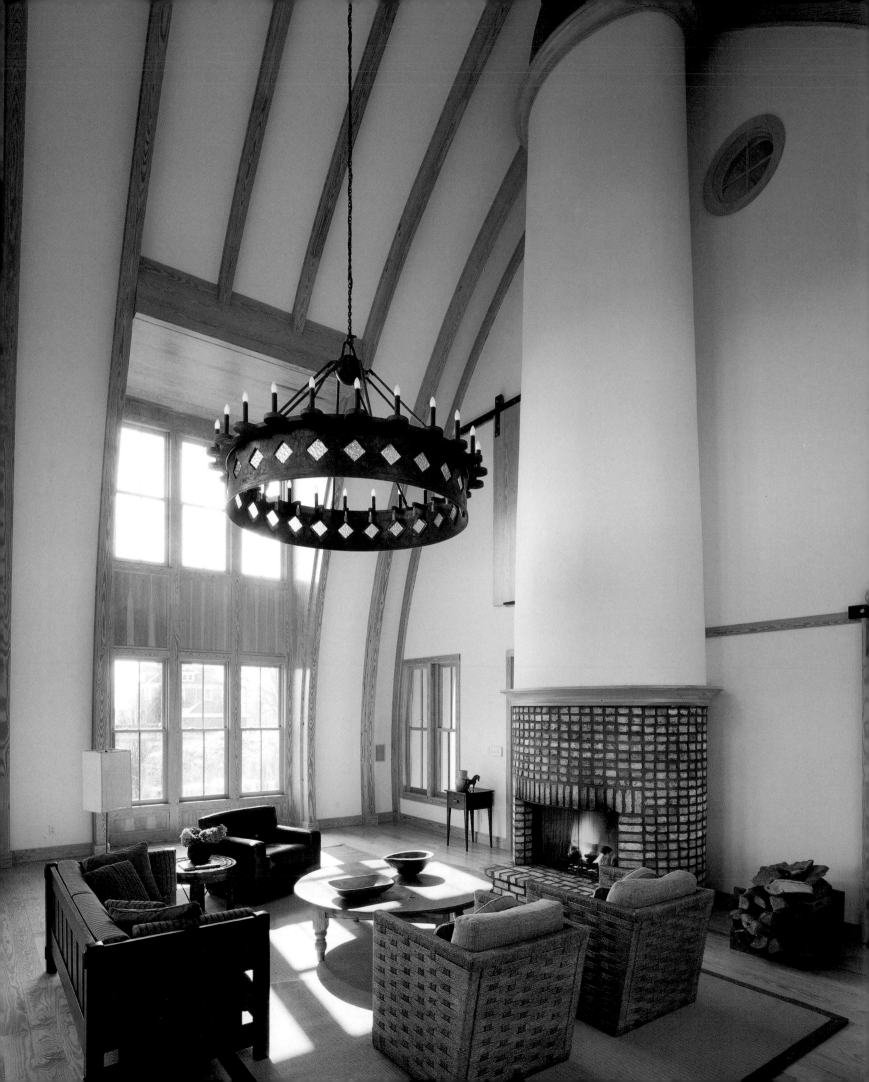

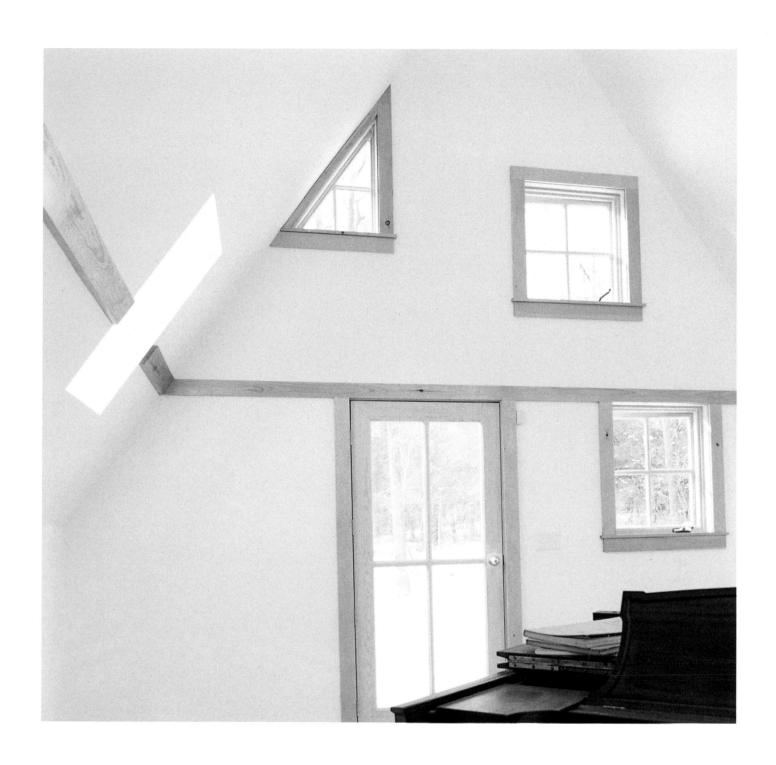

LEFT The tall, curving volume of this room, reinforced by beams that extend to the roof's peak, gives the room a theatrical character. The gigantic, curving fireplace and the wrought iron hanging lighting fixture provide strong focal points.

ABOVE An odd triangular window increases the viewer's awareness of the room's interesting shape.

PREVIOUS PAGE The swooping, curved wall of this kitchen not only serves the cook well but also makes an enveloping backdrop that invites guests to linger there.

Probably the most underrated element of the good house is an **ENTICING STAIRWAY**. Subconsciously, it's always an interesting experience to go from one level of a house to another—and that's especially true for visitors. Perhaps it has to do with the curiosity involved in leaving the public part of the house and entering the private areas. Whatever the reason for its attraction, we should make the most of the experience.

Think of the stairway in more than purely functional terms. Whenever possible, I design staircases along an outside wall so that windows can be inserted next to them—drawing natural light and offering a focal point and a view to the outdoors. It's good to include comfortable, not-too-tiny landings, which can be appealing spots from which to savor the view. In some instances, the landing can even accommodate a window seat. Such elements of domestic scenery enhance the enjoyment of dwelling in a house, and help everyday activities unfold more pleasurably.

I like a staircase to twist and turn. This enlivens the experience of going up and down the stairs still further, as our perspective shifts. The kind of wood that's used for the balusters, rails, and newel posts, and its degree of ornamentation, can make the difference between a mundane staircase and one that's far more interesting. In some houses, part or all of the staircase may be curved, which makes it feel extraordinary. A freestanding circular staircase, though not terribly comfortable for climbing, always seems enchanted. And to make entering an interior an adventure, you can even make built-in ladders (stationary or sliding) the means for reaching a place such as a loft.

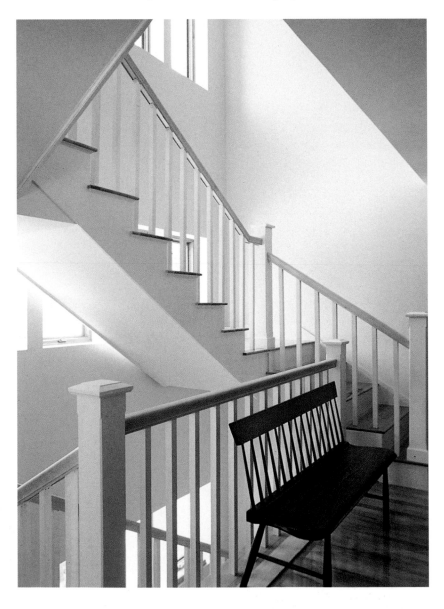

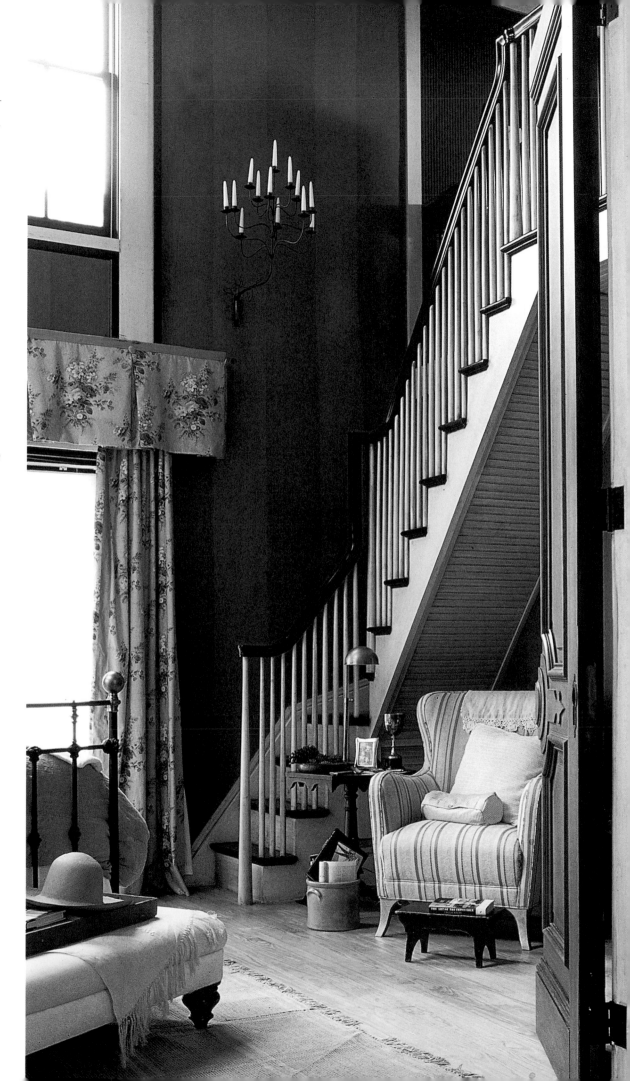

LEFT *This stairway seems almost to float in the air because of its placement next to a wall punctured by windows. A sequence of landings and turns, each with a newel post, makes the progression from floor to floor a varied experience with frequently shifting perspectives. Stairways assume a more sociable ambience when they contain places to sit.*

RIGHT *The uneven rise of the handrail and the rhythmic sequence of balusters enrich a stairway that leads to a loft. Such private stairs—connecting two or more levels within a single room—connote luxury and lend romance to a house. The picturesque approach to design is receptive to the notion of hidden stairs and back stairs, which hint at mysteries and secrets.*

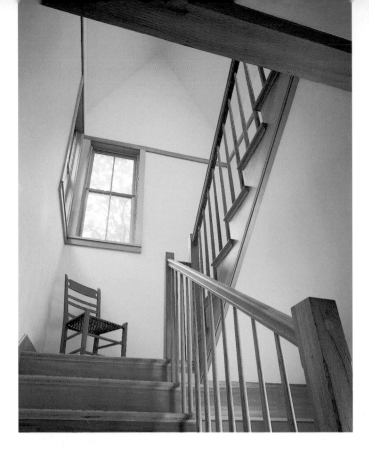

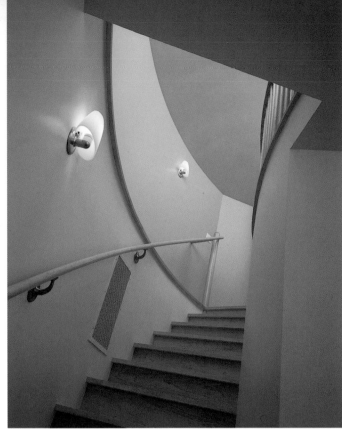

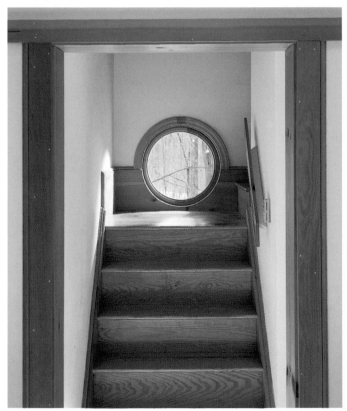

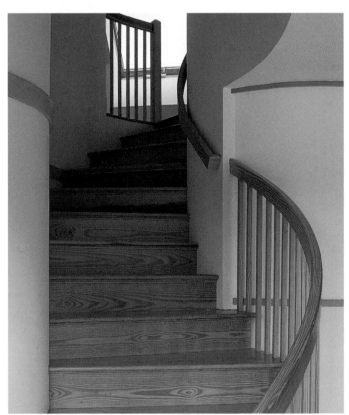

TOP LEFT A corner window, an oversized landing, and a towering ceiling compel one to climb.

BOTTOM LEFT A playful round window appears to be designed to allow the family dog to guard the children sleeping above.

TOP AND BOTTOM RIGHT Curving walls and winding stairs remind one of scaling mountains.

RIGHT Who can resist a spiral stair? This one entices with its curve set into a rounded corner. The strong horizontal line of molding makes the curves all the more prominent.

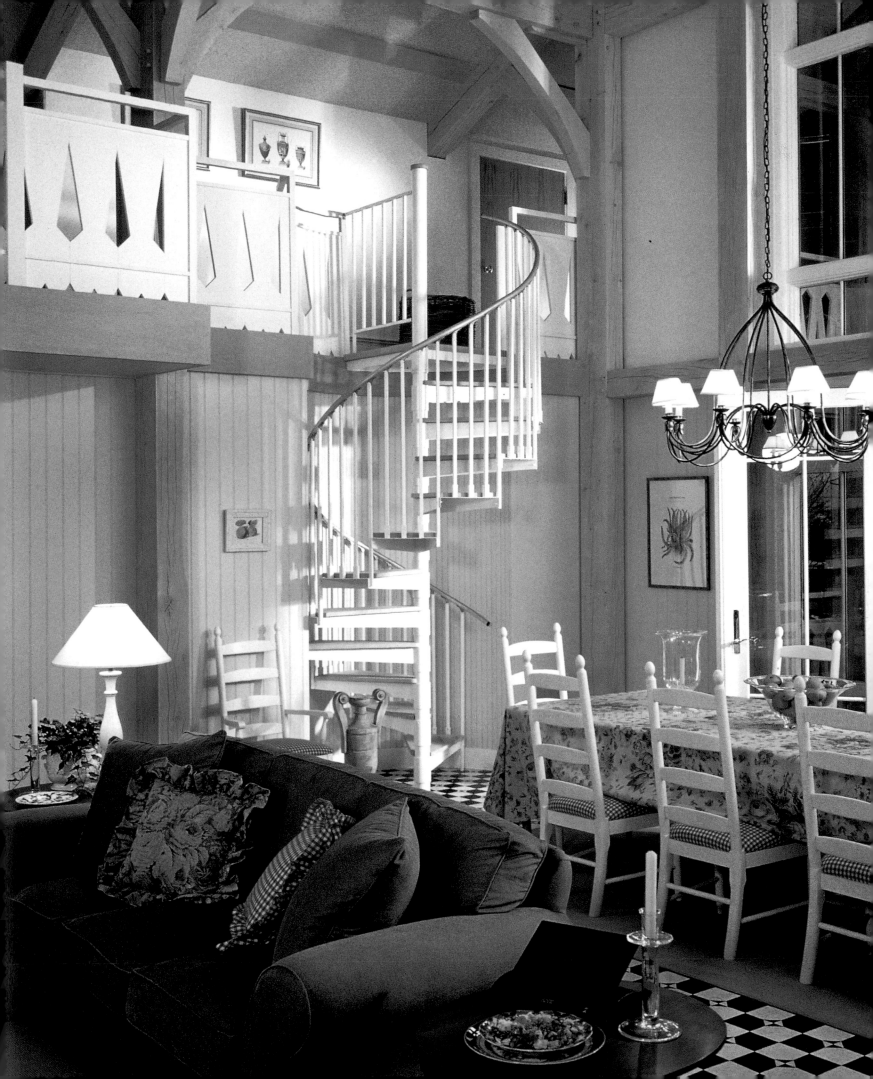

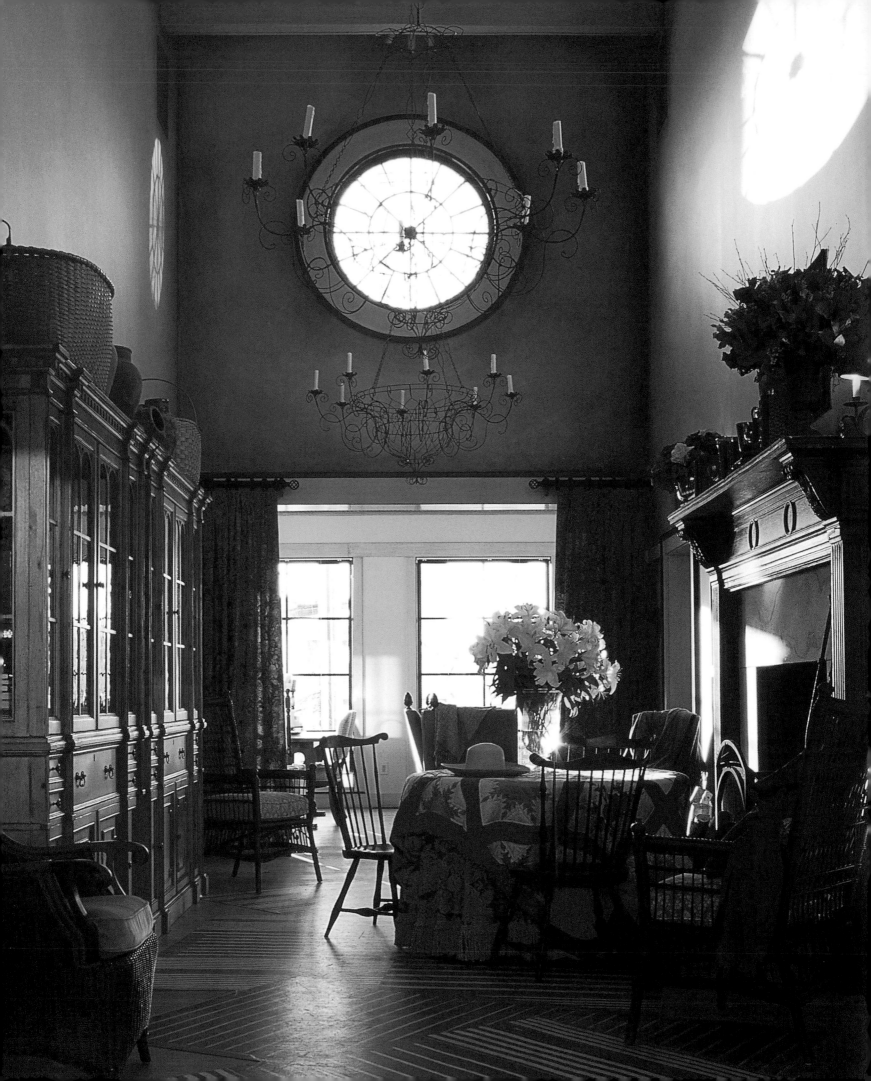

PICTURESQUE DETAILS

WINDOWS, DOORS, ALCOVES, WINDOW SEATS,
AND FIREPLACE MANTELS—TO NAME A FEW—
ARE HOUSE DETAILS THAT ADD CHARACTER.

A picturesque house requires attention to detail. The way things are put together does not have to be costly so much as it needs to be carefully thought out. For instance, I sometimes give windows an extra-deep ledge, which provides a place for plants or displays of objects and makes the house appear thicker-walled, more solid and substantial. Just adding a window in an unexpected place-for example, an interior window looking from one room into another—will provide a house with a touch of magic. Similarly, an alcove may be a place to take your boots off or a spot to crawl into and read a book, but it's really more than that: a romantic gesture that lifts the house into a realm of fantasy. Alcoves and window seats come straight out of storybook illustrations. Trim can transform rooms, pulling elements or spaces together. It can run between a series of windows, subtly unifying a room. It can form a consistent line for curves to play against. When arranged into patterns, trim can make the house seem rich with craftsmanship. Walls and ceilings can be lined with wood as well as trim for added charm. A fireplace may start as a mundane, prefabricated metal firebox, but once it's been encased in plaster with an intriguingly curved or tapered profile and embellished with trim, it's a truly evocative element.

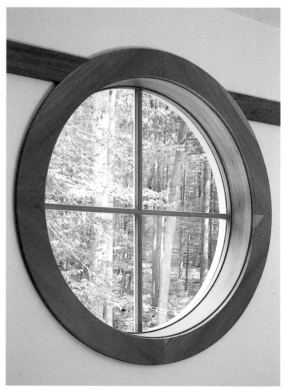

Windows and doors need to have character and must be constructed of good materials. I often choose plank doors or paneled doors, and windows with both mullions and substantial sashes. The added texture and patterns and the aura of authenticity are worth the expense. A good house should appeal to the spirit, and to do so, its materials and details must be well chosen.

LEFT The grand foyer is enhanced by a salvaged nineteenth-century round window and its ever-changing transmissions of sunlight.

ABOVE The circular shape, the thickness of the window-opening, and the way it meets the horizontal trim are details that make this simple window special.

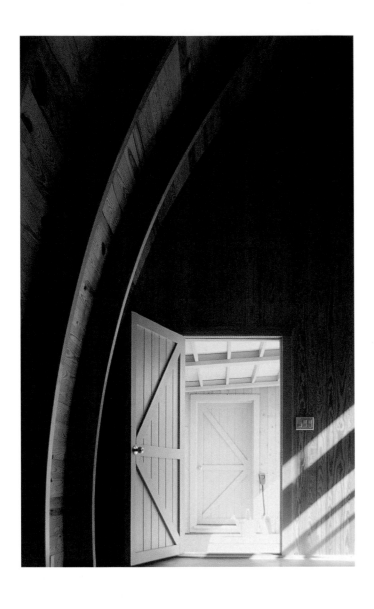

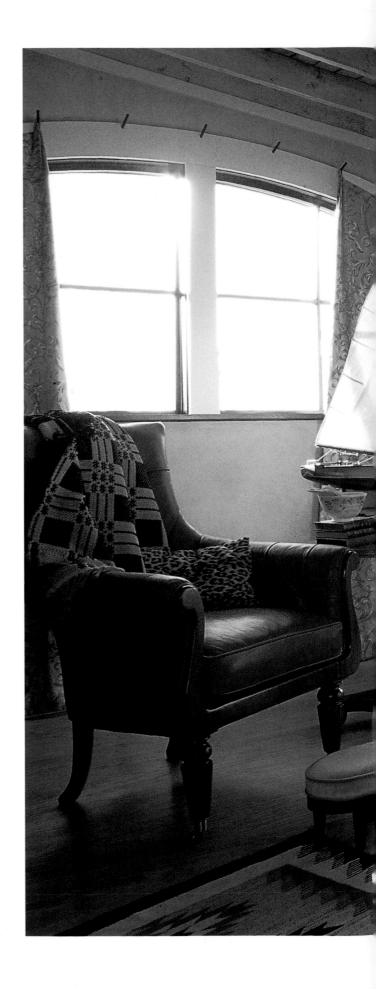

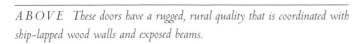

ABOVE These doors have a rugged, rural quality that is coordinated with ship-lapped wood walls and exposed beams.

RIGHT Exposed beams, French doors, and an arched window bring strong character to an otherwise ordinary room.

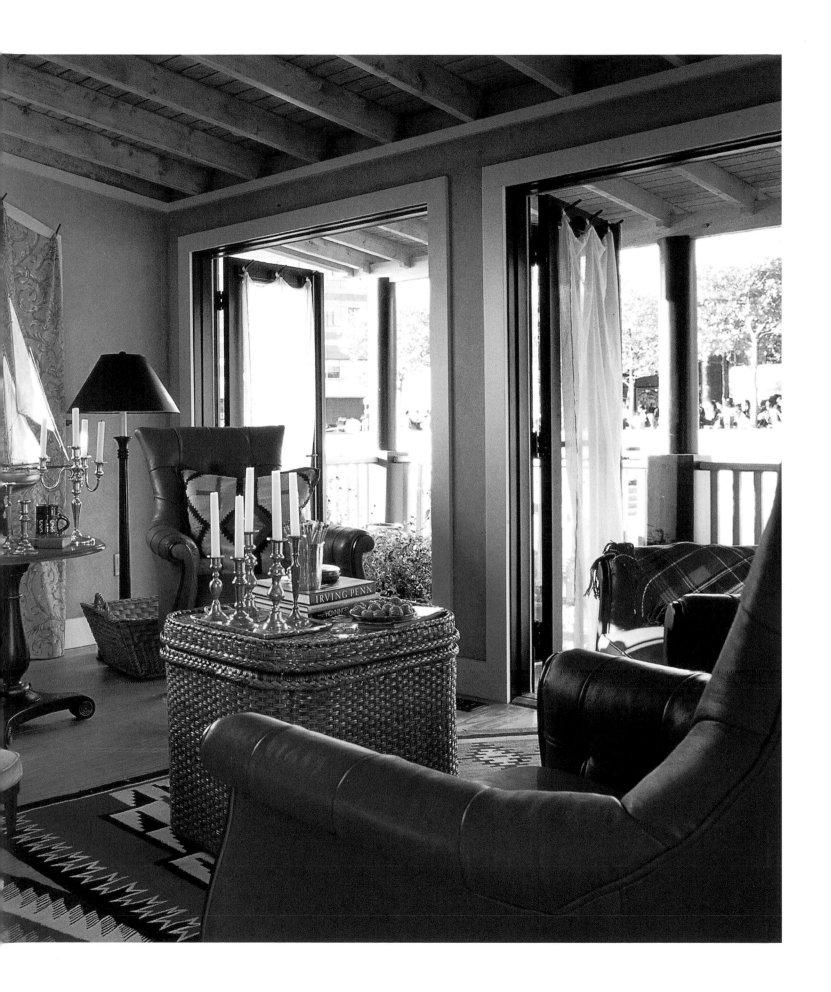

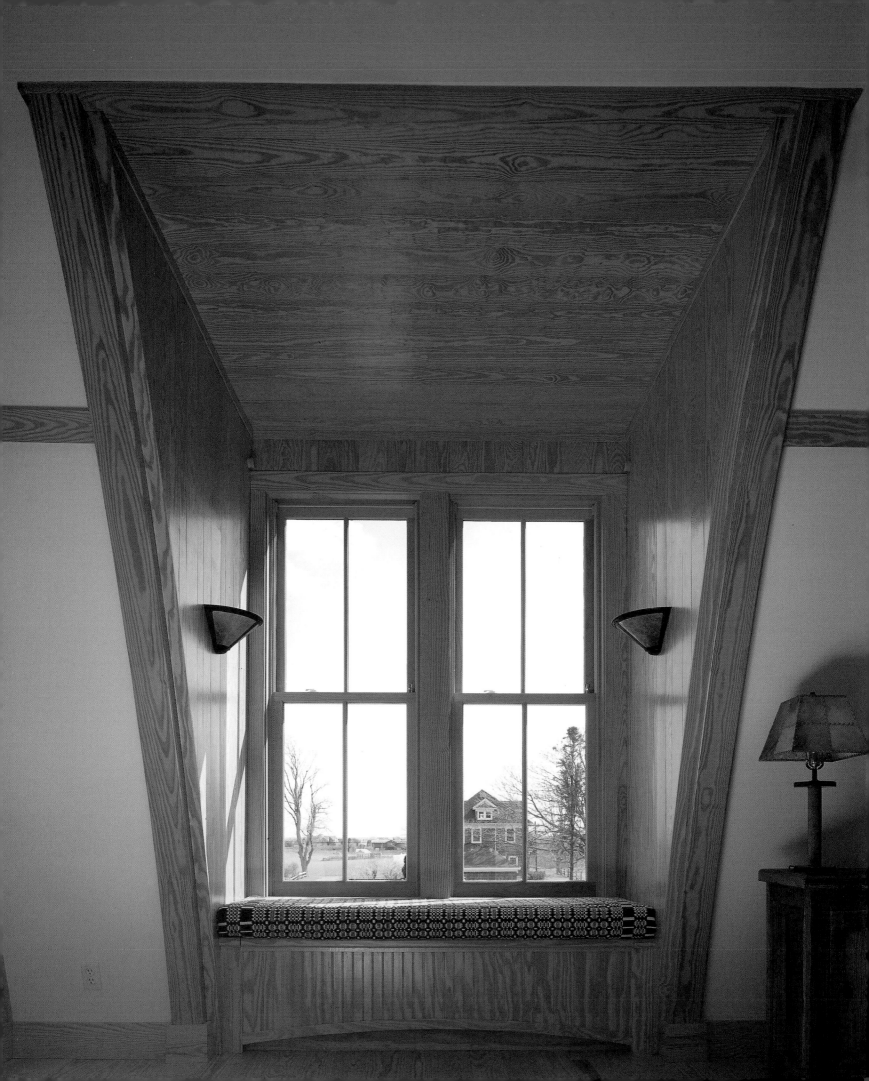

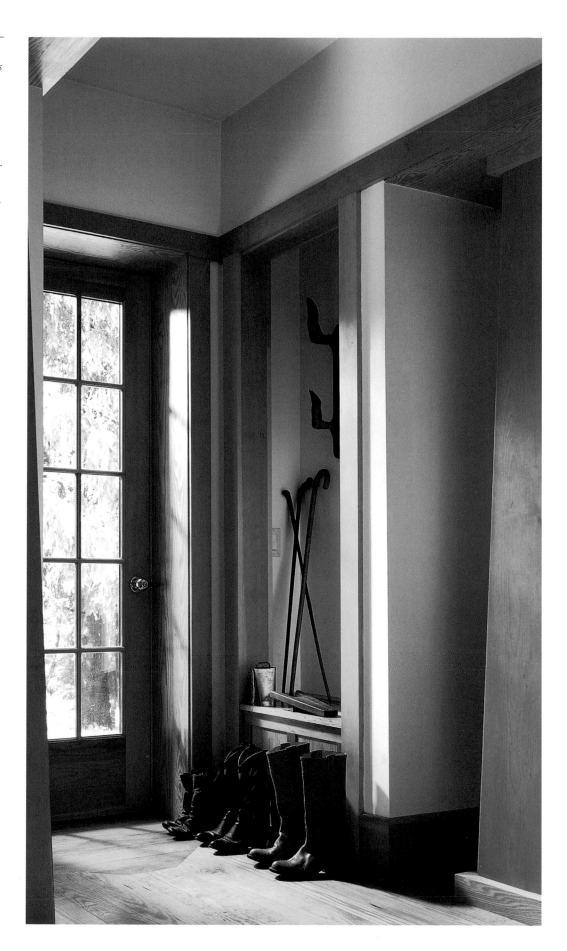

LEFT These are two ordinary double-hung windows. What makes them special is that they are contained within a pine-lined dormer, which in turn creates a cozy alcove for a window seat.

RIGHT The alcove by the door is a pleasant place to stop and take off boots. The open storage area sets up a nice rhythm with other openings in the framing.

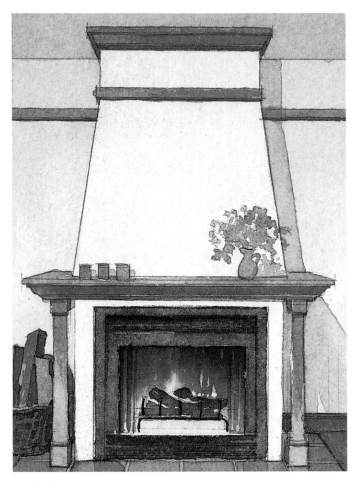

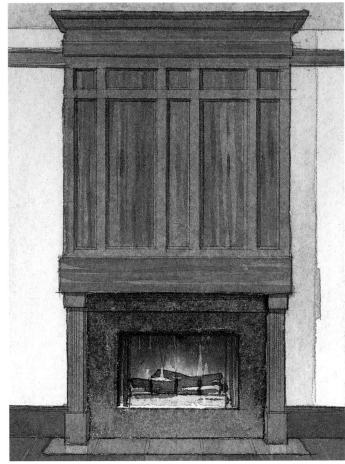

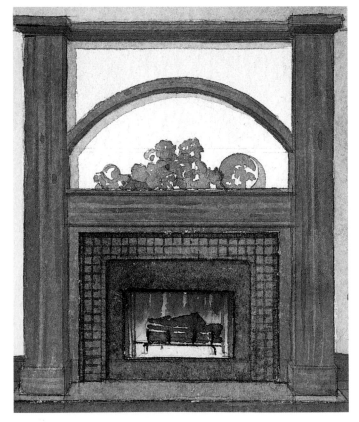

TOP, LEFT AND RIGHT With the Classically-inspired three-part composition of base, shaft, and capital, a fireplace can be detailed to become a mini-monument. Note how moldings tie the upper sections of fireplaces to the walls of their rooms.

LEFT Whatever is placed in the niche becomes a focal point.

RIGHT Details such as the timber framing, the balcony's pattern, and the trim on the massive fireplace wall give this open interior its Scandinavian feeling.

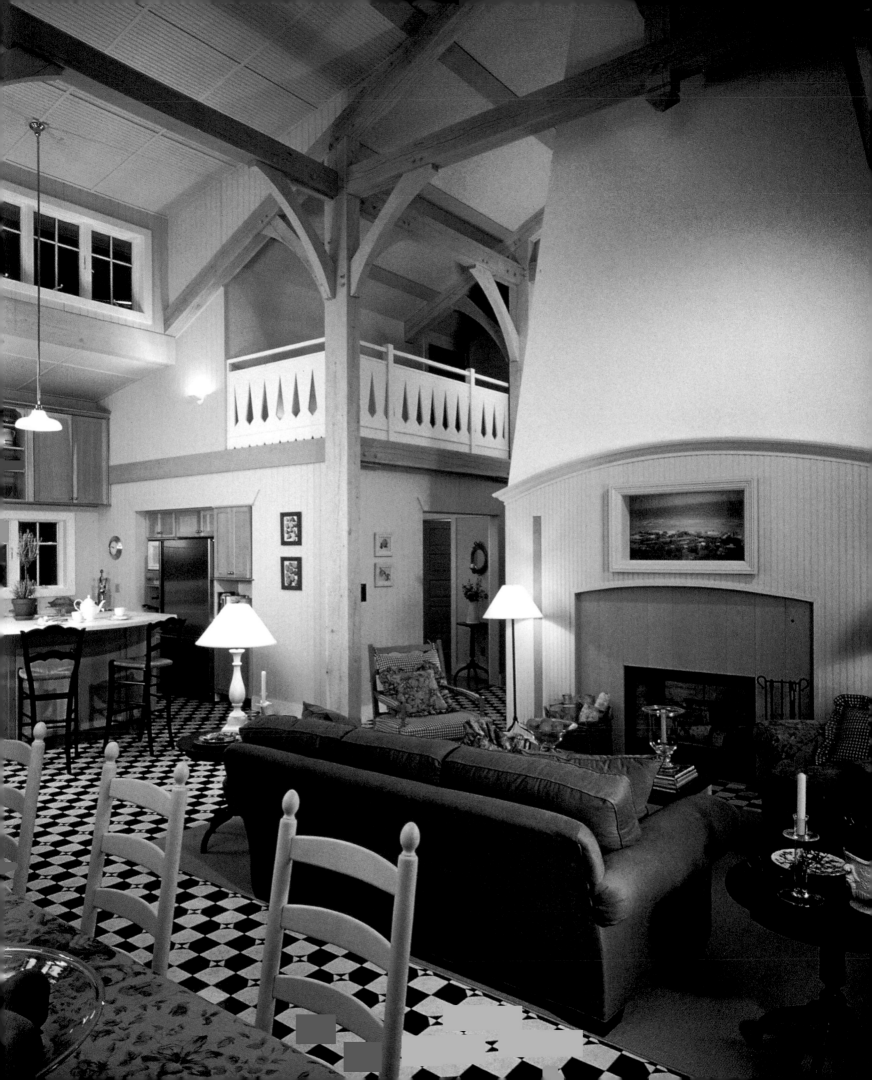

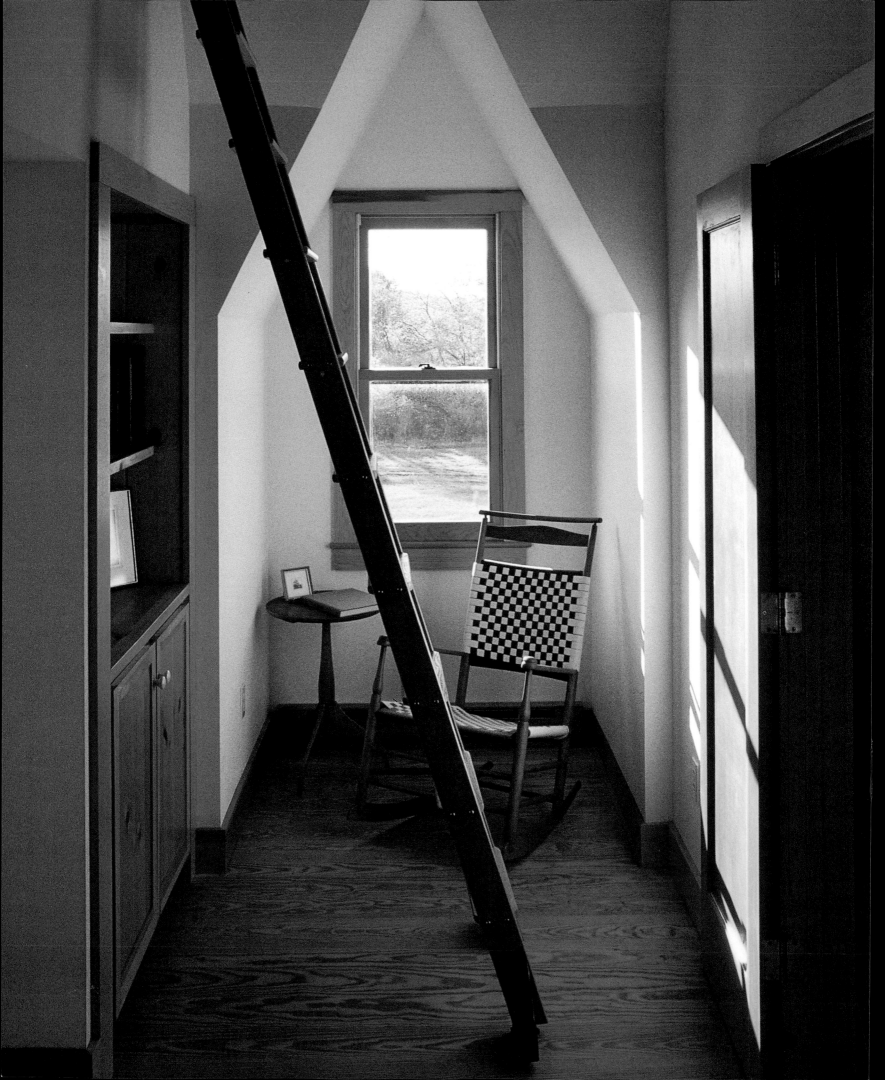

KINDERHOOK HOUSE

The good house can be very small. The entire first floor of this 800-square-foot house is only 15 feet wide and 25 feet long—smaller than some people's dining rooms. The house contains two full bedrooms and a sleeping loft. Certainly, all of the spaces are small, but through the picturesque techniques of enfilade and transparency they appear much larger than their actual dimensions. This kind of maximization of interior space is one reason why a picturesque house can be such an outstandingly good home.

Smaller houses are more cost-effective, easier on the environment, and in my opinion, more spiritual. A house that's built with a little less room and a lot more attention to detail will deliver more quality for the money. Large houses with underutilized interiors needlessly consume construction materials and energy. Oversized houses can feel empty and lifeless at times. Ultimately, there is a certain righteousness about living in a small house that has done its best to make use of limited space. This is part of the repertoire of Picturesque virtues.

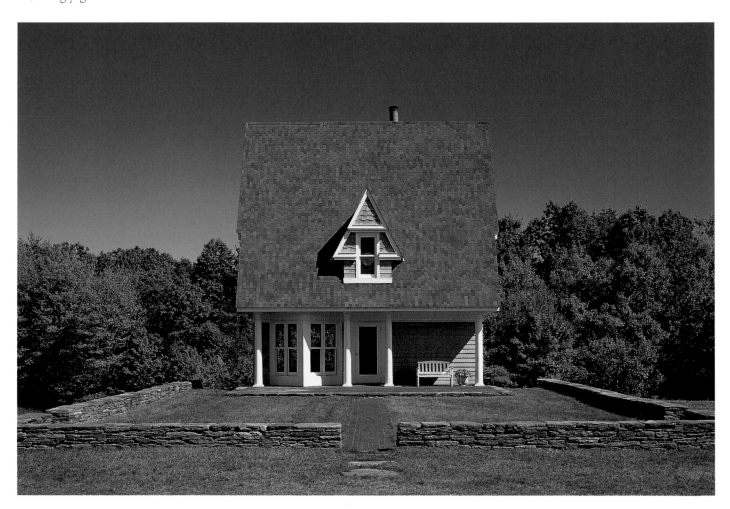

ABOVE The tiny, elaborate dormer of the Kinderhook house suggests a cozy little spot to relax in under the roof.

LEFT The dormer over the front door is a focal point for the exterior, and the shaped space created from it on the interior is both inviting and forceful. The ladder holds the intriguing promise of still more to be explored above—in the loft.

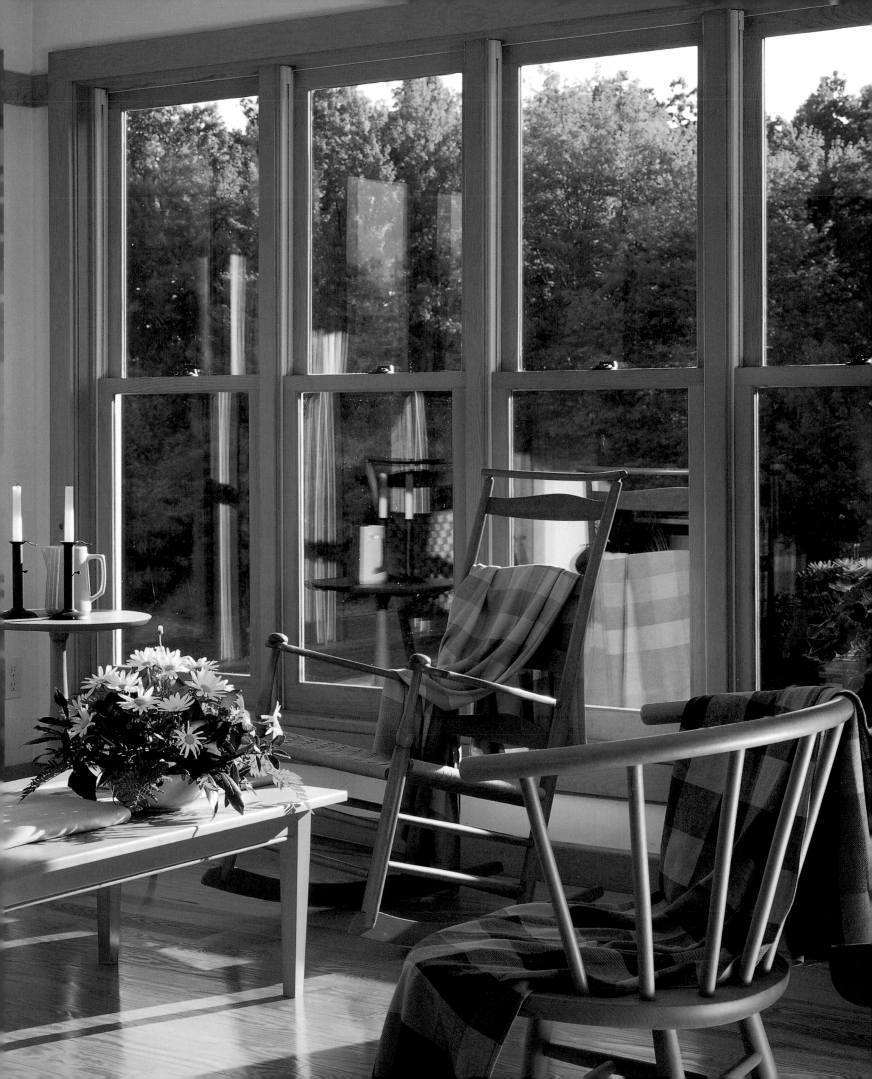

PREVIOUS PAGE The transparency of the corner provides a refreshing outdoor feeling, even in a living room rich with conversation pieces.

ABOVE Open shelves backed by knotty pine paneling.

RIGHT A dining area situated where ganged windows have created an eroded corner conveys a welcome openness despite the small amount of floor space.

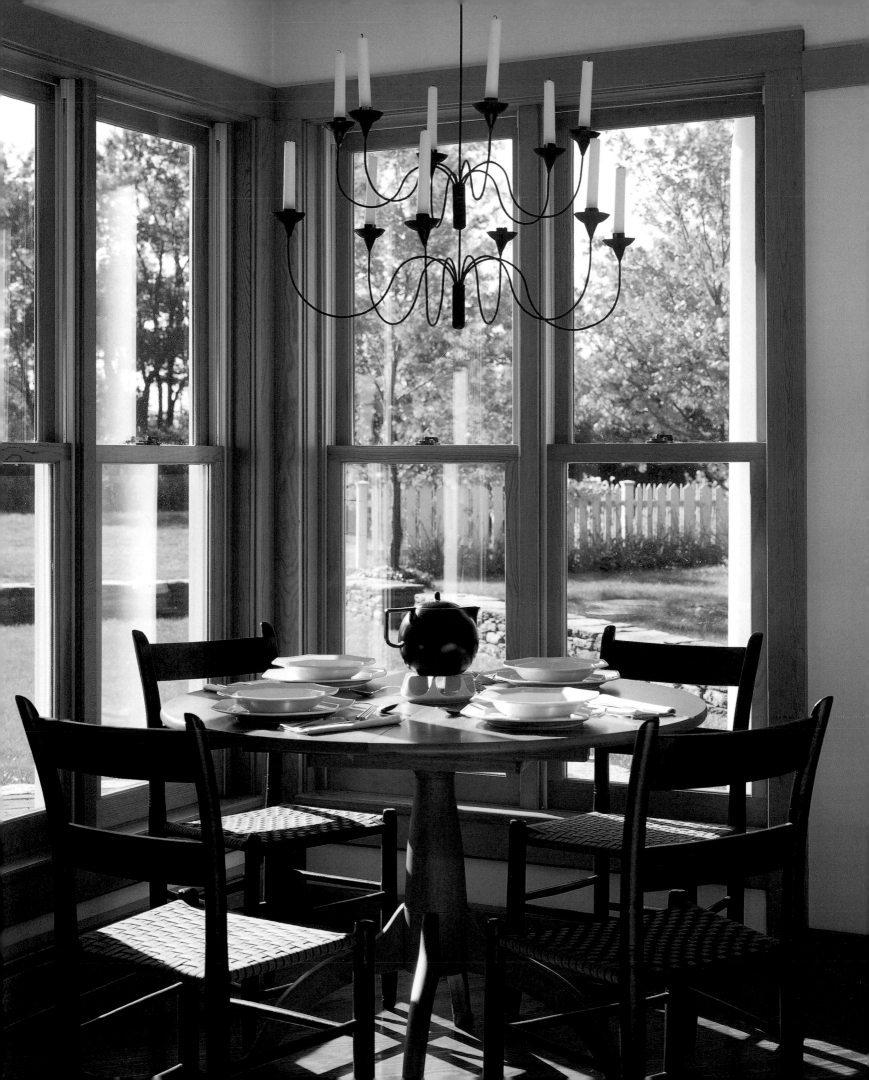

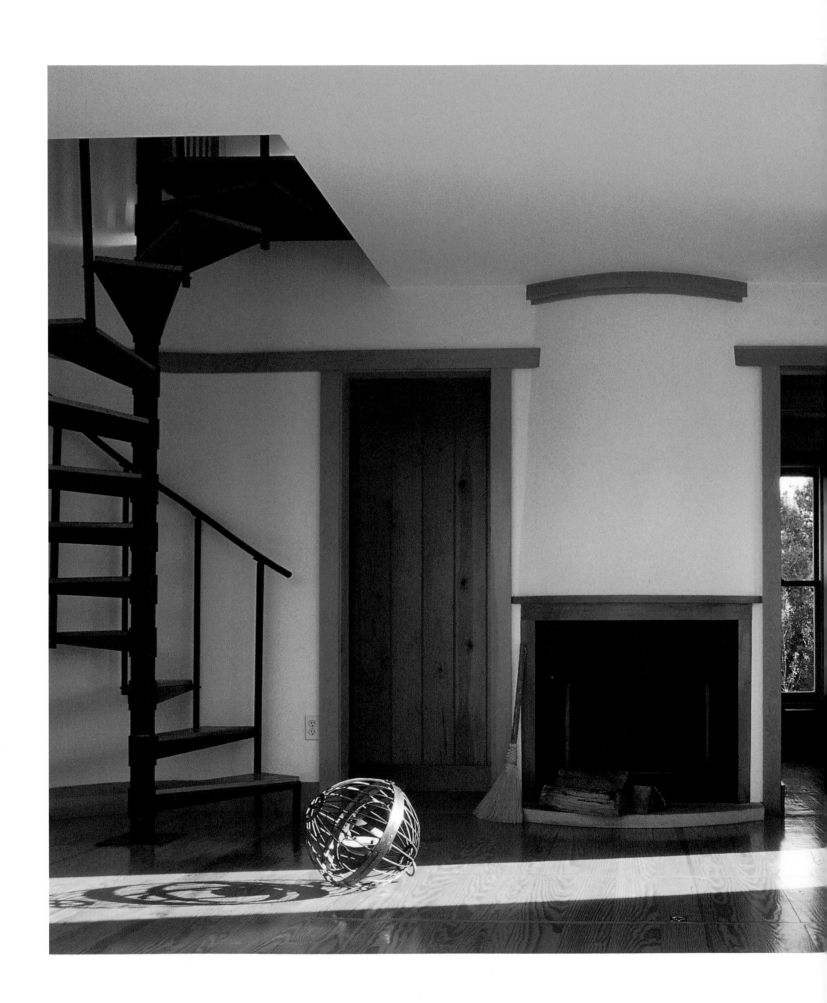

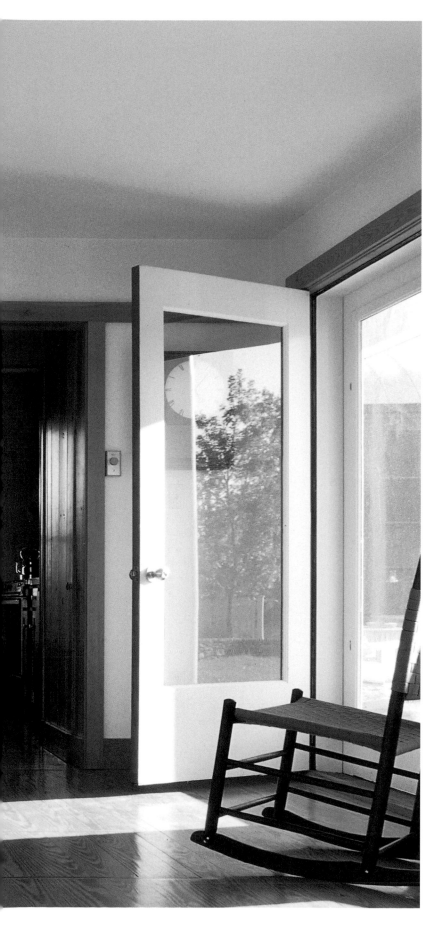

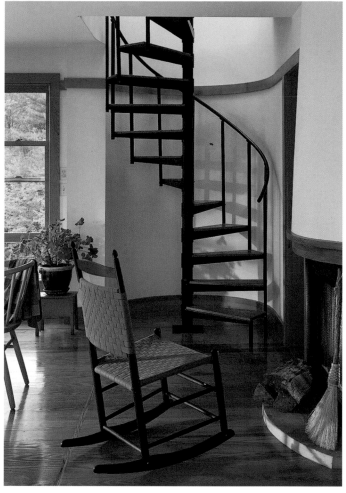

LEFT An open circular stair provides enticing access to the second floor without subtracting from the openness of the ground floor's compact 15- by 20-foot main room. The fireplace between flanking entrances to the kitchen and a bathroom is a calming focal point in a busy space.

ABOVE The spiral stair fits neatly into a curve created by a turret shape on the house's exterior.

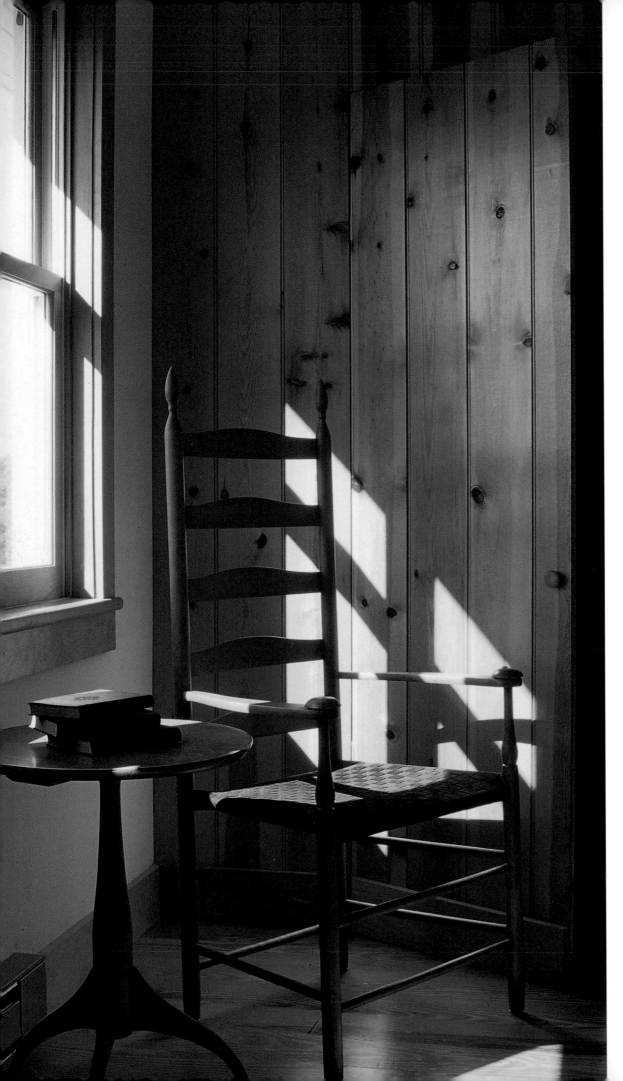

LEFT The knotty pine closet, clear pine floor, and pine windows together generate an enveloping warmth for this bedroom.

RIGHT The lining up of the loft's moveable ladder, the bedroom's double doors, and the wide window assembly gives an otherwise fairly simple interior an interesting complexity.

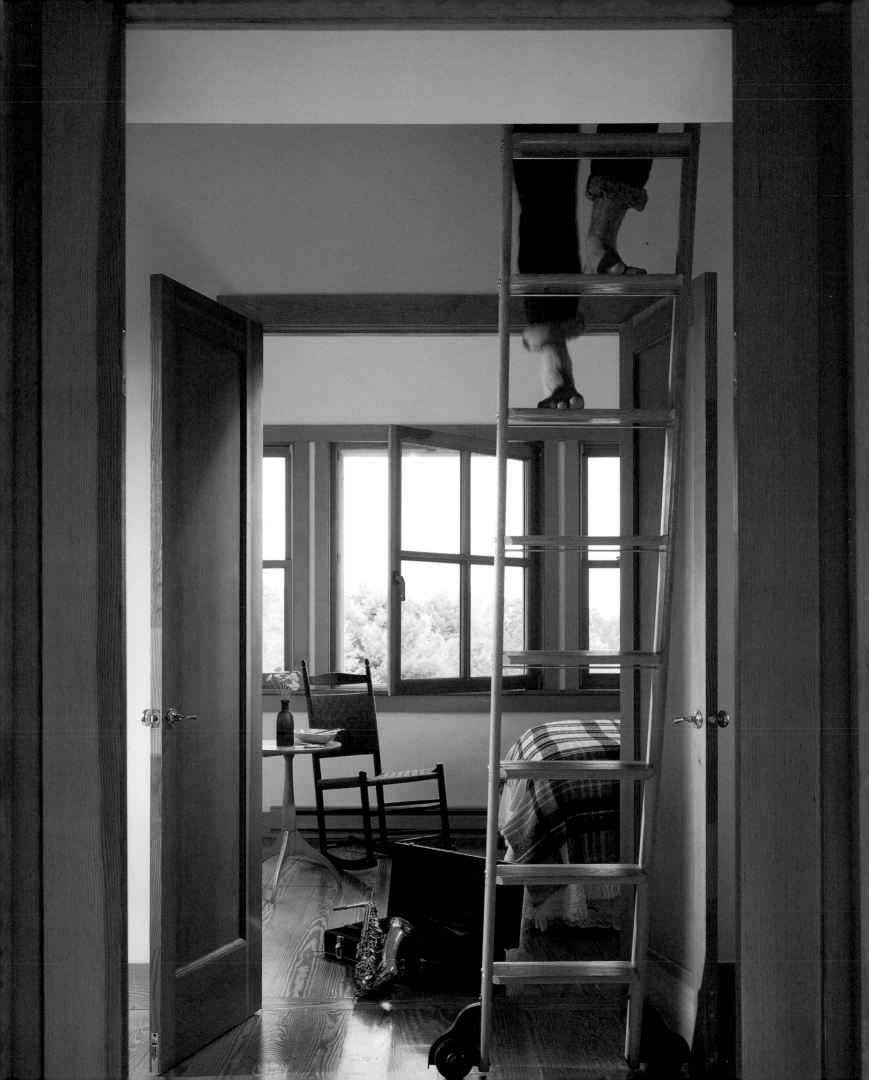

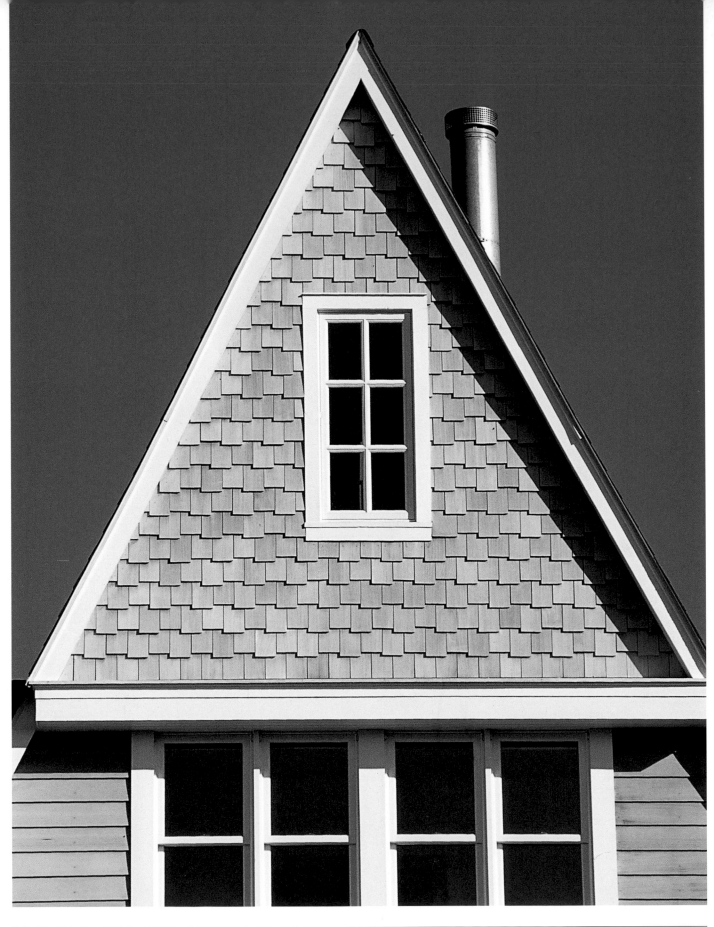

ABOVE The projecting third-floor gable suggests weight, so the group of four windows directly beneath it are a visual surprise—how can a heavy gable sit on something as fragile as windows?

RIGHT Inside the gabled room is a comfortable little hideaway.

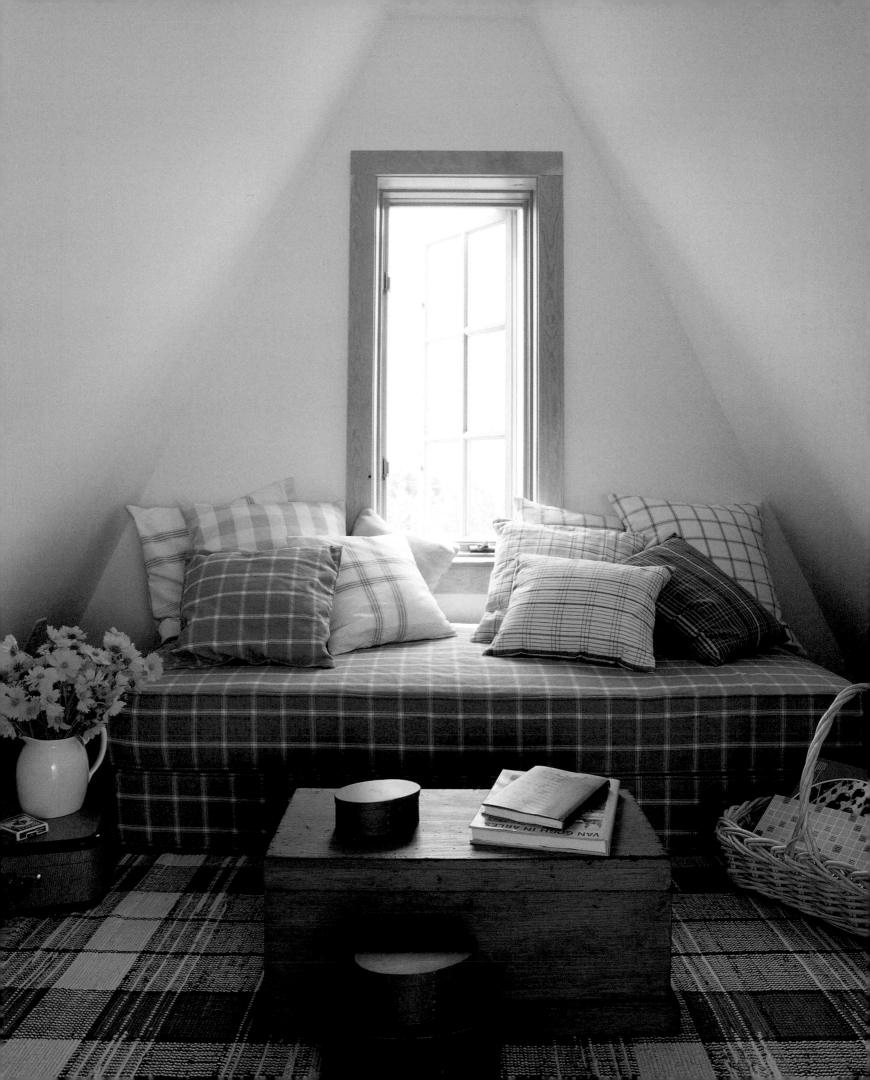

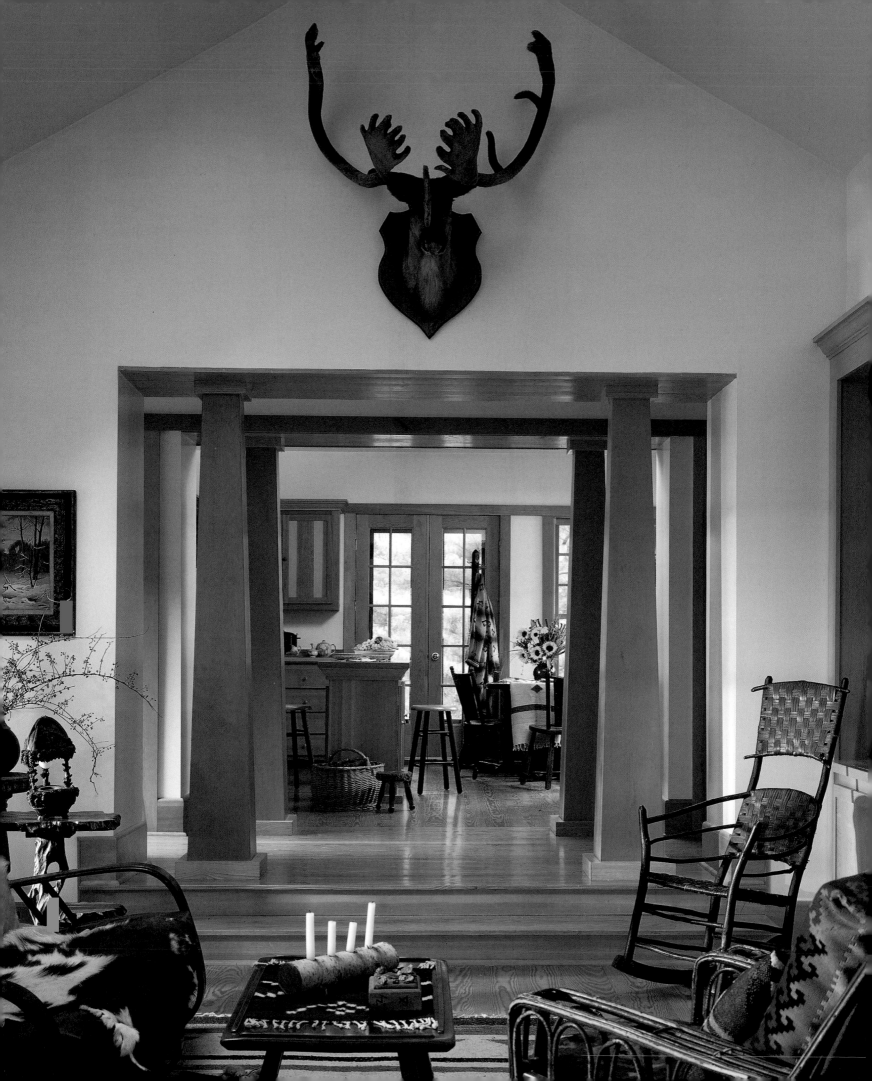

PUMPKIN HILL RENOVATION

An existing house can be transformed into a good house with a few picturesque moves. This former ranch house was in a very pretty setting but had no soul. The owners did not need a larger house when they decided to renovate; they needed a better house. Money was spent to create character and spaciousness, not square footage.

The owners' goal—to create a bucolic retreat incorporating elements of the Craftsman style—was accomplished through the same picturesque techniques that apply to a brand-new house. Two walls were dismantled and a porch and a dormer were added, turning a house that was one of a million into a building that's one of a kind. An enfilade of space framed by tapered bungalow columns provides the interior with the cabin-like look the owners admired. Transparency was achieved, but with a multitude of tiny window panes instead of a few large ones. This kept the look of the house appropriate for the Craftsman style. The focal point is a wood stove rather than a fireplace—this, too, generates a more cabin-like feeling. Imagery is at the heart of the picturesque.

Often a few carefully planned architectural details can make a more powerful impression than a slew of decorations. Picturesque techniques can be repeated from house to house, but the results that emerge are as varied as the homeowners.

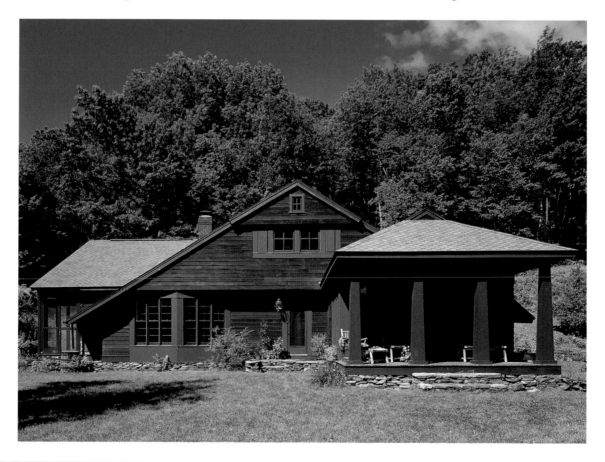

LEFT The family room and kitchen, each with an identical column-framed opening off the hallway, borrow space from each other so that the interior flows from room to room and feels large. The view terminates with French doors leading to the outside, alleviating any feeling of confinement.

ABOVE Renovation and additions created a composition with a looseness reminiscent of the Shingle Style. Varied, generous roofs evoke a sense of refuge.

FOLLOWING PAGE The family room is open to the hallway and kitchen, but focuses on the warmth of a wood stove.

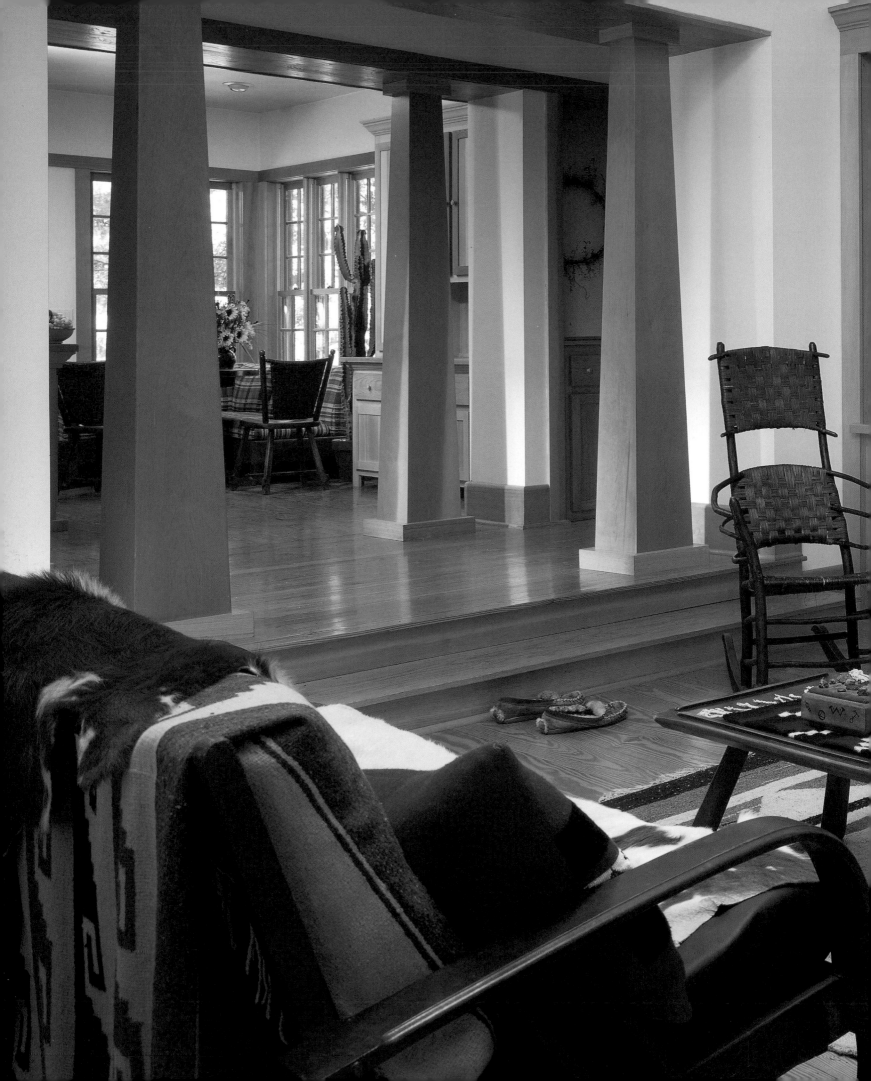

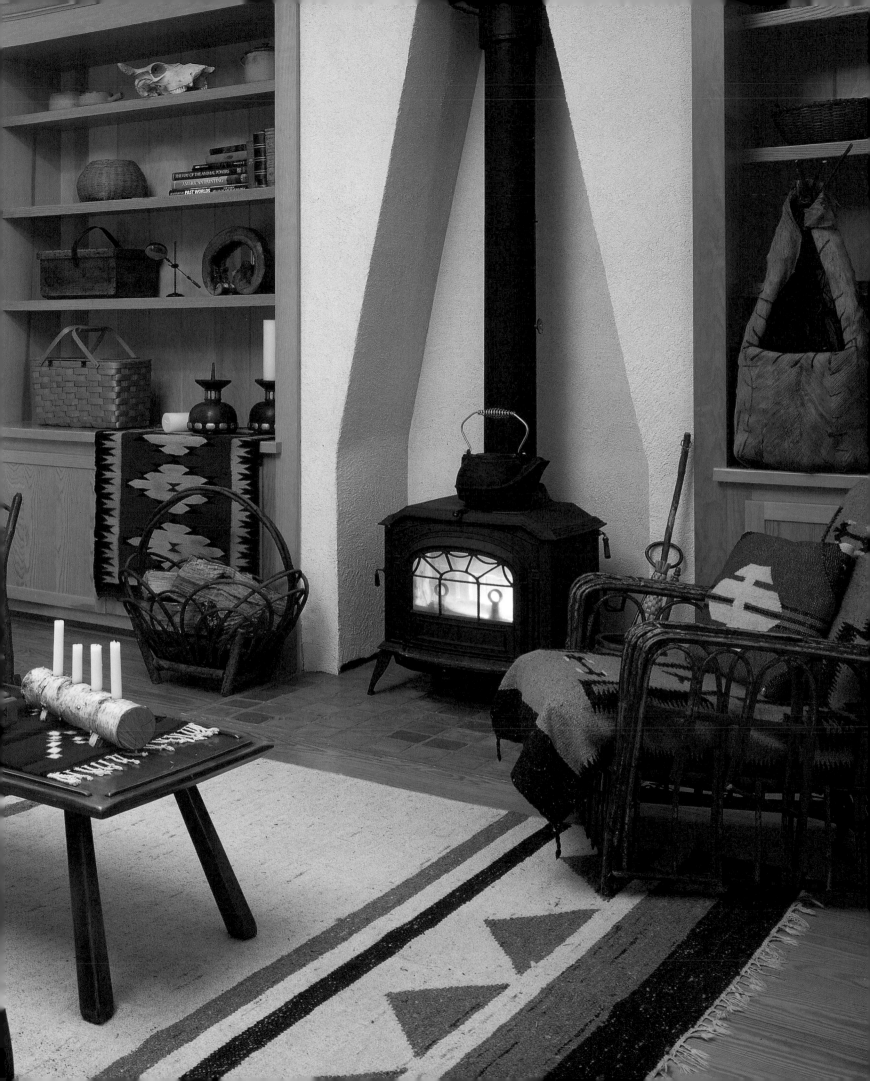

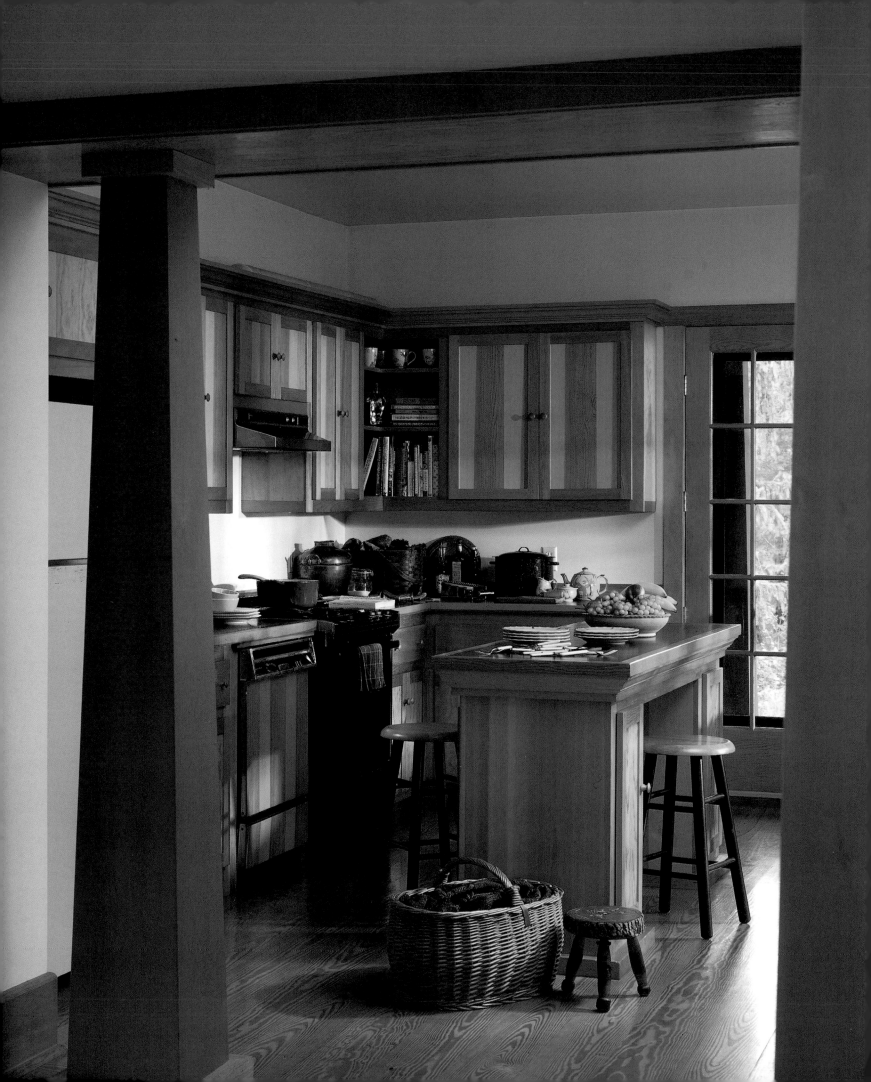

LEFT *The linear patterns of the striped veneer, the picture rail, the door mullions, and the interior and exterior posts lend a strong personality to this otherwise simple kitchen.*

ABOVE *A wall of six-over-six wood-framed windows makes a sunny yet intimate place to relax.*

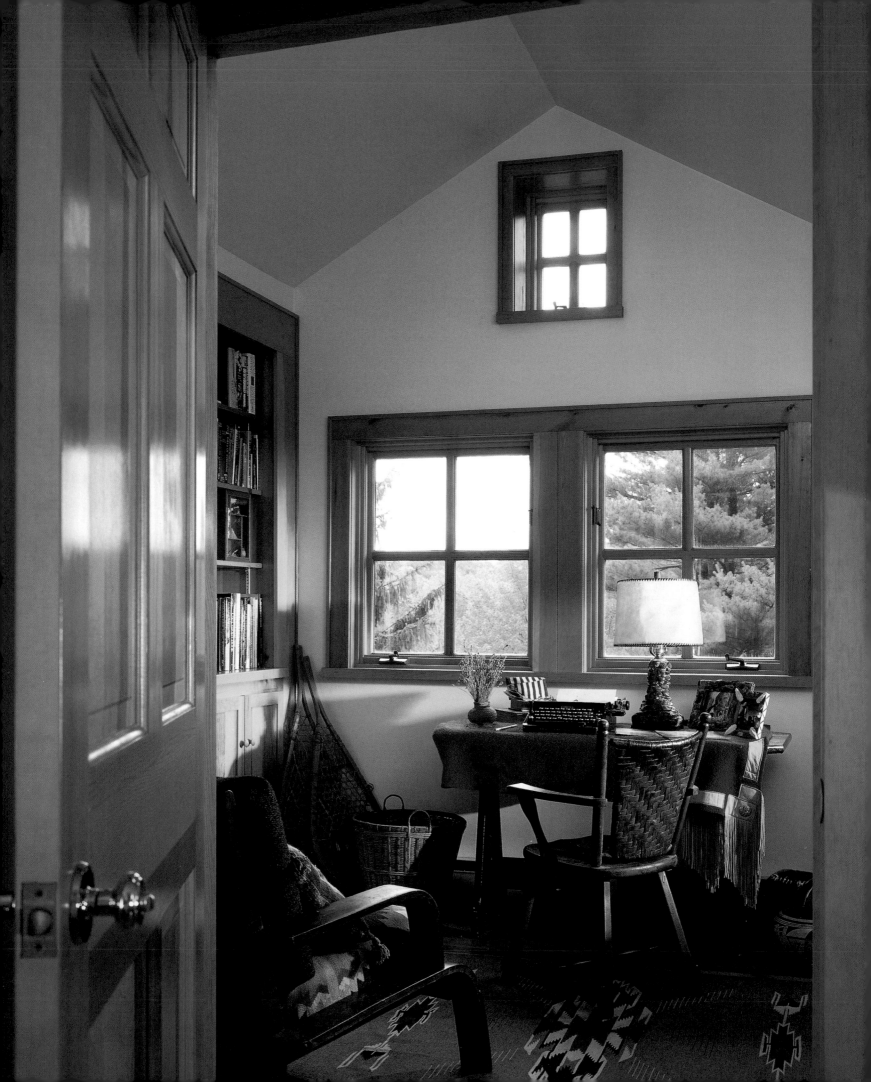

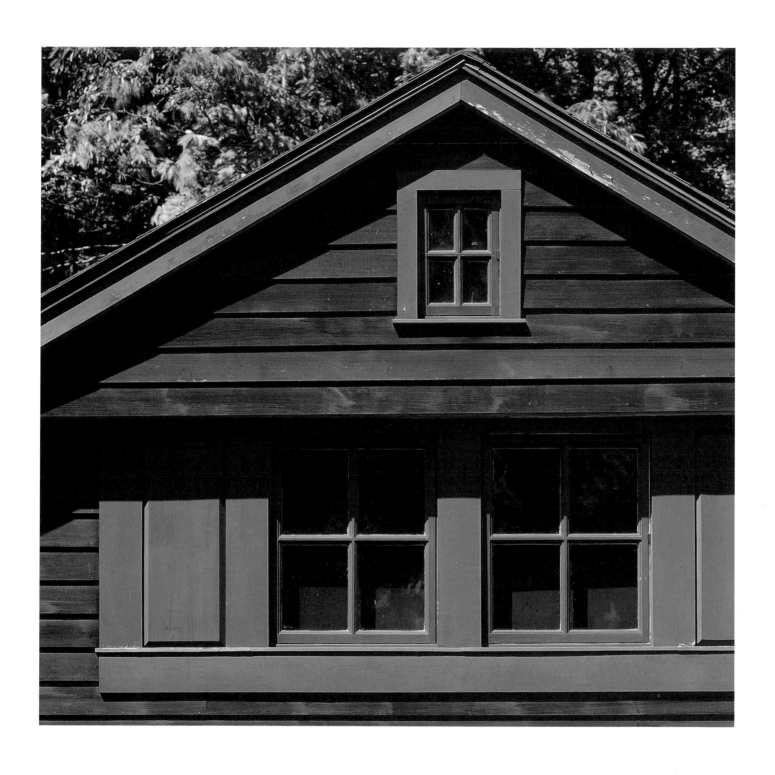

LEFT A symmetrical pair of windows centers the room and looks into the trees, while the deep-framed window at the peak elevates the viewer's imagination and mood.

ABOVE The use of overhangs, side panels, and trim on those same windows gives the exterior appearance a more subtle expression than the striking interior.

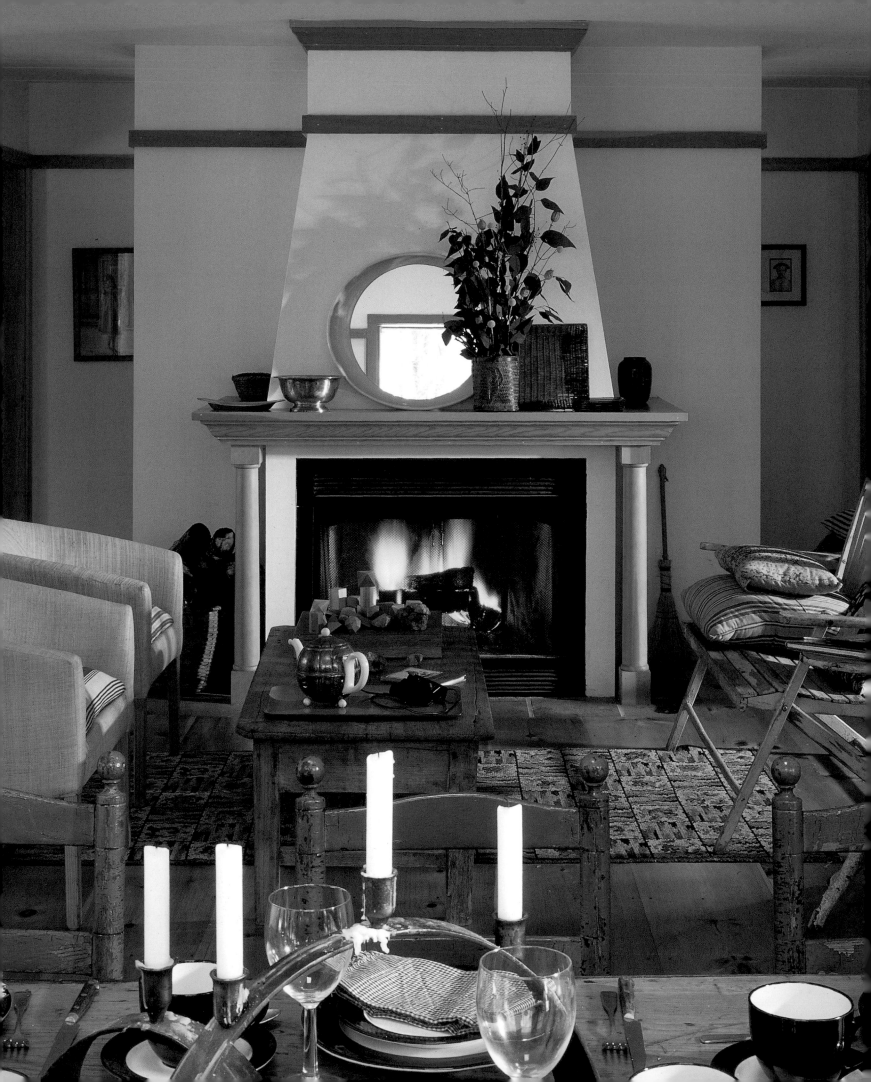

MAPLE GROVE HOUSE

This house was designed to be a weekend retreat from New York City—a woodland escape from the concrete jungle. The 1,500-square-foot dwelling sits on a low hill in the midst of maple trees. As a good house, it embodies the character of the countryside it celebrates.

The great outdoors is an endless space with few well-defined boundaries, and this sense of unobstructed openness is achieved on the interior of the Maple Grove House through the picturesque technique of transparency. Just as a walk through the landscape reveals a series of ever-changing, continuously open spaces, a walk through a good house finds one space opening to another and then another and yet another. There are times when you turn the corner in a good house and find a perfect combination of elements—such as an enfilade of rooms terminating with a fantastic focal point. This experience is comparable to that of a hiker who discovers a breathtaking vista in the middle of a long trek. Enfilades with windows at each end encourage cross-breezes to waft through a house; the occupant can stay indoors and yet enjoy an atmosphere of fresh air. Such bright, airy spaces with vistas that encourage activity and an adventurous spirit are picturesque. The outdoors is picturesque by nature; the indoors can be picturesque only by design.

LEFT and ABOVE The living/dining area of the Maple Grove House looks transparent from the outside, but inside, it feels snug with a fire burning in the fireplace—a focal point that draws the eye away from the cold view through the glass. Note how the walls step back, enhancing the sense of depth.

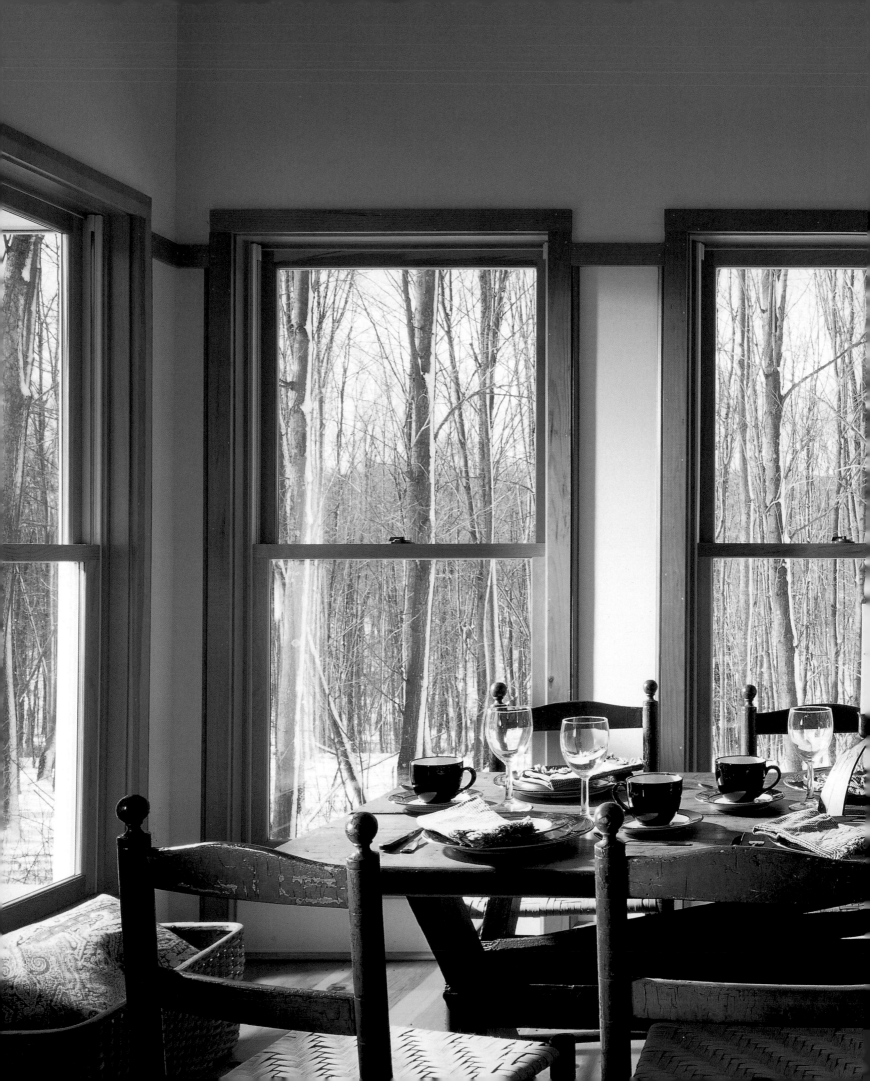

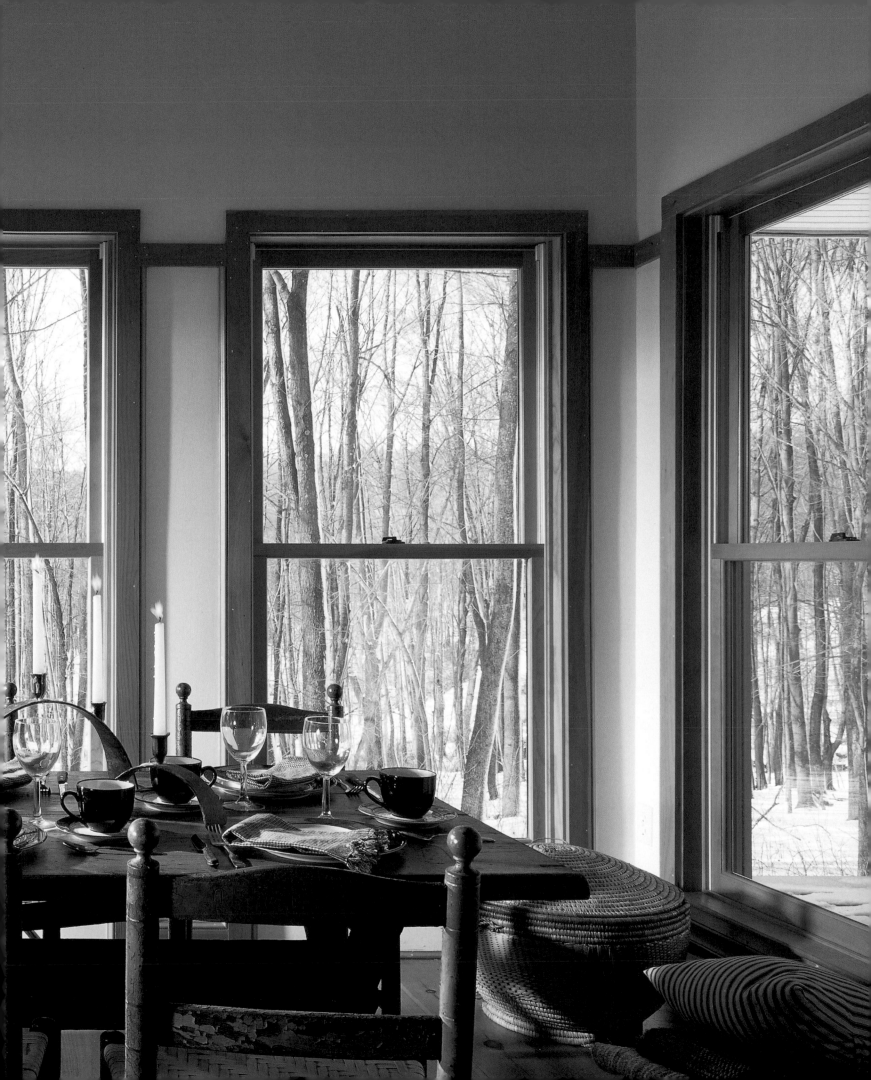

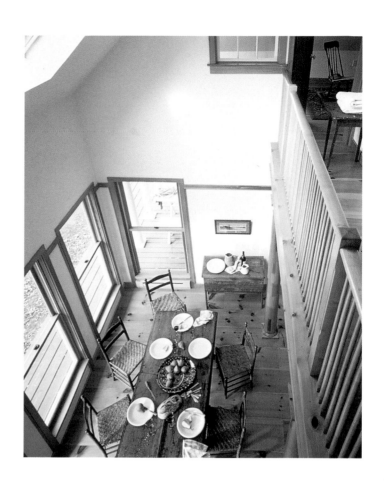

PREVIOUS PAGE Placing windows on three sides makes the dining room feel like the great outdoors. A few inches of trim between each window head establishes a unified pattern that alternates narrow strips of wall with the voids of the windows.

LEFT Centering a pair of windows in their wall and running continuous trim around the room at window height help to settle a busily furnished interior. A snowy landscape visible at the end of these spaces is also a calming influence.

ABOVE A long balcony above the dining area satisfies people's longing for a place where they can be above the scene, looking down.

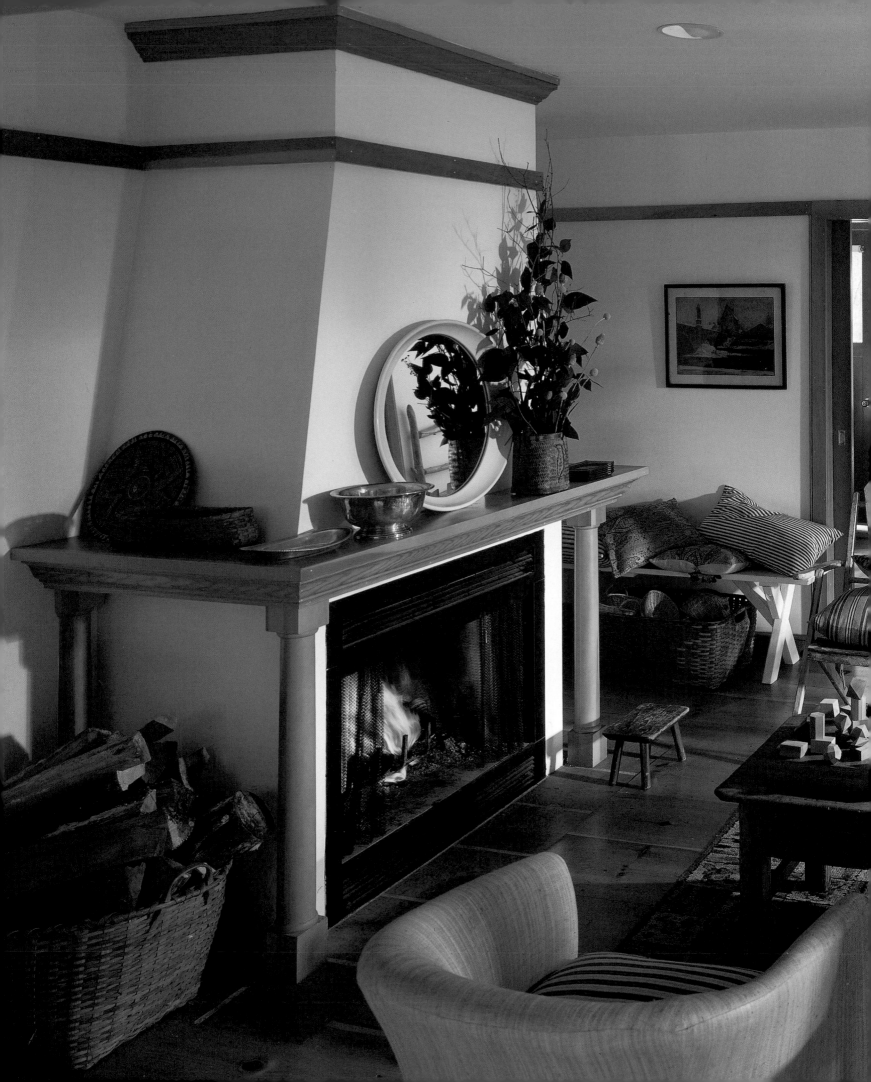

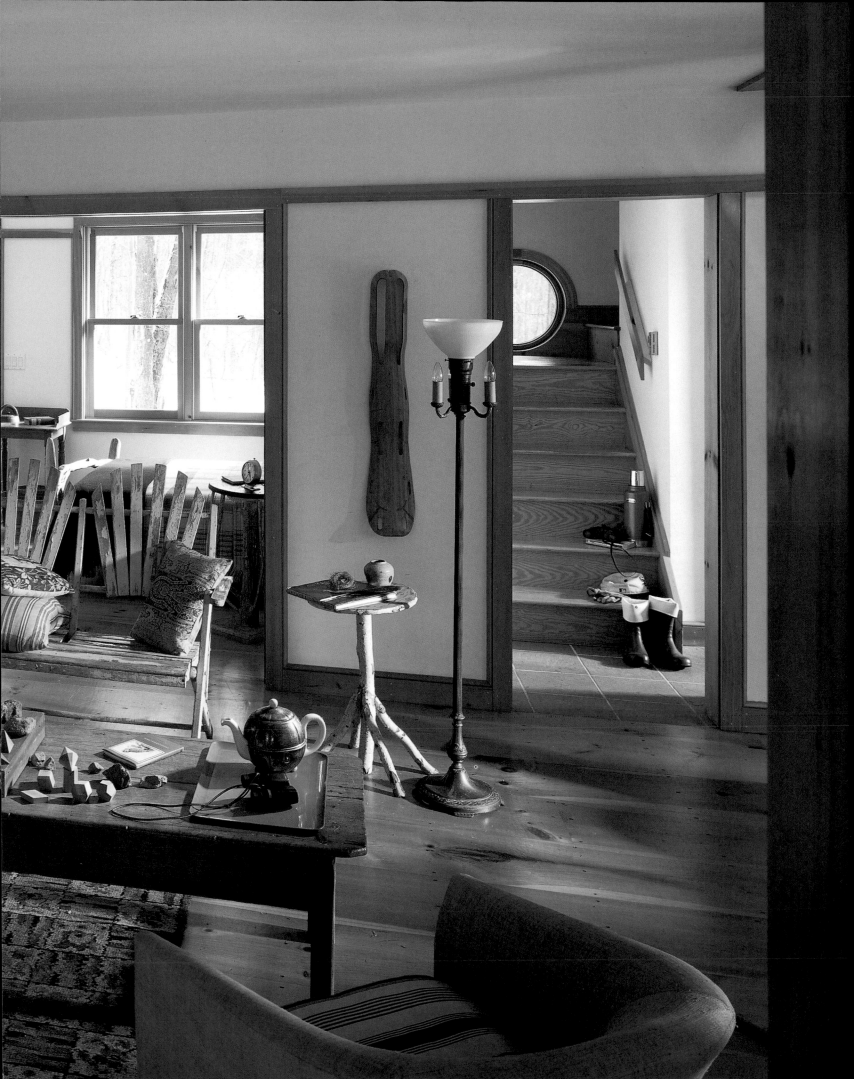

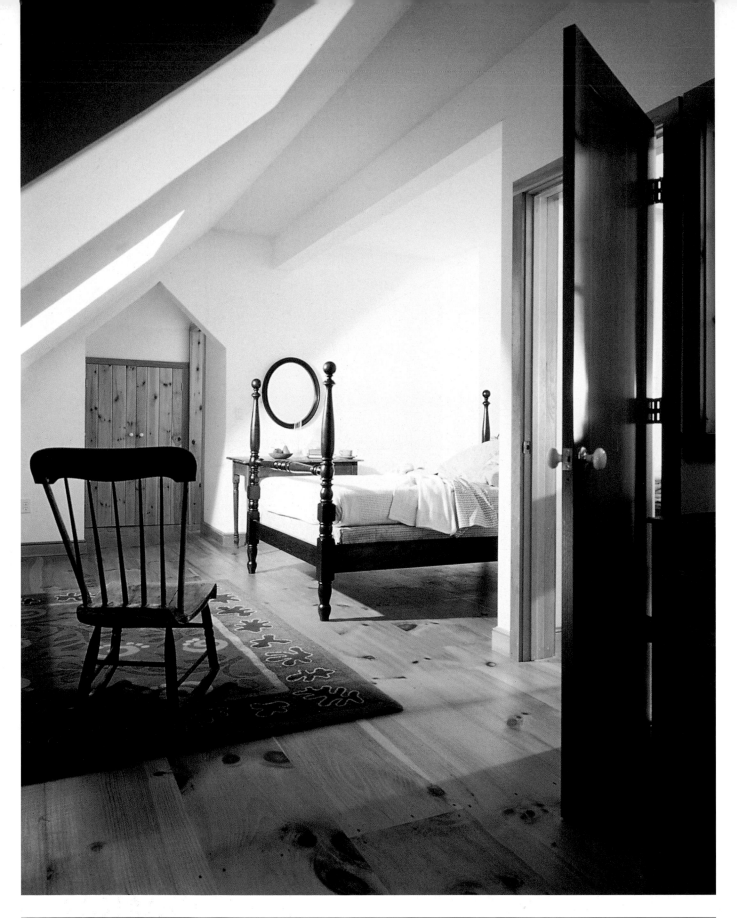

PREVIOUS PAGE The living room gains depth by borrowing space from an adjoining room and a stair hall. Partial views stimulate the imagination.

ABOVE Skylights and irregular shapes create a sunny and cheerful atmosphere in a bedroom tucked under a roof.

RIGHT The space is made still more like a fantasy by an interior window that gives a view to the hall and dining area below.

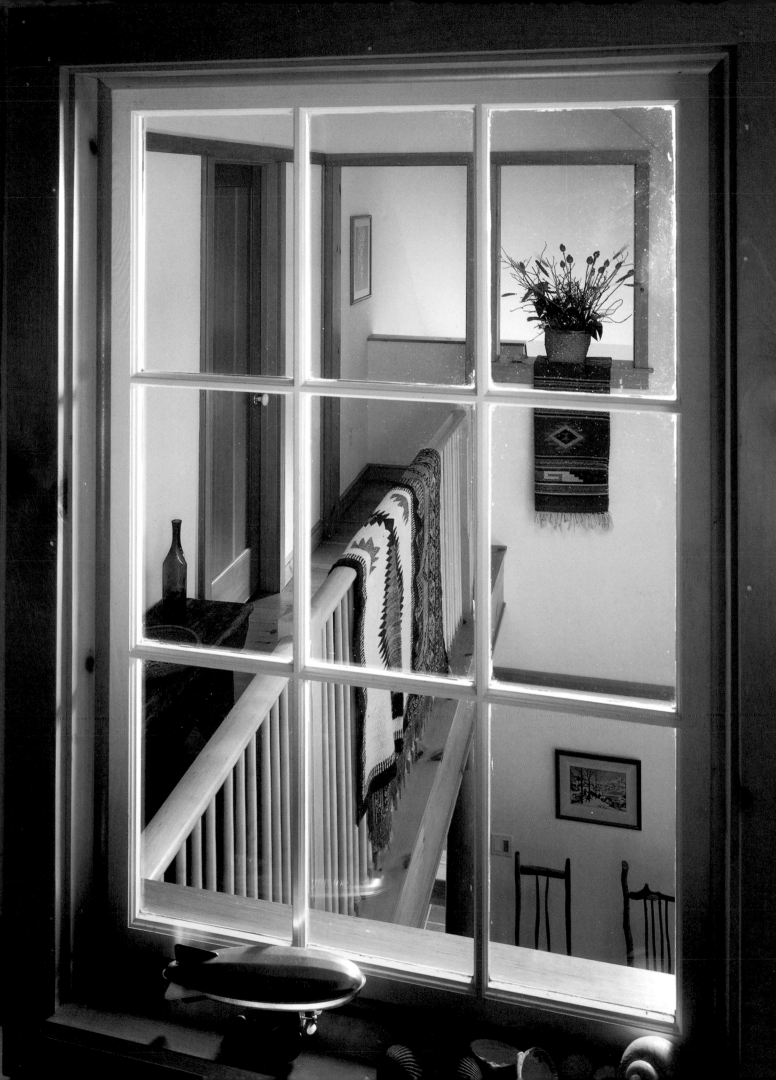

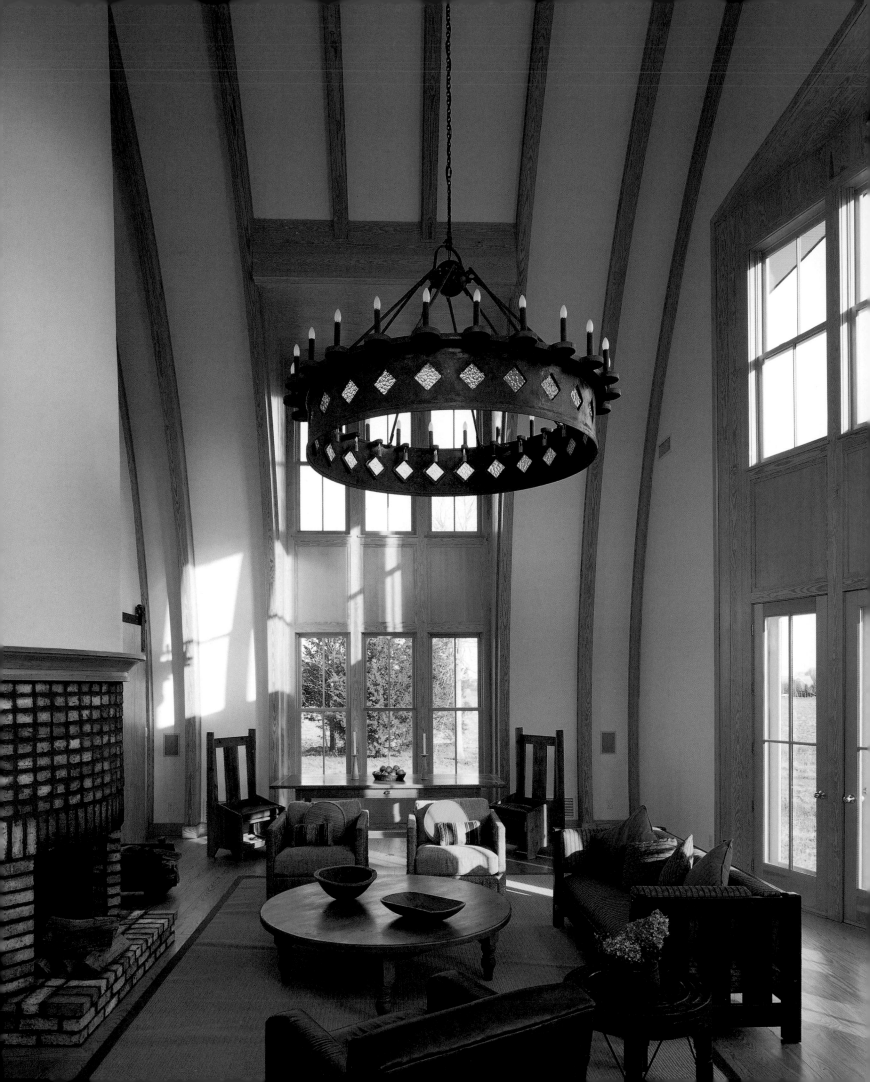

SAGAPONACK ARC

This house is shaped like a potato barn for a good reason: the homeowners have long admired barns for their strong profiles. The arc shape of a potato barn is one of the strongest profiles in architecture. Thanks to its wishbone structure, the structural timbers of the wall become the timbers supporting the roof—all in one swoop.

Inside, the results are a series of wonderfully shaped spaces—from the great room, which puts the full arc on display, to the bedrooms, which are accented by portions of the arc shape. The windows of all the rooms are set into two-story dormers, which engage the curved outer walls and reintroduce the arch profile each time it reappears. The picturesque barn imagery here is achieved mostly through shape.

The house has a simple floor plan consisting of one big rectangle divided into smaller rectangles—demonstrating that good, simple plans do not preclude picturesque qualities. Picturesque interiors can be created by repeating an overall theme. As you move from room to room in this house, the internal views enable your mind to constantly reassemble the overall barn shape. The details you encounter along the way, such as wood paneling, exposed beams, and barn-door hardware, are all reminders that the inspiration for the house came from a potato barn. A theme can exert a stabilizing effect on an interior. Even if the house is a mess, even if the decor falls apart, the ribs of the barn will never lose their picturesque strength.

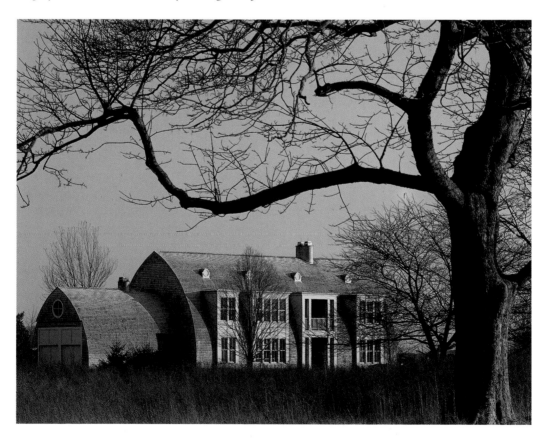

LEFT Interesting interior spaces such as the vaulted living-dining area of the Sagaponack house result from strong volumetric forms.

ABOVE The profiles of the house are vigorous despite the four large projecting dormers that bring in light. The interior is also enlivened by the niches where the dormers extend outward.

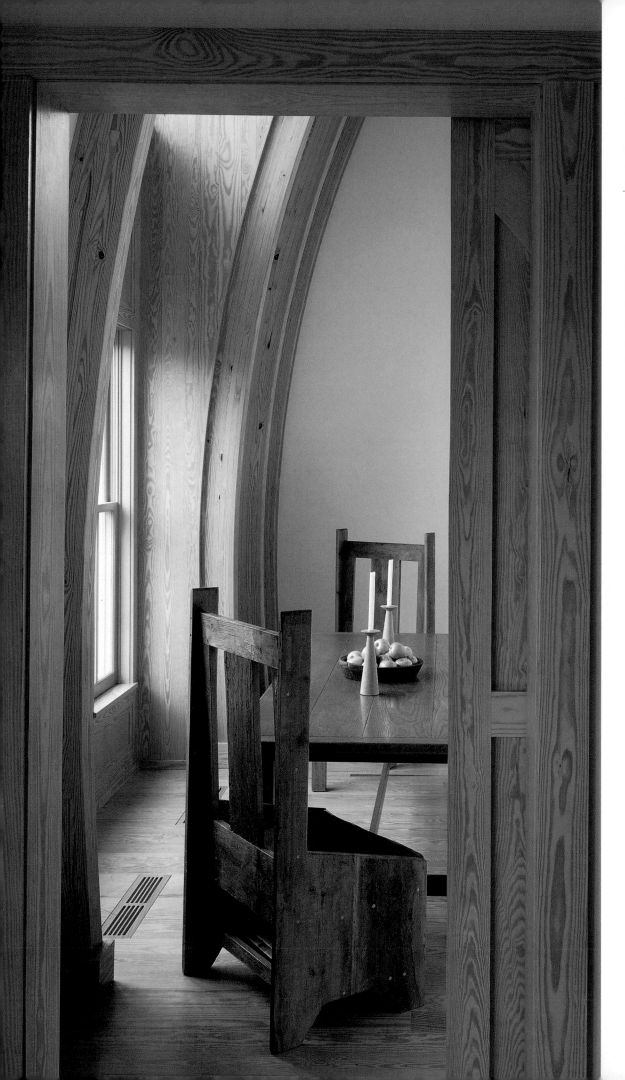

LEFT The dining area exudes a Shaker-like austerity. The room's strong forms, wood surfaces, and sunlight offer a sense of removal from the cluttered, everyday world.

RIGHT Upon walking into the living room, visitors only gradually discover that the large curving shape at left is a towering fireplace. A somewhat mysterious scene becomes clarified. The high windows, situated well above the French doors, work with the fireplace to create a monumental scale.

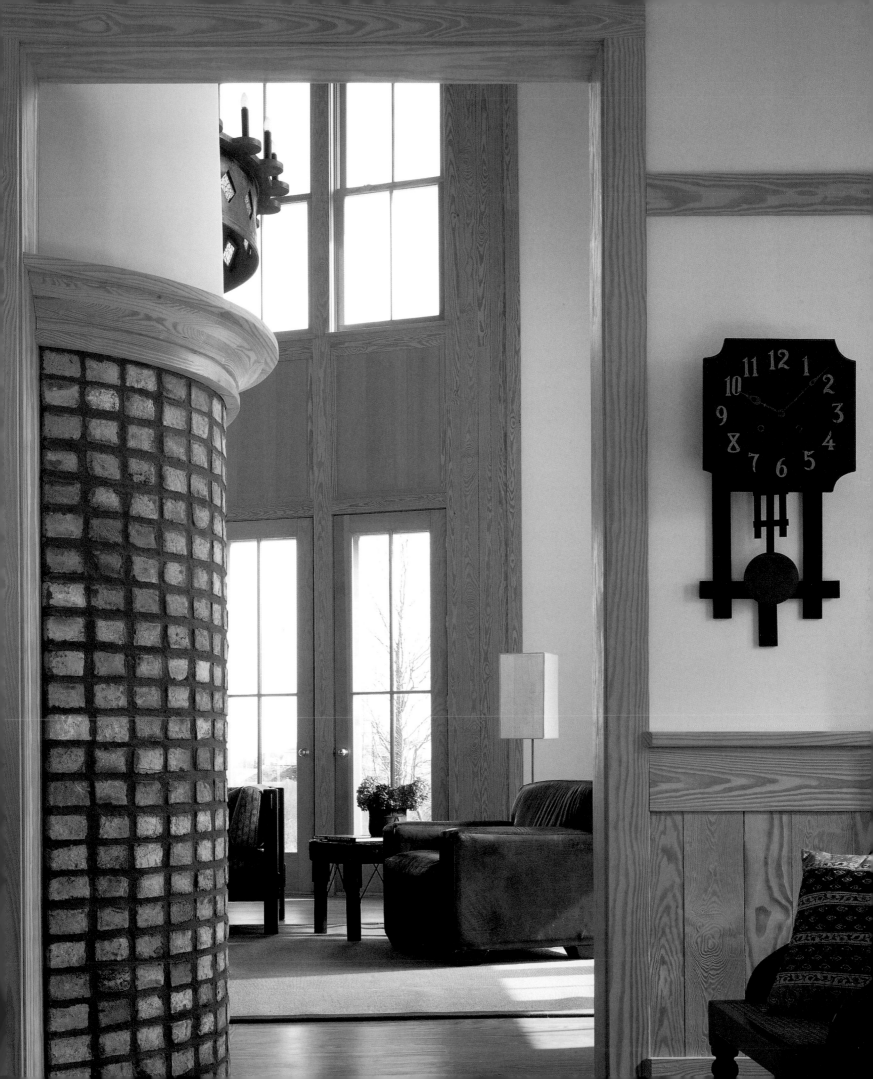

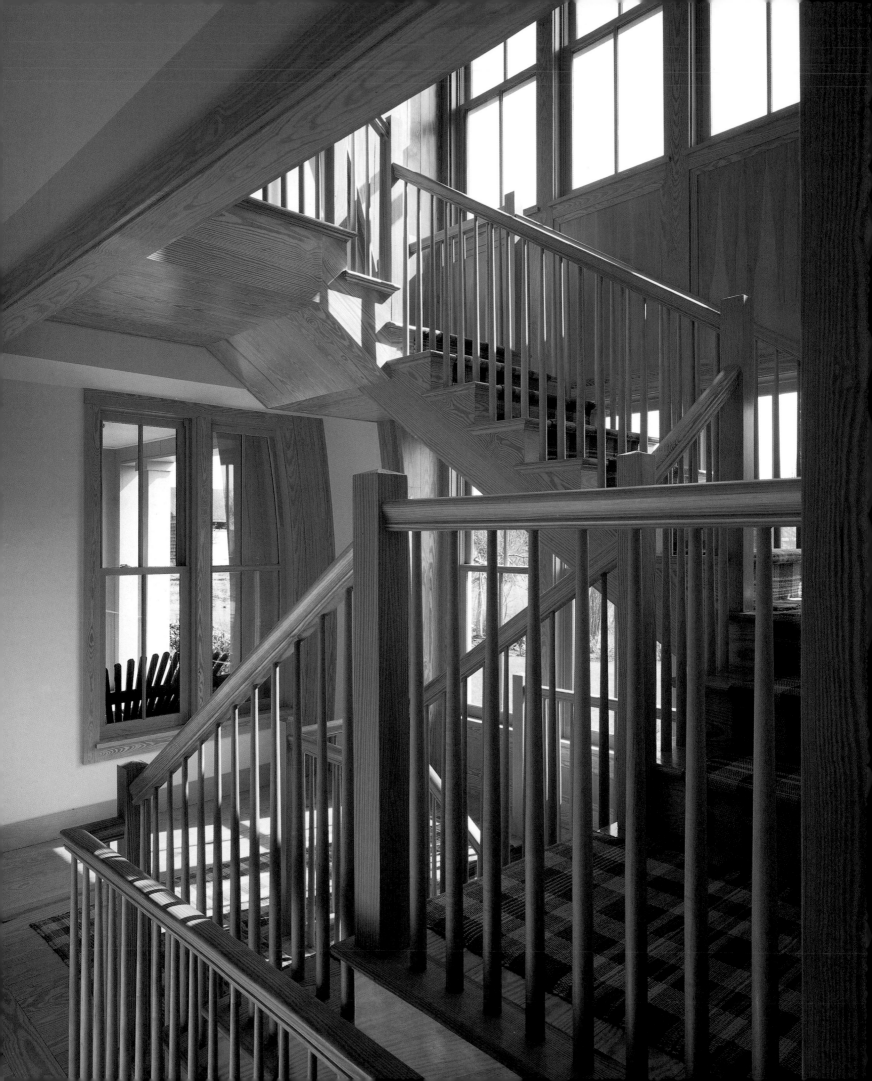

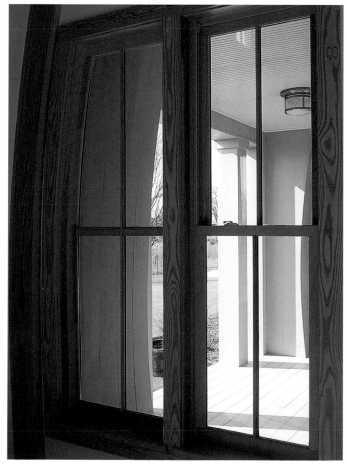

LEFT The elaborate stairway hangs in front of one of the double-height dormers prominent on the exterior. The numerous spindles create pattern upon pattern when layered in front of the multipane windows beyond.

TOP LEFT A small, round window at the peak of the living-room space provides a glimpse into the shaped space of the master bedroom.

TOP RIGHT The metal bar for the door roller is a barn detail brought indoors.

RIGHT A special-order curved double-hung window helps to make the house feel unique. This one (seen on the left) follows the curve of the structure of the house.

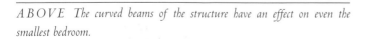

ABOVE The curved beams of the structure have an effect on even the smallest bedroom.

RIGHT This guest master celebrates the intersection of the dormer and the curve of the roof with the use of pine paneling.

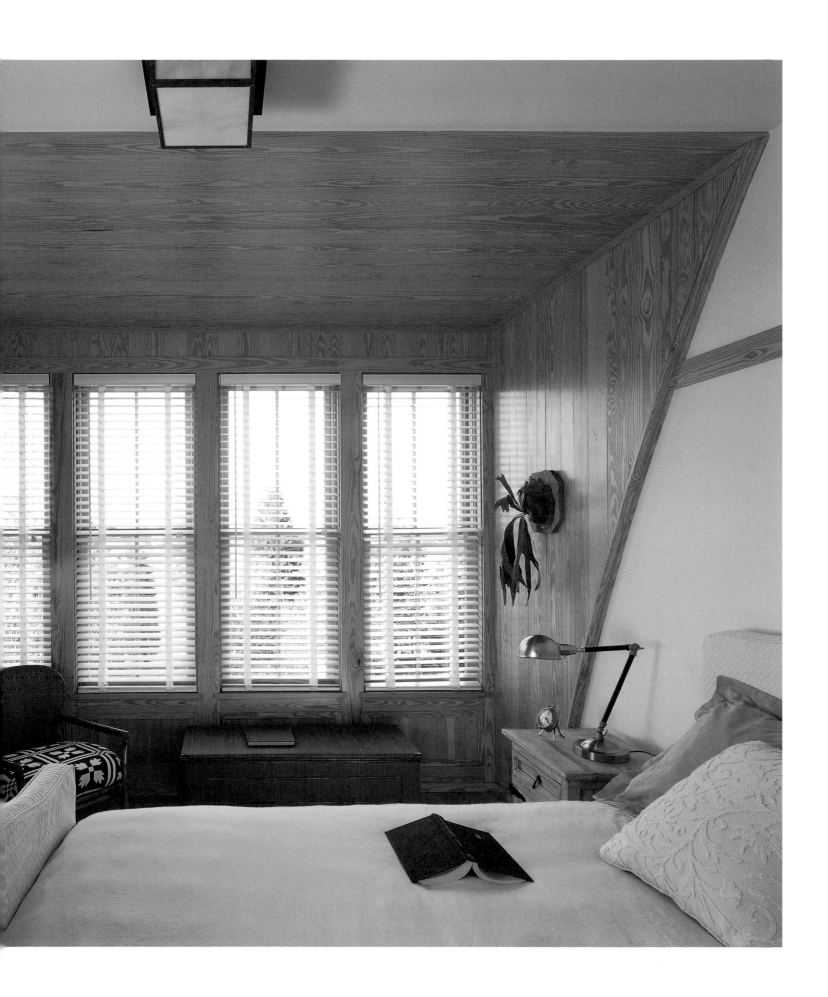

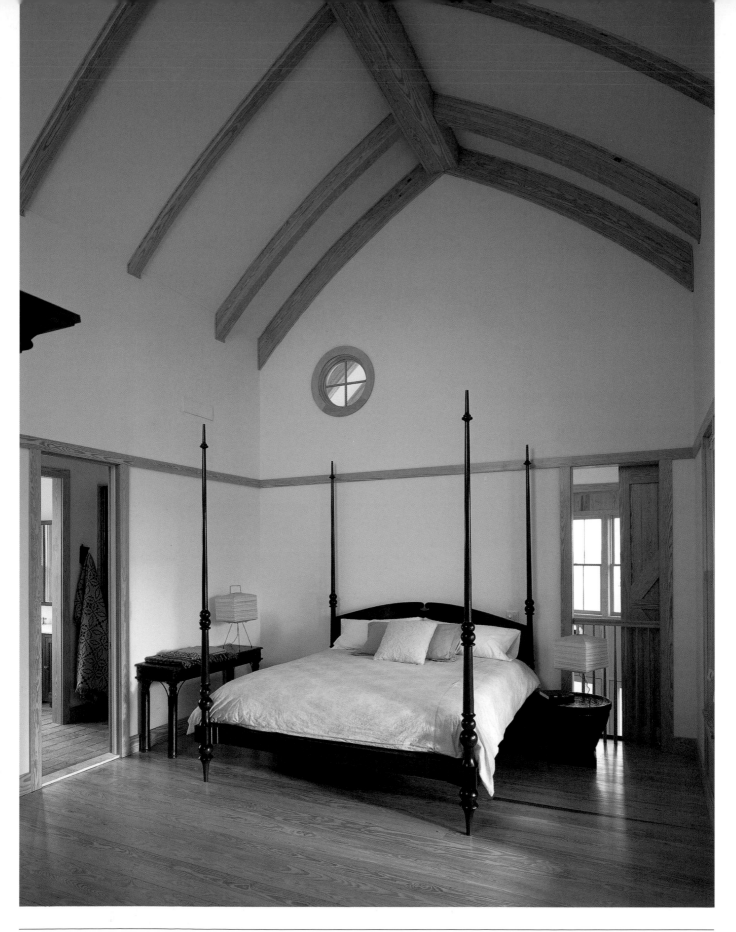

ABOVE The strong profile of the roof helps to create an intriguing space in the master bedroom. The fact that the roof profile is interrupted by the wall injects a touch of surprise. Two playful points in the room are the small, round window near the ceiling and the balcony opening near the bed.

RIGHT The bathtub is upstaged by the windows and the view. Note the wainscoting on the tub surround.

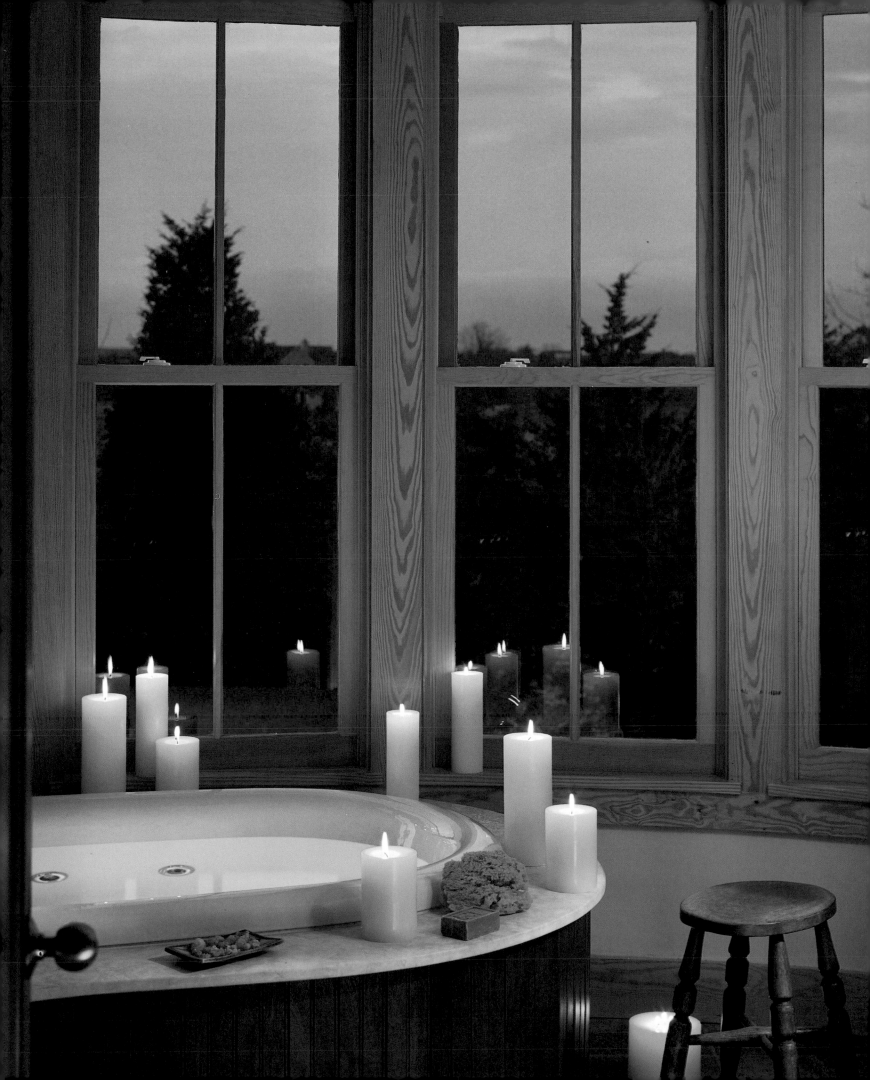

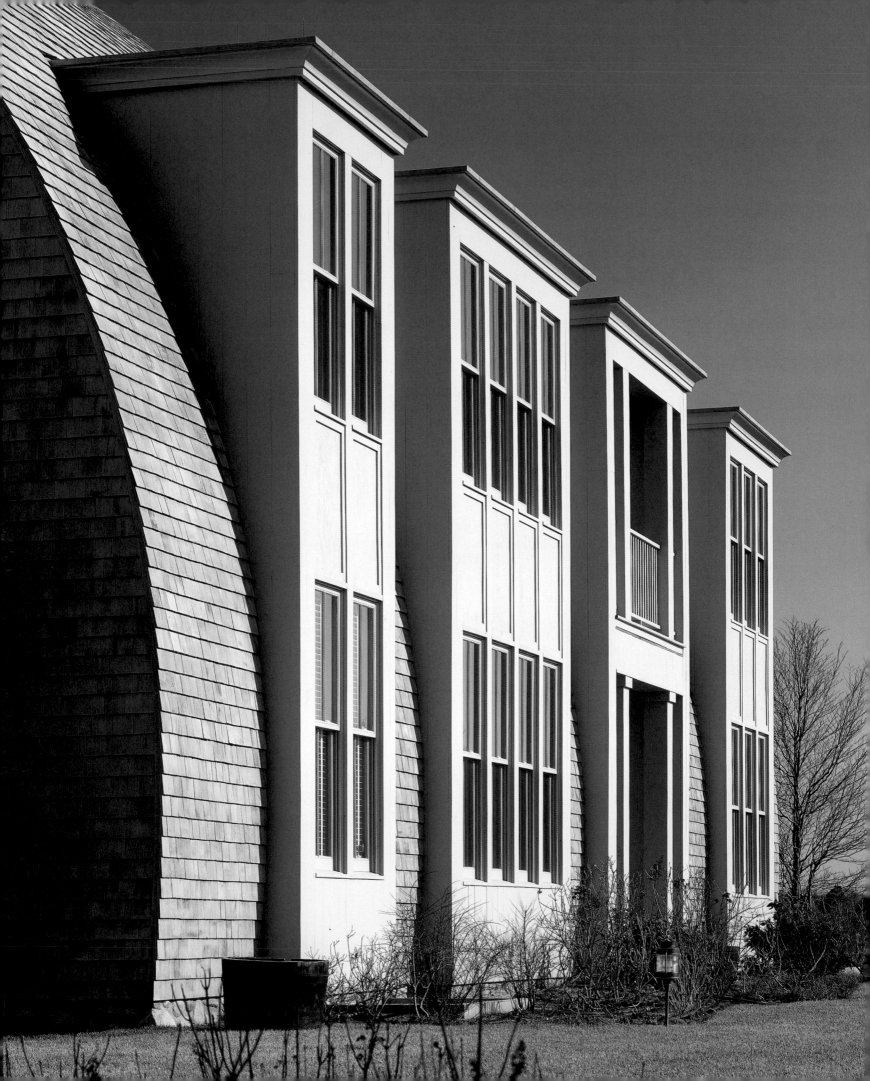

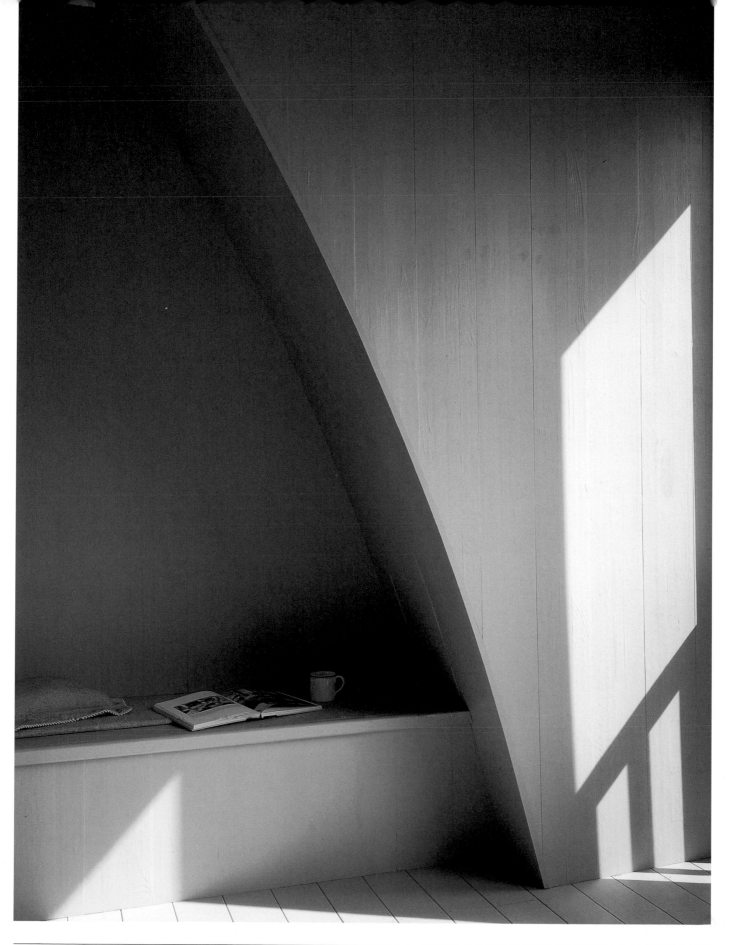

LEFT *The double-height dormers and curved walls of this unusual house guarantee one-of-a-kind interior and exterior spaces such as the second-floor porch.*

ABOVE *The balcony located off the master bedroom, which is fitted with an alcove, is a perfect spot to have morning coffee.*

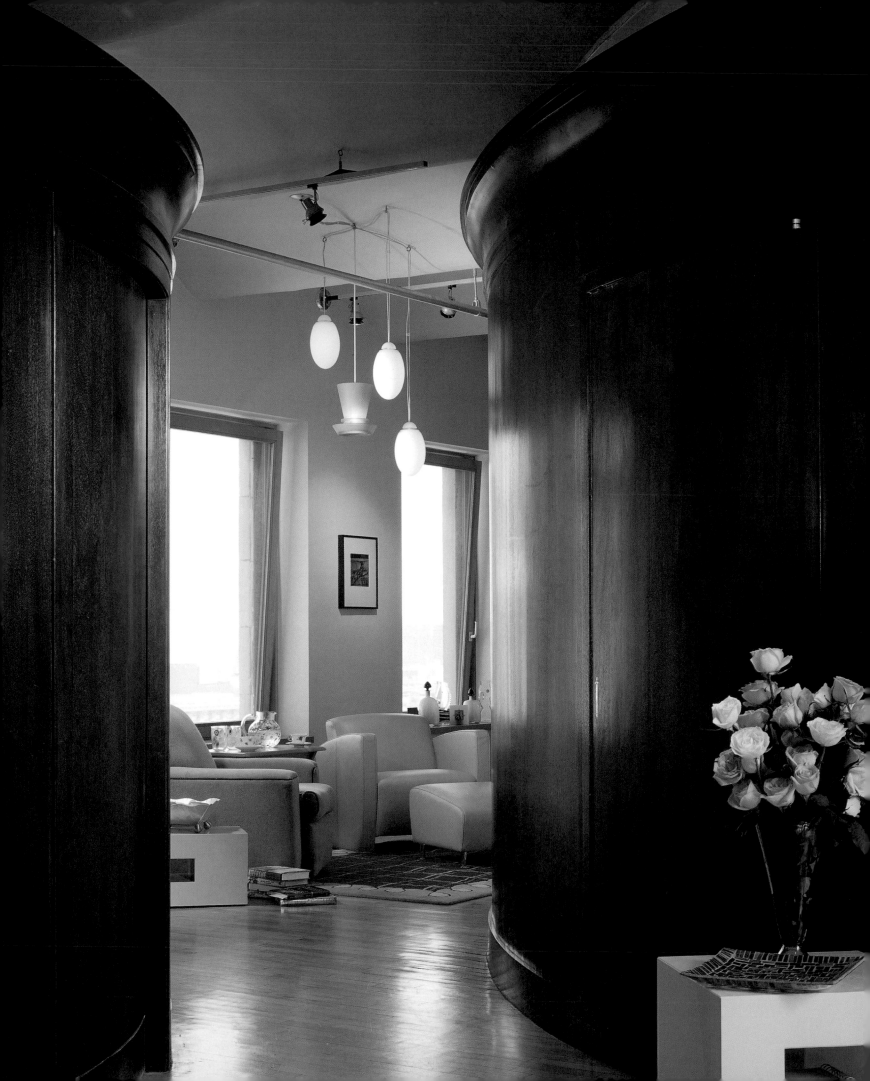

NOHO LOFT

In the city, the good house is often not a house at all. It may be a picturesque apartment, a picturesque townhouse, or a picturesque converted loft space like this one. This New York penthouse loft has windows on all four sides, but since they're within a solid nineteenth-century masonry shell, the effect is not one of transparency. Instead, like many urban interiors, the loft is more inward than outward in its focus. The interior space therefore needs to provide not only the qualities of good shelter but also the spirit and serenity associated with an appealing landscape. Shape is the driving force behind the solution. Through the introduction of curving walls that stand free like a forest of absurdly wide and preposterously short trees, the whole interior is transformed into a landscape of spaces.

Moving from space to space is always a matter of turning a corner and generating feelings of anticipation and surprise. The hollowed-out trunks are lined with colorful woods, bleached woods, and stainless steel. From certain angles the shapes form completely enclosed rooms. But from a slightly different angle you can see from one end of the loft clear to the other end, 120 feet away. Places to go, places to hide, wide-open spaces, and small, intimate areas are all created within the confines of four city walls.

As a bonus, a rooftop terrace caps the loft. To entice you to climb up, a steel staircase is set against the outermost wall. Along the way to the to the top of the stairs, the city streets fall ten stories below your feet. The rooftop landscape, designed by Margie Ruddick, brings the picturesque outdoors. All the picturesque techniques that were used in the interior are applied to an urban garden. Shaped spaces are enfilades made of shrubs and decks, and the picturesque details are accomplished through grasses, textures, and water.

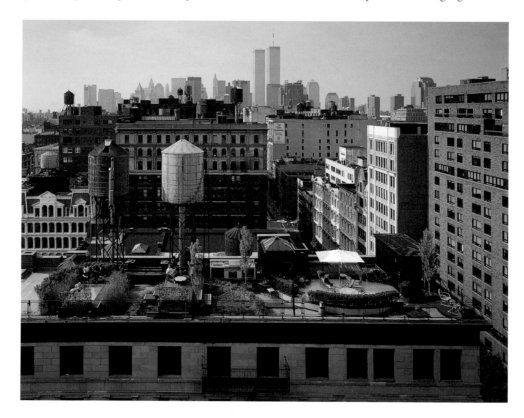

ABOVE Set in Manhattan, this penthouse loft and roof garden represent picturesque living in the city.

LEFT Curved mahogany partitions set off the view into a sitting area. There's nothing to hold the space. It undulates, yet is defined.

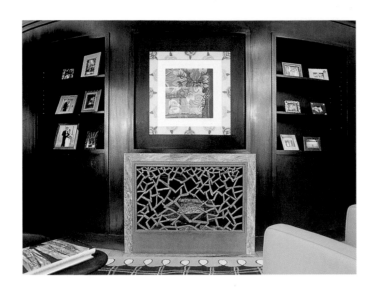

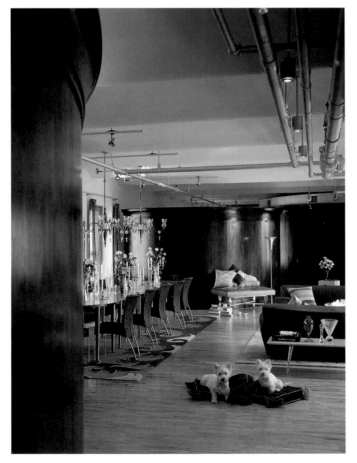

TOP A fireplace with a handmade grille is a focal point, flanked by symmetrical curving bookcases.

ABOVE The mahogany partitions stop short of the ceiling, allowing the space to flow around them.

RIGHT The view from the master sitting area to the main living area. Depending on where you focus your eye, you are either in a room within a larger loft, or in one large open space.

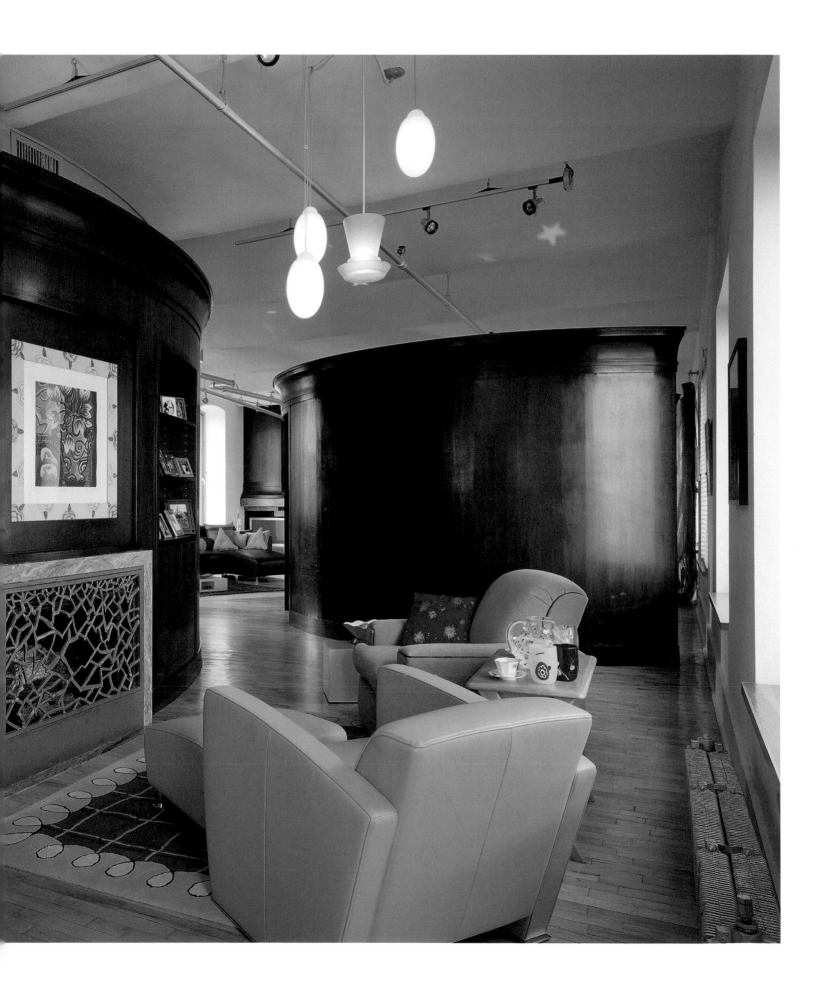

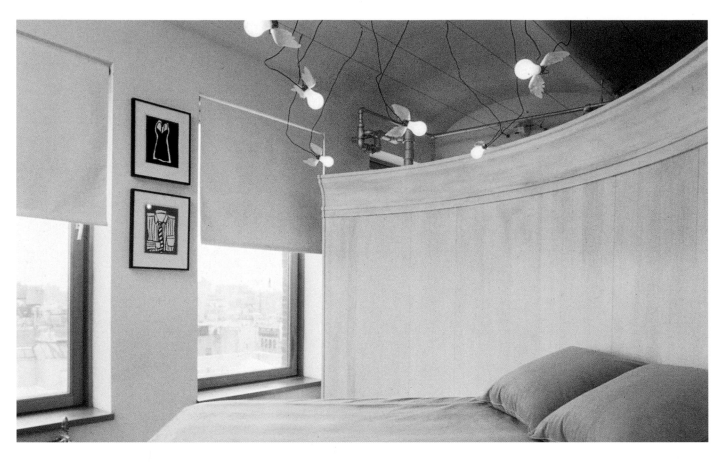

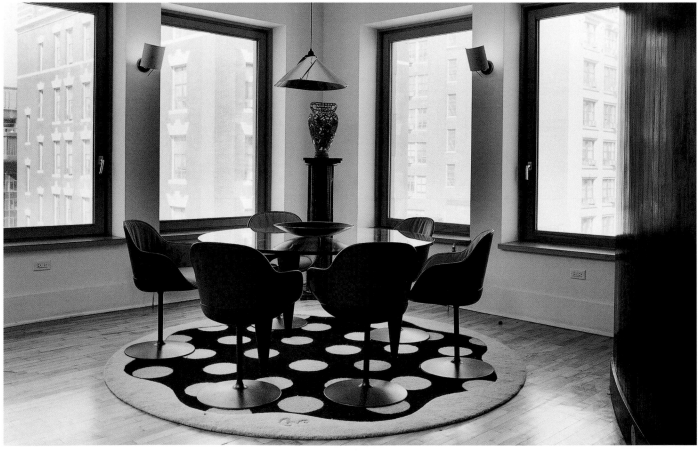

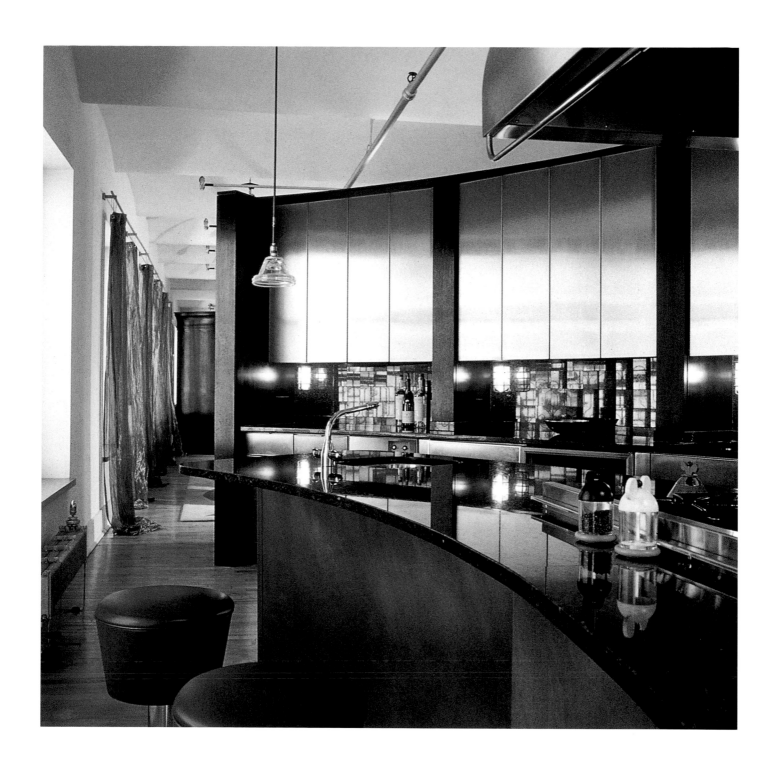

LEFT TOP *This whitewashed bedroom partition provides a minimum of visual privacy, but half of the loft is the master wing, so privacy is not really an issue.*

LEFT BOTTOM *The breakfast corner is the only space in the loft that is not interrupted in some way by the curving walls.*

ABOVE *The partitions stop short of the building's exterior walls, creating a slight enfilade which runs from end to end.*

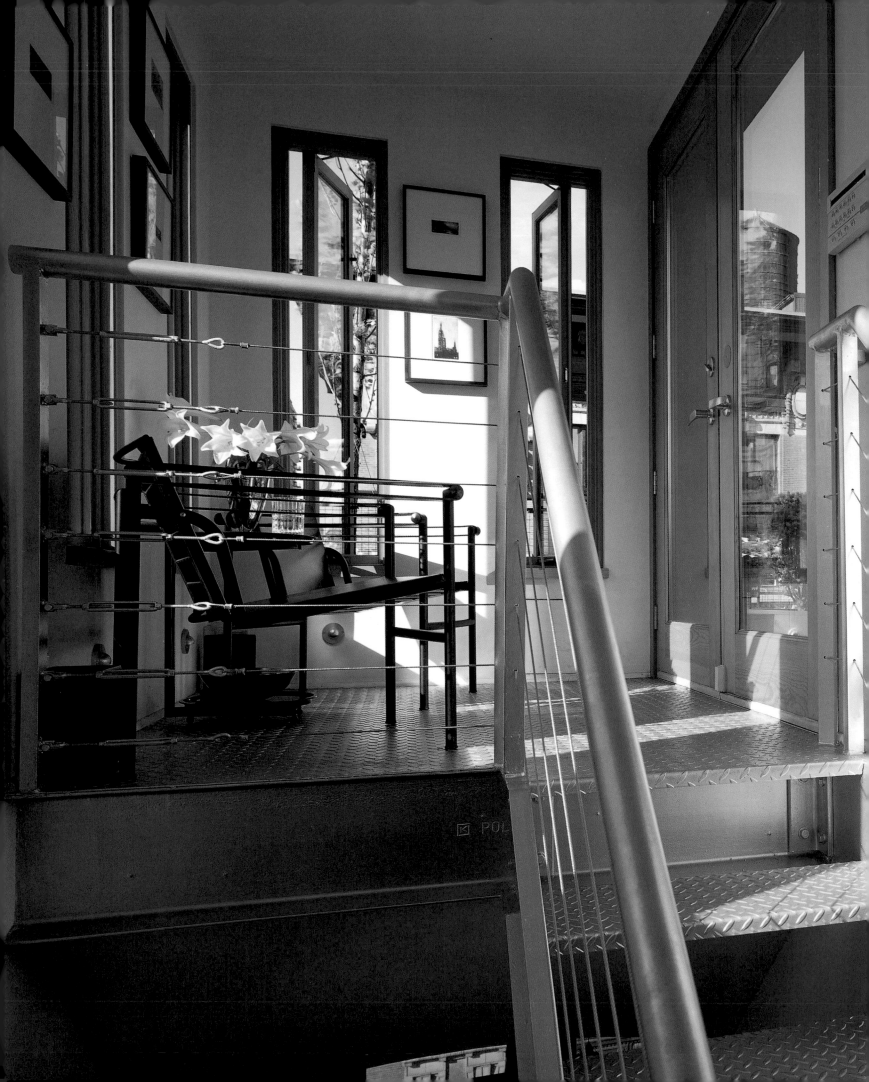

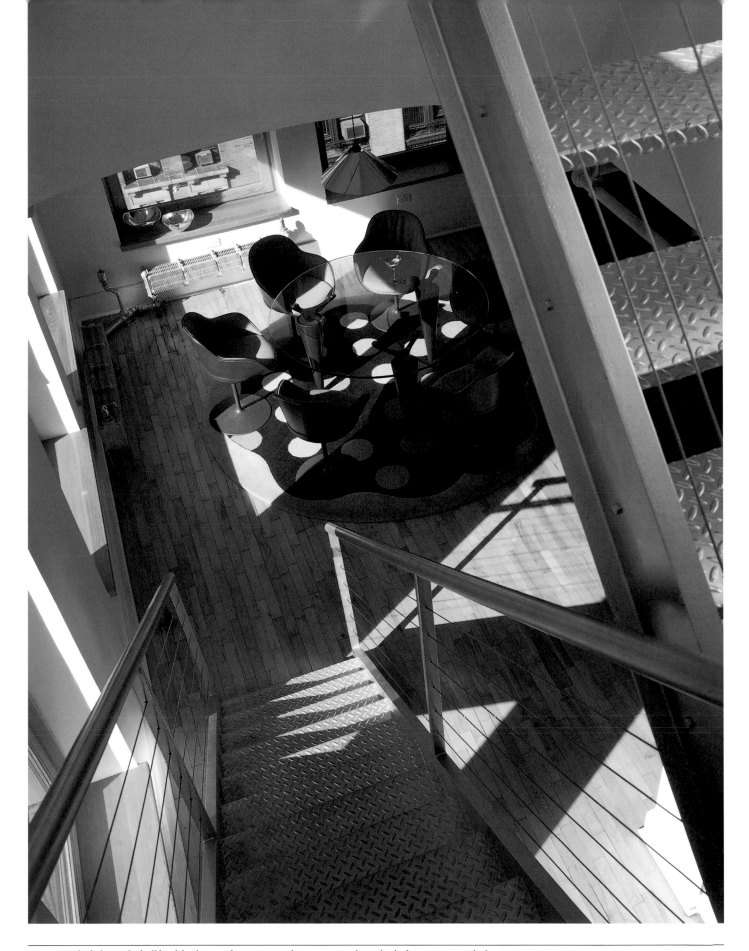

LEFT The light in the bulkhead leading to the rooftop garden entices people to climb the stairs to reach the view.

ABOVE Steel treads on the stairway from the breakfast area maintain the loft's industrial air. It's like climbing a fire escape.

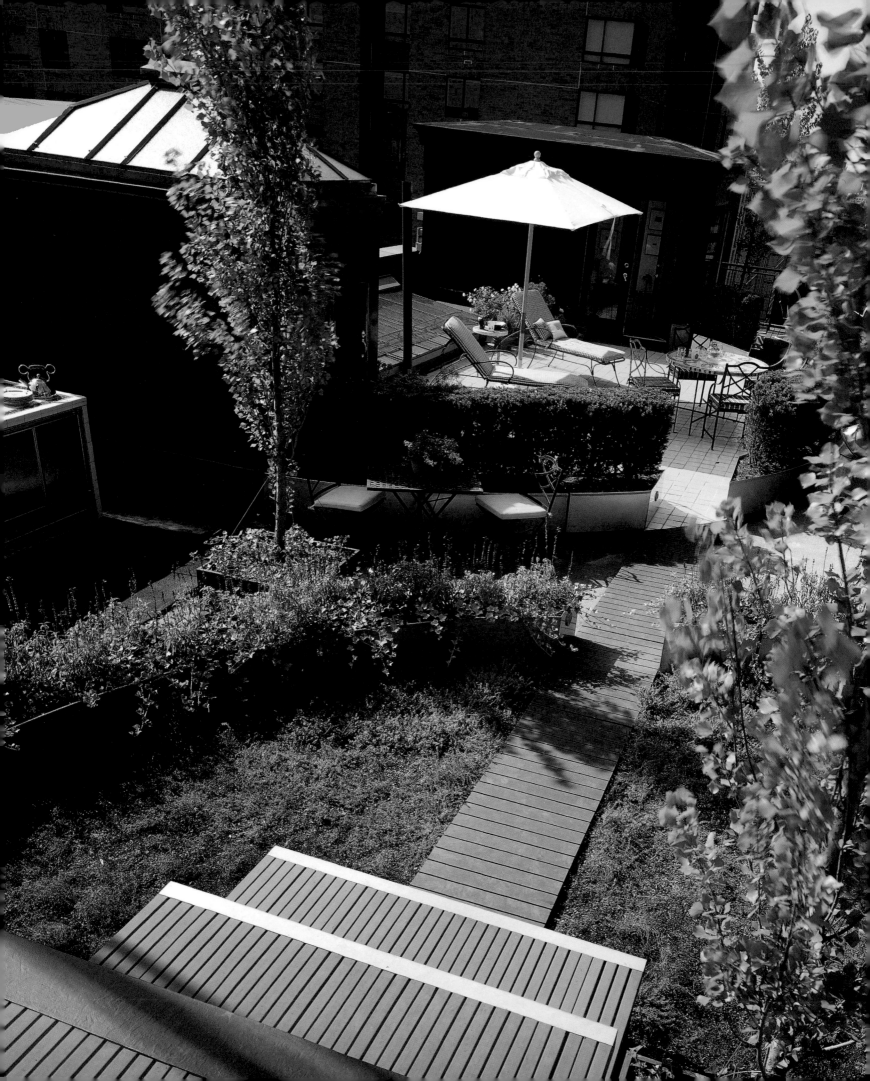

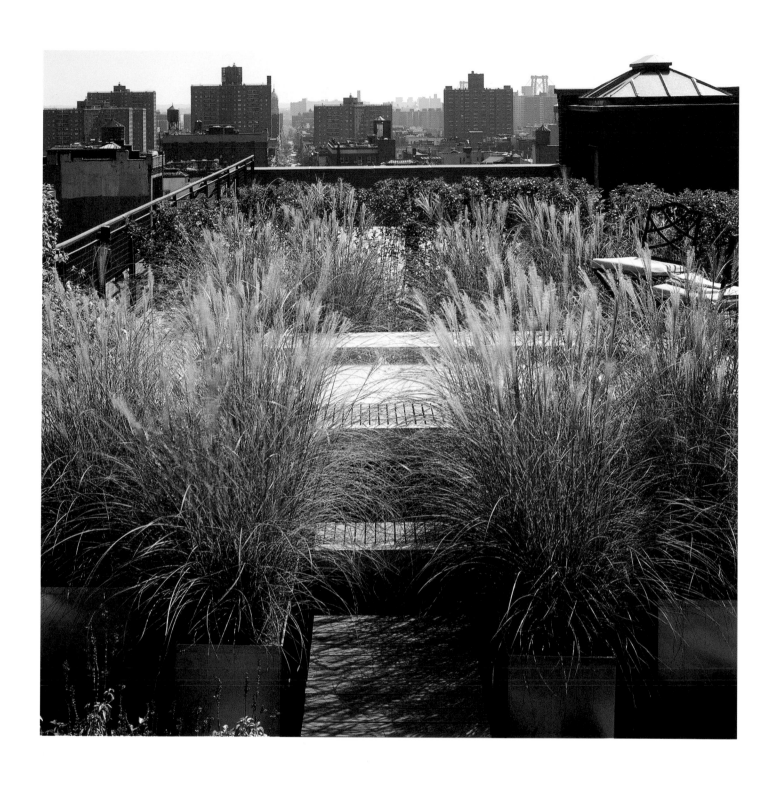

LEFT *The view from the raised deck toward one of the more private spaces. The rooftop spaces are shaped by shrubbery and planters.*

ABOVE *The garden uses the technique of enfilade—spaces in succession. The focal point here is a reflecting pool.*

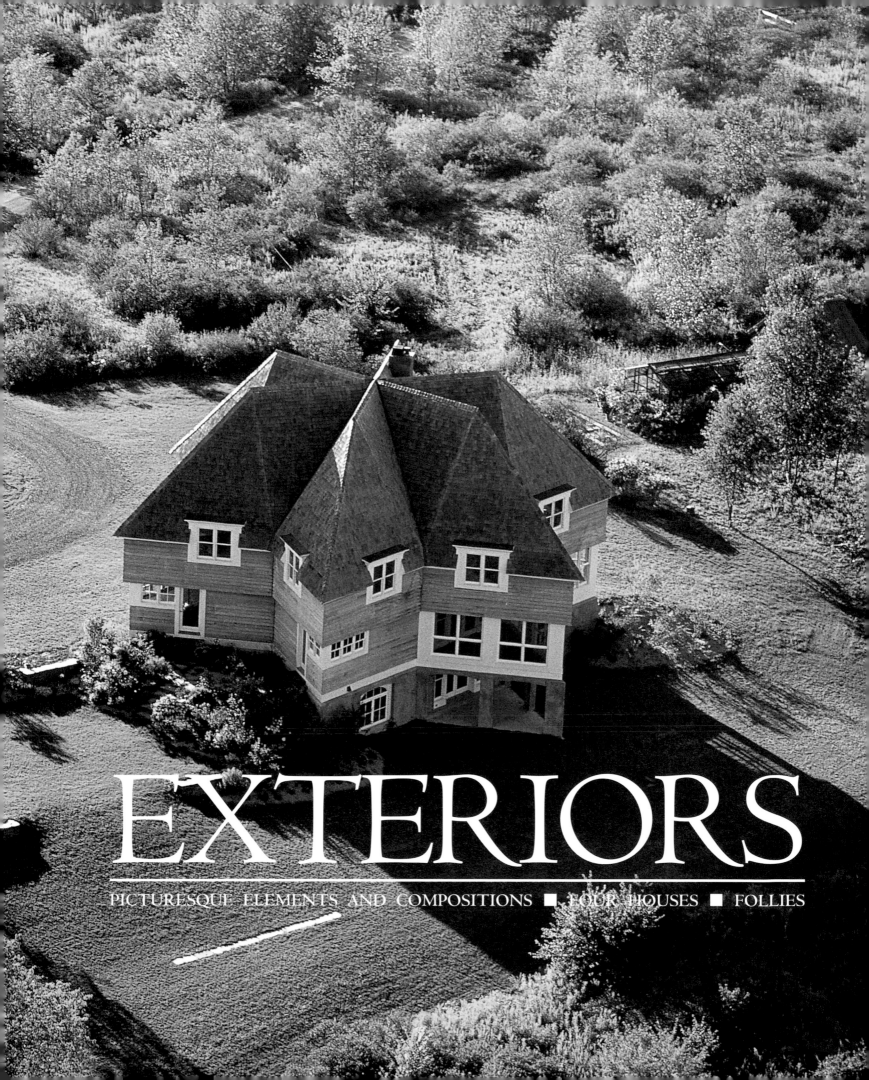

EXTERIORS

PICTURESQUE ELEMENTS AND COMPOSITIONS ■ FOUR HOUSES ■ FOLLIES

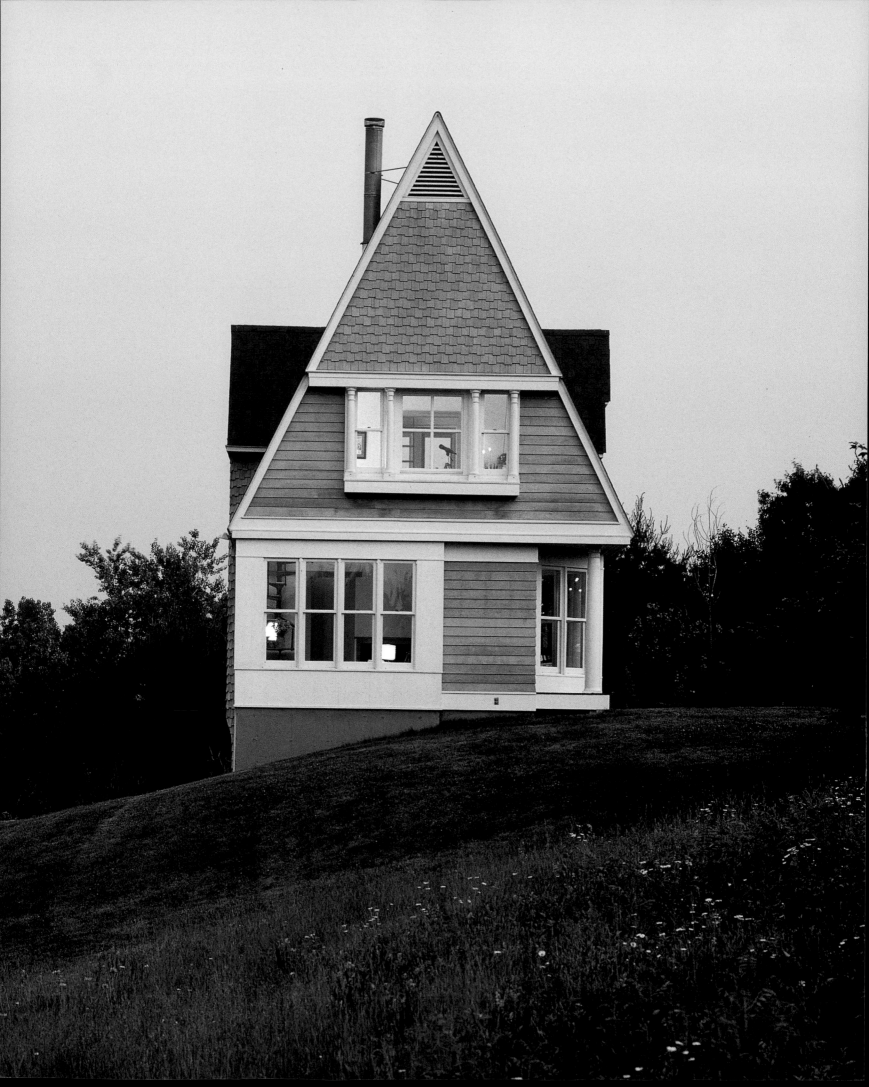

PICTURESQUE ELEMENTS

TO MAKE THE OUTSIDE OF A HOUSE EXPRESSIVE,
DRAW FROM THE POWER OF THESE SIX PICTURESQUE ELEMENTS:
1) ROOFSCAPES, 2) DORMERS, 3) COLUMNS, 4) ENTRYWAYS,
5) FENESTRATION, AND 6) SURFACES AND SHADOWS.

When you first look at a picturesque house, what do you notice? Almost certainly, your eyes are drawn to the roof, which is not only one of the house's most basic elements, but often one of its most evocative as well. If the roof is visually pleasing—if its shape and character suggest shelter and protection—the entire house starts to take on an appealing tone. The roof has the power to embody deep-rooted feelings about "home"—about our need for refuge and emotional comfort.

What the roof should do, beyond basic functions such as keeping out the rain, is stir interest and express personality. Many houses built in the last twenty years have a profusion of gables, hips, ridges, valleys, and other forms, but more often than not, an indiscriminate piling-on of visual effects makes the exterior composition appear nervous and busy, at odds with the psychology of the good house. Gratuitous complexity should, as a general rule, be avoided. The best results often are achieved with just a few well-chosen gestures: a steepening of the roof pitch, an exaggeration of the roof's size, or the deployment of a few dramatic or whimsical embellishments.

An interesting roofscape is just one picturesque element that can be used to provide a house with character. People often assume that fancy doors and windows are all that's needed to give a house pizzazz, but they may be overlooking the banality of the house's other elements. A dormer or a row of columns will add far more interest than any one door or window. A house's siding and shape offer still more opportunities to give it an expressive and unique quality.

LEFT The steep roof pitch and the projecting peak of the gable accentuate the homeyness of this small dwelling.

PREVIOUS PAGE A roof in the shape of a six-pointed star is this house's dominant feature.

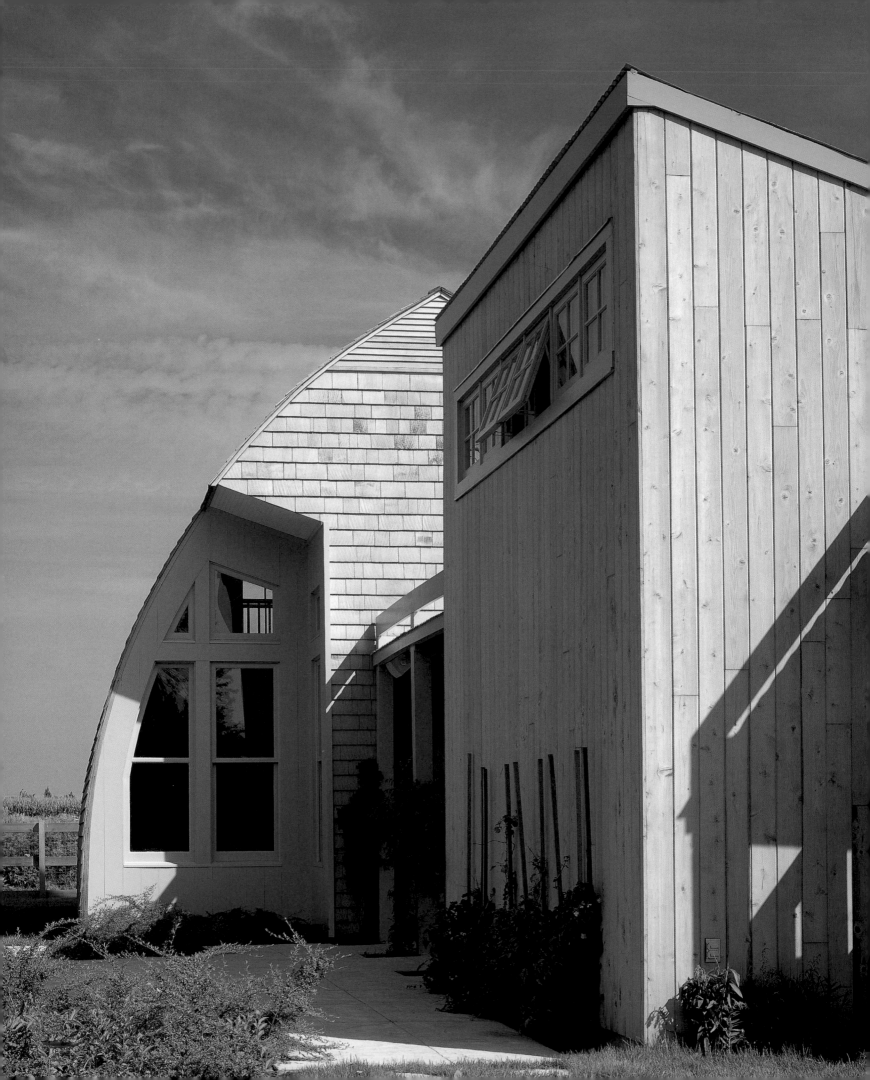

Unlike the interior, the exterior of a house is defined by profiles, for the house is a volume set against a backdrop. For this reason, I often consider the ROOFSCAPE—the shapes of the roof against the sky—at the outset of any design. In a house of almost any style, the roof is generally the most defining feature. Medieval Dutch dwellings are characterized by their steeply pitched roofs set between brick walls, Renaissance manors are known for their low-pitched roofs hidden behind Classical pediments, and Modern houses are famous for flat roofs. Picturesque roofs are embellished with many forms. Sometimes you'll notice a house in which the gable-end—the usually triangular wall area beneath a pair of roof slopes—projects outward a few inches, making the top of the house slightly more prominent than the main floors. The slight projection of the gable-end infuses the gable with

energy, creating a focal point on the house's exterior. You may also notice roofs in which a shape is repeated for visual effect. Stepped gables—a small gable nesting within a larger one—can generate an appealing rhythm. Another technique, applicable when two roofs of different heights come together, is to have the taller roof overlap the ridge of the lower roof; when people look up at the section of overlapping roof, they get a hint that there's more to the house than meets the eye.

Near the top of a gable wall, it's often nice to insert something that attracts people's attention, such as a round window or a pretty louver. This directs a viewer's gaze upward and provides more than just the roof edge to look at. Still greater expressiveness can be achieved through the use of a recognizable roof form, such as a turret; features of this sort arouse people's imaginations.

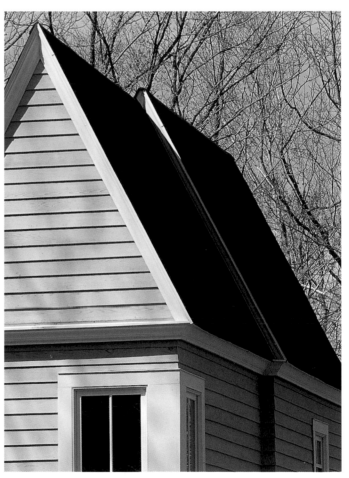

LEFT A flat-line roof above a flat wall creates a profile that contrasts sharply with the curving roof seen in deep shadow. Simple gestures such as tilting the windows open bring life to the composition.

ABOVE LEFT Twin gables, one nested in the other, create a stepped profile. Their rhythm makes an interesting roofscape.

ABOVE RIGHT Overlapping roofs hints that there's more to come as you turn the corner.

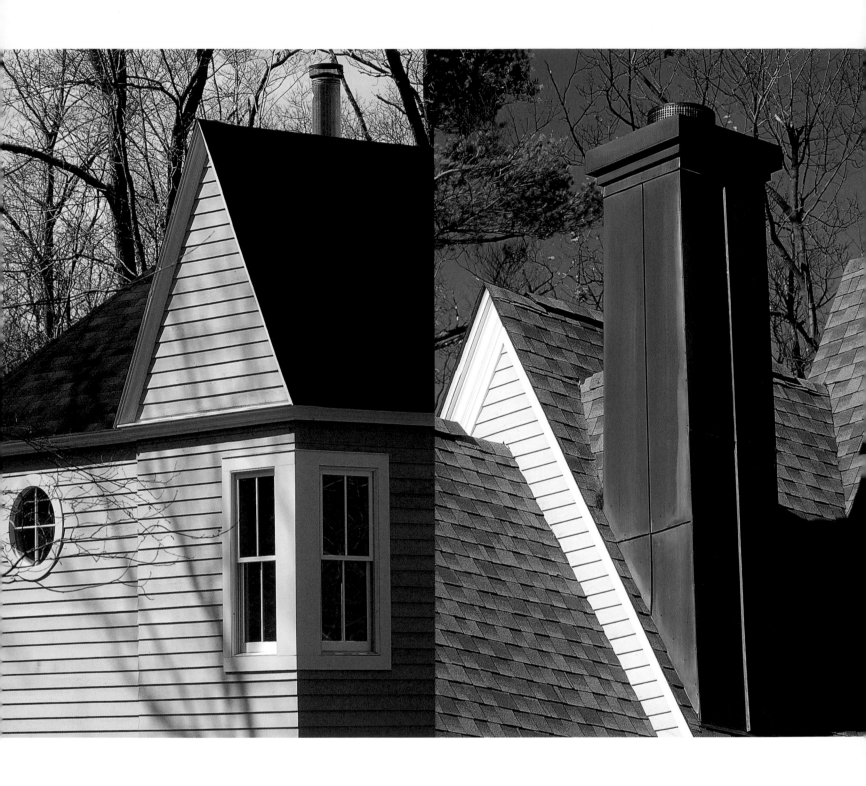

ABOVE LEFT A steep, triangular gable is a strong form in itself, and it makes a strong contrast with the adjoining hip roof. Roof components' proportions can make a house expressive.

ABOVE RIGHT A chimney adds drama to a complicated roof, its red surface suggesting the warmth inside the house. Chimneys infuse great character into roofscapes.

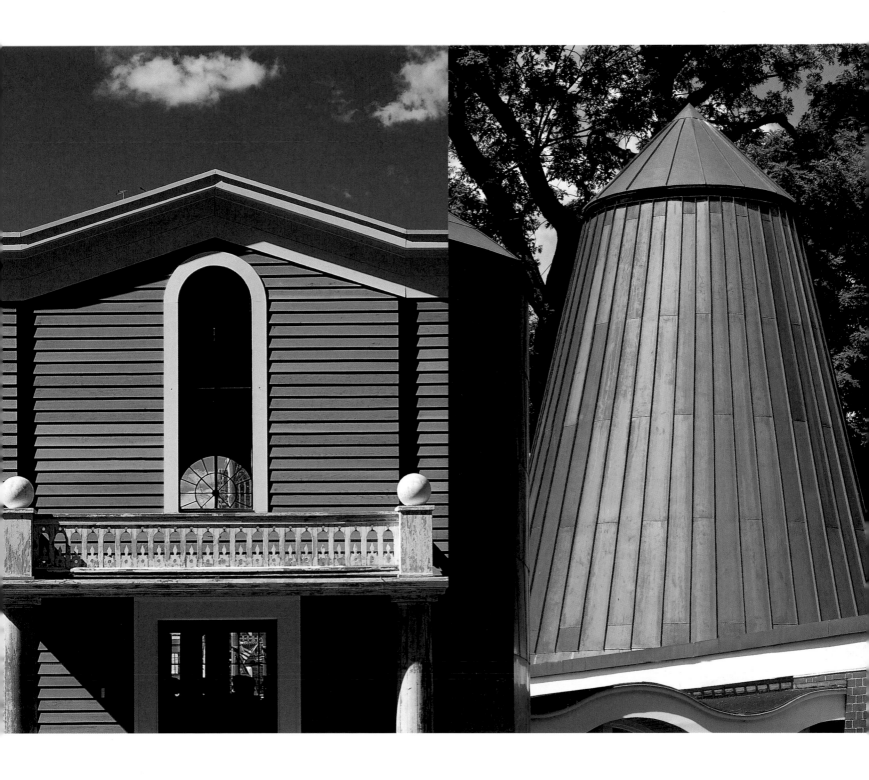

ABOVE LEFT A round-headed window brings the viewer's eye to the peak of a small gable on an otherwise flat roofed house.

ABOVE RIGHT A turret-like shape makes an arresting and whimsical impression, inciting curiosity about the nature of the space inside.

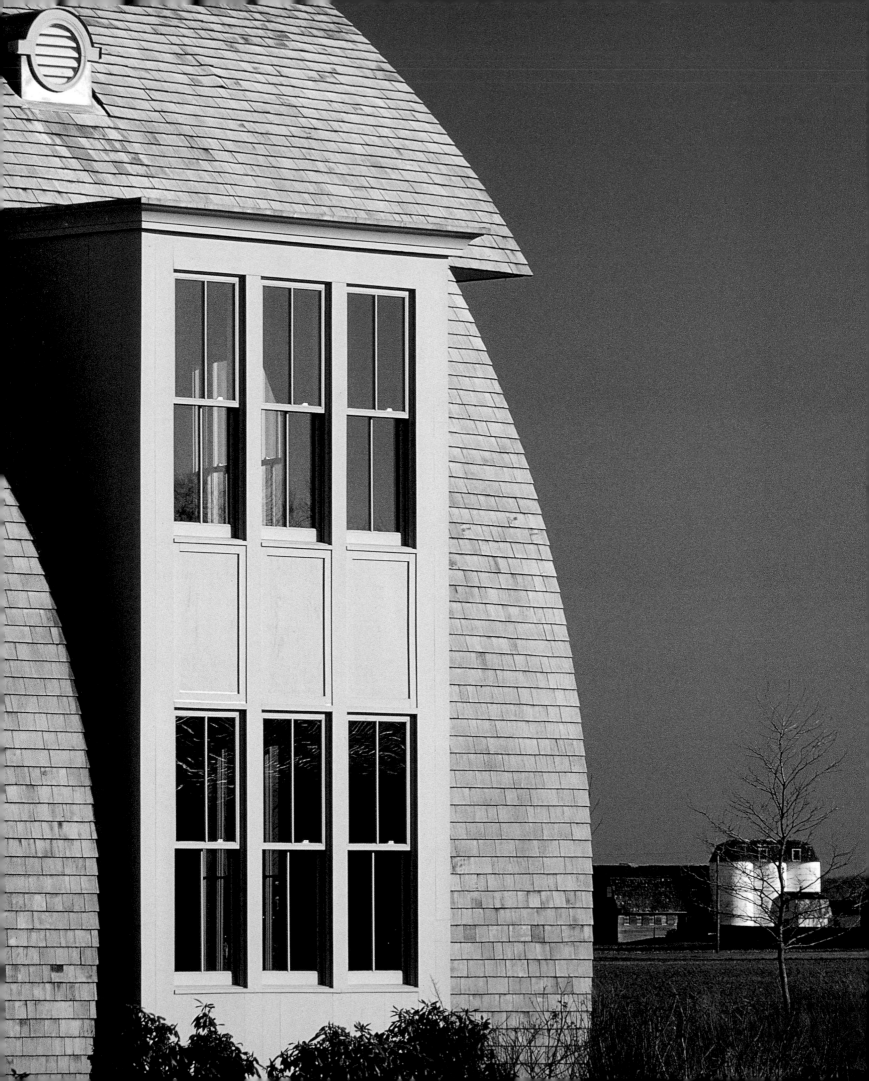

The long slope of a picturesque roof may be enhanced by dormers. One beguiling **DORMER** is sometimes enough to give the whole house a lift. Gazing up at it, a person imagines the coziness of the spaces it encloses.

Dormers accent the roof through contrast. Sunlight strikes the dormer at a different angle than it strikes the roof surface, and the light varies over the course of the day, generating a changing series of effects. A dormer can be a focal point standing out against the roof, and it can also be a focal point against the sky, creating visual interest that would not be achieved by the roof alone.

Dormers take a variety of shapes. On a house in Sagaponack, Long Island, I used double-height dormers, which project from the surface of an enormous curving roof. The dormers supply plenty of light and views while allowing the all-important roof shape to retain its power. When a house has a complex roof or a roof that's the star of the show, as in Sagaponack, the most suitable dormer may be a flat-roofed one, which doesn't compete for attention. A flat-roofed dormer can be a welcome resting point in a roof that's visually energetic.

On the other hand, there are instances when it's appropriate to make the dormer an elaborate composition in itself. One of the smaller dormers I've designed (shown below) is composed of a rectangular base with a triangular shape on top of it. The window pulls the rectangle and the triangle into a unified but unusual composition; projecting above the window is a second, smaller triangle—a triangle within a triangle. With its moldings, its mix of materials, its three-dimensional quality, and its Classical division of base, middle, and top, the diminutive dormer has a remarkably strong presence.

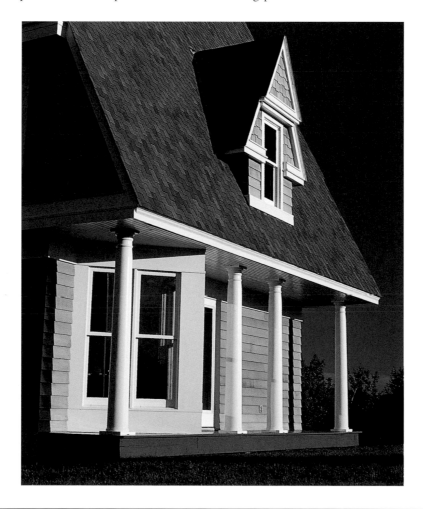

LEFT A double-height dormer projects from a mammoth, sloping wall; this form of dormer lets light and ventilation into the interior while protecting the roof volume's power. Even an element as mundane as a roof vent can be formed into a mini-dormer.

ABOVE One prominent dormer gives this tiny house a strong presence.

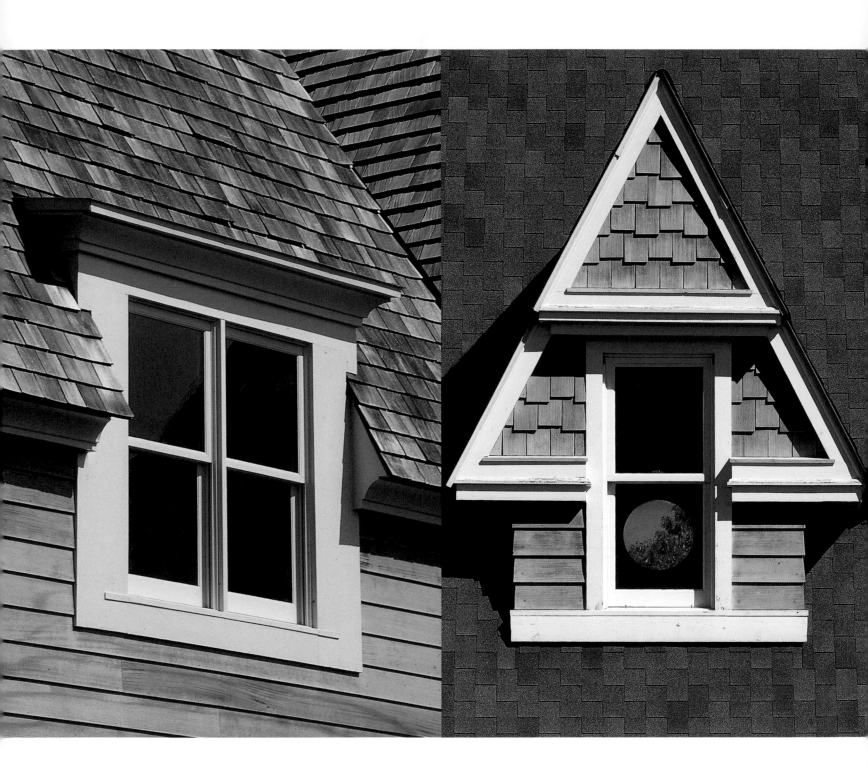

ABOVE LEFT An engaged dormer begins in the wall and then pushes through the roof so that it ends up being really only half a dormer. It creates an interesting jog in the otherwise straight line of the roof's edge.

ABOVE RIGHT A dormer can be a surprisingly elaborate composition, practically a tiny reproduction of a house. This one has a three-part structure of base, middle, and top, with overhangs that cast shadows to enrich the effect. All this for one narrow window; a sense of humor lurks behind these shingles.

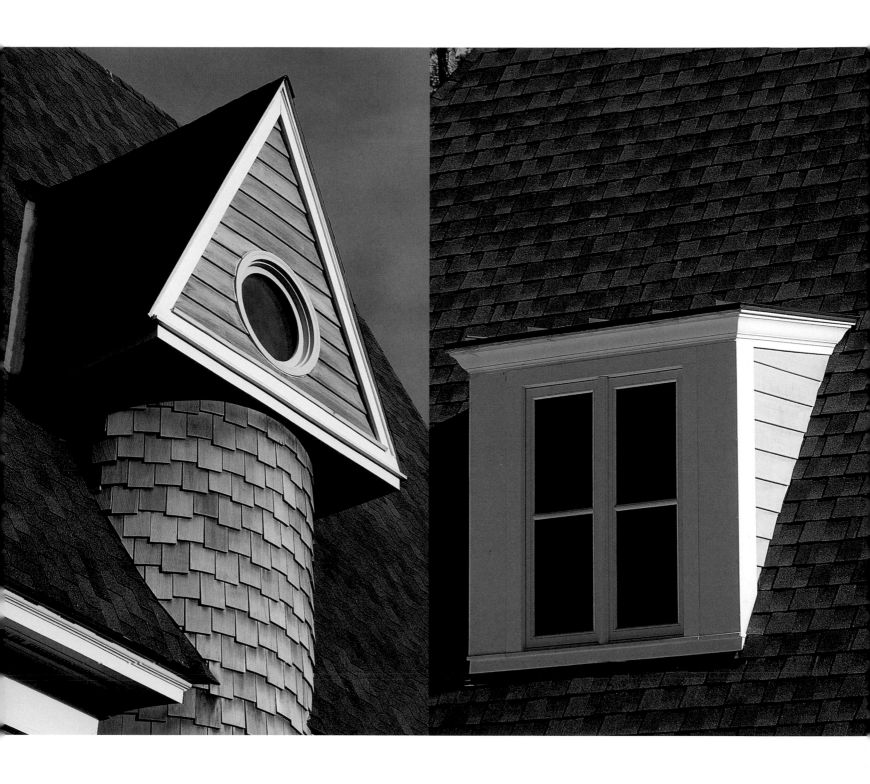

ABOVE LEFT *This dormer is a strong focal point jutting into the sky. Such a dynamic effect would have been impossible to achieve if the house had only a single mass of roof. Dormers can animate a roof tremendously.*

ABOVE RIGHT *The contrast of the dormer's smooth wood against the rough texture of the roof shingles injects interest into the roof.*

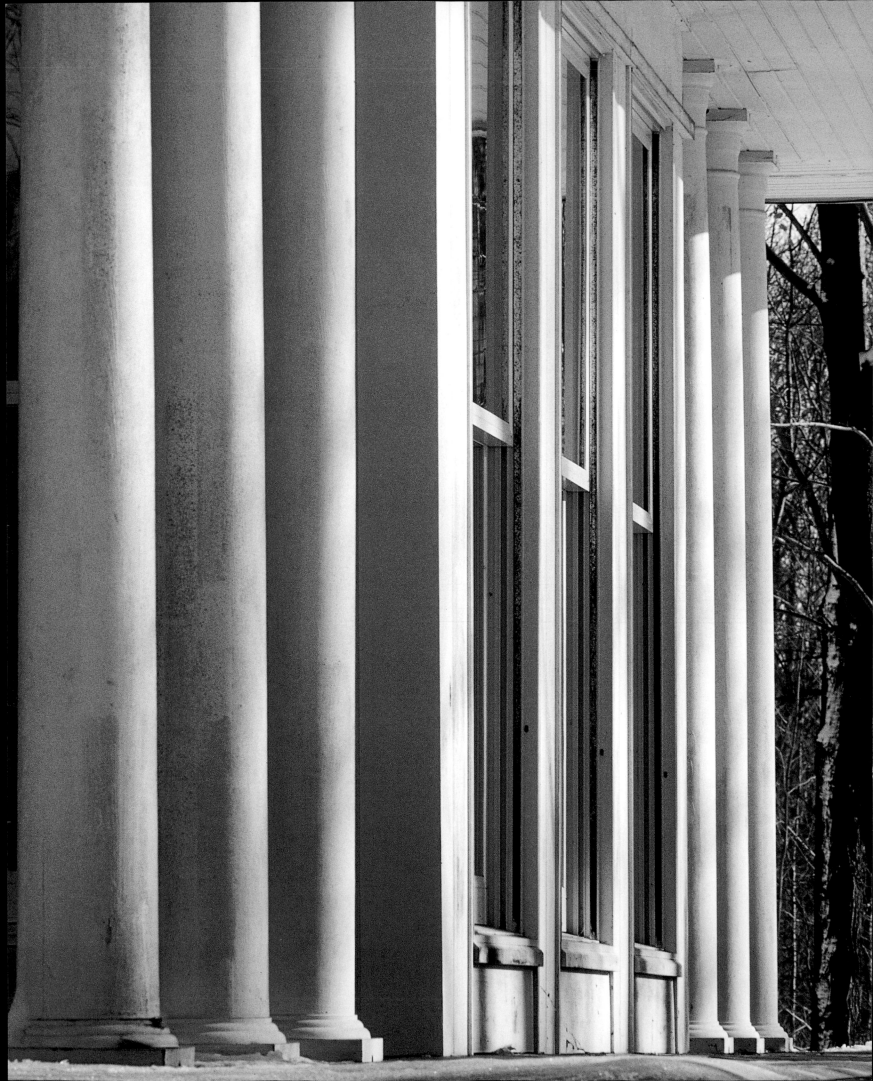

Like dormers, COLUMNS can make a tremendous addition to a house's visual character. How the columns are positioned and what shapes they assume will help determine their ultimate visual and emotional impact. It's an odd fact that square columns (or posts or piers) seem less prominent than round columns. The right angles of square columns blend in with the typically orthogonal geometry of the house itself. Round columns engage viewers' emotions more fully; they stand out as elements distinct from the house. Their roundness also seems to enable them to modulate sun and shadow more interestingly than square columns can.

An evenly spaced line of columns has a far different effect than columns spaced at differing intervals. Evenly spaced columns separate the area in front of them from the area behind them; they create a perceived barrier, which silently tells visitors, "Maybe you should look for another way to enter this house." Columns positioned irregularly are less of a barrier, and can serve to frame a view or suggest where to enter. When columns stand on a porch edge, a large opening between them can suggest a natural spot for a bench.

Small columns, especially if they're recessed from the porch's perimeter, have a surprising ability to make the roof appear heavier; they conjure up a weightiness that appeals to our desire for protection. Large columns make the house seem imposing and thus encourage visitors to pause before entering. Tapering the columns, or embellishing them by adding ornate tops or elaborately formed bases, will further influences the columns' expression.

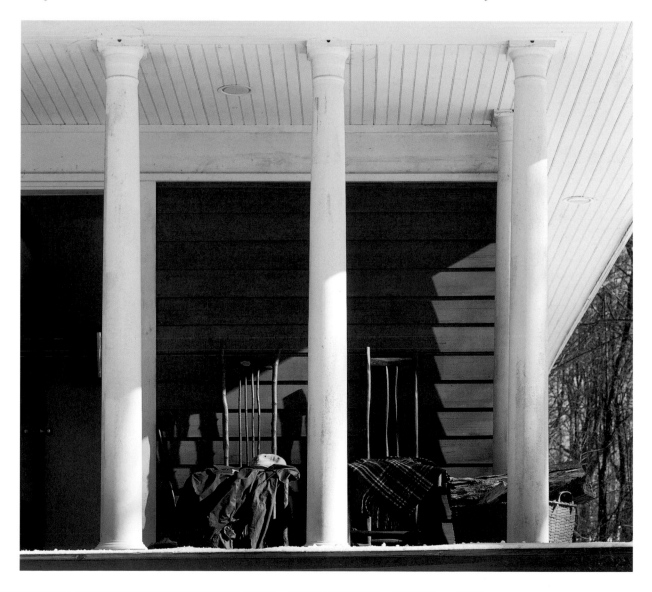

LEFT and ABOVE From an angle, these evenly spaced columns form a solid barrier, yet they appear porous and revealing from head-on.

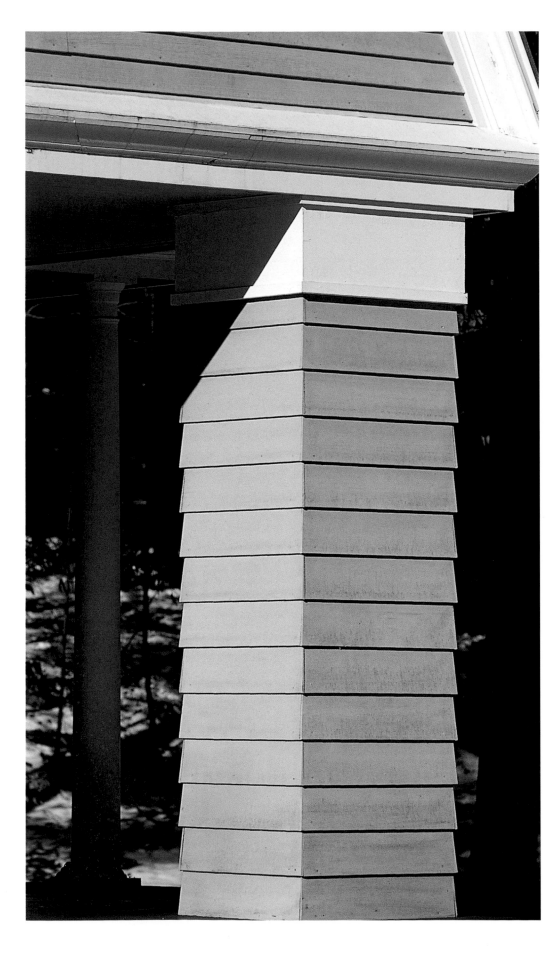

LEFT *A square, shingled pier projects a sense of strength and solidity.*

RIGHT *Piers and columns can be played off each other, enriching the composition of the house. The round, smooth column seems refined and delicate when contrasted with the shingled pier or the surrounding pine tree trunks.*

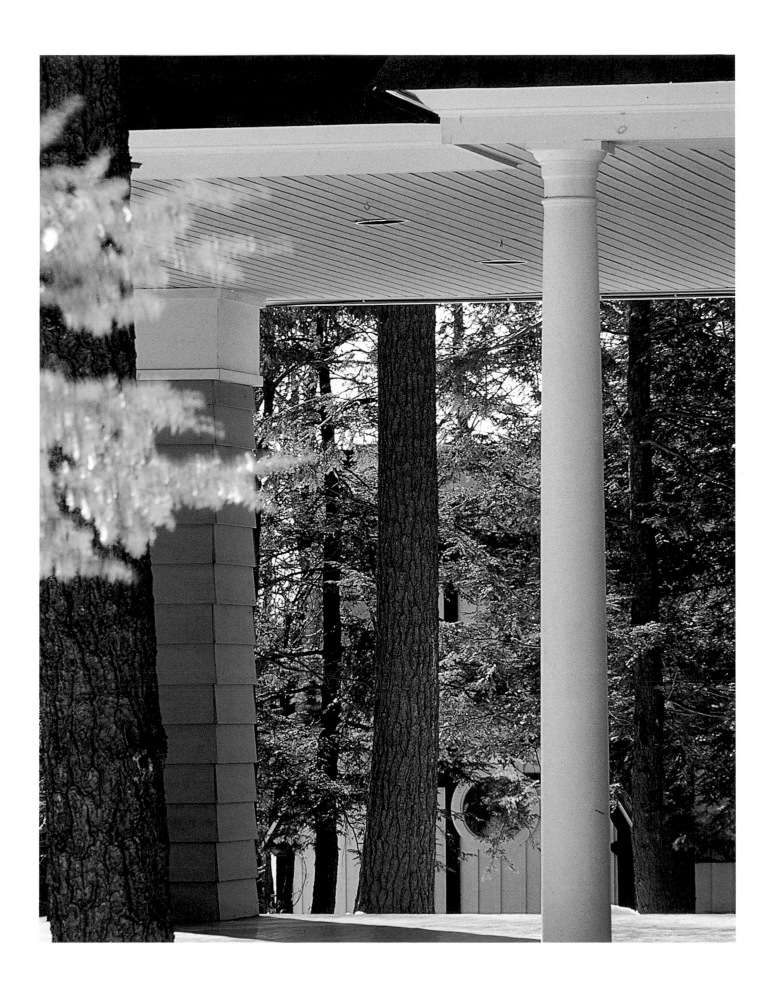

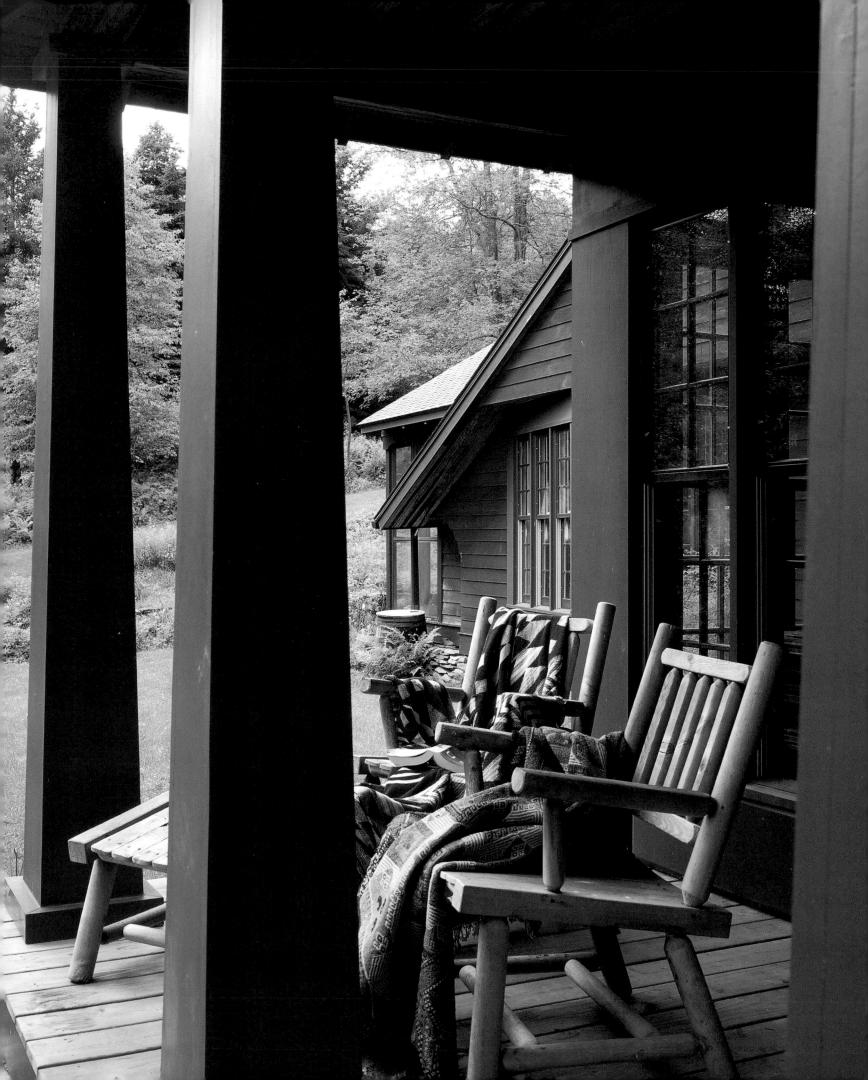

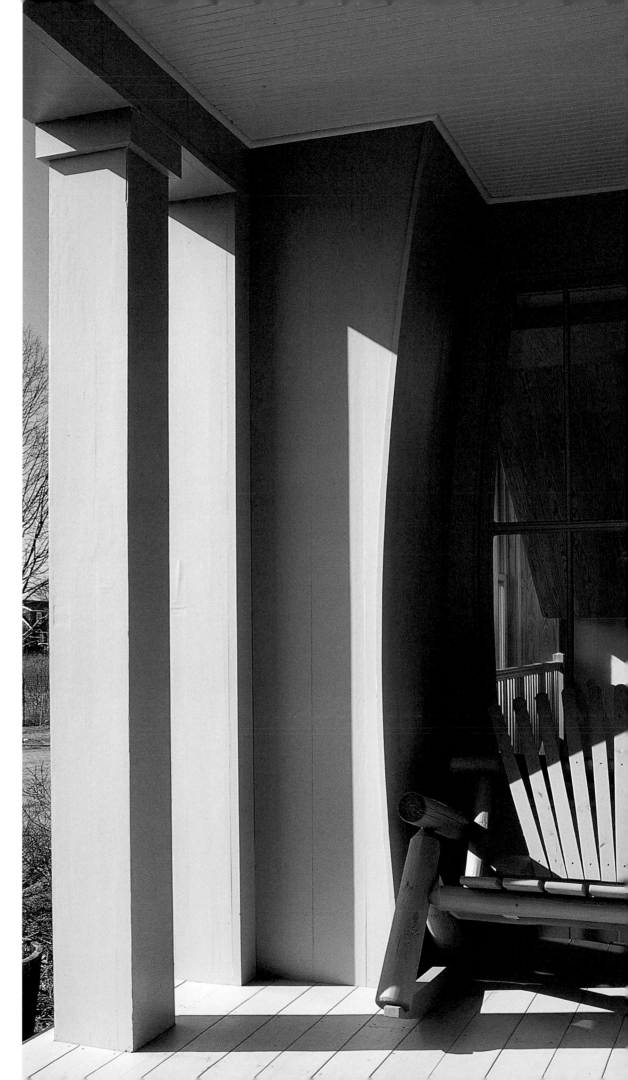

LEFT The smooth, tapered columns of this porch are reminiscent of the trees from which the rugged log furniture was cut.

RIGHT Square piers stand like soldiers guarding the entrance.

An **ENTRYWAY** sets up an expectation about what a house's interior and occupants are like. Entryways can be friendly, mysterious, or intriguing—or they can warn you to display your best manners. A secluded entrance usually suggests that the occupants value privacy more than sociability. When the entryway is not visible from the street or road, the home seems more of a hideaway than when the door opens directly onto a public thoroughfare.

The entryway should be planned as part of a spatial sequence. Sometimes it makes sense to compress the area outside the doorway—placing it under a low ceiling, for instance. Then, if the interior of the house is large and spacious, people will be bowled over when they step inside.

Often the entryway includes a porch, with the roof of the house extending over it. A porch is a wonderful transitional space—a not-quite-private, not-quite-public zone that softens the sharpness of the division between interior and exterior. It gives people a semi-enclosed outdoor space that is somewhat sheltered from rain, snow, or blazing sun. Porches form extended thresholds; walking across them makes the experience of coming and going more satisfying.

Ultimately the entryway is more than just the front door. It is all the elements that lead the visitor—whether assertive or reluctant—to the interior. The entrance is where the magic of the outside gives way to what lies within. Set within a solid wall, it makes the interior seem completely mysterious and guarded; set within a glazed wall, it renders the interior open and tempting. The character of the entryway and all its elements can be what sets the feel of a picturesque home.

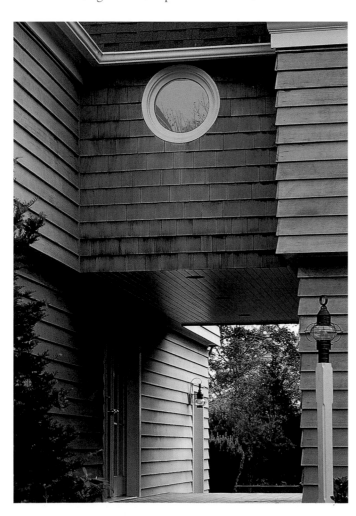

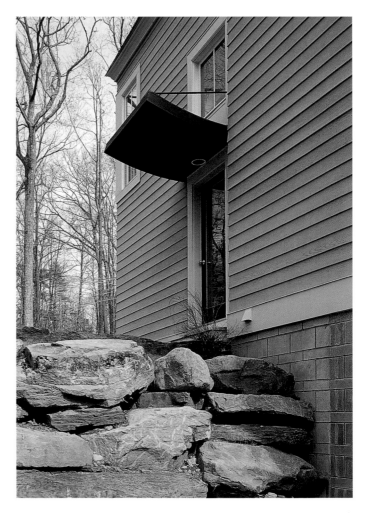

ABOVE LEFT A second-floor bridge hanging low above the doorway makes this entrance reticent and mysterious. Door-to-door solicitors will keep their distance.

ABOVE RIGHT The entrance canopy playfully suggests a drawbridge, implying that visitors are—sometimes—welcome.

RIGHT The simple door, the lantern, and the slight overhang create a low-key entrance, implying that the occupants welcome, but do not necessarily seek, visitors.

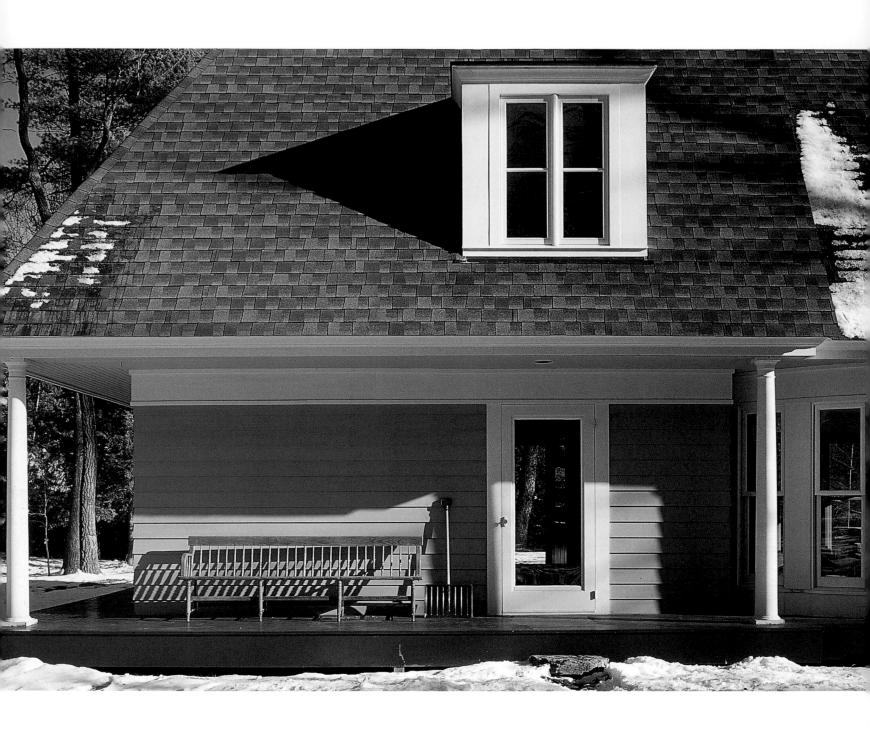

ABOVE This entrance is one part of an overall composition, its lack of symmetry implying a loose, informal atmosphere within. The shallow porch is pleasant and unassuming. The placement of a dormer above the doorway subtly calls attention to the partly shadowed entrance.

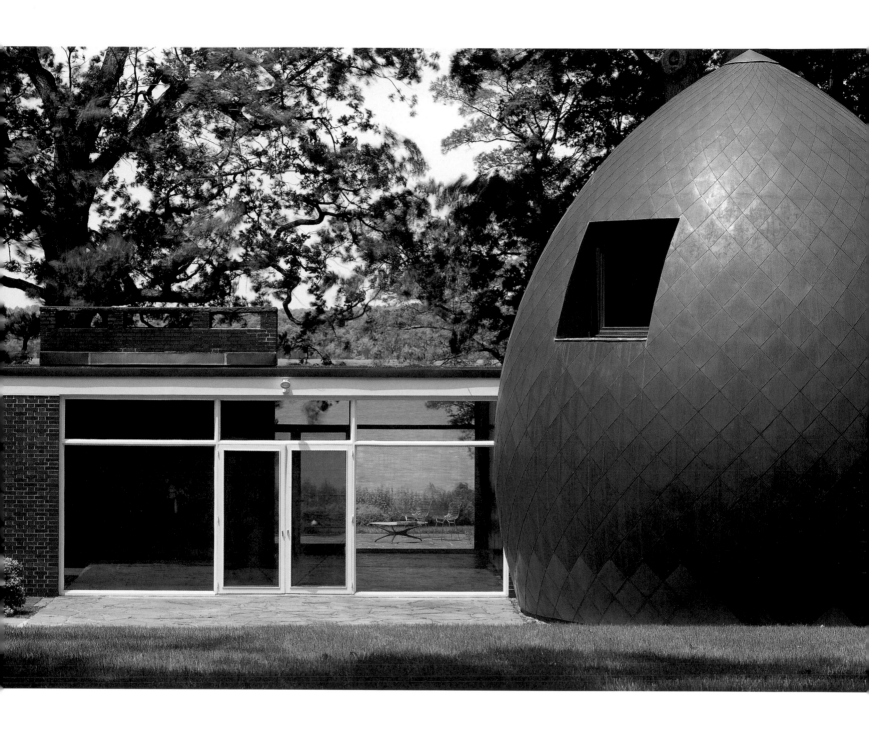

ABOVE The spare Modern doorway is so restrained that a visitor might not recognize that it is the entrance. Transparency was what mattered most when the house was built. The pineapple-shaped pavilion was added in a renovation, providing additional interior space and helping to lead visitors toward the door.

PICTURESQUE ELEMENTS 127

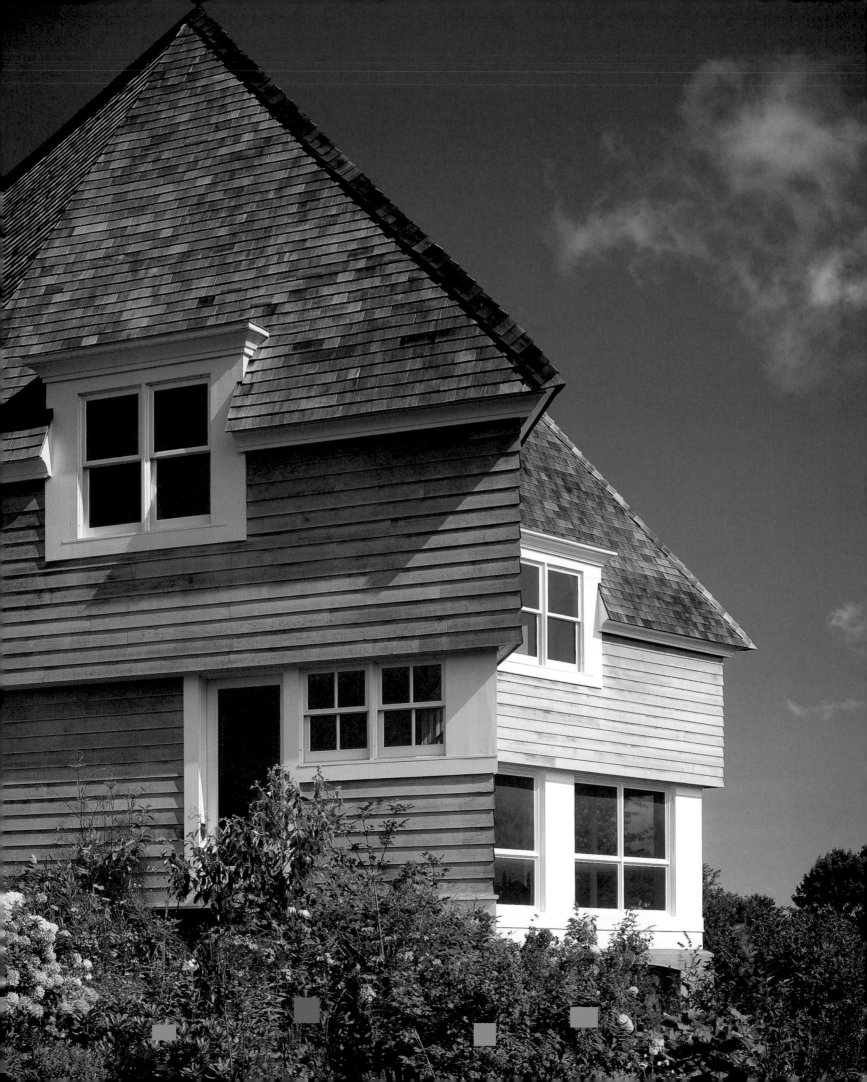

FENESTRATION is a fancy term for the arrangement of windows on the exterior of a house. A good house doesn't just have windows; it is fenestrated. That is to say, its surfaces are cut carefully—with design and purpose—not only in order to let light in but also to adorn the exterior. There are many shapes and forms of fenestration, but most of them naturally fall into one of three categories. The fenestration of a Modern house that has walls made almost entirely of custom glass windows is referred to as a curtain, as in a "curtain wall." It's a bit like the mosquito netting that's draped around canopy beds in the tropics—a separating structure, but a very light one. A second type of fenestration consists of regularly shaped windows like the ones you would find in most traditional houses—double-hung windows, casement windows, and the like. These windows are commonly found in any house-supply store, ready-made in a variety of sizes. The third type of fenestration is referred to as a punch, as in a "punch window." These windows are also usually custom-made and they come in unusual shapes. If they're round, they give the impression that a hole-puncher was used on the outside wall of the house. They may also be ordinary rectangles. What makes them "punch windows" is that they barely break the surface. Their compositional purpose is to call attention to the solidity of the wall by adding a perfect little hole. A blank wall can be deadly, but one with a limited amount of fenestration can be serene, and a nice relief from the busyness of highly transparent walls.

I enjoy adding windows in groupings, ganging the windows together and making them project from the wall as in the fashion of the "bay window." But instead of an ordinary bay, I prefer more unusual forms; prow-like windows are a bit more modern and dynamic. Another way to gang windows and make a composition with them is to form a kind of box with them: the windows are drawn tightly together and projected just a few inches beyond the wall. At the corner of a house, such boxed windows can form a striking block of color against the textures and colors of the roof and siding.

Ganging windows generates interesting forms and gives the interior the benefit of a sense of transparency; in addition, it turns normally mundane items into elements of the picturesque. Standard double-hung windows, when ganged together, are simply beautiful. A pair of 2- by 4-foot windows forms a poetic square with an attractive crossbar. A series of short double-hung windows along the exterior creates a ribbon. I like turning the corner of the house with these ribbons of glass or contrasting them with tall, skinny windows placed at the opposite end of the house.

LEFT The cross-patterned windows of this house are arranged on the surfaces in a variety of ways, from small ones wrapping a corner to medium-sized ones ganged together in a dormer to giant ones forming curtain-like walls.

ABOVE The casement windows appear to be laid drunkenly onto the surface of this folly of a studio building.

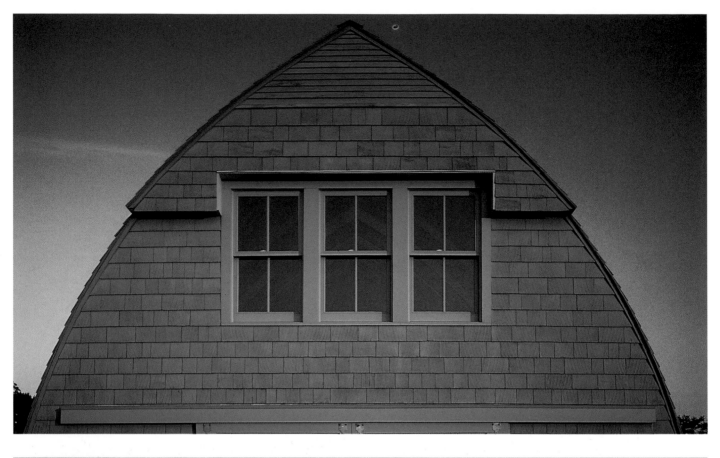

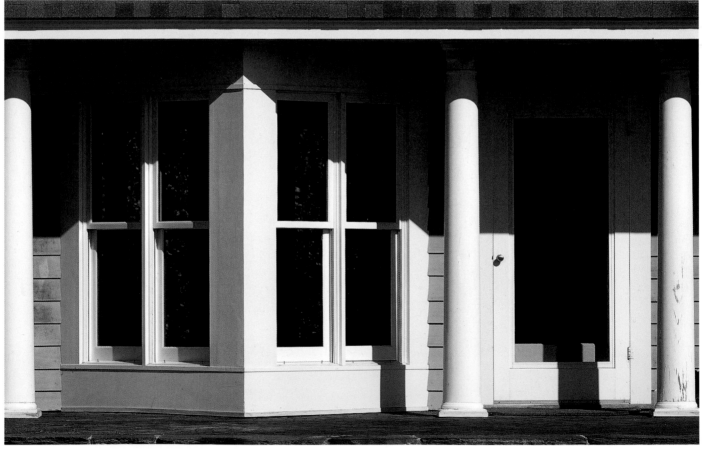

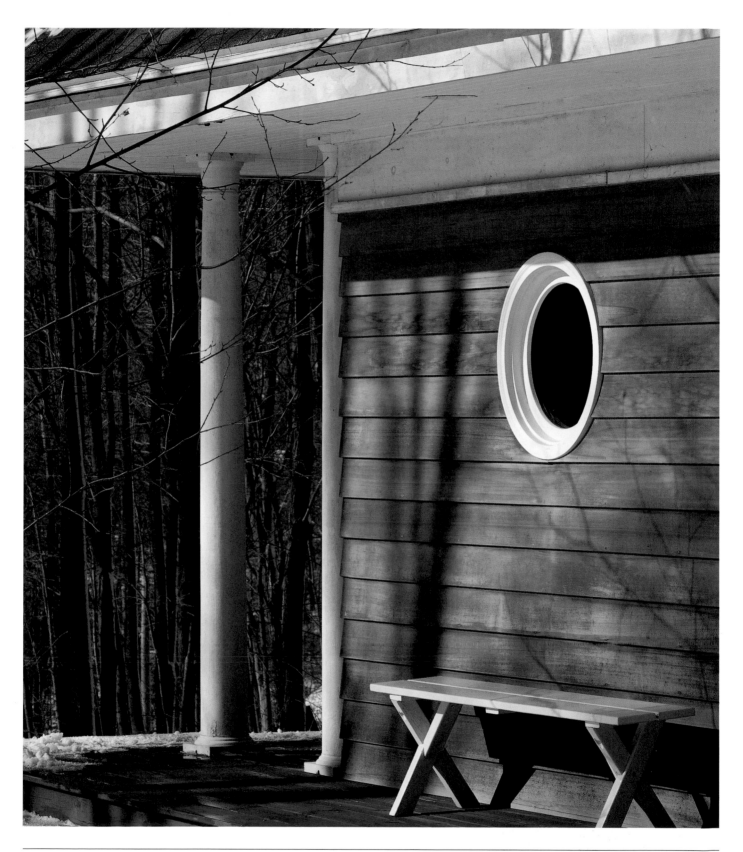

LEFT TOP Three ordinary double-hung windows are given an unusual character by their placement and surrounding trim.

LEFT BOTTOM Larger versions of this same type of window are ganged together to form a prow that crowds between two porch posts.

ABOVE A single round window punches through a rough-textured cedar-clad wall, bringing as much attention to the cedar as to itself.

A good house gains much of its expressiveness through its **SURFACES AND SHADOWS**. By carving away or cutting into the house's architectural forms, particularly its roof or walls, you can create deep shadows that make the composition dynamic. For obvious reasons, heavy shadows dramatize a house's appearance. Perhaps more surprisingly, thin shadows—like those cast by shingles, clapboards, and trim—also enrich a house's feeling.

I like cedar shingles for many exteriors because they create soft horizontal lines where one row of shingles overlaps another. The shingles themselves possess texture that subtly affects the feeling of the exterior. Board-and-batten siding is also interesting; it casts strong shadow lines that can add a dramatic and appealing verticality to surfaces.

When planning a house, think twice before using imitation materials for your exterior elements. Whereas wood clapboards, cedar shingles, painted pine, and stone look handsome and feel good to the touch, a springy wall of vinyl cladding is unsatisfying to lean your hand against. And because of its inauthentic, molded contours, it's never quite right visually. Your friends may be too polite to comment, but discerning eyes cannot help but measure the discrepancy between a natural material and a "low-maintenance" artificial product.

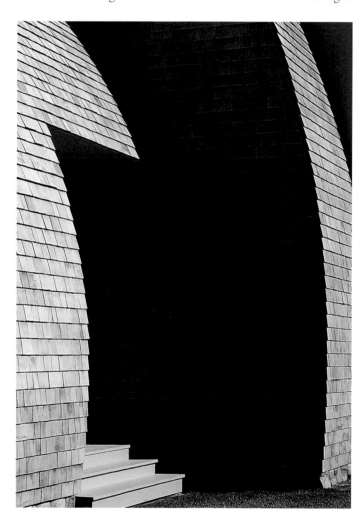 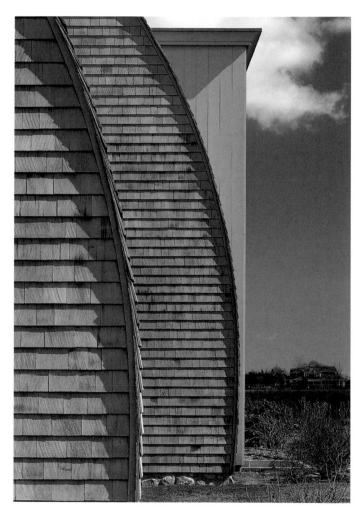

LEFT Board-and-batten siding exudes lightheartedness, which is emphasized by alternating black and white and by exaggerating the proportions of the top window. The black line of the trim is accentuated by the shadows the battens make.

ABOVE LEFT Carving away part of the volume of the roof-wall accentuates the dynamic pattern created by the shadow. The shadow points toward the side door.

ABOVE RIGHT The texture of shingles makes an appealing, tactile contrast against smooth wood. Depending on what shape they take, shingles can yield varied effects.

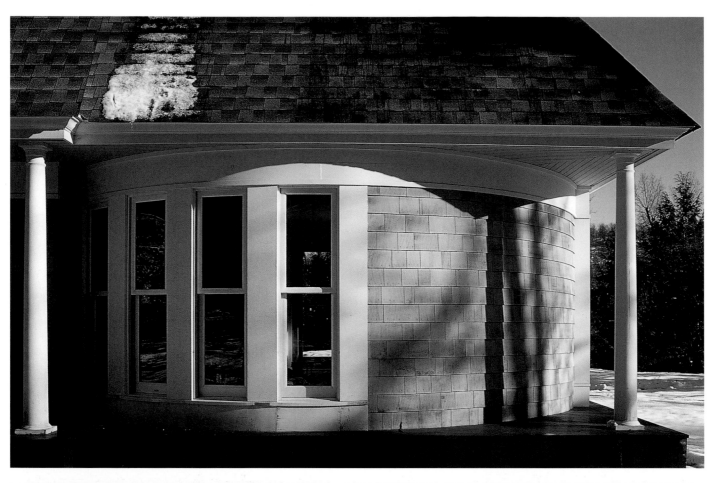

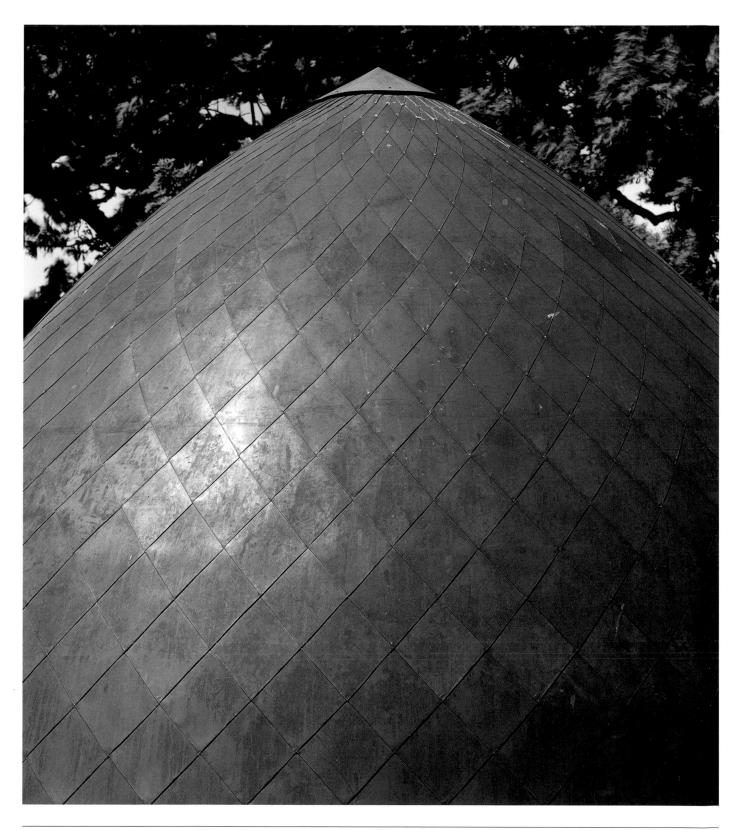

LEFT TOP A curving set of windows catches sunlight and shadows more interestingly than a straight wall of windows would.

LEFT BOTTOM The long, horizontal shadow cast by each red-stained cedar clapboard contrasts with the deeper shadow of the novelty curve at the end of the low-slung roof.

ABOVE The diamond pattern of the copper shingles works magically with the pineapple shape of the pavilion to make this strange object captivating.

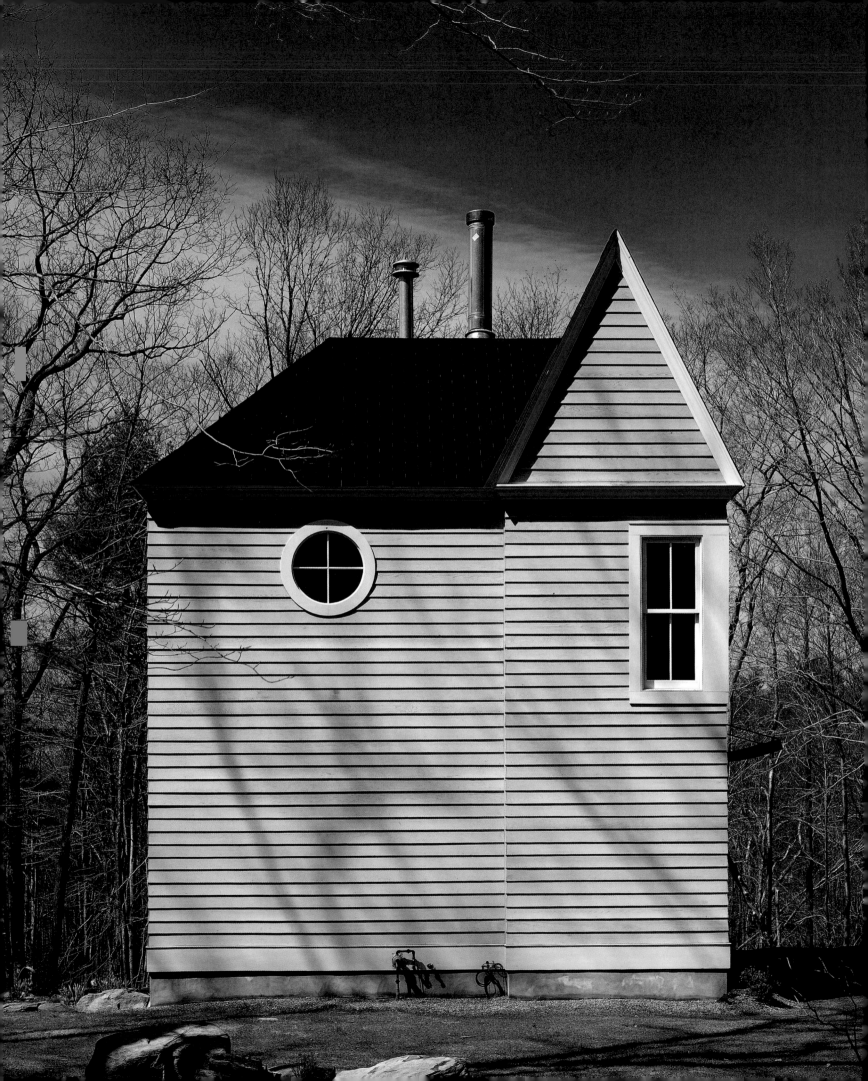

PICTURESQUE COMPOSITIONS

THE GOOD HOUSE'S COMPOSITION IS WHAT BRINGS
IT ALL TOGETHER, ESPECIALLY AS IT IS SEEN IN THE
LANDSCAPE AND AT NIGHT.

Composition is the key to the picturesque approach. How the exterior elements come together will determine what the house conveys. A steeply sloped roof and symmetrically arranged windows and doors on a small cottage will say something very different than will a low-slung roof and asymmetric fenestration on that same cottage. Perhaps the steep roof is an appropriate nod to the verticality of nearby woods and the symmetry is an expression of a quiet formality. In contrast, a low-slung roof could be reflective of a shoreline horizon and combined with an asymmetrical arrangement of openings, the house could be the perfect expression of a relaxed ocean getaway.

An unusual shape used for a house or outbuilding may conjure up images from exotic locales or even literary scenes. Some strangeness in the proportions or some eccentricity in one or more of its elements can give the house its spark of interest, a unique personality. Distorting the ratio of height to width even moderately can give a fresh look to an otherwise familiar style, which allows the house to blend into a neighborhood and at the same time be set apart. Departures from the ordinary are at the very heart of the picturesque.

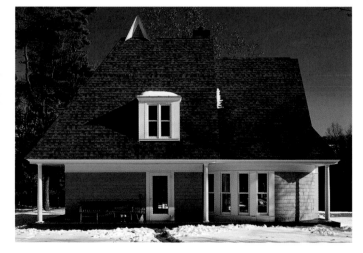

LEFT *An interesting interplay occurs between the symmetrical wall segment containing a round window and the narrow wall with its rectangular window shoved to the corner.*

ABOVE *Projections and overhangs, often very slight ones, work wonders at amplifying a composition. Here, the roof is divided into three volumes, the third of which peeks over the left-hand side, giving this tiny house a complicated composition. The result is a beguiling top for an interesting, volumetric first floor.*

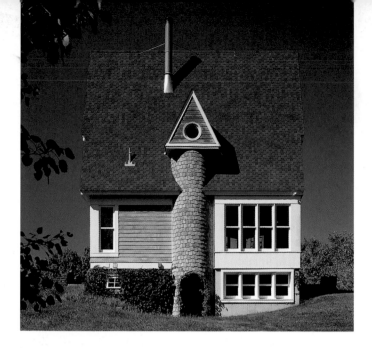

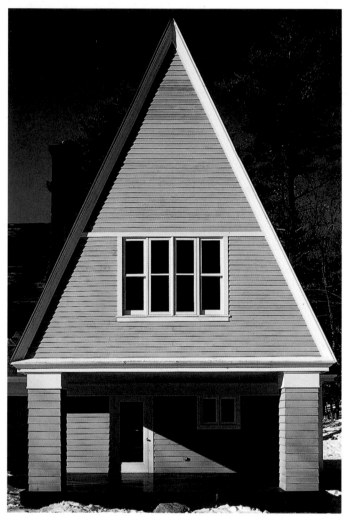

TOP *A turret divides a house with an asymmetrical window arrangement.*

BOTTOM *The symmetrical gable gives an asymmetrical house a settled feeling.*

RIGHT *Angles and overhangs generate energy, partly by casting changing shadows across a rigorously symmetrical composition.*

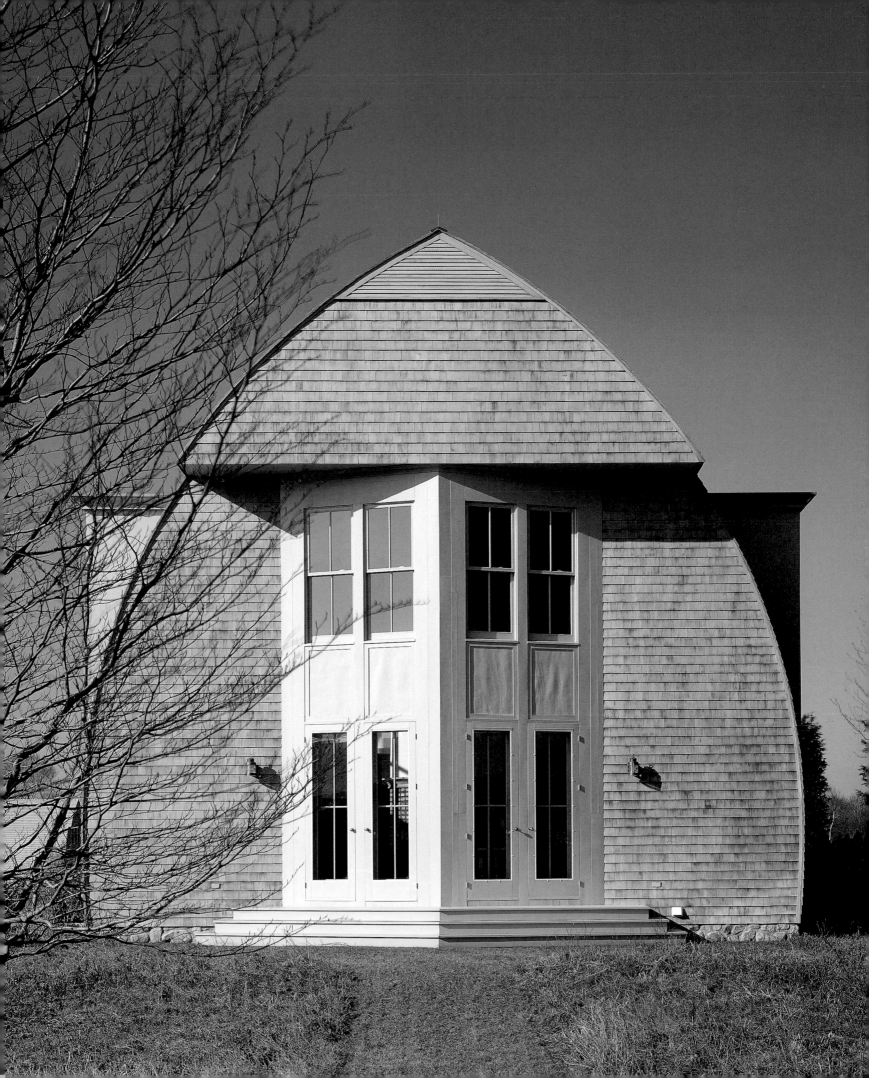

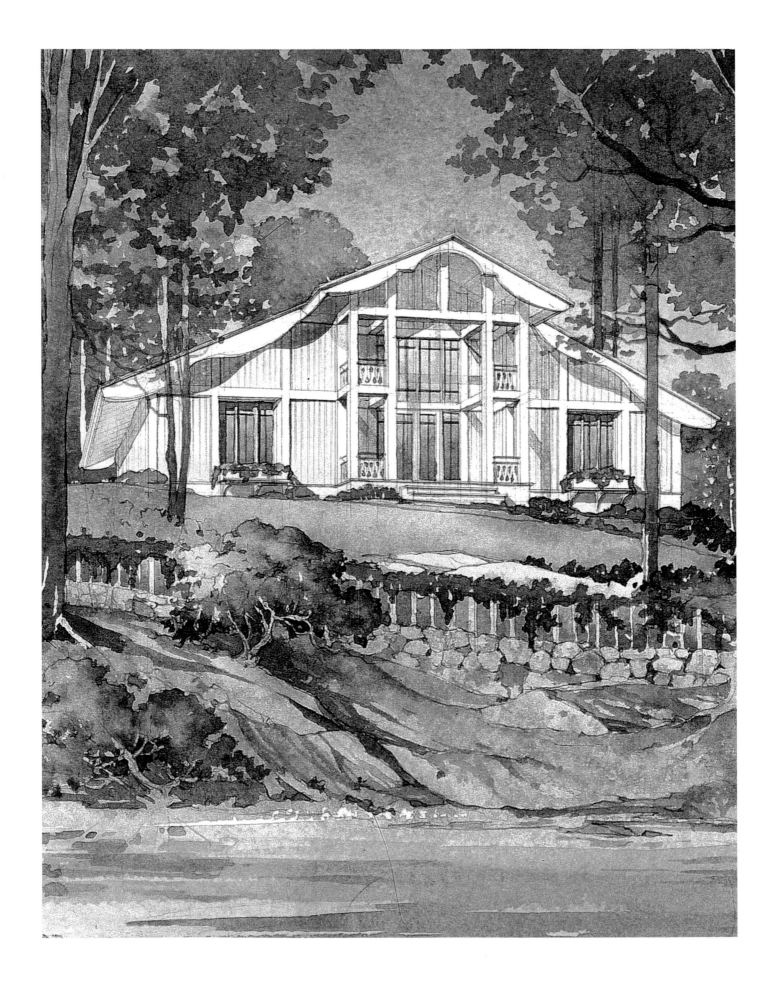

While designing the house, consider how its volume will relate to its surroundings, including the landscape. Together, house and grounds form a **COMPOSITION IN THE LANDSCAPE** that's much more powerful than either element in isolation.

Often the best course is to design the house to harmonize with the topography. In a rural location, the landscape could be kept mostly rustic, but some parts of the terrain, such as a front yard or a terrace, may need to be reworked in order to form a suitable foreground for the house and a setting for outdoor activities. I prefer spots that are close to the edge of a drop-off. This way, the volume of the house changes as it is seen from different vantage points. A house whose entire property is flat land does not have topography to compete against, so it can take on a strong silhouette of its own. It might employ strong volumetric forms; perhaps ones inspired by farm buildings or exotic structures.

When property borders a lake or ocean, the goal is to enjoy views or simply the light and sounds of the nearby water. Plentiful windows are called for, and should be shaded by large overhangs to keep out the summer sun. Indoor/outdoor spaces such as porches are also a must. The long sweep of the roof of the porch or the house itself is often a good complement to the movement of the water. In an urban or built-up suburban setting, the house is part of an ensemble, so it's best to keep the volume of the house relatively consistent with neighboring homes. Expression in this situation comes less from the character of the individual house than from the way a group of houses work together. Idiosyncrasies in the façade should be subtle. The interior and the rear of the house, by contrast, can dispense with those inhibitions, since they don't bear the same public responsibility as the front.

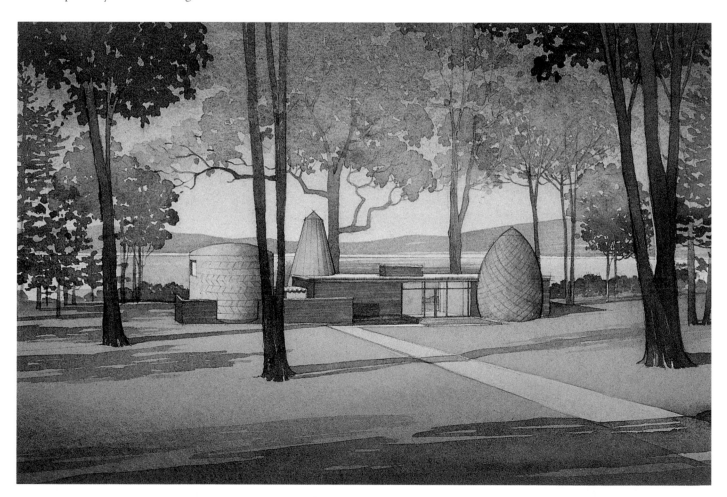

LEFT The idea of a Minnesota lakeside setting suggested large windows and cheerful Scandinavian-inspired detailing.

ABOVE The oddly shaped additions to a disciplined Modern house suggest landscape follies. They help the house to harmonize with the park like setting.

RIGHT This design for the LIFE *Dream House, a magazine-sponsored house-plan offering, was intended to be adaptable for all parts of the country. In an exurban northeast setting, the house was to be oriented with the picture windows toward the neighbors and the street.*

TOP In a more tropical, suburban location, the same house may be turned sideways with large, sun-shading overhangs added all around.

ABOVE On a lake, the "front" of the house could be oriented toward the waterside backyard, and a porch may be added.

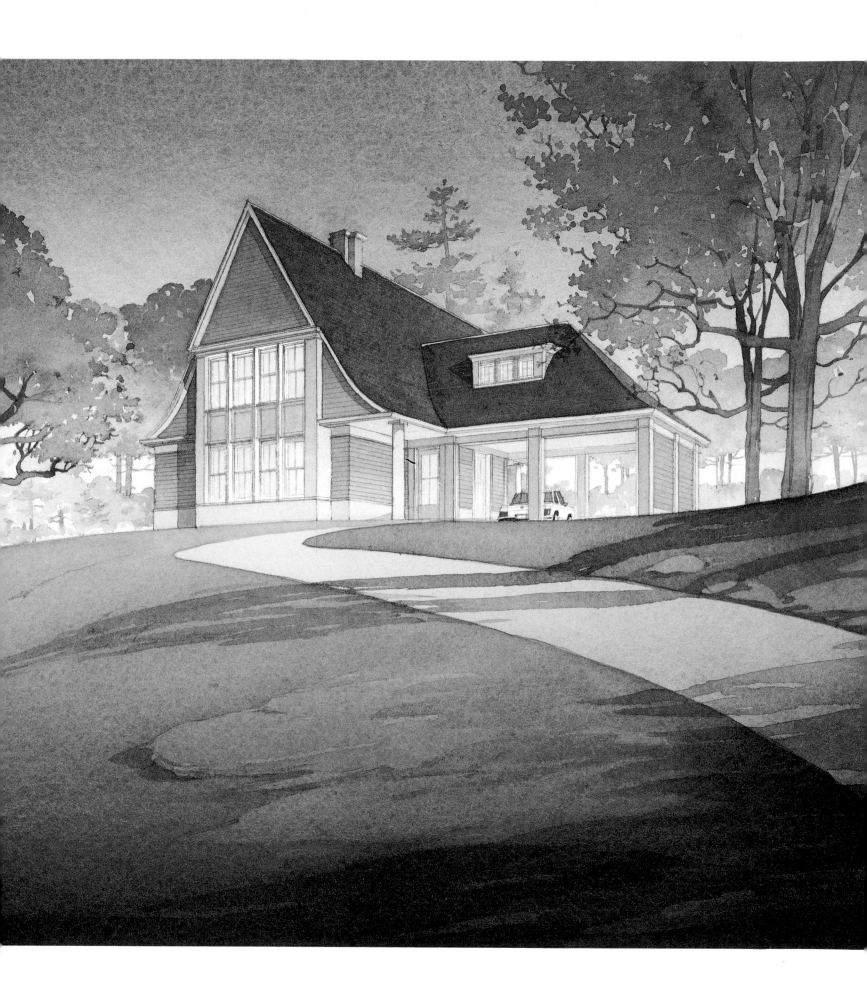

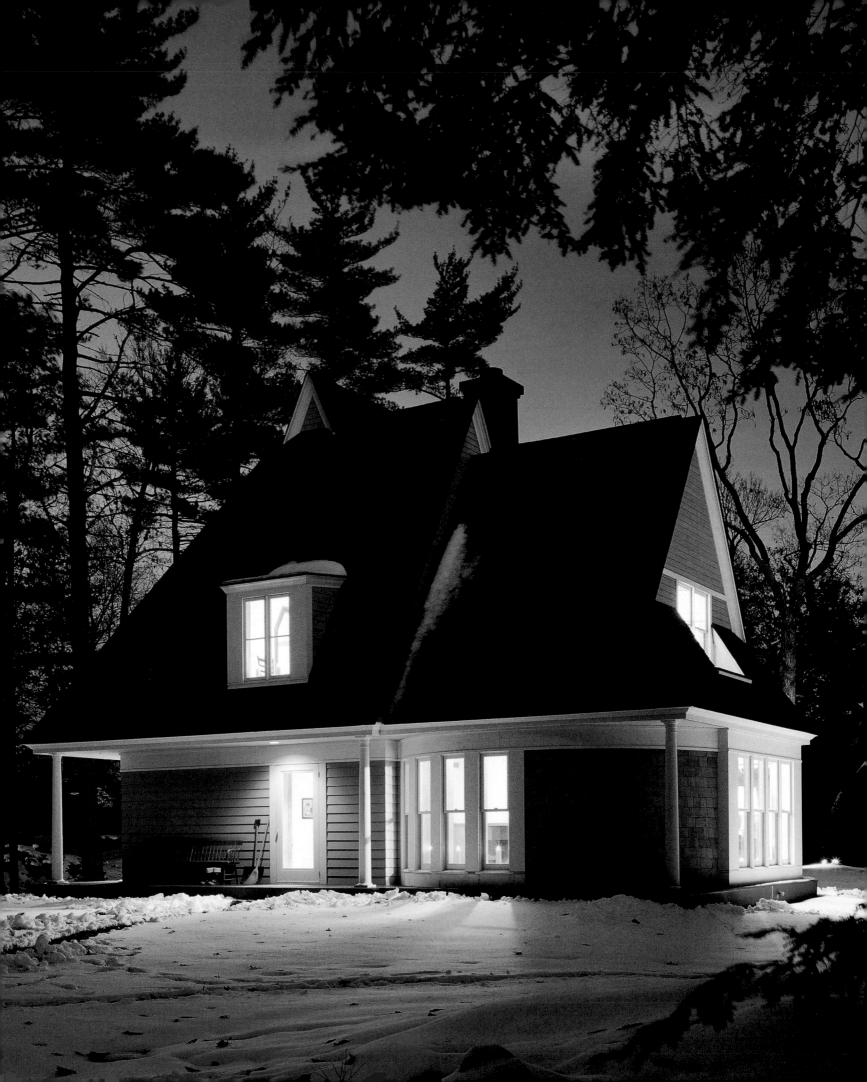

A house practically reverses character when night falls. Solid surfaces that were imposing during the daytime almost disappear. Voids, such as windows, glass-walled surfaces, and porch openings, move to the foreground. Alluring **NIGHT SCENES** emerge from a skillful combination of transparency and composition

Think about how voids will balance the solid surfaces. After dark, when the roof and the overall shape of the house recede into darkness, it's the windows that become the main compositional features. Large windows have the effect of placing the interior on display, like a stage play. You may want to organize a series of windows to create strong bands or patterns of light. Individual windows off by themselves—such as a small, round window in a gable—can, on the other hand, create intriguing touches of light, which will give the house a more romantic feeling. Porches take on a magical atmosphere when light washes across them. They become wonderful places to look at from a distance, and interesting places to sit. The porch columns can become pillars of white, framing views even more effectively than they do in the daylight.

You may want to consider a lighting program that will accentuate the best elements of the house and its grounds. Interesting textures and focal points can be dramatized with outdoor lighting fixtures. But many effects can be achieved without bright, conspicuous illumination. Subtlety may be best. Rarely does it hurt a house to retain a bit of mystery; not everything need be fully disclosed.

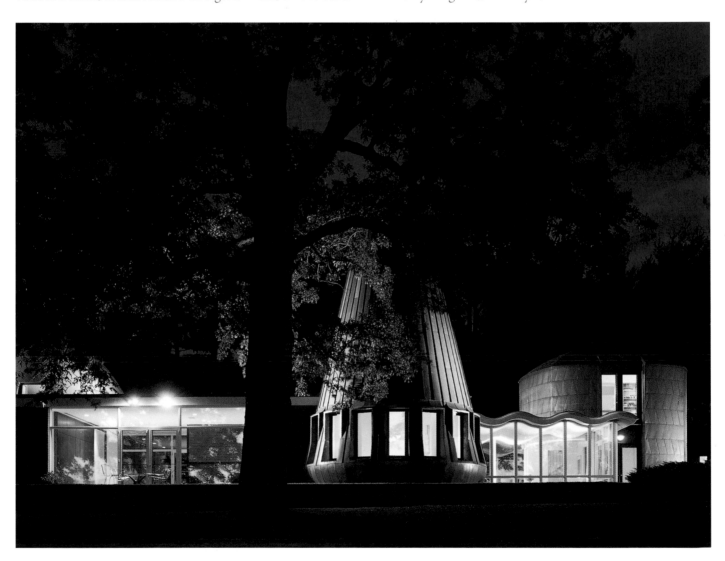

LEFT When dusk comes to this house , the porch and its ceiling glow, and the windows turn into lanterns.

ABOVE The interior become strikingly defined against the darkening landscape. The structures themselves recede into the background.

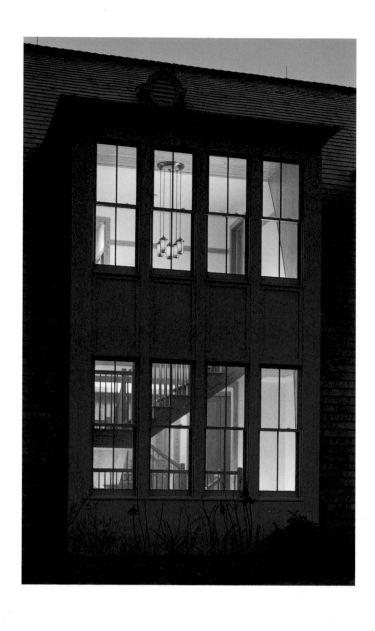

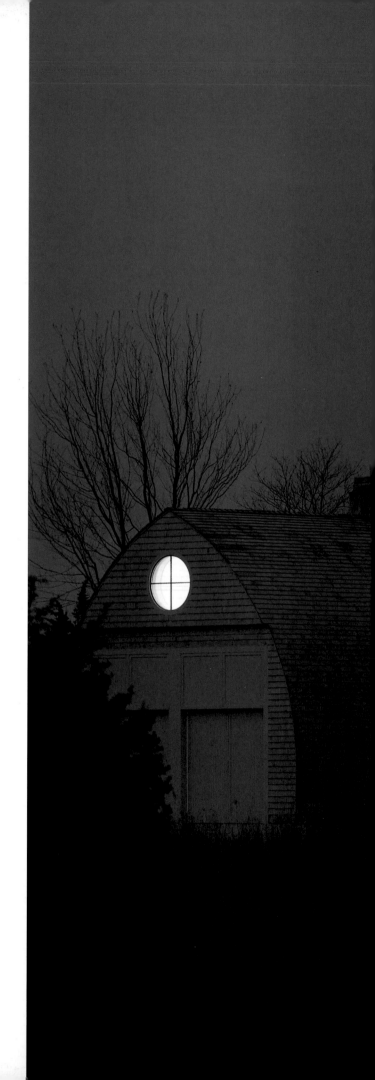

ABOVE Transparency can make a house come to life at night, when the space behind the windows becomes bright and animated.

RIGHT As the mass of the house recedes into the darkness, illuminated areas become the composition. The round spot of light, distant from the main portion of the house, lends a magical touch to the scene.

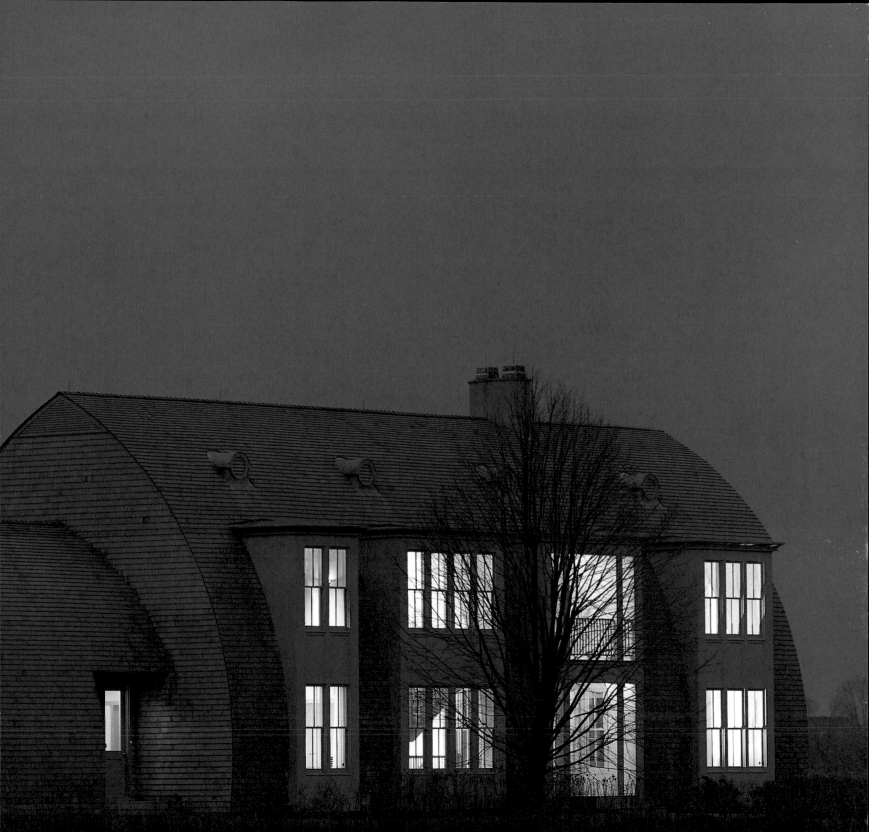

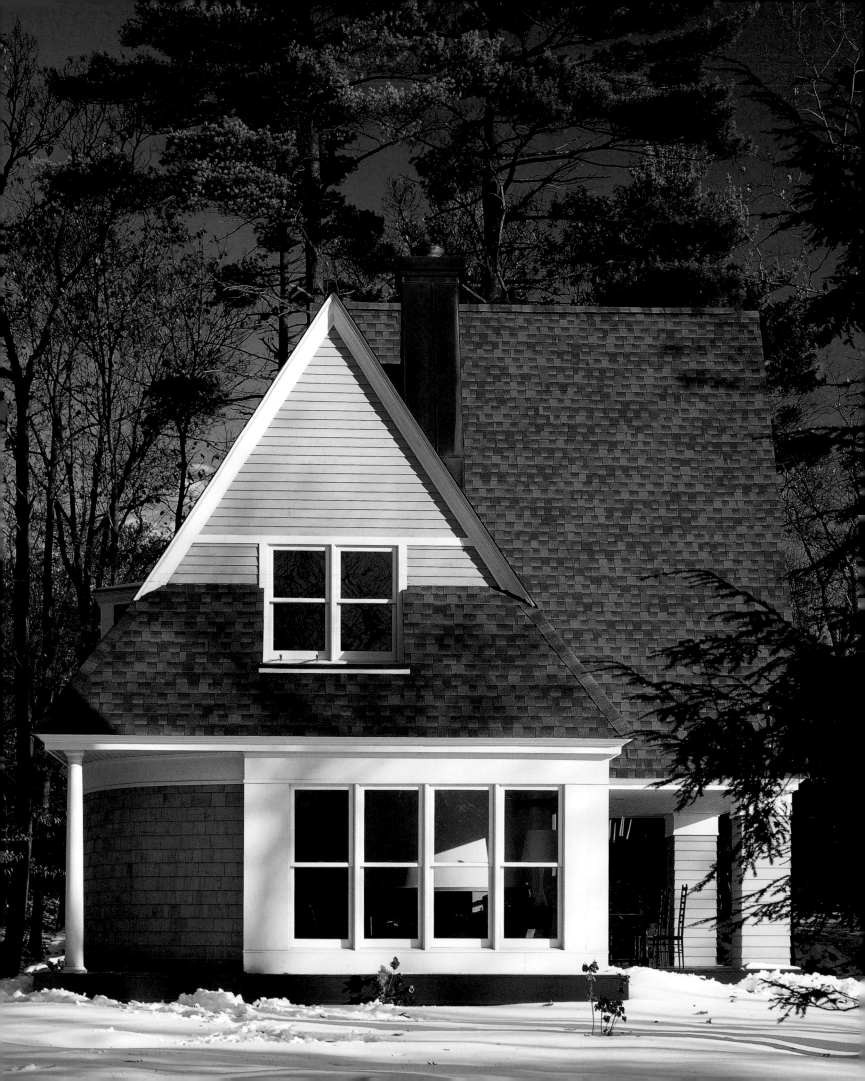

CLINTON CORNERS COTTAGE

The picturesque house is lyrical. This one is a woodland cottage for a renowned composer. The prelude to the house is a drive so long, winding, and rough it's a wonder that a house could actually be waiting at the end. When the house does come into view, it is a relief—and a surprise, provoking questions. How small is this house? How steep is that roof? Why so many parts to the roof? Who inhabits this dwelling? Is this an old house or a new one?

The house evokes curiosity. It may also evoke skepticism—"Is it practical?" And cynicism—"It's too cute." And glee—"It's so cuuute!" The house is built from the most common residential construction materials: double-hung windows, clapboard siding, asphalt roofing. Yet it has a decidedly uncommon look. All of this is accomplished through picturesque composition. It's not what the house is made of, but how it is composed. The rhythm of the roof, the single note of one dormer, the high pitches, the drum shape—all these are musical arrangements of everyday house parts.

The house adds variety to the surrounding landscape. Before construction, this spot in the midst of continuous second-growth forest was hardly noticed. Now the front of the house creates an open green area juxtaposed with the backdrop of a simple façade. To the left is a woodland that winds its way around a series of pavilions. To the rear, a slight drop of land is transformed to resemble a mountain ledge with a covered lookout at its ridge. The house is the previously missing landscape feature that turns the property into a picturesque setting.

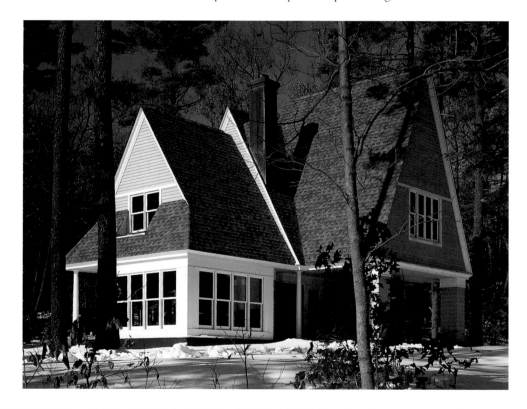

LEFT The symmetry of the front-facing gable contrasts with the asymmetry of the ground floor and of the house as a whole. The shingled corner at left, curving away behind a single column, is an unusual touch that quietly stirs the viewer's curiosity about the interior.

ABOVE Steep roofscapes, relating to one another in subtly interesting ways, give the house an almost childlike quality. This rear view shows how close to the property's trees the house has been built.

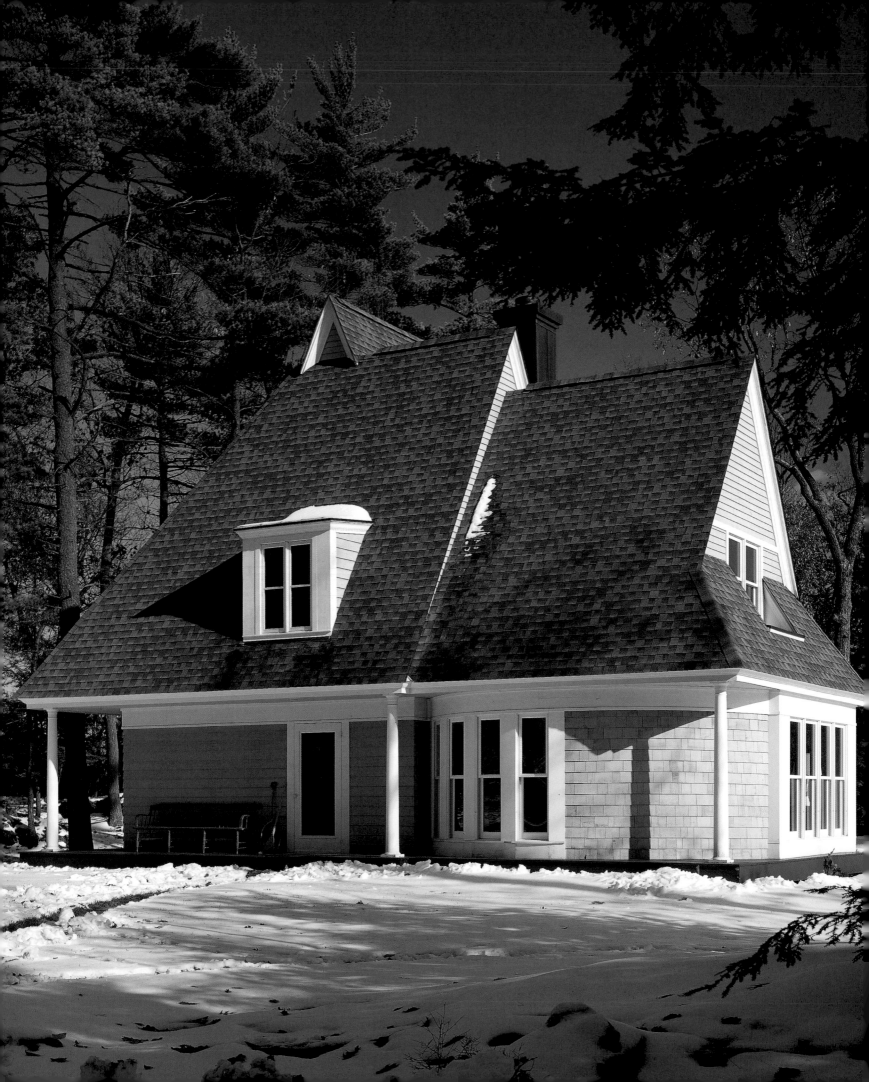

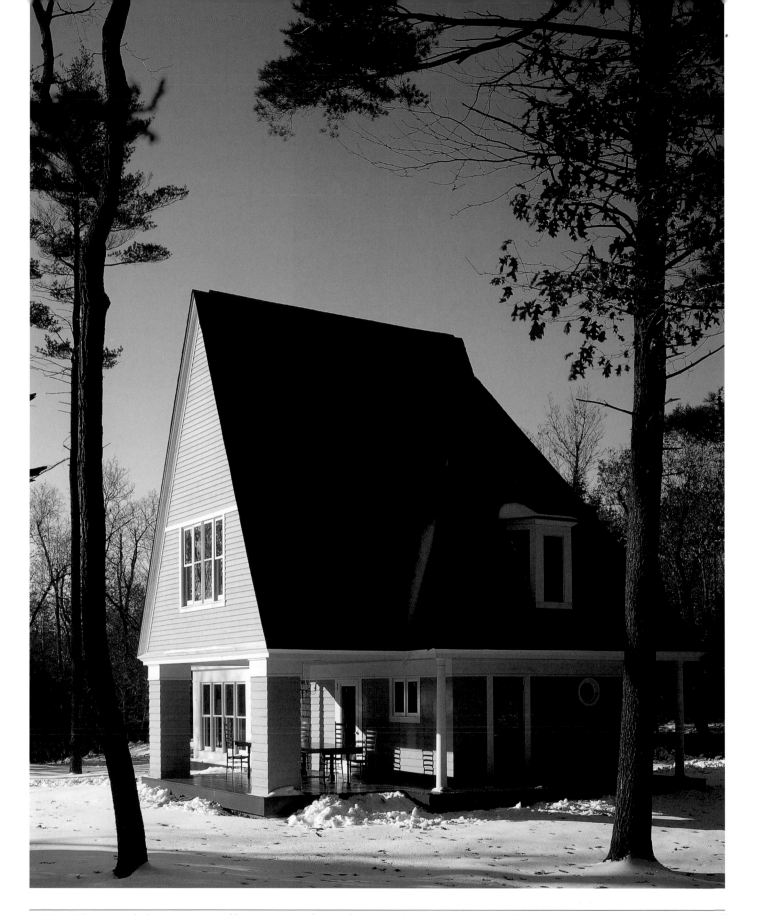

LEFT The front of the house presents an odd mixture of simplicity—decoration is kept to a minimum—and complexity—because of the big roofs, the overall asymmetry, and the contrasts of different shapes.

ABOVE The back porch feels weighty, with its heavy square piers supporting the gabled second floor, but the weightiness is contradicted by the thinness of the columns in the background. Such contradictions generate a whimsical, picturesque quality.

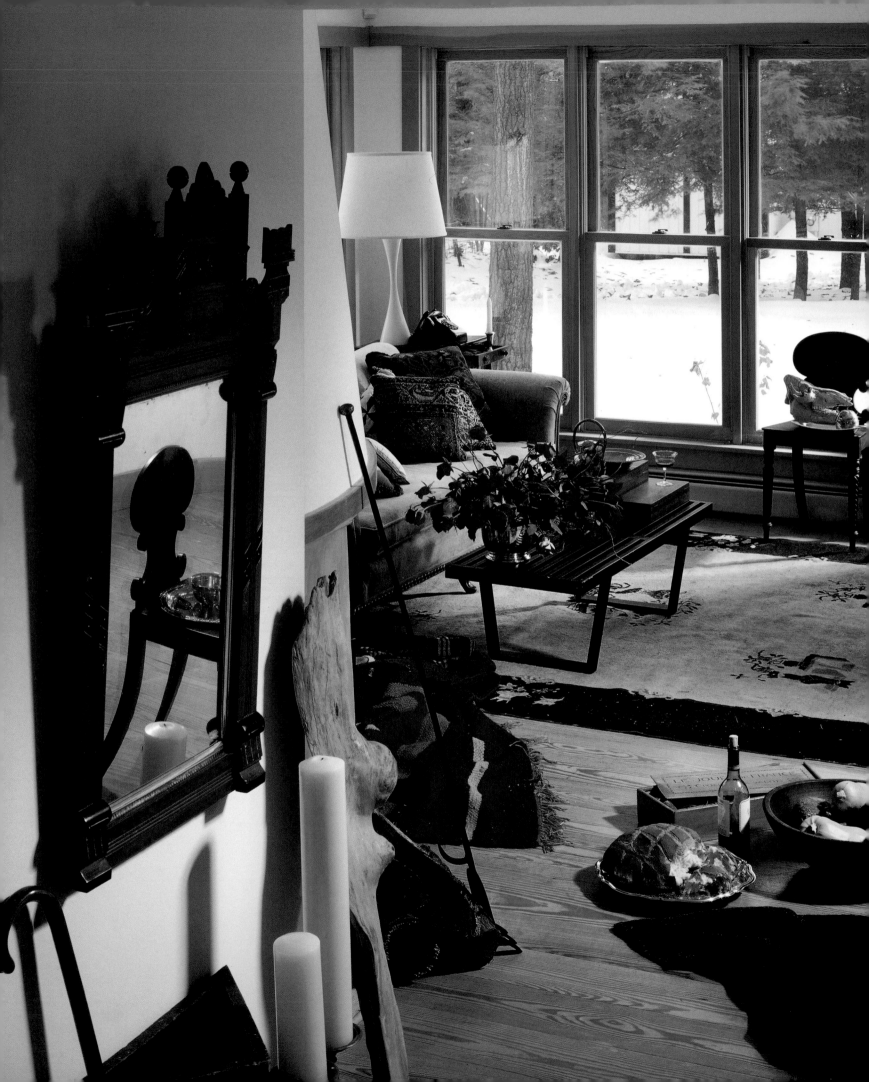

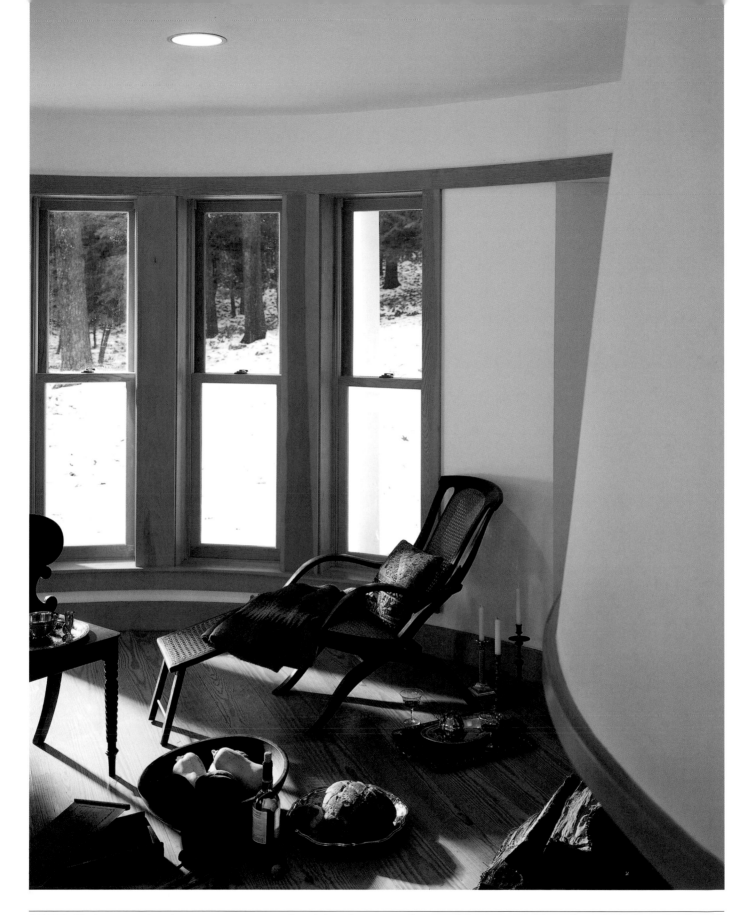

LEFT The living room has plenty of transparency, supplying light and views. But the unusual shaping of its spaces, with part of the area just out of sight around the corner, creates suspense. This house reveals itself a bit at a time, generating a sense of anticipation.

ABOVE A uniquely shaped corner—an interesting place to unwind—is formed by the junction of the curving wall of windows and the curving fireplace to the right.

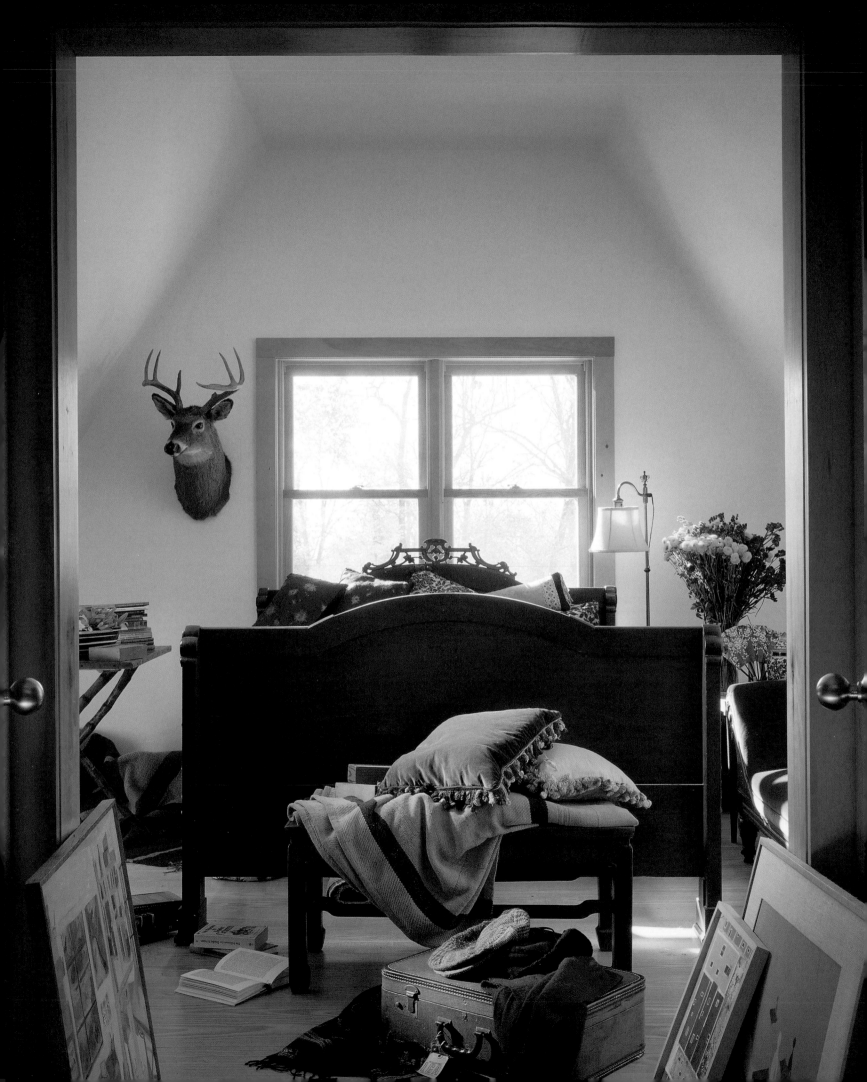

LEFT A second-floor bedroom is symmetrical, with its double windows placed exactly in the center of the wall, yet it also has an appealing quirkiness because of the sloping walls beneath a big gable.

ABOVE The wide stair hall makes a place, not just a corridor, and is made more distinctive by the slope of part of the ceiling at right. Spaces are lined up so that part of a window is visible in the distant bedroom.

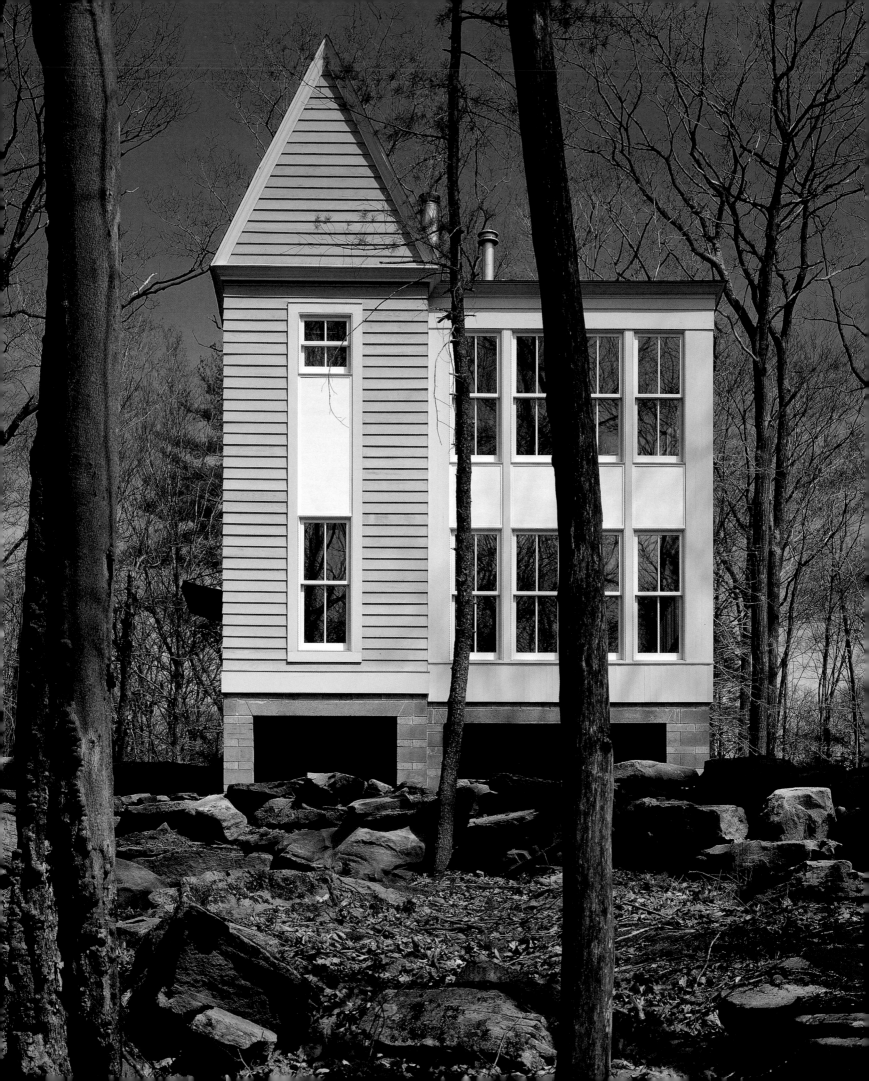

FORESTBURG HOUSE

This tiny house appears taller than other two-story homes of its size, demonstrating once again that quality, not size, is what counts in a good house. The house is composed of four parts. Since it's so small—only 20 by 25 feet—the even smaller quarters within it produce tower-like masses. The tall and slender proportions not only fit the castle imagery sought by the clients; but also complement the towering pine trees that surround the house. Set on barely more than an acre, this little sanctuary is completely hidden from view.

Inside, verticality is celebrated with the towering space of the stair hall. In such a tiny dwelling, it may seem odd to dedicate more than a minimum volume of space to the stairs, yet life in a house is as much about moving around it as it is about reclining. Seen from outside, the tall, nearly windowless walls of the castle stair tower hint at the majesty of its interior.

In contrast, the diagonally opposite corner of the house has an almost all-glass quadrant. Here, the dining area is on the first floor and the reading/writing room on the second floor. Positioned to overlook the running brook on the property, this part of the house lets the sights and sounds of water permeate the spaces within.

But not all spaces in a house need be defined by transparency. These woods can get cold, so a cozy spot is often appreciated. The neighboring section to the sunny quarter is the snug quarter. On the first floor is the living room, with its monumental fireplace, and on the second, the bedroom. The last quadrant of the house is reserved for the service needs—the kitchen and bath.

With so few rooms, this house is obviously for just two people, but a house designed for a particular purpose can be especially sensible when it is so small. That is what is so picturesque about it all: It is a home for those two and only those two.

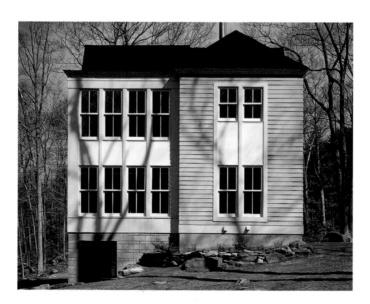

ABOVE One volume contains two sets of four tall, double-hung windows, while the adjoining volume contains just two pairs of windows, yet the two volumes balance each other well. The transparency of the left, containing a dining room on the ground floor, plays off the relative solidity of the right, containing a living room. One volume is open to the outdoors, the other more closed and sheltering—yin and yang.

LEFT One volume—the dining room—repeats its form after having turned the corner, but this time it's matched against a skinny, tower-like element that has a triangular gable to climax its vertical thrust. A long, vertical panel and an even longer frame around the windows of the tower portion energize this unusual composition.

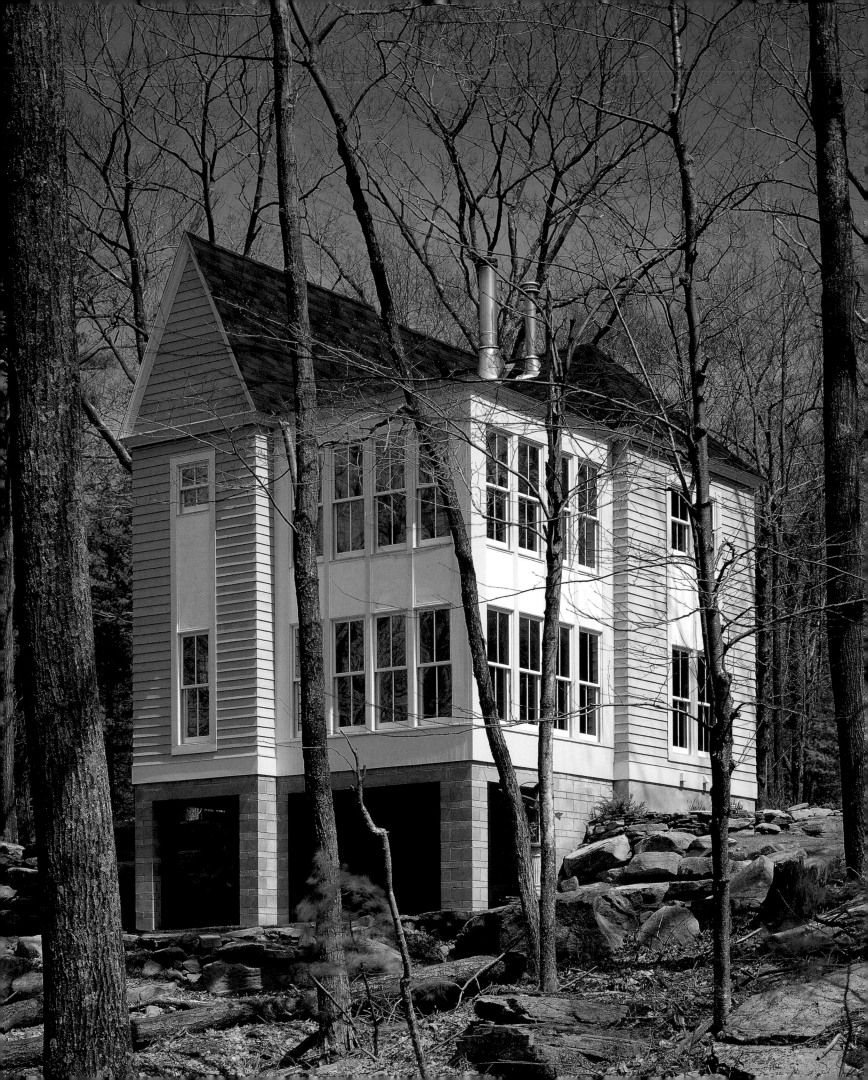

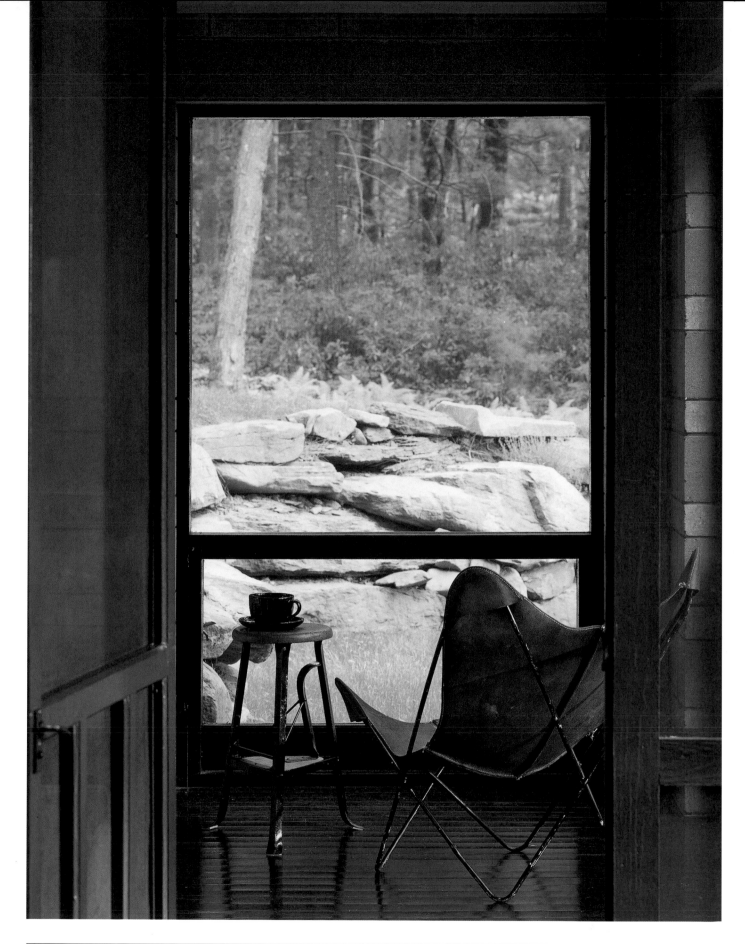

LEFT One metaphor for a house is a collection of different buildings. Different surface treatments allow each separate component to retain its individuality.

ABOVE A deeply shadowed space is a restful, cozy setting for looking out at the rocky, sunlit landscape.

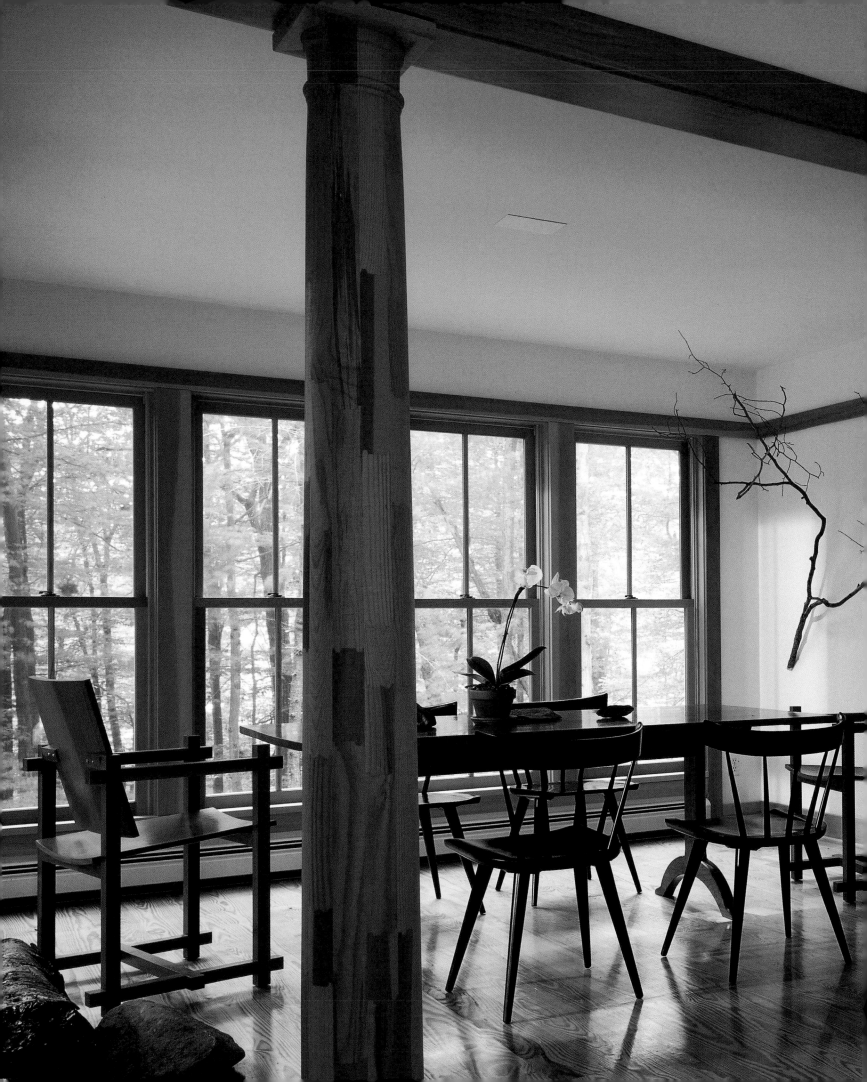

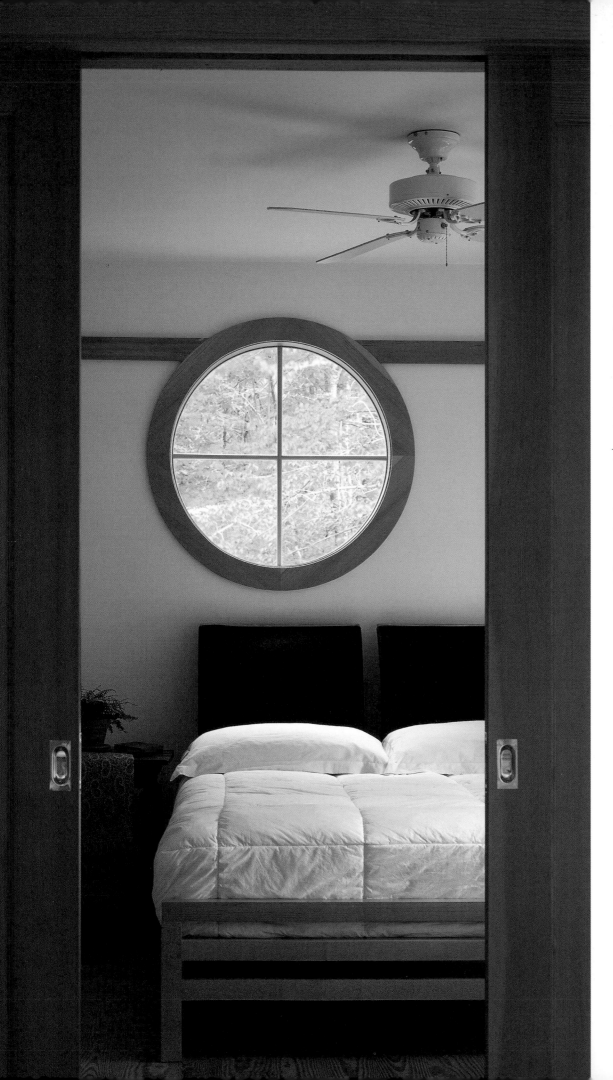

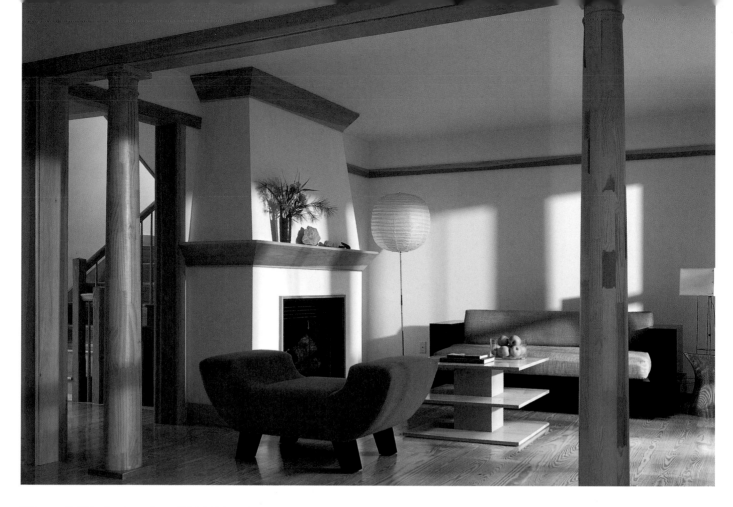

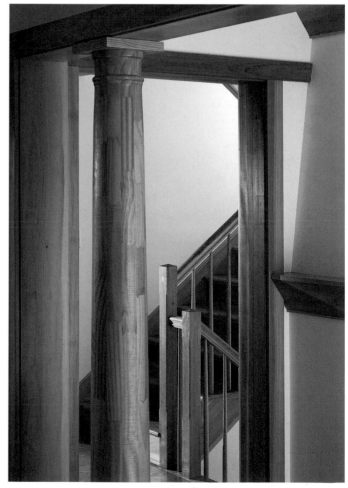

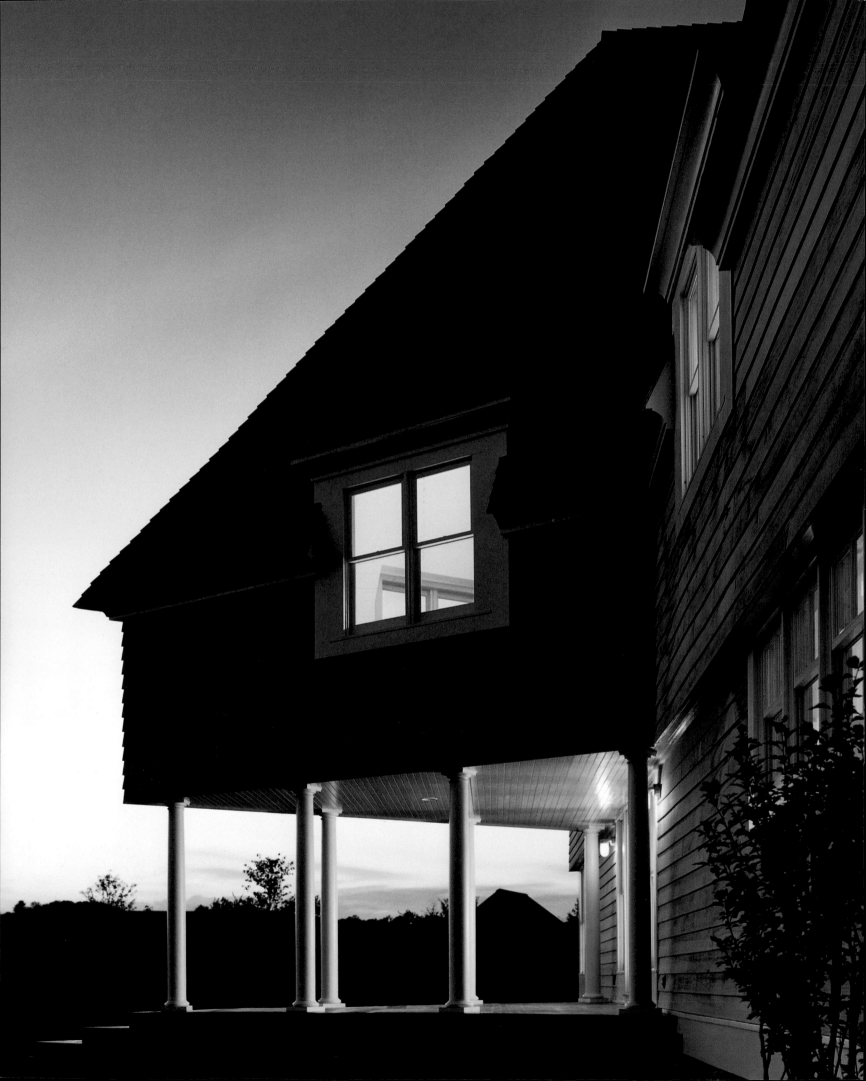

MALDEN BRIDGE HOUSE

Why would anyone want a house in the shape of a six-pointed star? The picturesque house often incorporates eccentric choices. There is no reason to build a custom house that does not distinguish itself in some way. Sometimes subtlety is appropriate, but at other times projects can benefit from bold moves. This is one of those times. The shape of the plan was inspired by the family structure. Each family member—father, mother, sisters, brother—had an equal say in household decisions. Therefore each needed an equal bedroom wing, with the parents getting a double.

The plan is carried out with architectural details common to the industry as well as the neighborhood, so the shape is actually the only exotic aspect of this house. In plan, the angles produce multiple complex effects on the exterior. Inside, the organization is remarkably straightforward. A six-pointed star is formed with surprisingly parallel lines. For the interior, this means that the outside walls run straight, like the outside walls of a rectangular house. The magic arises from the fact that the intermediate walls offer corners that can be filled with glass—for transparency, cross-breezes, and settings for focal points such as sculpture, light fixtures, and plantings. The corners also make for inviting niches in which to sit.

Peculiarity is at the heart of the picturesque. The spirit of the good house lies in the complexity of its character, from the beautiful to the strange.

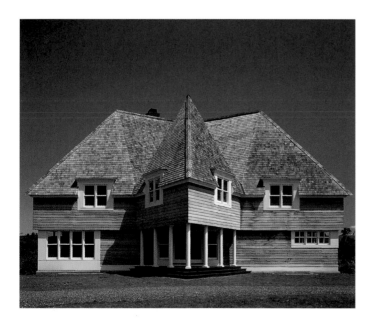
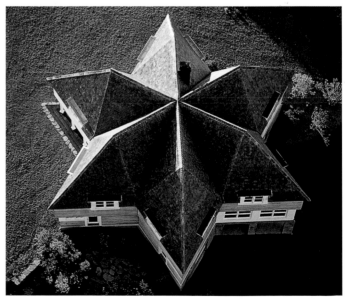

ABOVE RIGHT The true shape of the house can only be seen from a bird's-eye view, while from the front (*ABOVE LEFT*), its form is a mystery.

LEFT The entryway is tucked under one of the projecting points of the star.

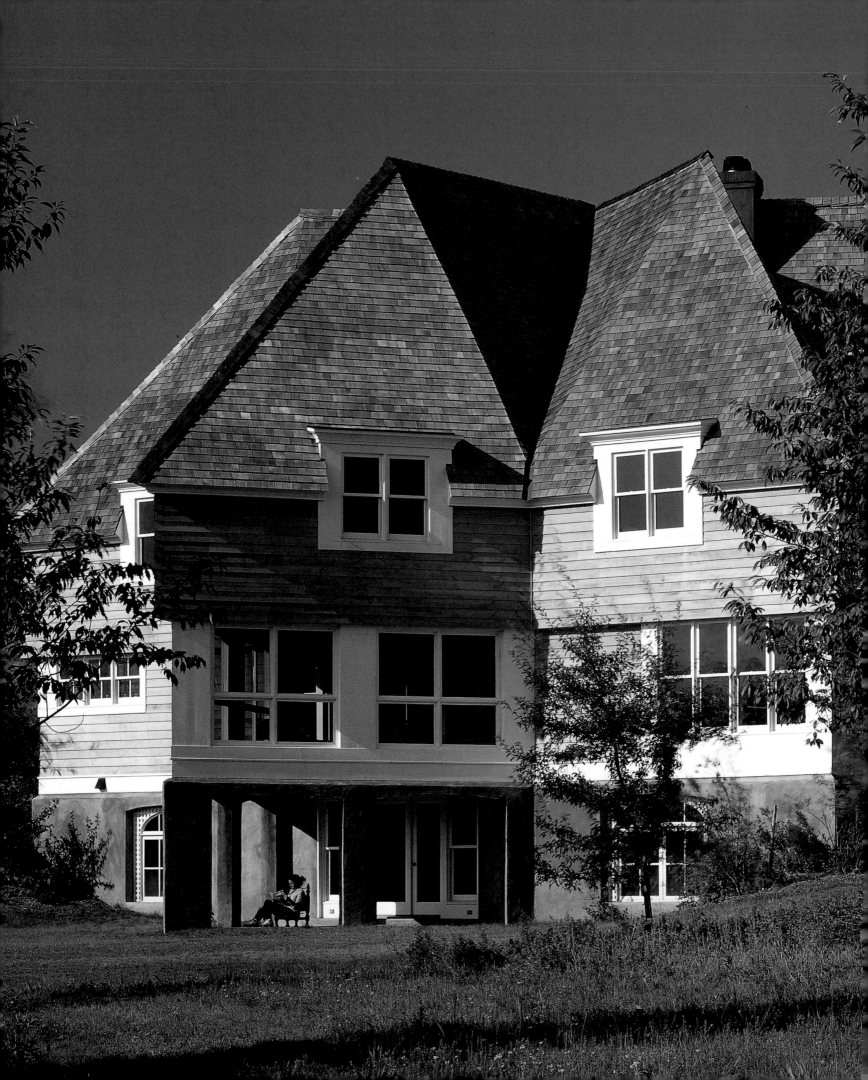

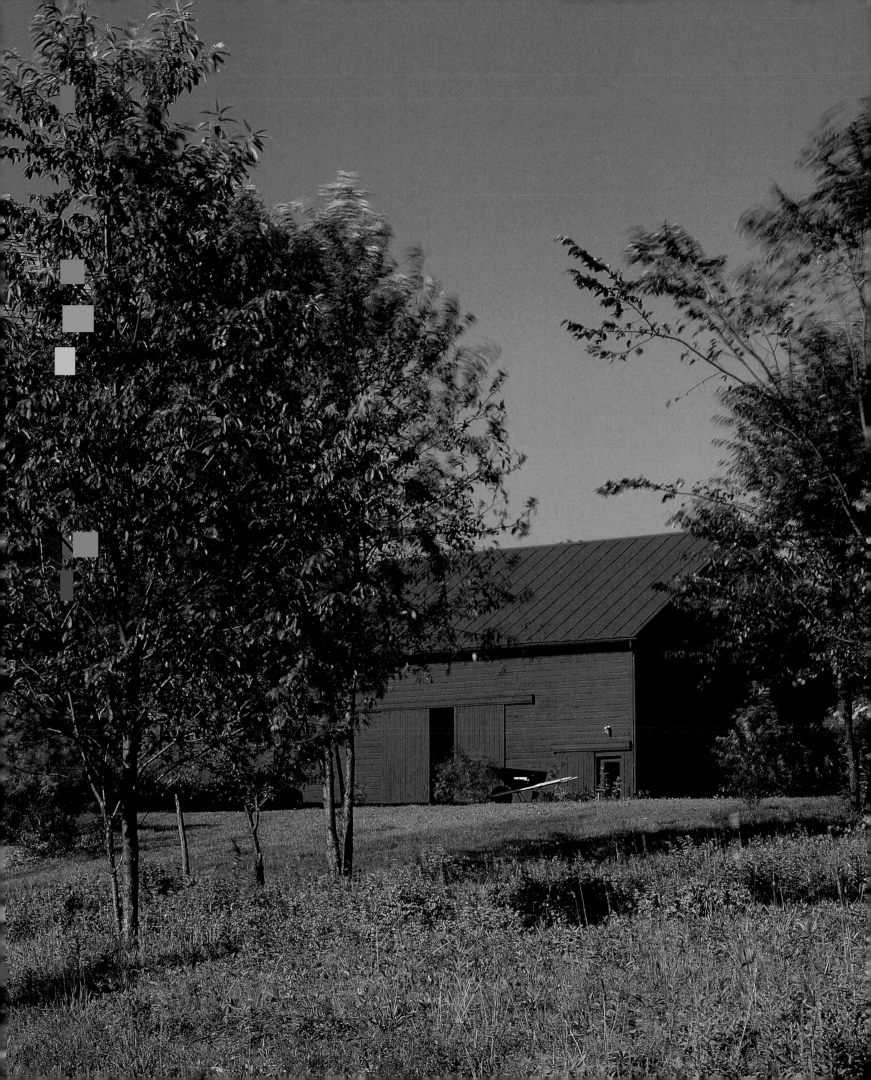

PREVIOUS PAGE The peculiar roof configuration—a challenge to understand from the entrance—becomes clearer when seen from a distance across the rear landscape. The exposed basement opens onto a patio where the air is cooler and the house begins to seem more vertical than horizontal.

ABOVE Columns become glossy pillars of light as darkness falls. Across the way, light spilling out of a barn door is wonderfully evocative.

RIGHT The prospect to the rear, where the slope sits in late afternoon shadow, is more dramatic than the level view from the front.

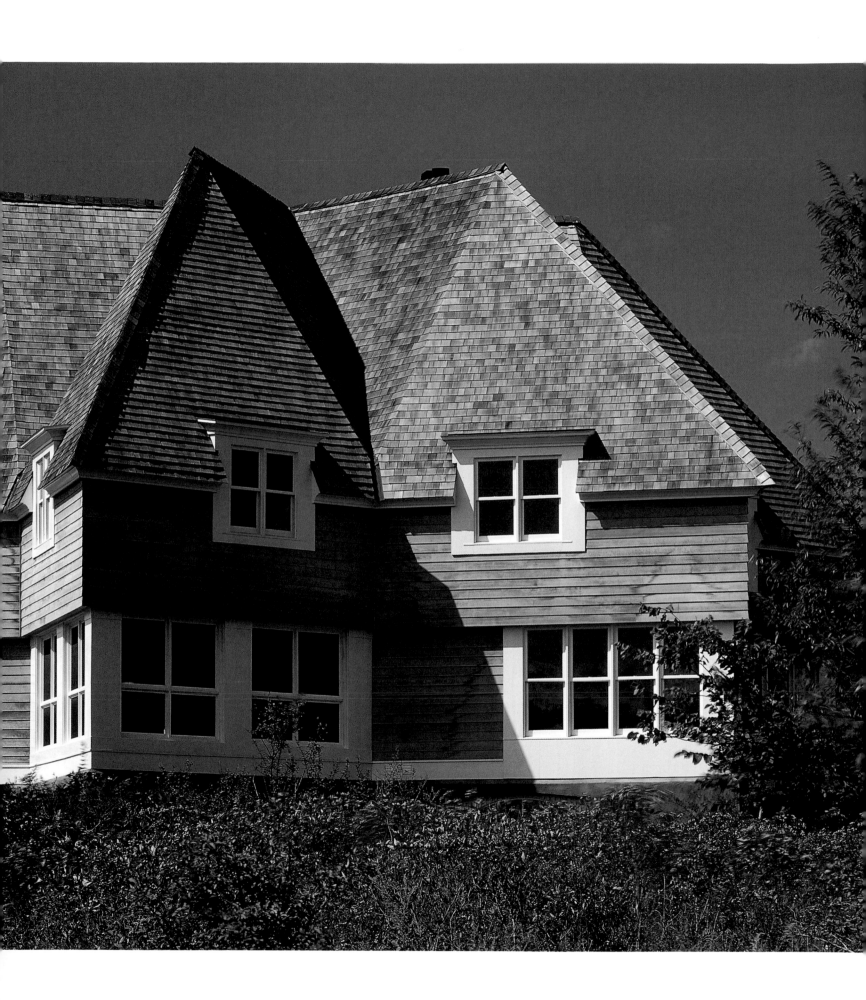

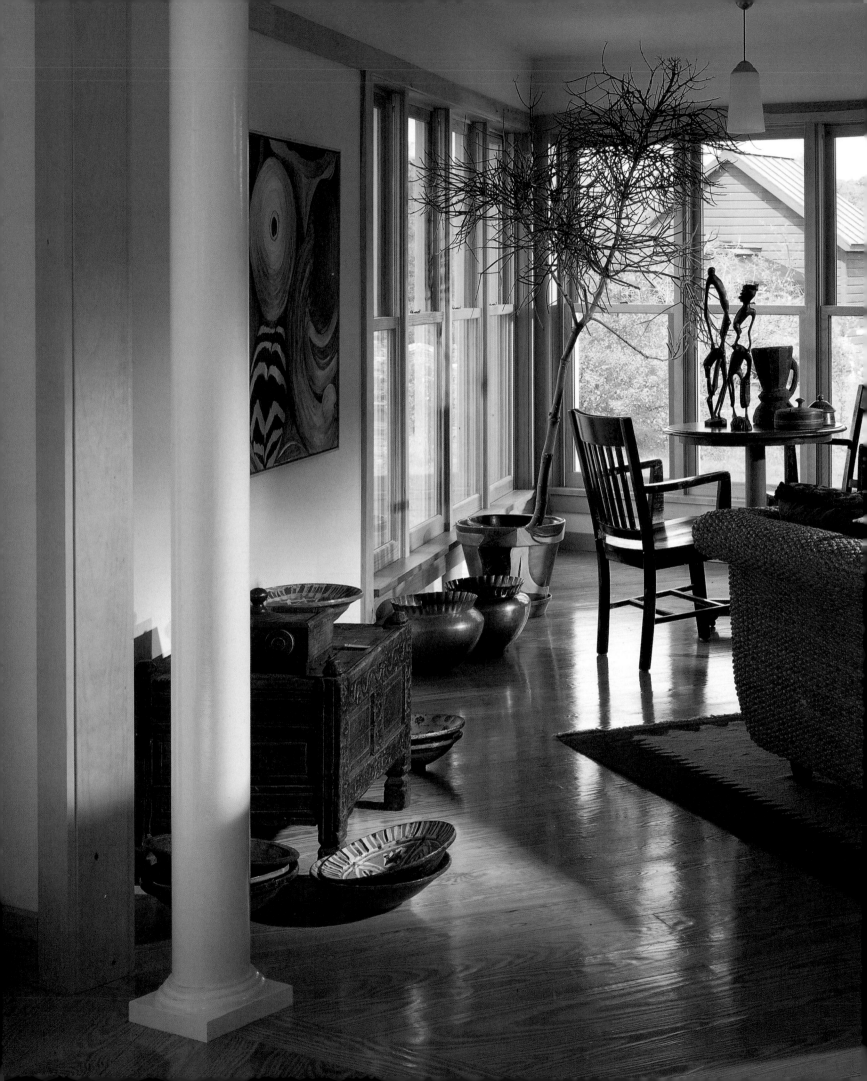

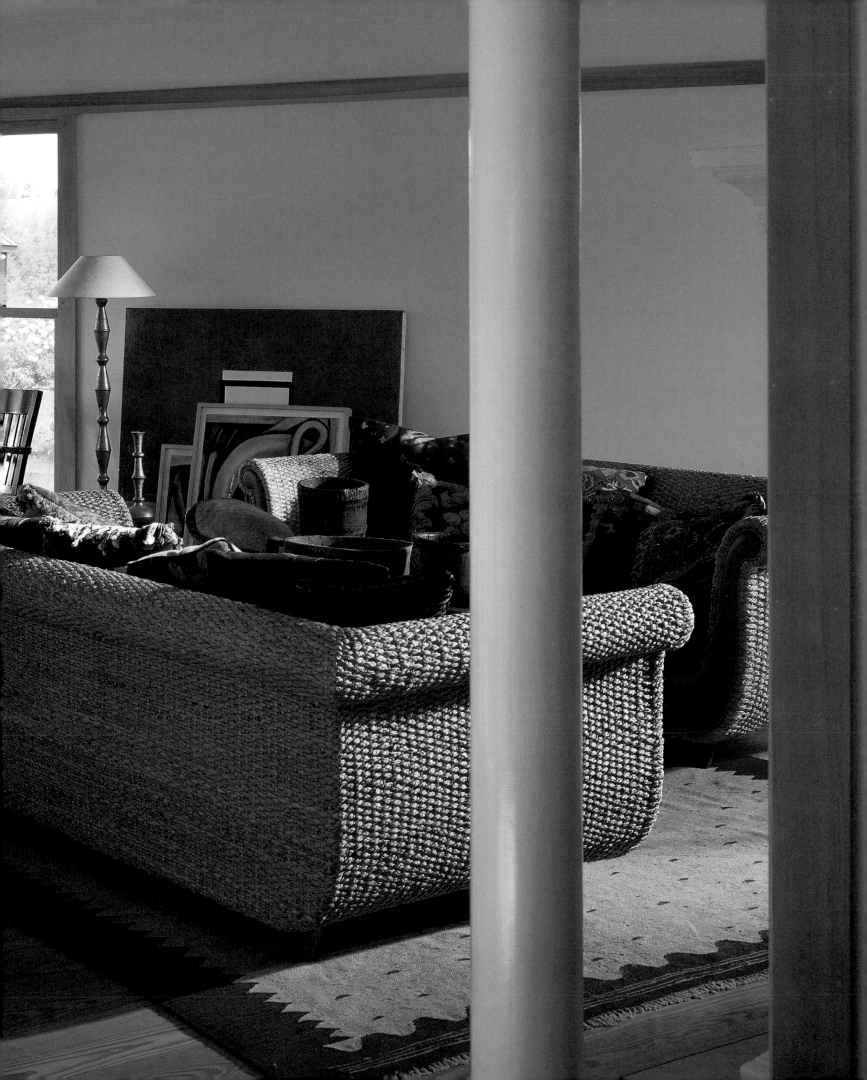

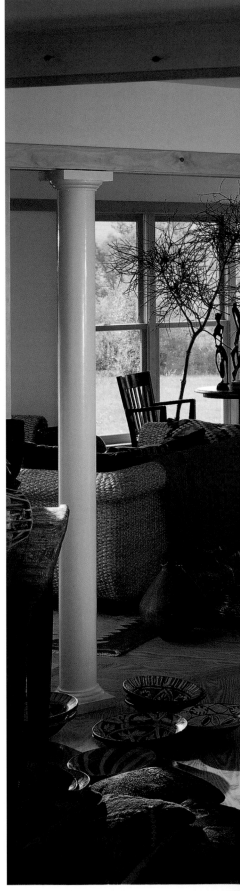

ABOVE The ganged windows in the corner above the sink allow people working in the kitchen to command beautiful views across the countryside. Transparency is attainable even when windows have to stay above counter level. The warm tone of the wood floor is accentuated by sunlight streaming through a glass door.

RIGHT The dining room borrows space from an adjacent living area and gets the benefit of some of that room's light and view. Though the rooms angle into points, the complex layout feels quite comfortable in the interior. A frame of wood running at ceiling height helps to unify the interior.

PREVIOUS PAGE A room in the wide-open interior is defined by decorative columns at its edge. The eye is drawn to the light-filled corner—one of the points of the star.

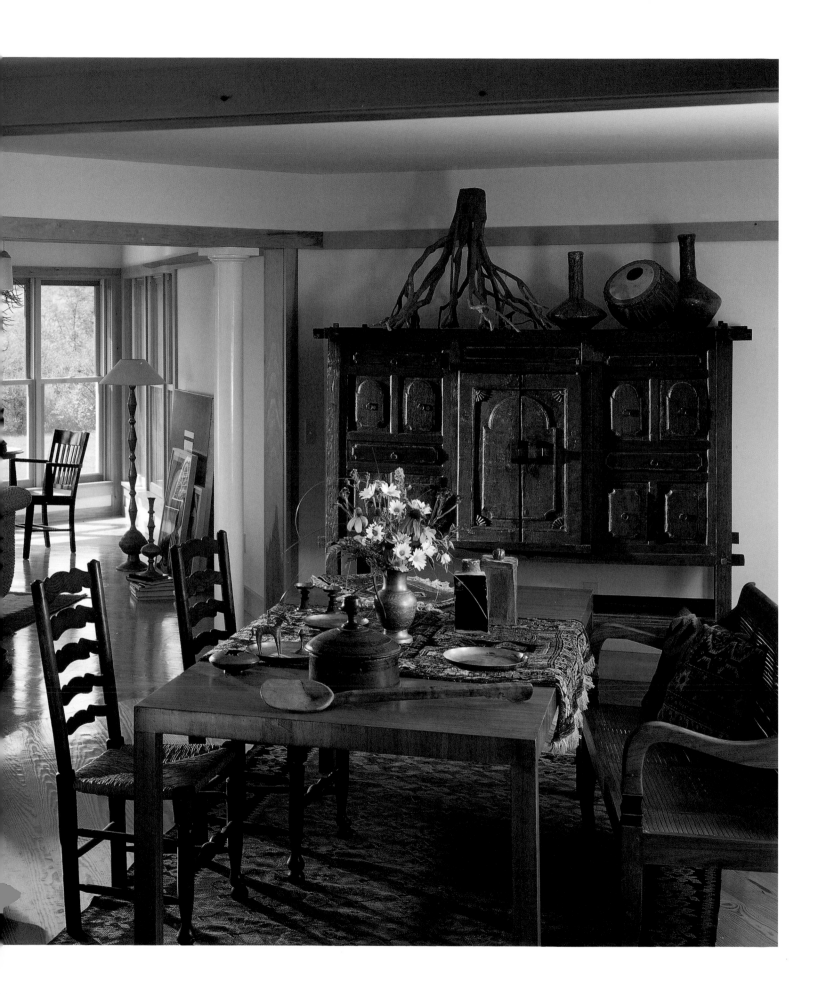

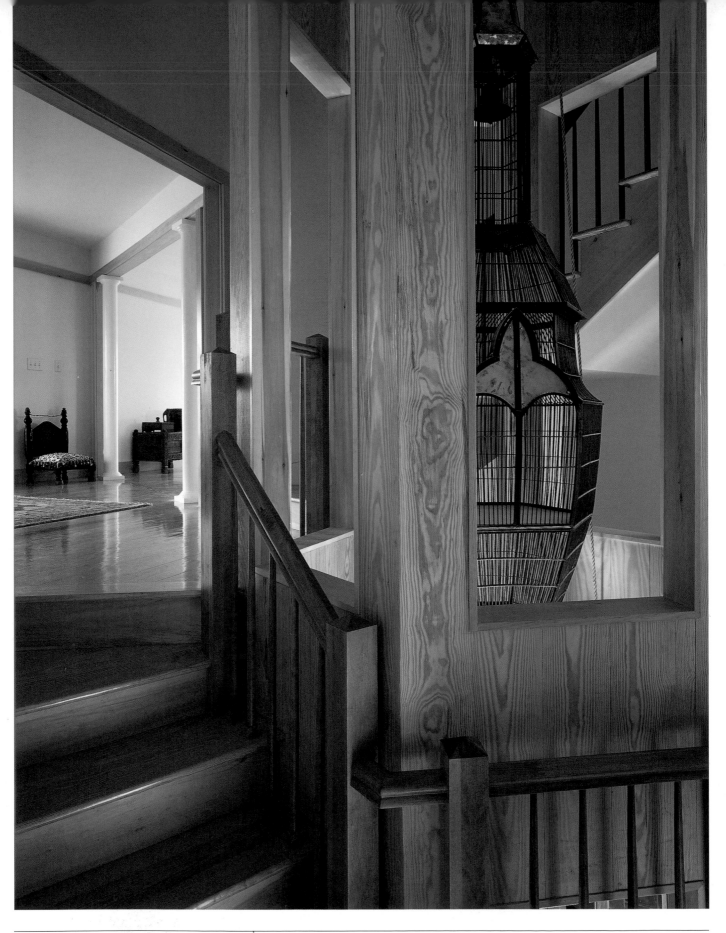

ABOVE From the entry hall and other locations in the interior, an enormous suspended birdcage is a stunning focal point. It occupies a wood-framed shaft in the house's center, with the home's stairway wrapping around it, providing dramatic and constantly changing perspectives.

RIGHT A point of the star is a great place from which to survey the property.

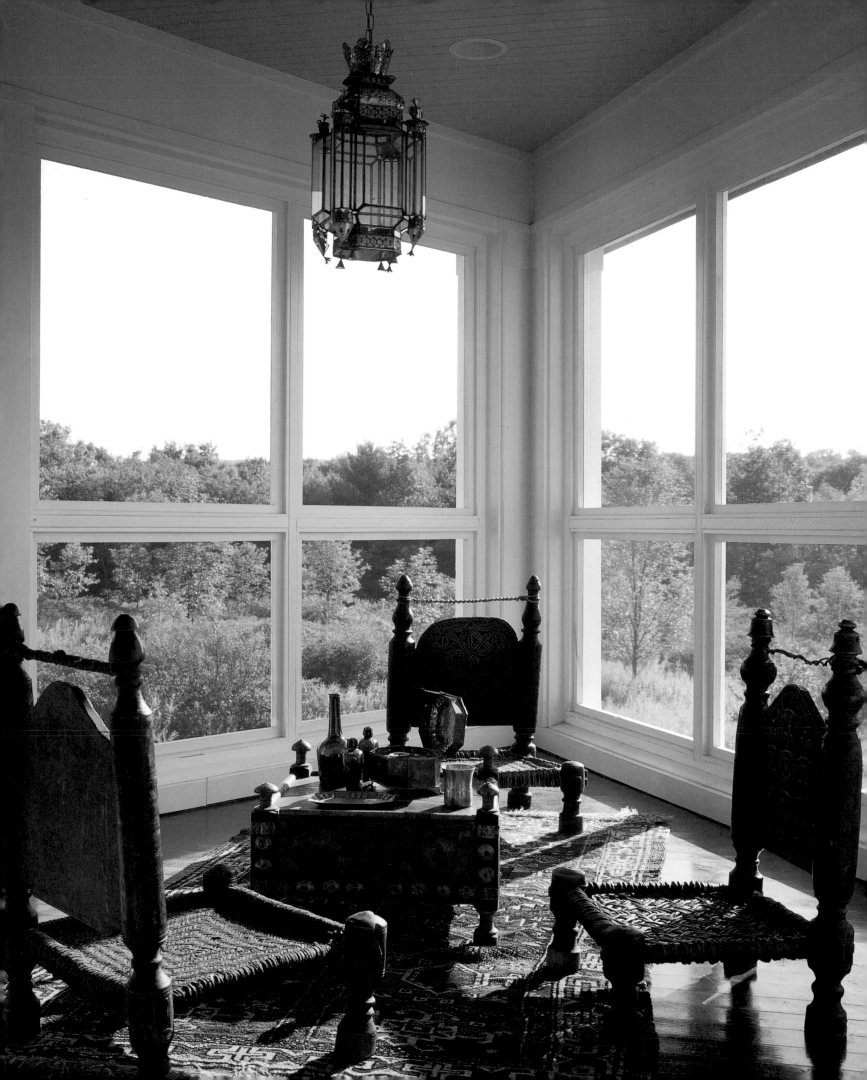

LEFT *A long, straight wall accommodates an enfilade of doors and spaces that eventually terminates at a window. An interior window near the ceiling is a fun touch that allows the hallway to borrow light.*

RIGHT *The bedroom area "borrows" space by opening to a bathroom, a technique that makes a room feel more generous in dimension. Note how the slope of the roof creates an interestingly shaped wall.*

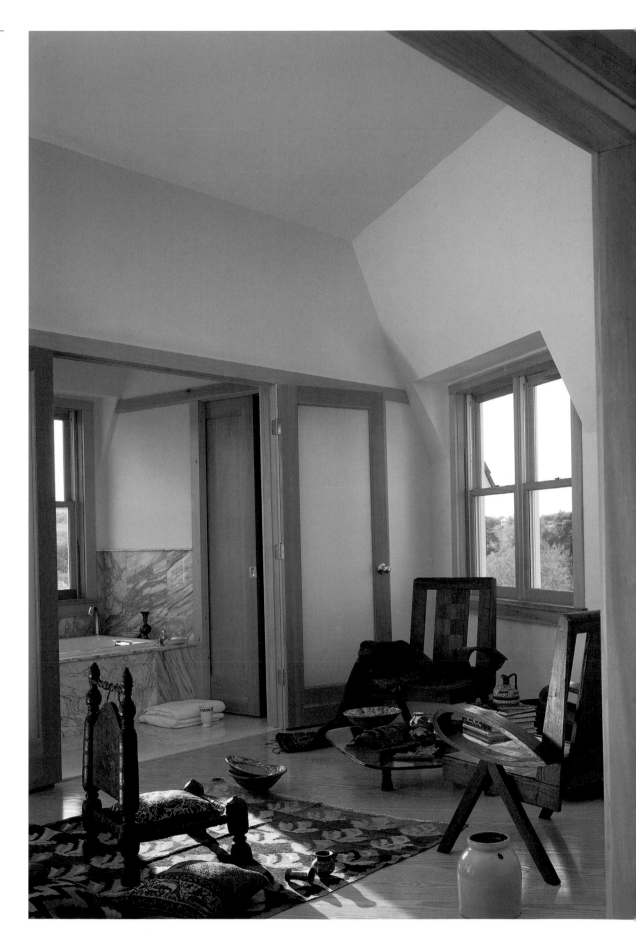

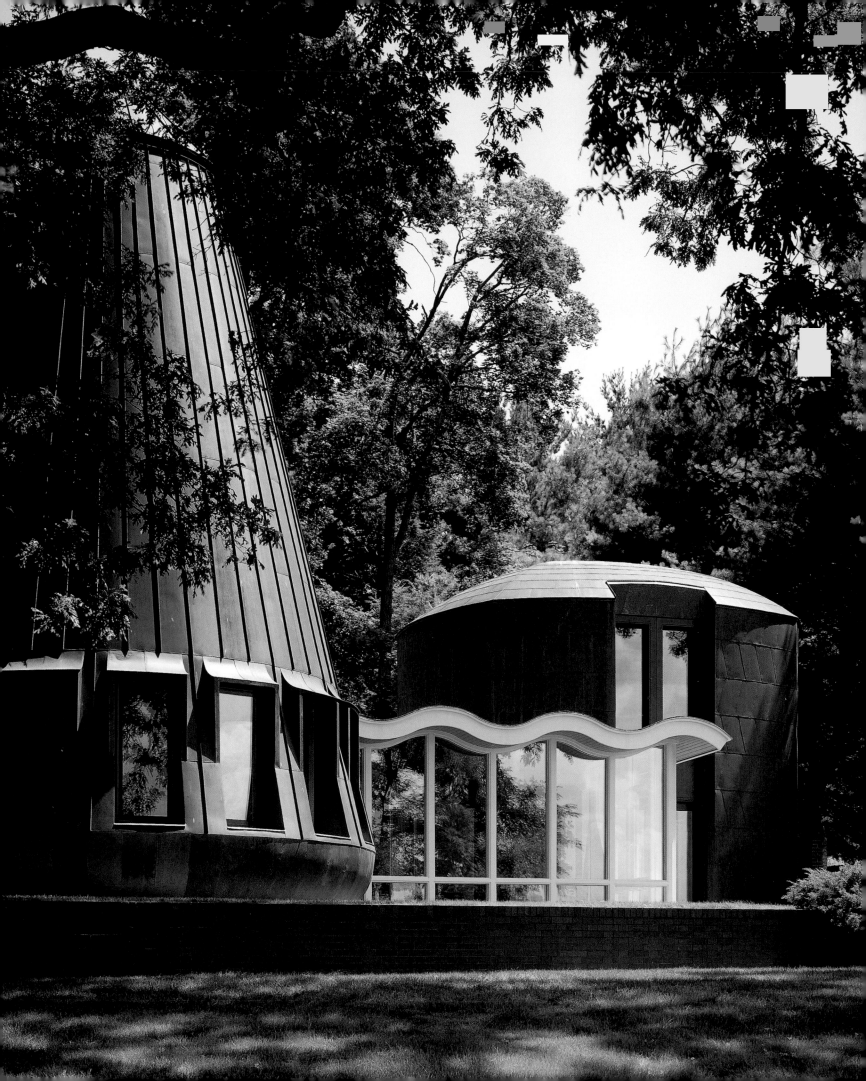

ADDITIONS TO ONETA HOUSE

This renovation of a classic Modern house that Philip Johnson designed at the start of his career was my most fantastic commission. The original house was a severe design: a brick box. If the original house were lifted up and set down in an empty parking lot, you would say it was heartless design. It is the setting and the few—but significant—garden elements that Philip Johnson added to the house in response to its setting that gave it soul. He placed a long, brick garden wall at the front of the house, but just to one side. An off-center pathway led visitors to the garden instead of the front door, concealing the view of the Hudson River just beyond—saving it for a surprise once inside. A pergola was built to the south. The retaining wall on the river side enabled the house to perch above the water, assuring a fine view from within and from the back patio. Finally, the curve of this retaining wall at one side preserved the old oak tree the house nestled against. These moves transformed a cold, albeit elegant, brick box into a picturesque garden pavilion.

My clients loved the landscape and the house's devotion to it, but they needed a home twice as large. The original house was not nearly adequate. There was no dining room, no playroom, no powder room, and certainly not enough bedrooms and baths. The new owners were a family with two children and another on the way. If possible, they said, they would like just to add to the landscape around the house, and not to the house itself. So that's what I did, with "plantings" of annexes for bedrooms and family rooms. Each new addition is profiled after trees and shrubbery. These copper-clad structures, which will acquire a patina of bark brown and perhaps bluish-green, are arranged around and overlapping the original modern house. Although the older portion of the house is less than half the size of the total space of the additions, it remains the focal point. The strong contrast of the sharp shape of the brick-and-glass pavilion with the original rolling landscape remains intact. Although far less subtle and far more eccentric, the architecture continues to be a picturesque composition.

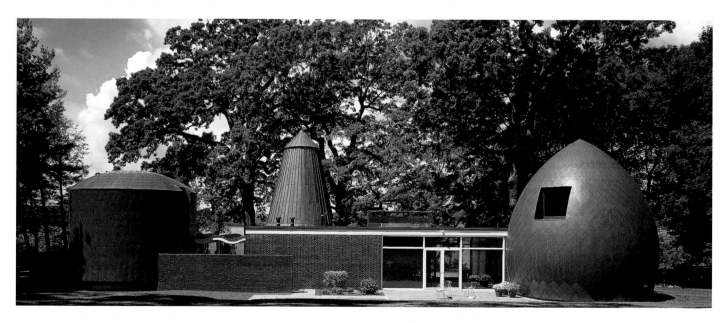

LEFT The back of the house, looking toward the Hudson River, is much more glassy and open than the front. Contrast is generated not only by the new pavilions' distinctive forms but also by their surfaces, especially the vertical lines of the turret's copper standing-seam roof and the round pavilion's dark copper shingles.

ABOVE The three new pavilions create a roofscape of imaginative shapes that work by being dramatically different from the restrained, rectilinear composition of the original house.

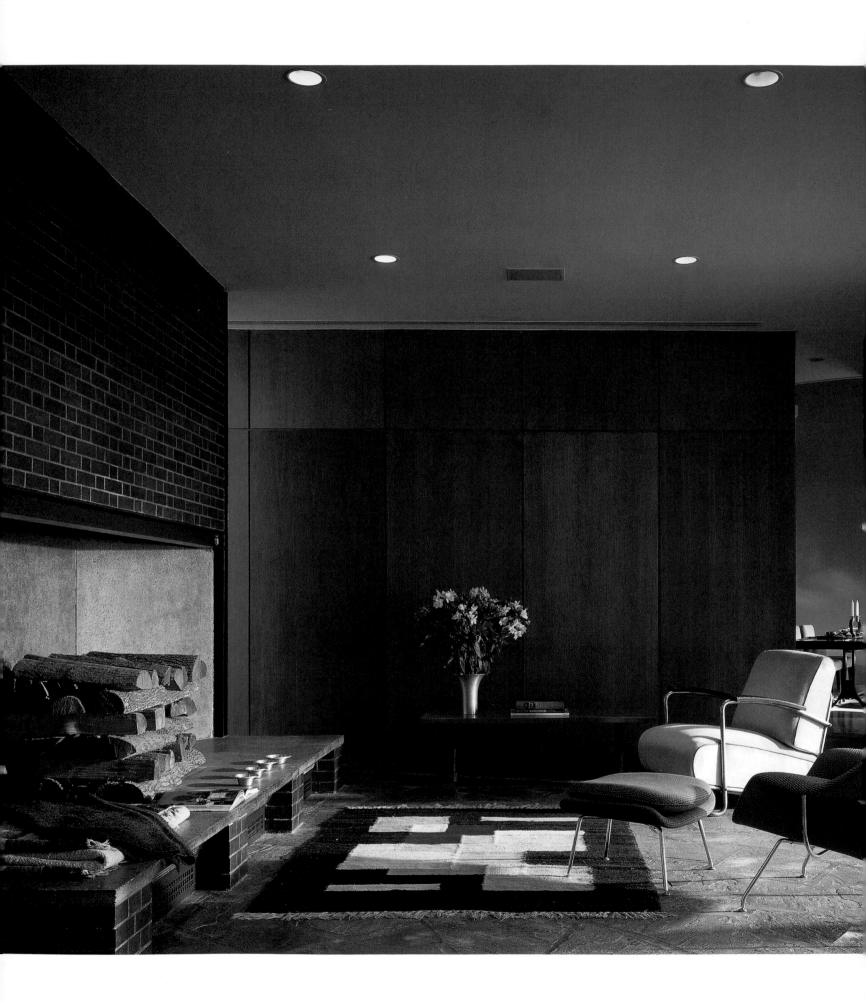

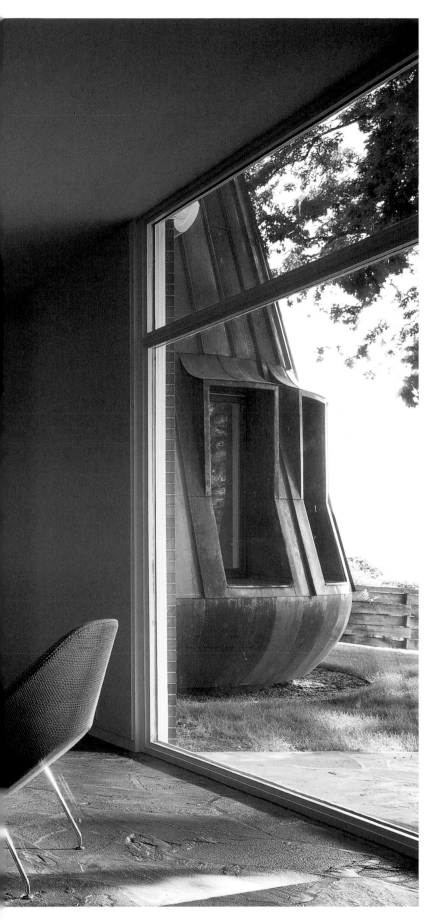

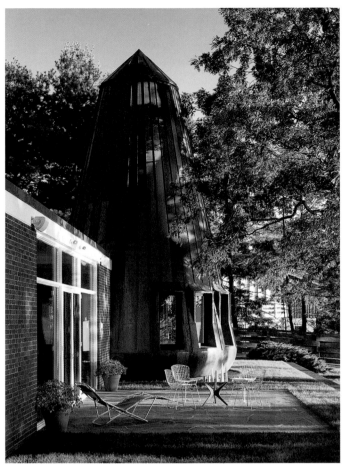

LEFT *The new and the old are tied together by placing the turret-like pavilion where its exterior can be seen from the living room of the original house. On the interior, a sliver of space opens from the living room to the dining room, helping to unify the two and accentuate the sense of spaciousness.*

ABOVE *The exterior of the dining room pavilion is a focal point for the living room patio and an intriguing shape for the patio to nestle against.*

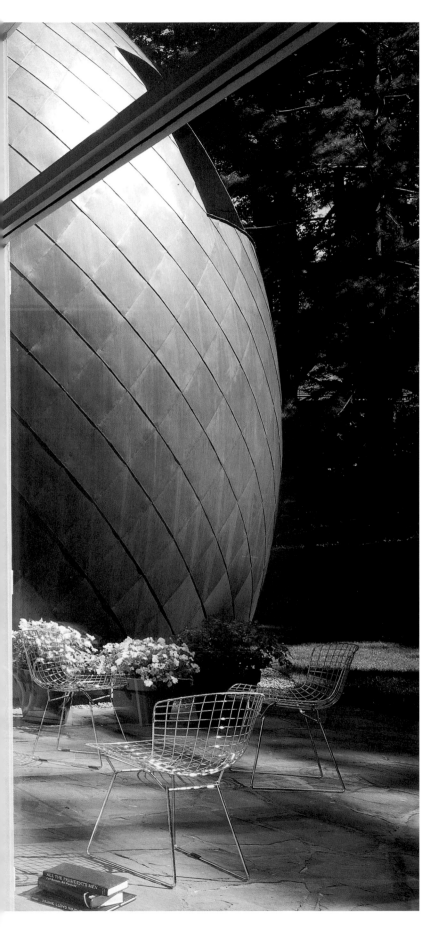

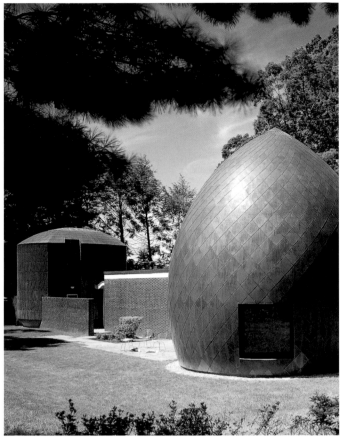

LEFT The entryway flooring of stone continues from the interior to the exterior of the house, blurring the line between inside and outside. Beside the outdoor terrace stands the new addition, which is entered via a hole in the brick wall beyond.

ABOVE The new additions are as dramatic in their shapeliness as the original house was dramatic in its minimalism.

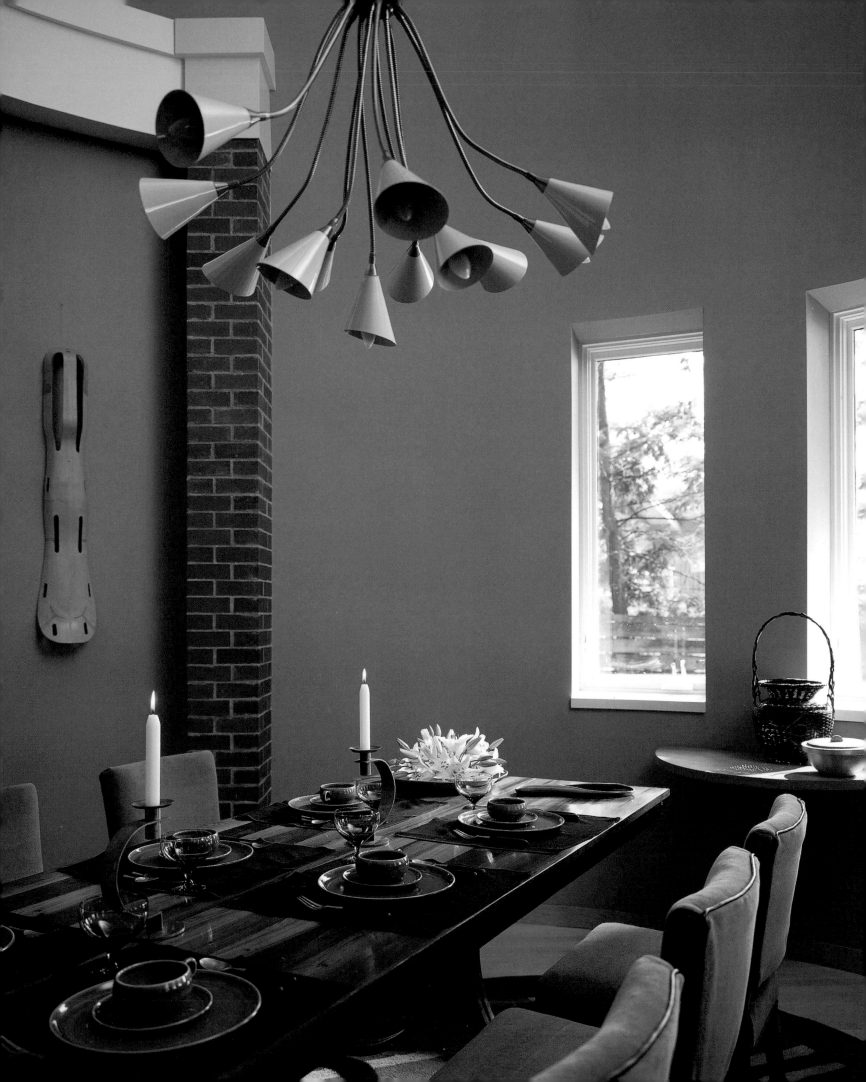

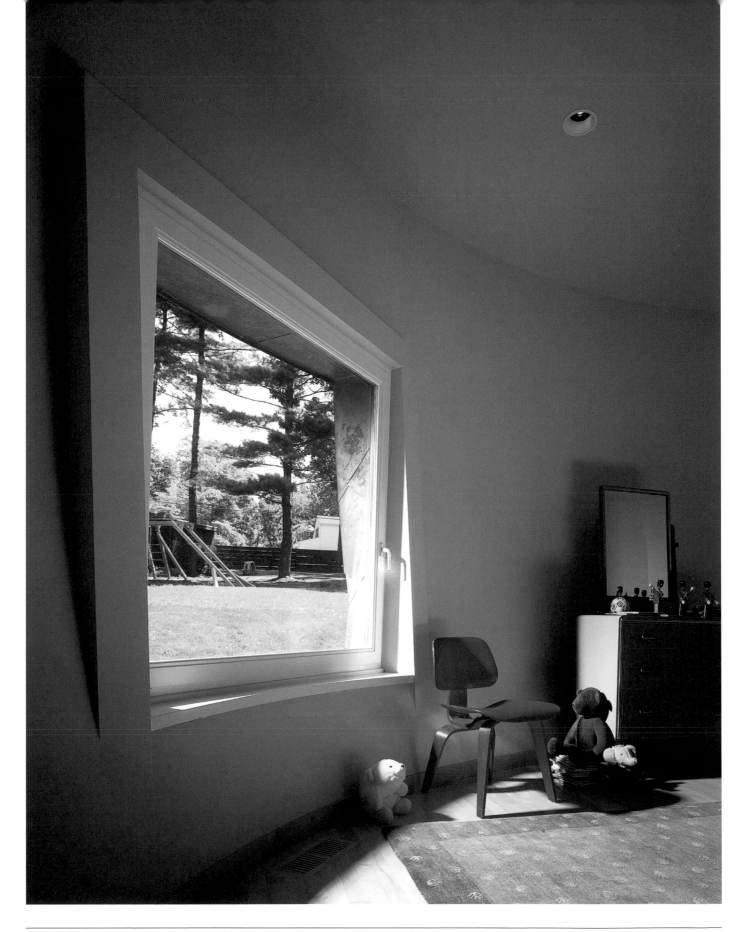

LEFT *The new dining room's plaster surfaces contrast with the rough texture of a bit of brick wall. The brick is part of a wall of the original house, its regularity playing off the dining room's curves.*

ABOVE *The interesting effect of placing a window in a shapely wall is illustrated by this window.*

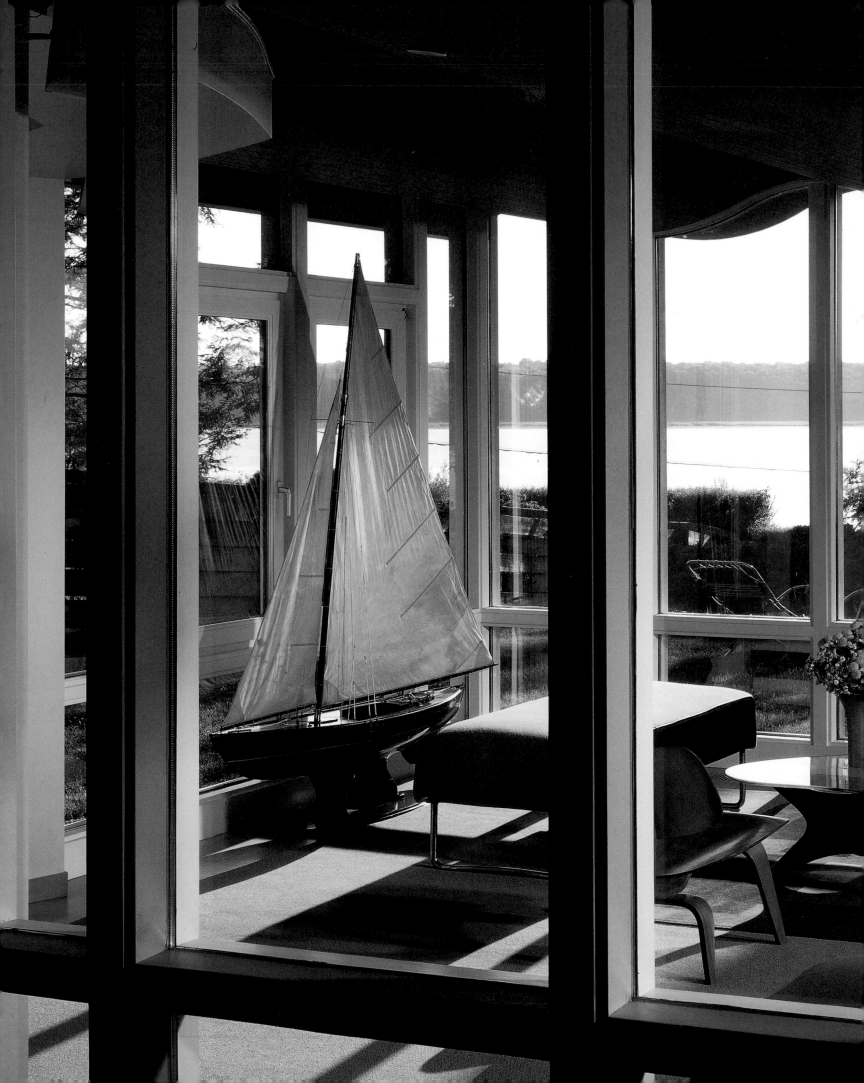

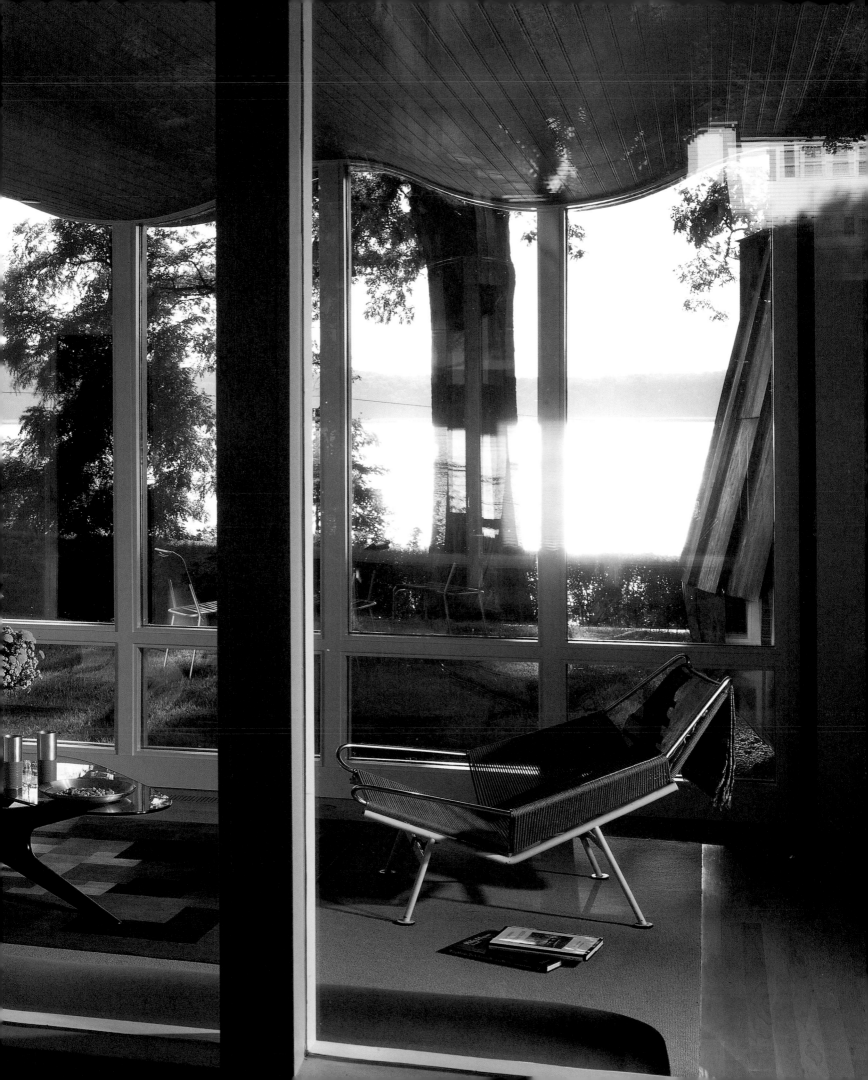

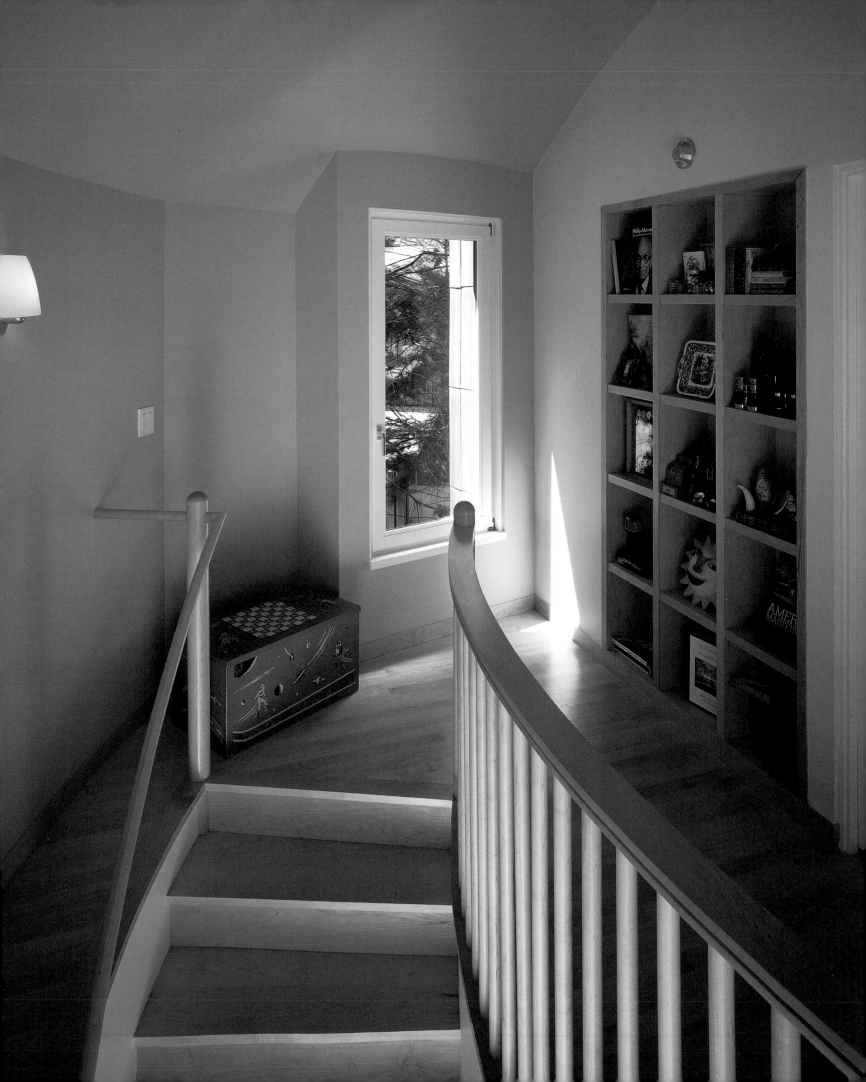

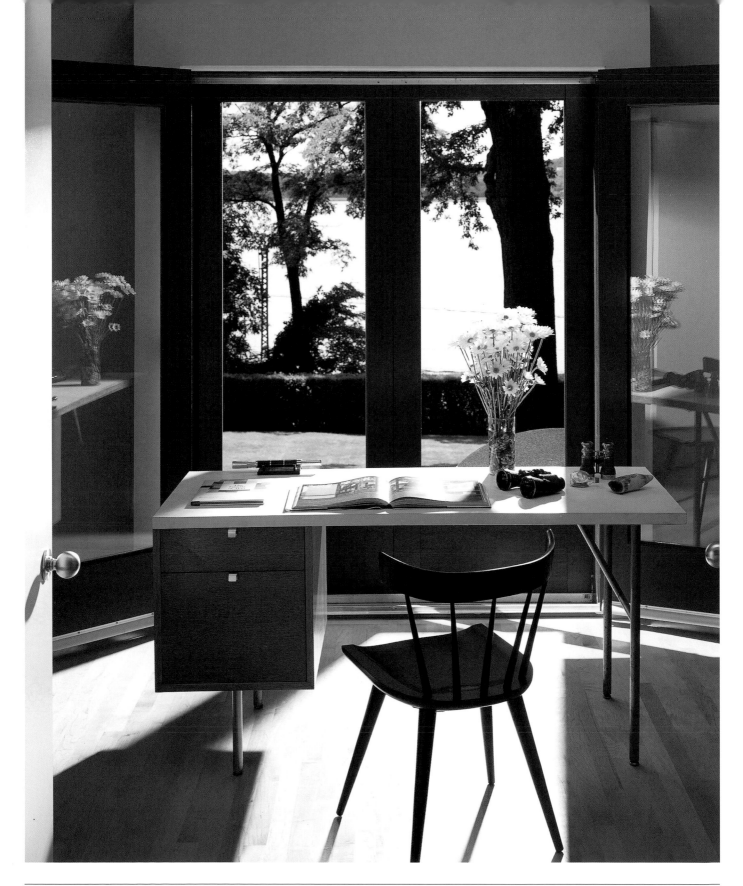

PREVIOUS PAGE The newly added family room is nearly surrounded by glass. This curtain wall, with its undulating top, not only provides for uninterrupted views of the river beyond, but also reflects the water and surrounding hills on its surface.

LEFT In this wing, the windows are set into deep notches into the curving volume. Note how on the interior, the window and its surround make for an interesting focal point at the top of the curving stairway.

ABOVE A potent enfilade is created by having a hallway open into a study, which then provides a vista through French doors to the river.

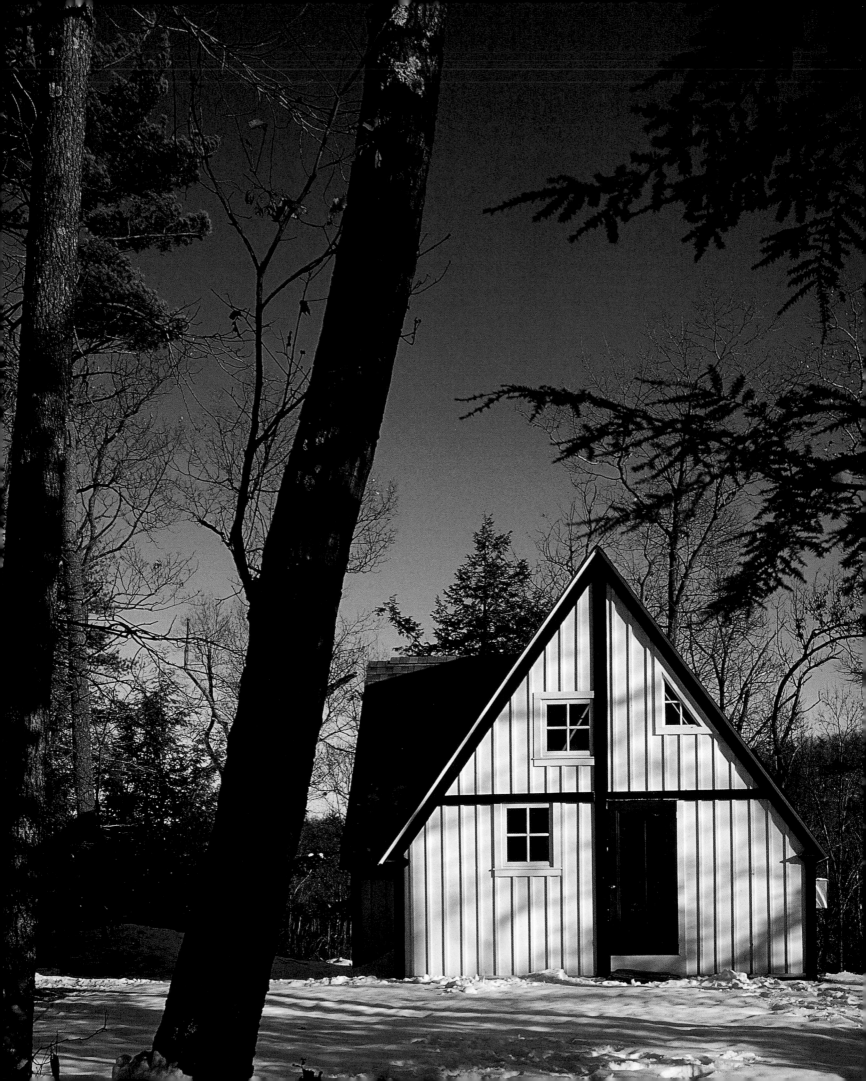

CLINTON CORNERS STUDIO

Though living in a good home is wonderful, living in a good place is truly amazing. When is a private property a place and not just a home? Part of the answer is that a place requires two or more buildings. A single good house can relate to its landscape, creating indoor and outdoor spaces of variety and interest. But when you not only build a good house but add another structure to the property—such as a pool house, guest quarters, a garden structure, or a barn—you have much greater picturesque potential; you have the ability to create a place. From certain angles the house will be seen all on its own, as will the outbuilding. From other angles both will be visible, and they will be juxtaposed in different ways at different turns.

A small property may be made to seem larger by placing a miniature building at a far end; an expansive landscape can be made more intimate by enclosing a portion with the sides of two or more structures. This artist's one-room studio is tiny, only 16 by 16 feet. Although the property here consists of many acres, it is thickly wooded. Placing this studio apart from the house in the trees, yet within sight, makes the woods appear less barren and foreboding.

The cottage and the studio carry on a dialogue, even though their architecture is different. The studio is even more petite, yet it is also divided. The house has natural, bark-colored siding with an earth-tone roof, whereas the studio is a white-painted building wrapped in a graphic black ribbon. Because of that difference, a person looking from the studio toward the house would get the impression that the house is somewhat distant, whereas when looking from the house to the studio, the distance seems shorter. This is an advantage to the composer who wants to feel as if the studio is not far away when he's in the house, and at the same time wants the house to feel miles away when he is in the studio. It is all about illusion—the trick of the picturesque landscape.

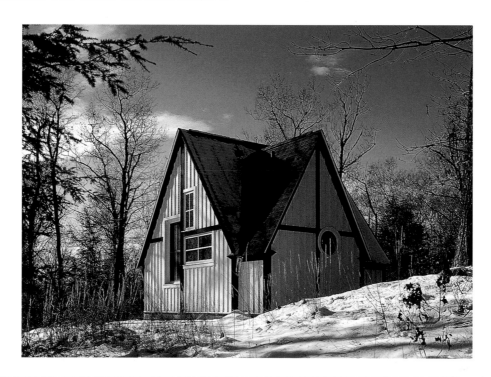

LEFT and ABOVE The studio obtains a rich texture and pattern of sun and shadow from its board-and-batten siding. The black cross of trim within each gable is essentially identical. However, the windows give each gable a dramatically different character—whimsical and partly transparent where three rectangular windows play off one another, more reclusive and mysterious where the wall is broken by a single circle of glass.

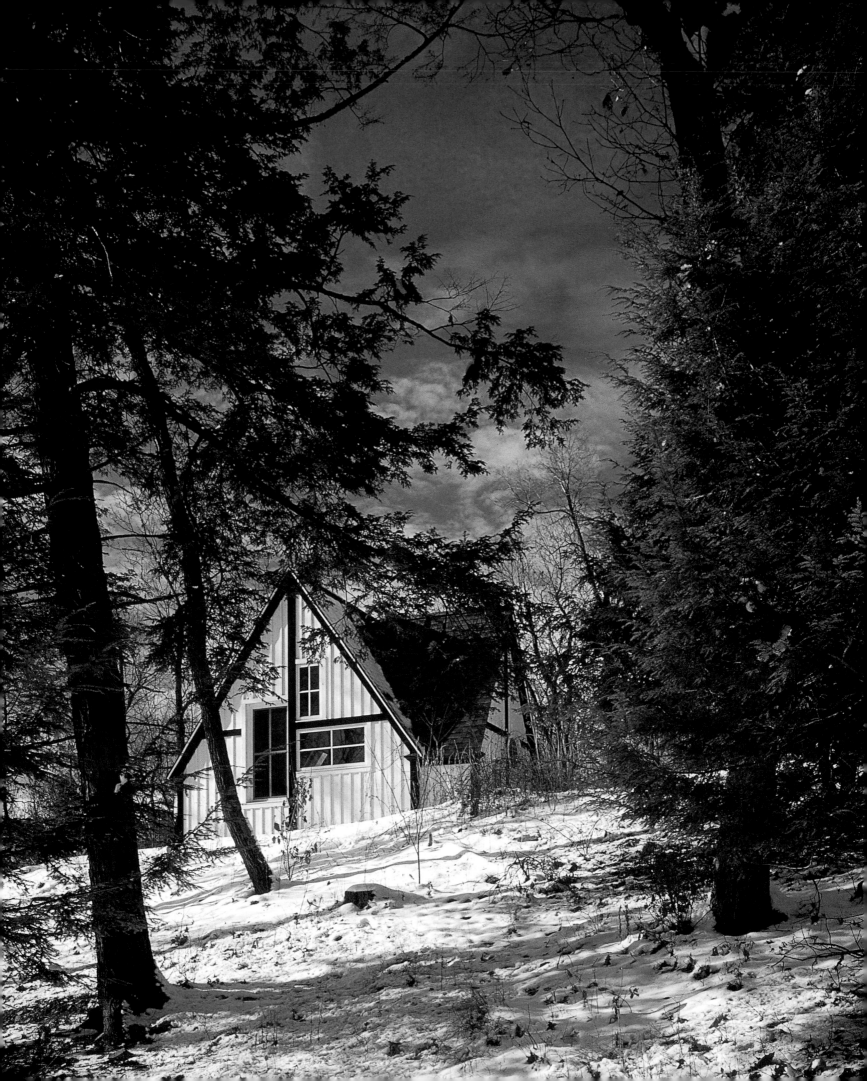

LEFT and ABOVE The composer's studio could be taken for a crazy house, with some of its windows placed almost willy-nilly. It has an air of strangeness and mystery, but it also has a pleasing quality of light indoors, and intriguing patterns of windows and trim against the cozy shapes of the walls and roof.

FOLLOWING PAGE The studio is set far enough away to feel remote and private, yet it is still within sight of the main house.

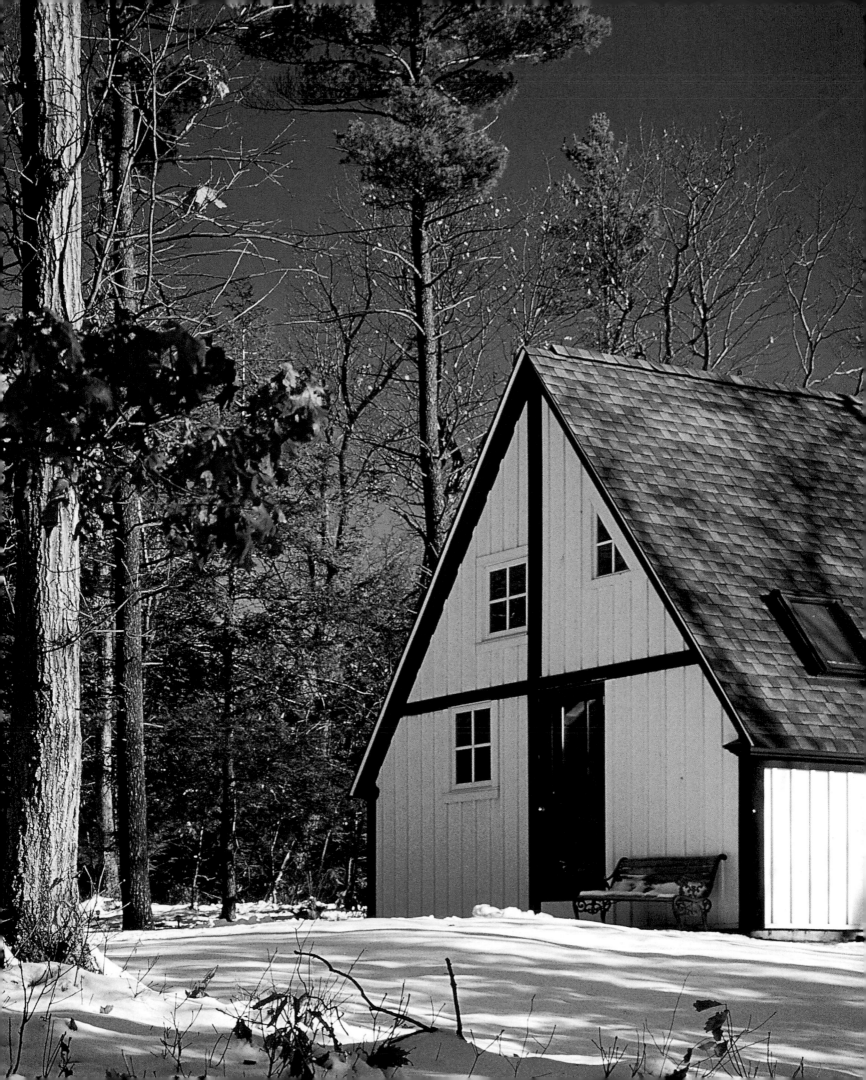

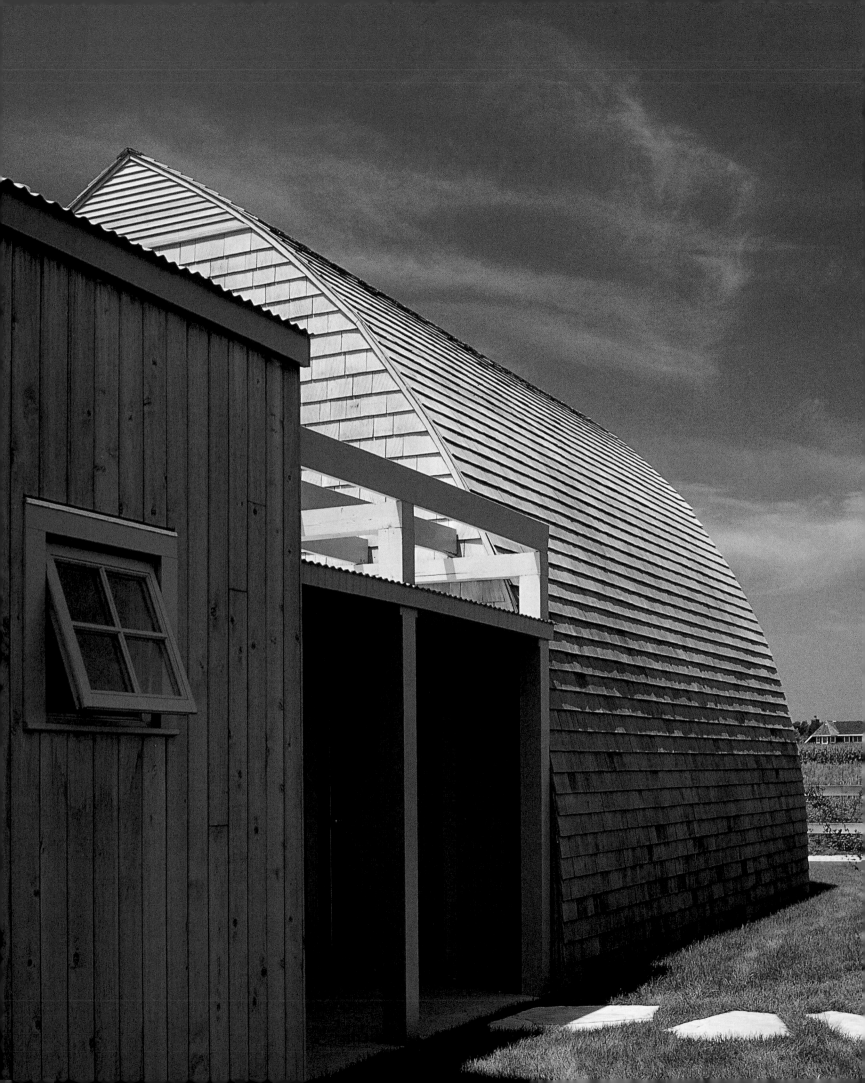

SAGAPONACK POOL HOUSE

There is no logic to a picturesque composition in the sense of specific rules. Adding to an arrangement of house and landscape in one way may produce desirable results; adding in a completely different way may also produce desirable results. It all depends on the desire. The feelings that people seek, the sentiment they long for, the harmony or the excitement they want—all these form the basis for good designs that vary from one another. Yet it's quite easy to make a mistake. For example, you may decide you wish to add to a composition in a way that is harmonious with the original because you love the existing buildings. But repeatedly adding wings or structures in keeping with the original theme can destroy the original, much as adding too much salt to a dish you're preparing will throw off the balance of other spices.

This pool house on the Sagaponack property was built to accompany a pool located a considerable distance from the house. The property was sliced from an open meadow and is shaped like a "C." One end contains the garden and play area, the middle contains the arc-shaped house, and the opposite end has the pool. The yards of neighboring houses fill the center, separating the garden and play area from the pool. The pool house's arc shape is designed to tie the pool to the homeowner's house rather than the closer residence of a neighbor. In addition, the smaller structure's distant position creates a context for its oddly shaped parent. To ensure that the house stands out as the property's main feature, the pool house is divided into sections. For the showers, locker rooms, and wet bar, one more arc would have been one too many, so I placed these functions in a different-shaped structure. The landscape around the pool also benefits from the variety of forms on the property.

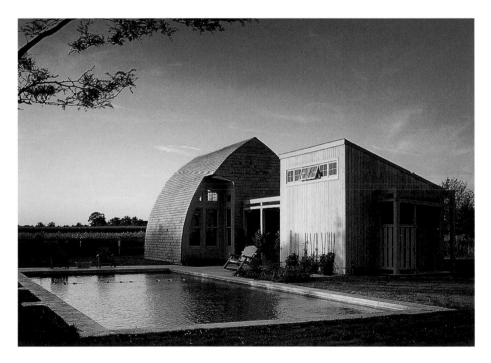

LEFT Despite their tremendously different forms, the pool house buildings are united by the soft tone of their wood exteriors. Curvature plays against flatness to create an intensely varied yet harmonious composition.

ABOVE LEFT Adding to the variety of shapes, the barnlike curved building has one symmetrical end with a prow at the peak and one asymmetrical end with the corner near the pool cut away, providing for a view of the pool from the inside (ABOVE RIGHT).

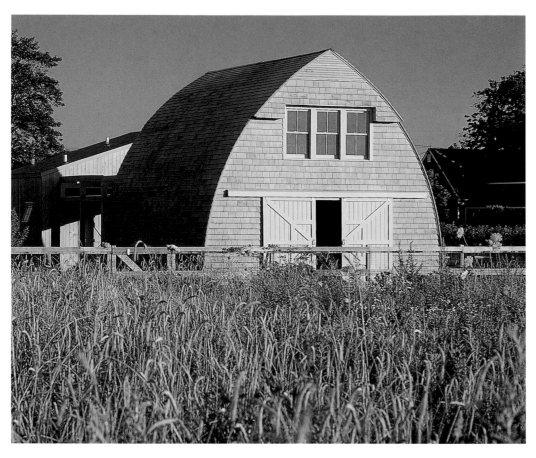

LEFT TOP Seen here, the barn like shape, split-rail fence, materials, colors, and textures all relate to the landscape.

LEFT BOTTOM From other angles, the structure becomes an ever-changing collection of forms.

RIGHT TOP The barnlike building gains an interesting complexity from the carving away of a corner volume for windows. The flat-sided, angular building retains a powerful simplicity with windows laid onto the surface, not cutting into its volume.

RIGHT BOTTOM The trellis-like breezeway strengthens the composition by tying the opposing volumes together.

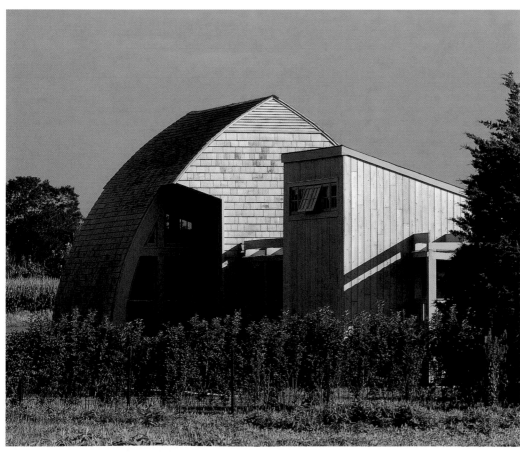

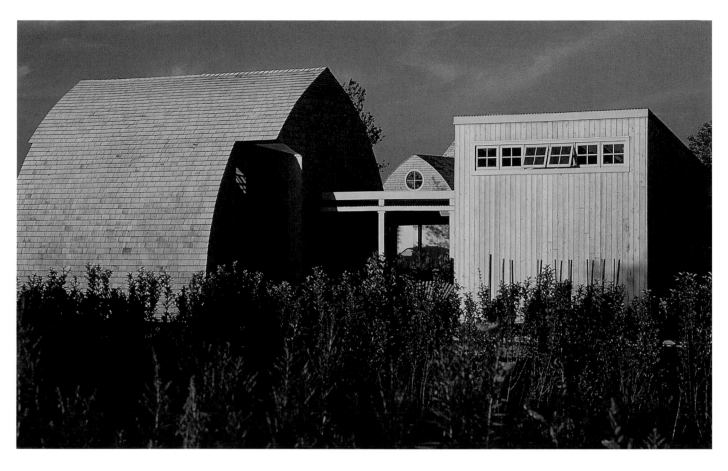

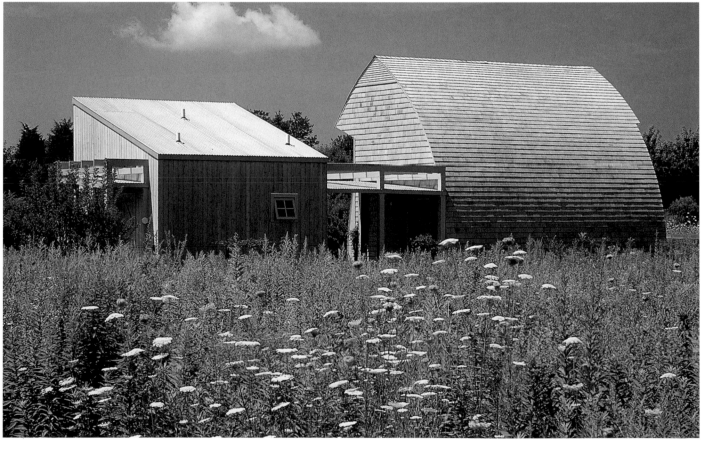

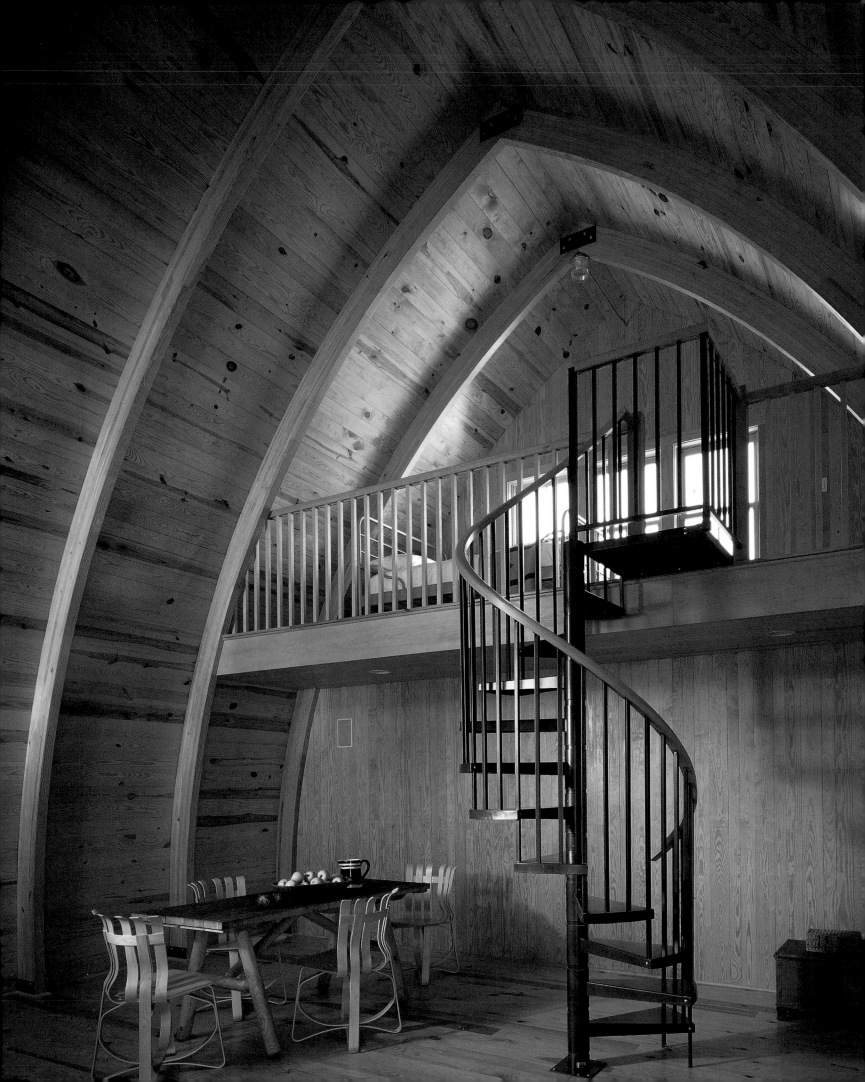

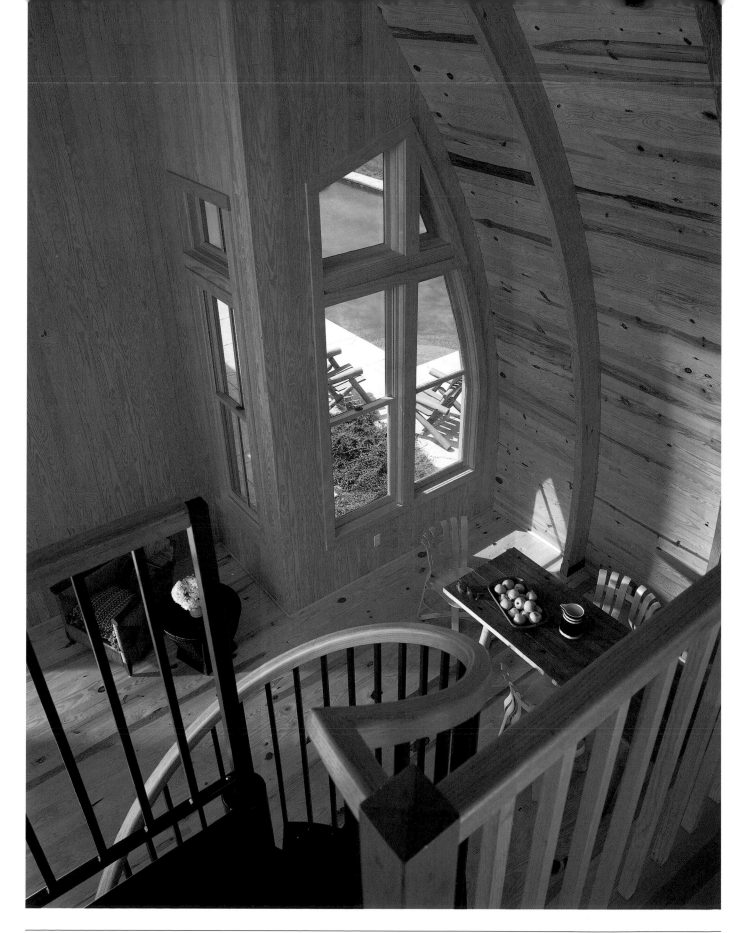

ABOVE and *LEFT* The spiral staircase creates a focal point for the pool house and is an enticing way to reach the loft. The knotty pine underside of the roof contrasts with clear pine surfaces.

FOLLOWING PAGE The pool house complex and the main house in the background make a varied but harmonious composition in the landscape.

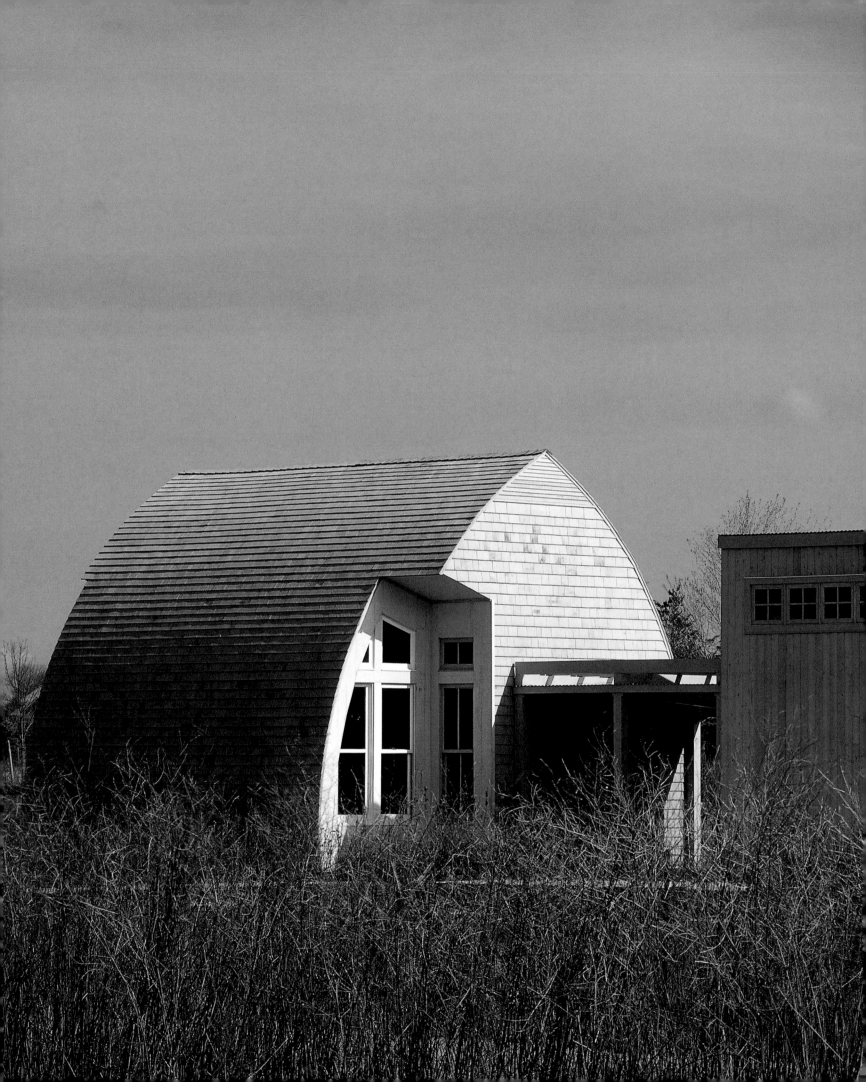

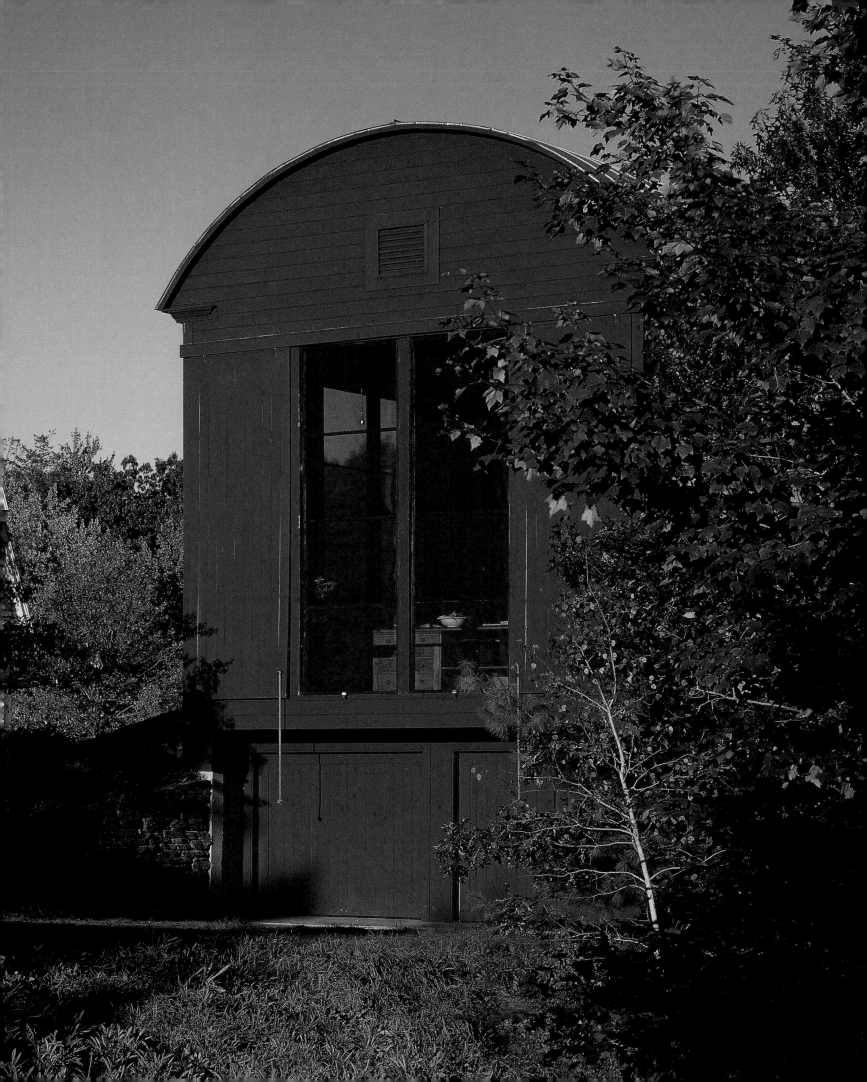

KINDERHOOK BARN

In architecture there is a term for when one building visually affects another: architects say the two structures have a dialogue. Generally, saying that a dialogue exists between buildings is a positive statement; it implies that the buildings enhance each other visually. In an unexpected way, two buildings that use very different picturesque techniques sometimes render a new, more dynamic overall picturesque composition. The barn built on my property was intended to speak well of my house by contrast, rather than complement. Not using any techniques to reduce the visual impact of the barn's largeness had the effect of highlighting the house's small size. The barn's lack of detail emphasizes the many details of the house. The barn's simple volume and shallow, curved roof call attention to the house's sharp angles and complex volumes.

This kind of picturesque composition has risen throughout the rural landscape, often without architectural intent. Simple barns have frequently been constructed solely for practical purposes, at low costs and with little attention to detail. At the same time, houses have been given a bit more detail, sometimes as much as the budget would allow. These unintentional compositions establish a romantic precedent for recreating them. The functions accommodated by this particular barn did not require a structure that looked like a barn. Yet having the building resemble a barn helps to create a rural place, even though its actual setting may verge on suburban. On this property, with house and barn in your vista, all the tranquility and innocence of farm life are present, even though not a single animal or crop is to be found on the premises.

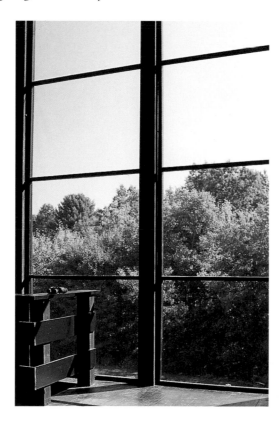

LEFT The tall barn, almost somber in its round-roofed symmetry, is a stunningly strong form. Yet from the inside the barn, what's most noticeable is how much it feels like the outdoors.

ABOVE, LEFT AND RIGHT Big openings in the walls look out onto trees, grassland, and the adjoining house.

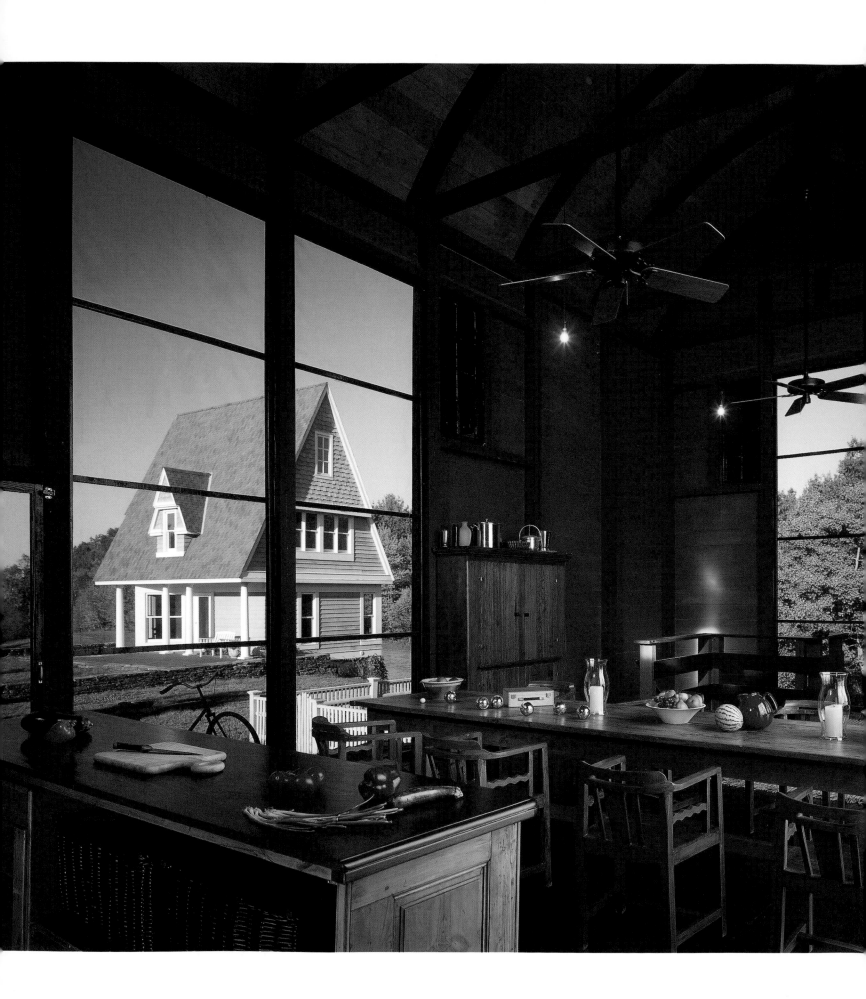

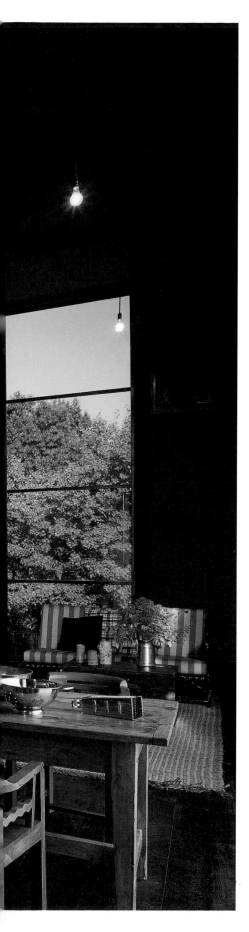

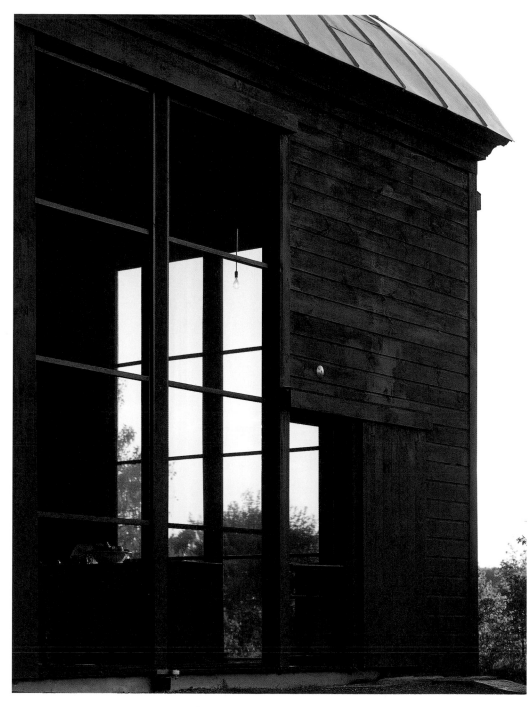

LEFT With its fairly elaborate design, the main house holds its own. Exposed structure inside the barn reinforces the feeling of a big volume.

ABOVE Tall windows give views into the barn and then out again.

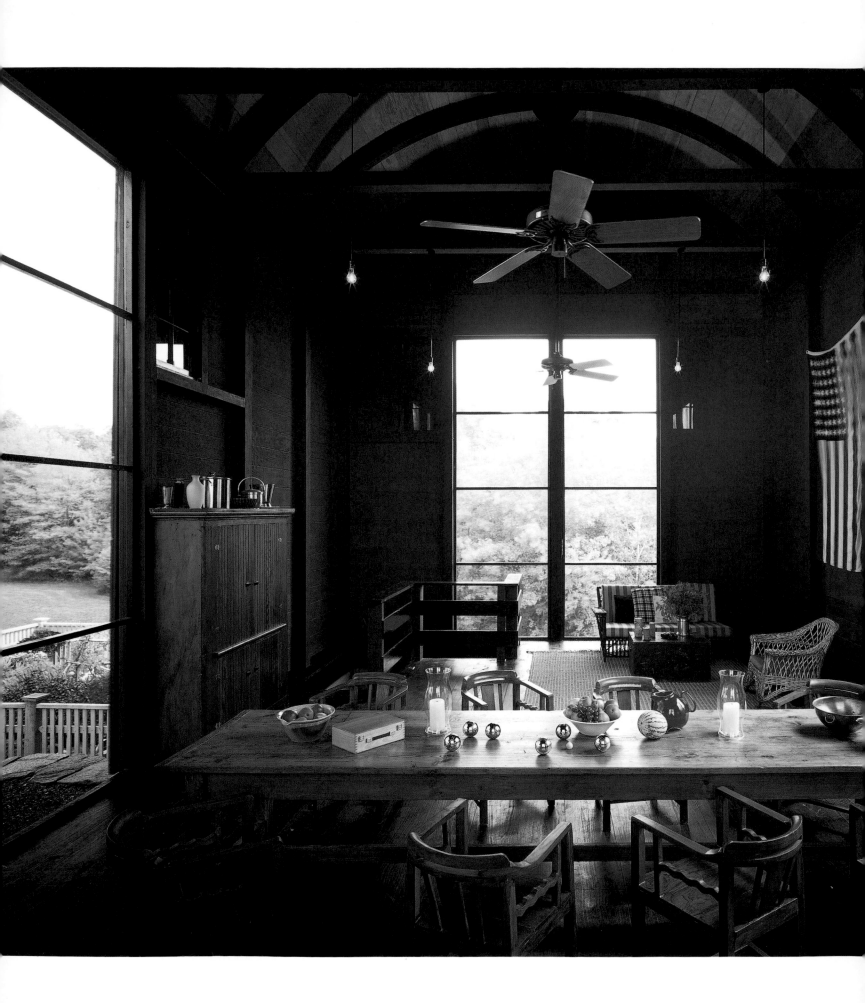

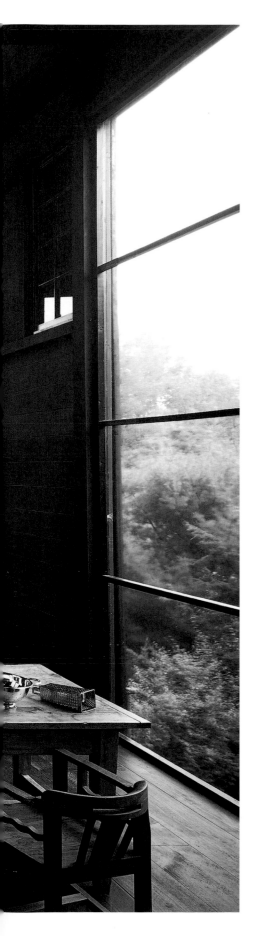

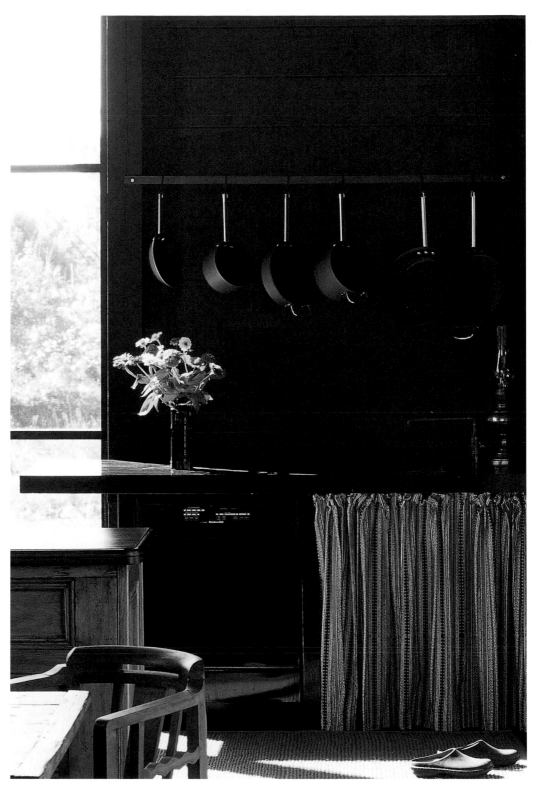

LEFT *The barn is a high space reminiscent of a basilica. It uses the technique of enfilade to create continuity between inside and outside in two directions.*

ABOVE *The pot rack spans the exposed timber-frame structure.*

FOLLOWING PAGE *The barn is twice as large in volume as the house, but its monochromatic exterior keeps it in the background.*

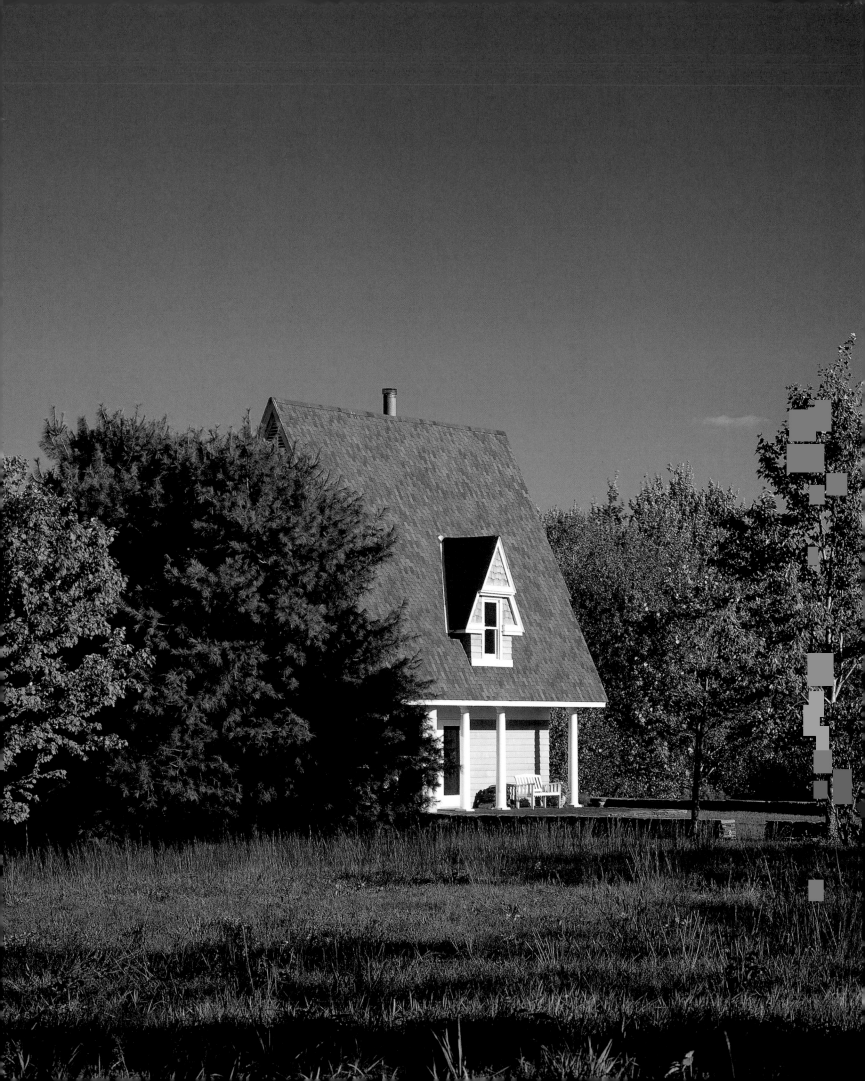

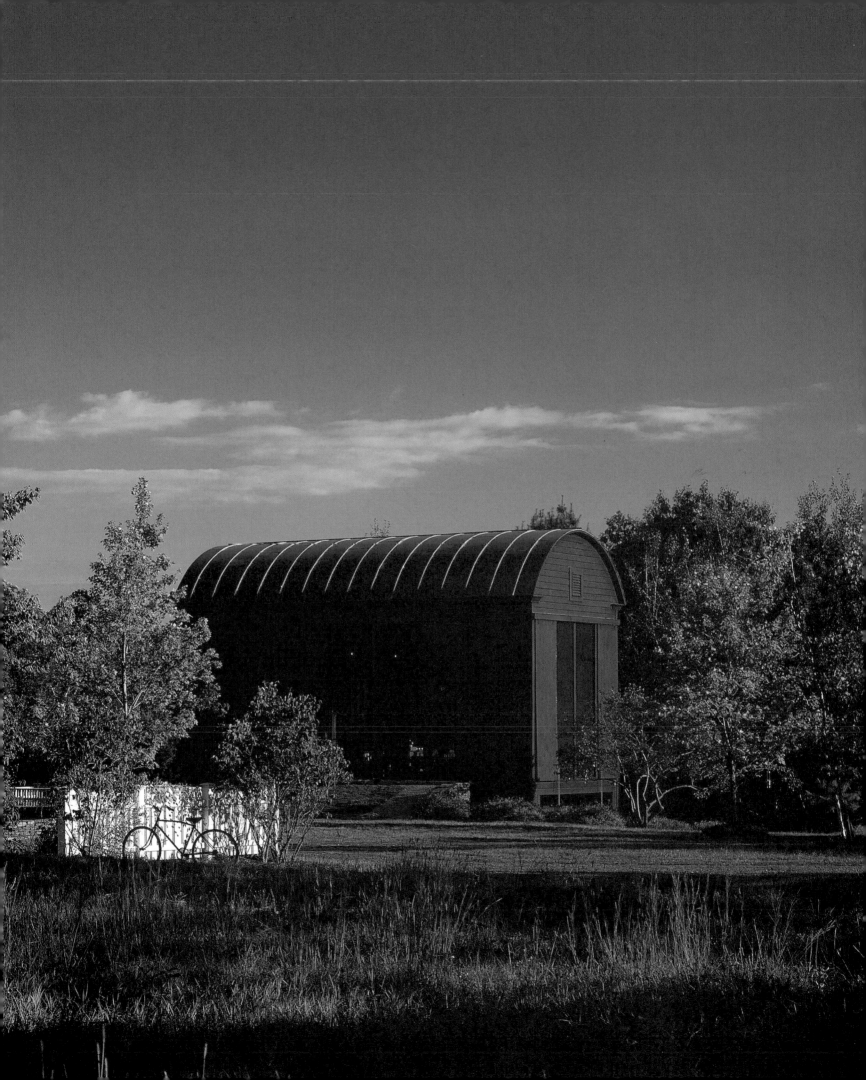

KINDERHOOK HOUSE

PAGES 54–65

FIG. 1
FRONT ELEVATION

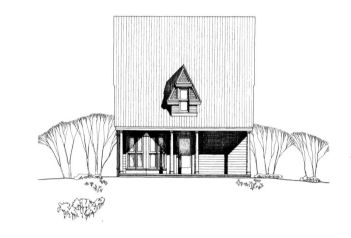

FIG. 2
LEFT ELEVATION

FIG. 3
REAR ELEVATION

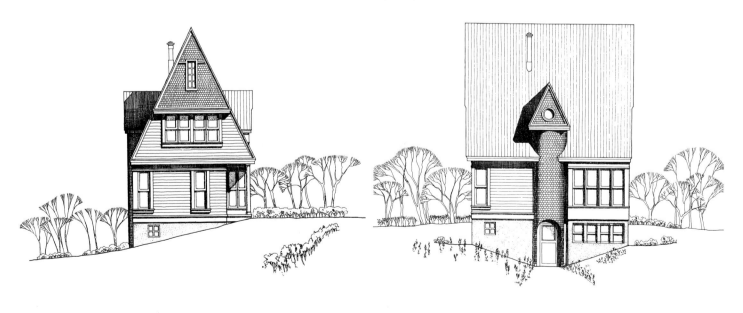

FIG. 4

SECOND-FLOOR PLAN

F. Master Bedroom

G. Hall (Loft Above)

H. Guest Bedroom

FIG. 5

FIRST-FLOOR PLAN

A. Entry Porch

B. Dining Area

C. Living Area

D. Kitchen

E. Bath

MAPLE GROVE HOUSE

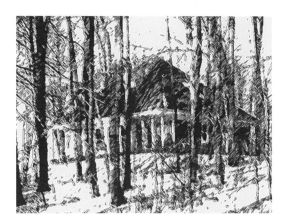

PAGES 74–83

FIG. I
FRONT ELEVATION

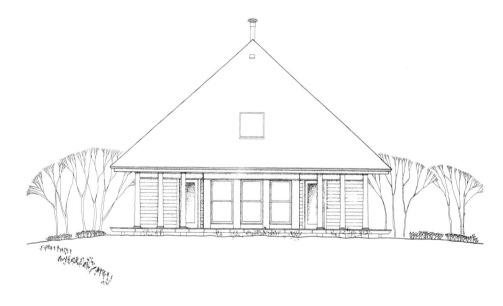

FIG. 2
RIGHT ELEVATION

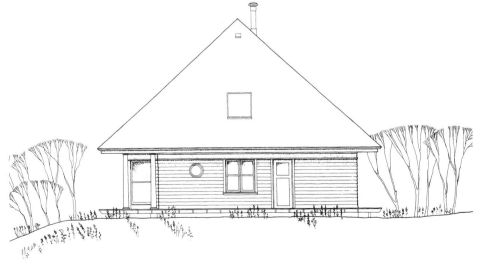

FIG. 3
SECOND-FLOOR PLAN

K. Open to Below

L. Hallway

M. First Bedroom

N. Master Sitting Room

O. Master Bedroom

P. Dressing Vestibule

Q. Master Bath

R. Bath

S. Dressing Vestibule

FIG. 4
FIRST-FLOOR PLAN

A. Entry Porch

B. Dining Room

C. Dining Porch

D. Guest Room

E. Living Room

F. Study

G. Bath

H. Kitchen

J. Mud Room

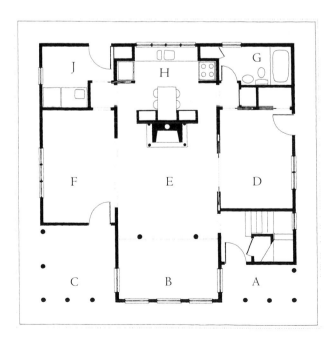

SAGAPONACK ARC

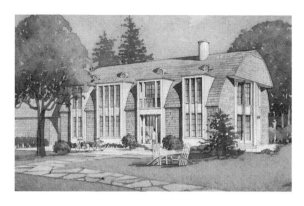

PAGES 84–95

FIG. 1
LEFT ELEVATION

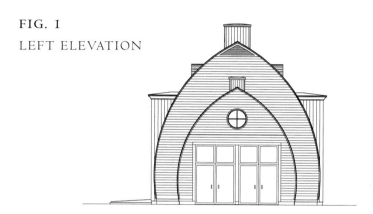

FIG. 2
RIGHT ELEVATION

FIG. 3
FRONT ELEVATION

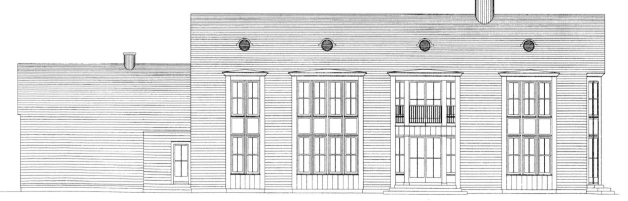

FIG. 4
SECOND-FLOOR PLAN

K. Office

L. Bedroom

M. Bedroom

N. Bedroom

O. Master Bedroom

P. Master Bath

Q. Porch

R. Open to Below

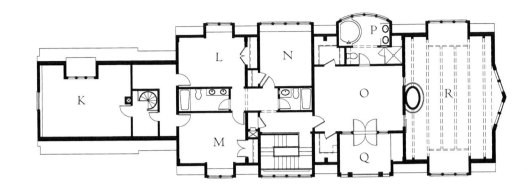

FIG. 5
FIRST-FLOOR PLAN

A. Entry Porch

B. Entry Hall

C. Living/Dining Room

D. Country Kitchen

E. Family Room

F. Bedroom

G. Bedroom

H. Mud Room

J. Garage

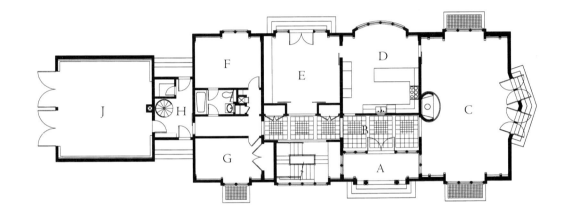

FIG. 6
SECTION

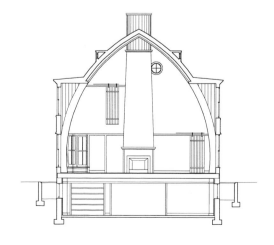

FIG. 7
SECTION

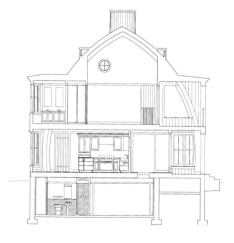

CLINTON CORNERS COTTAGE

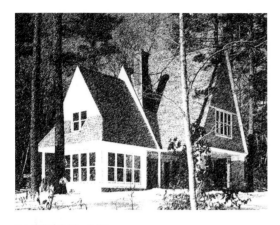

PAGES 148–155

FIG. I

FRONT ELEVATION

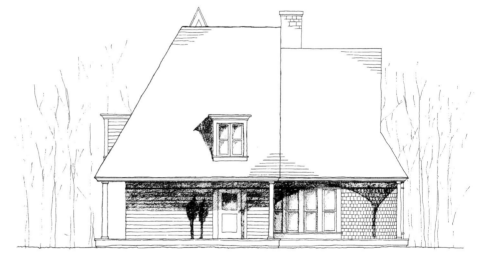

FIG. 2

RIGHT ELEVATION

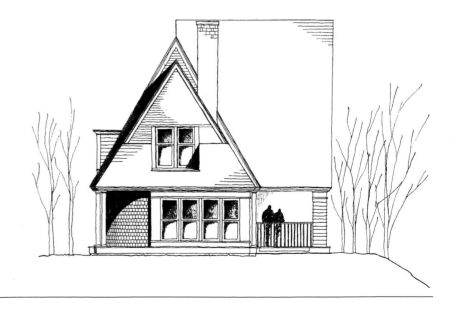

FIG. 3
SECOND-FLOOR PLAN

H. Hall

J. Bedroom

K. Master Bedroom

L. Bath

FIG. 4
FIRST-FLOOR PLAN

A. Entry Porch

B. Entry Hall

C. Dining Area

D. Living Area

E. Back Porch

F. Kitchen

G. Stair Hall

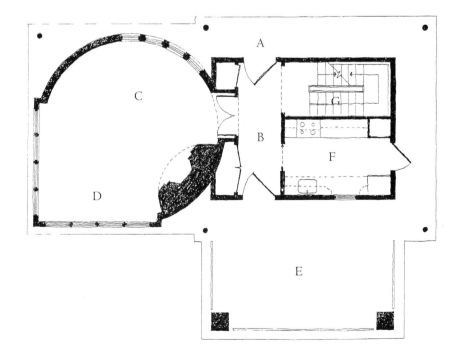

FORESTBURG HOUSE

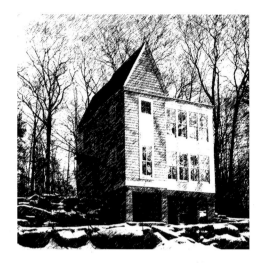

PAGES 156–163

PAGES 156–163

FIG. 1
FRONT ELEVATION

FIG. 2
RIGHT ELEVATION

FIG. 3
LEFT ELEVATION

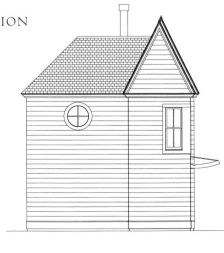

FIG. 5
SECOND-FLOOR PLAN

K. Stair Hall

L. Master Bedroom

M. Study

N. Wash Room

O. Bath

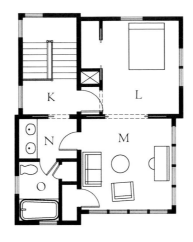

FIG. 4
FIRST-FLOOR PLAN

A. Entry/Stair Hall

B. Living Room

C. Dining Room

D. Kitchen

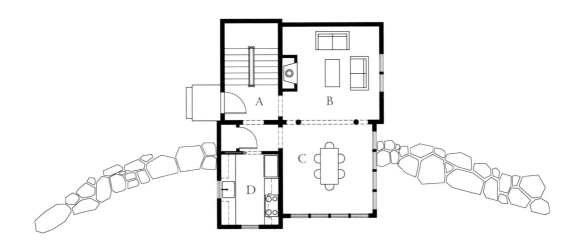

FIG. 5
LOWER FLOOR PLAN

E. Stair Hall/Laundry

F. Guest Bedroom

G. Bath

H. Mechanical

J. Porch

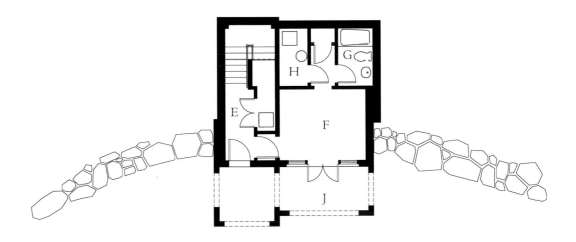

MALDEN BRIDGE HOUSE

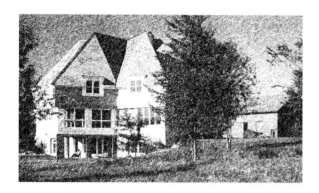

PAGES 164–177

FIG. I

FRONT ELEVATION

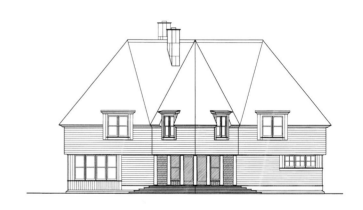

FIG. 2

RIGHT ELEVATION

FIG. 3

REAR ELEVATION

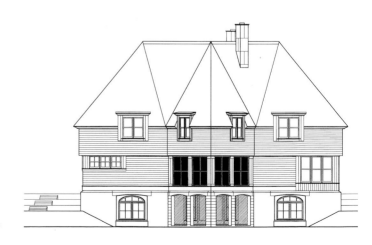

FIG. 4
SECOND-FLOOR PLAN

J. Bedroom

K. Master Sitting Room

L. Master Bath

M. Master Bedroom

N. Bedroom

O. Bedroom

P. Bath

Q. Bath

FIG. 5
FIRST-FLOOR PLAN

A. Entry Porch

B. Entry

C. Living Room

D. Dining Room

E. Breakfast Room

F. Screen Porch

G. Kitchen

H. Study

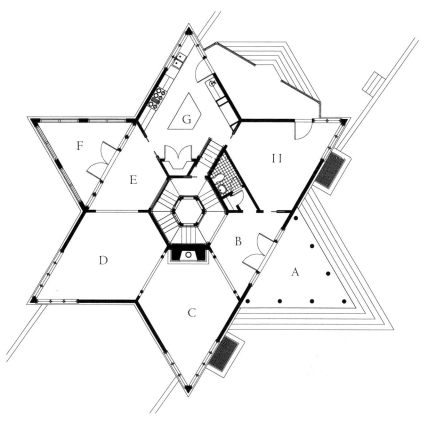

ADDITIONS TO ONETA HOUSE

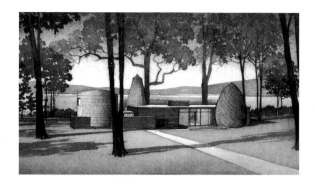

PAGES 178–189

FIG. 1
FRONT ELEVATION

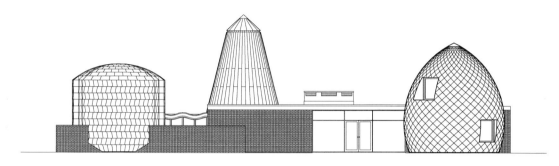

FIG. 2
REAR ELEVATION

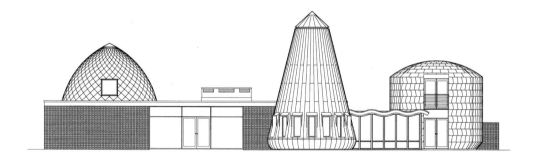

FIG. 3
RIGHT ELEVATION

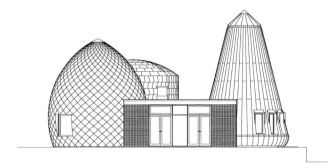

FIG. 4

SECOND-FLOOR PLAN

L. Hall

M. Study

N. Open to Below

O. Bedroom

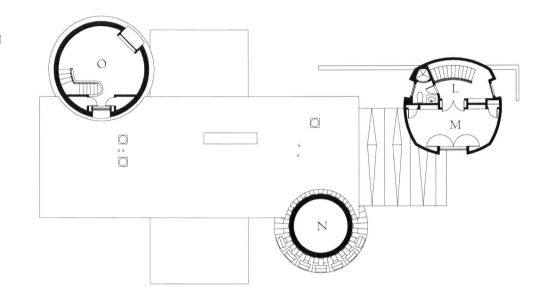

FIG. 5

FIRST-FLOOR PLAN

A. Entry Hall

B. Living Room

C. Dining Room

D. Kitchen

E. Family Room

F. Bedroom

G. Mud Room

H. Bedroom

J. Bedroom

K. Master Bedroom

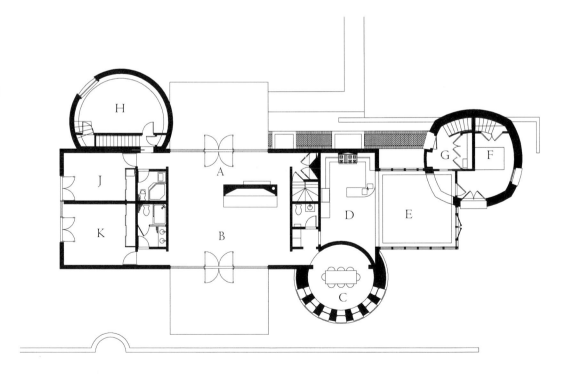

SAGAPONACK POOL HOUSE

PAGES 196–203

FIG. 1

RIGHT ELEVATION

FIG. 2

FRONT ELEVATION

FIG. 3

REAR ELEVATION

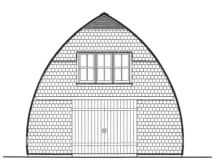

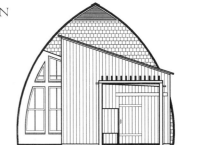

FIG. 4
FLOOR PLAN

A. Storage

B. Recreation Room

C. Pergola

D. Bath House

E. Pool

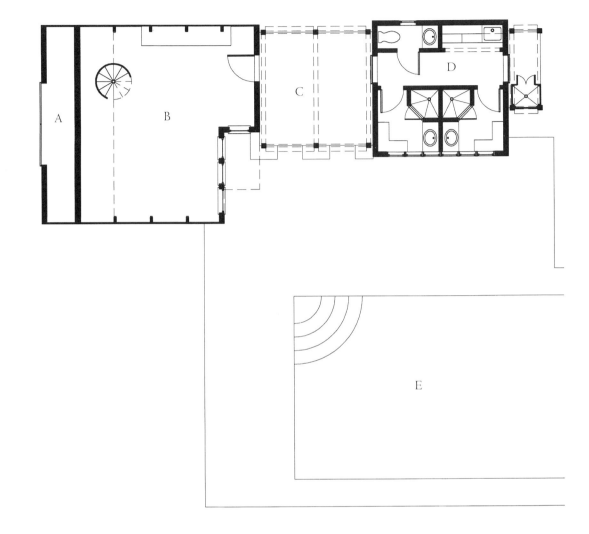

FIG. 5
CROSS SECTION

FIG. 6
LONGITUDINAL
SECTION

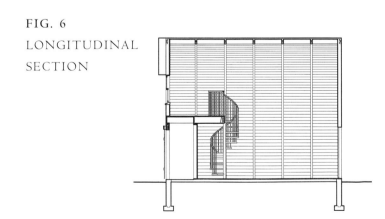

KINDERHOOK BARN

PAGES 204–211

PAGES 204–211

FIG. I
FRONT ELEVATION

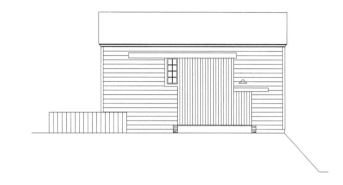

FIG. 2
REAR ELEVATION

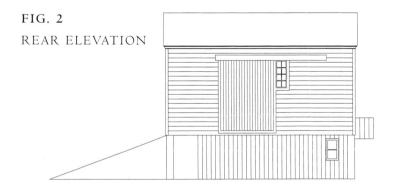

FIG. 3
RIGHT ELEVATION

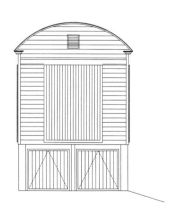

FIG. 4
FLOOR PLAN

A. Great Room
B. Kitchen

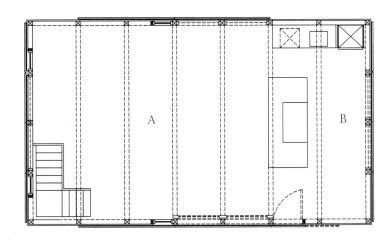

FIG. 5
LONGITUDINAL
SECTION

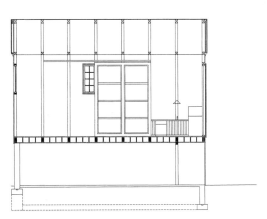

FIG. 6
CROSS SECTION

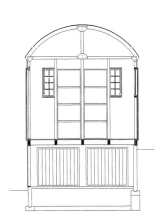

LIBERTY HOUSE

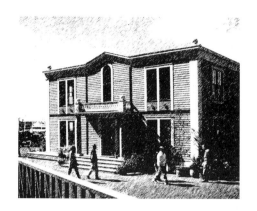

PAGES 24, 35, 43, 46, 49

FIG. 1
FRONT ELEVATION

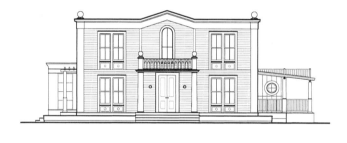

FIG. 2
RIGHT ELEVATION

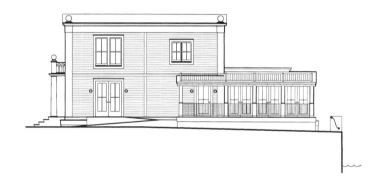

FIG. 3
REAR ELEVATION

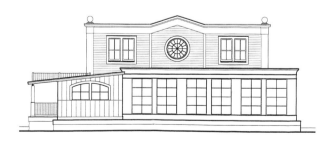

FIG. 4
LEFT ELEVATION

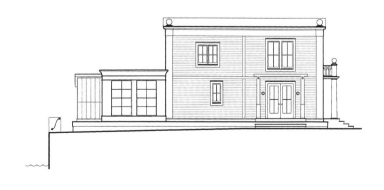

FIG. 5

SECOND-FLOOR PLAN

J. Open to Below

K. Guest Bedroom

L. Guest Bath

M. Master Bath/Dressing Room

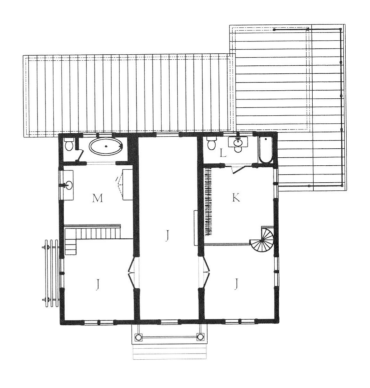

FIG. 6

FIRST-FLOOR PLAN

A. Great Hall

B. Family Room

C. Kitchen

D. Study

E. Mud Room

F. Laundry Room

G. Guest Suite

H. Master Suite

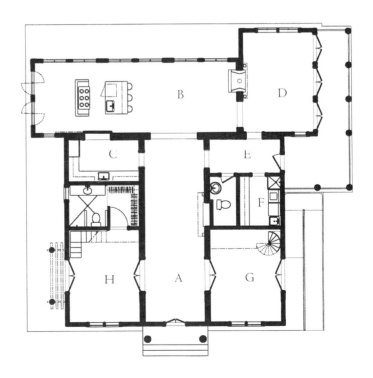

CLERMONT RESIDENCE

PAGE 27

FIG. 1

REAR ELEVATION

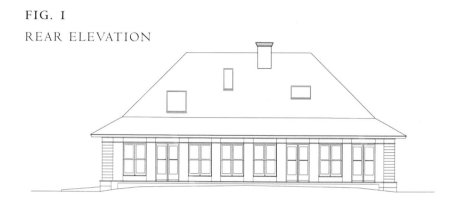

FIG. 2

LEFT ELEVATION

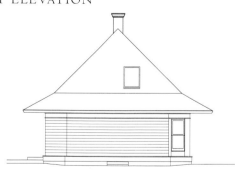

FIG. 3

FRONT ELEVATION

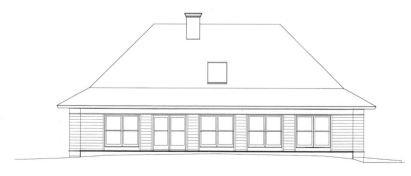

FIG. 4
SECOND-FLOOR PLAN

J. Bath

K. Bedroom

L. Stair Hall

M. Bedroom

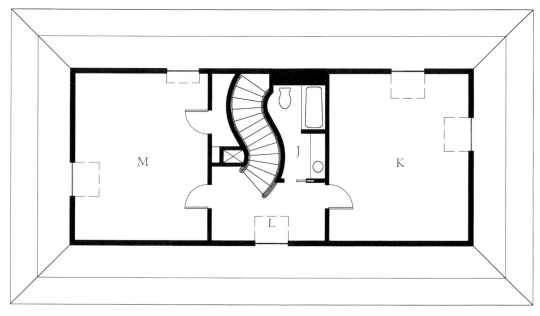

FIG. 5
FIRST-FLOOR PLAN

A. Entry

B. Living/Dining Room

C. Kitchen

D. Powder Room

E. Study

F. Master Bedroom

G. Master Bath

H. Storage

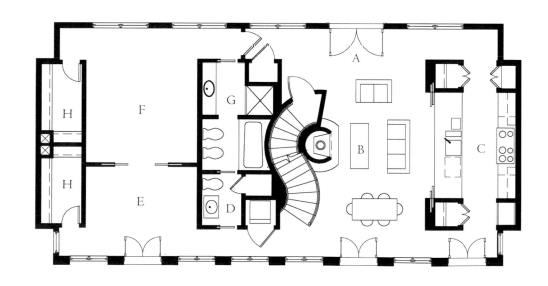

SCANDINAVIAN COTTAGE

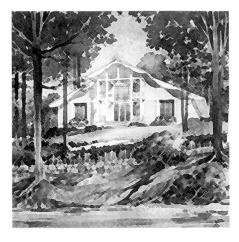

PAGES 45, 53, 140

FIG. I
FRONT ELEVATION

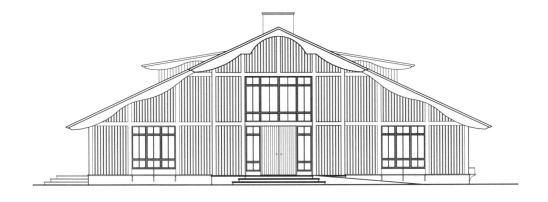

FIG. 2
SIDE ELEVATION

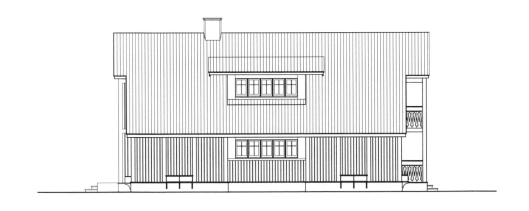

FIG. 3
FLOOR PLAN

A. Front Porch

B. Entry Hall

C. Living Area

D. Dining Area

E. Kitchen

F. Bedroom

G. Office/Guest Bedroom

H. Rear Porch

J. Master Bath

K. Master Sitting Room

L. Master Bedroom

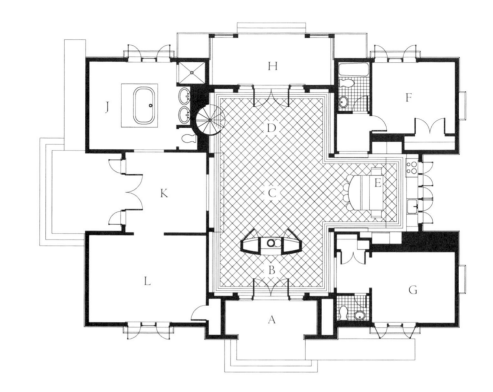

FIG. 4
LONGITUDINAL SECTION

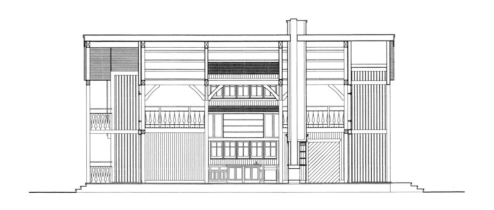

SOUTH HAMPTON HOUSE

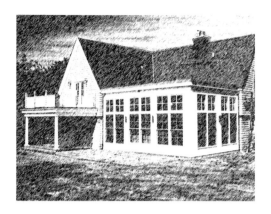

PAGES 20, 21, 26, 124

FIG. 1

FRONT ELEVATION

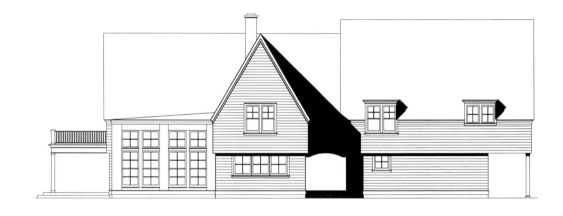

FIG. 2

REAR ELEVATION

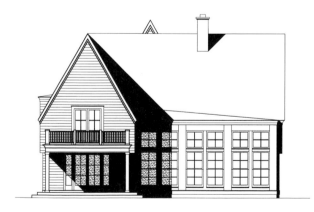

FIG. 4

SECOND-FLOOR PLAN

J. Stair Hall

K. Bedroom

L. Open to Below

M. Master Bedroom

N. Master Bath

O. Master Porch

P. Bedroom

Q. Bedroom

R. Guest Suite

FIG. 5

FIRST-FLOOR PLAN

A. Entry

B. Entry Hall

C. Living Room

D. Dining Room

E. Kitchen

F. Guest Bedroom

G. Rear Porch

H. Garage

INDEX

INDEX